Horror Film and Affect

Challenging theories of abjection, complicating cognitivism and recalibrating approaches to identification, this work brilliantly embodies the future of Horror Studies. Xavier Aldana Reyes slashes through received wisdoms: whether tackling New French Extremity, digital found footage, or the multiplex 3D movie, *Horror Film and Affect* is never less than razor sharp.
—Matt Hills, Professor of Film and TV Studies at Aberystwyth University and author of *The Pleasures of Horror* (2005)

Aldana Reyes presents a powerful, directly experiential approach to body horror which will have lasting impact on the field of horror film spectatorship. His innovative "affective-corporeal" somatic model considers how the affective encounter with abject images of torture, pain and dismemberment works not just to frighten and repel but to mobilise our emotional empathy.
—Anna Powell, Research Fellow at Manchester Metropolitan University and author of *Deleuze and Horror Film* (2005)

Aldana Reyes' book gathers insightful excursions into the twisted realm of affect and horror cinema, and finally manages to re-evaluate and fuse influential body theories in his courageous and very original genre criticism.
—Marcus Stiglegger, Lecturer in Film Studies at the University of Siegen, Germany, and author of *Terrorkino: Angst/Lust und Körperhorror* (2010)

This book brings together various theoretical approaches to Horror that have received consistent academic attention since the 1990s – abjection, disgust, cognition, phenomenology, pain studies – to make a significant contribution to the study of fictional moving images of mutilation and the ways in which human bodies are affected by those on the screen on three levels: representationally, emotionally and somatically. Aldana Reyes reads Horror viewership as eminently carnal, and seeks to articulate the need for an alternative model that understands the experience of feeling under corporeal threat as the genre's main descriptor. Using recent, post-millennial examples throughout, the book also offers case studies of key films such as *Hostel*, *[●REC]*, *Martyrs* or *Ginger Snaps*, and considers contemporary Horror strands such as found footage or 3D Horror.

Xavier Aldana Reyes is Senior Lecturer in English Literature and Film at Manchester Metropolitan University, UK.

Routledge Advances in Film Studies

For a full list of titles in this series, please visit www.routledge.com.

Horror Film and Affect
Towards a Corporeal Model of Viewership

Xavier Aldana Reyes

Routledge
Taylor & Francis Group

NEW YORK AND LONDON

First published 2016
by Routledge
711 Third Avenue, New York, NY 10017

and by Routledge
2 Park Square, Milton Park, Abingdon, Oxon OX144RN

First issued in paperback 2018

Routledge is an imprint of the Taylor & Francis Group, an informa business

Library of Congress Cataloging-in-Publication Data

Names: Aldana Reyes, Xavier, author.
Title: Horror film and affect: towards a corporeal model of viewership / by Xavier Aldana Reyes.
Description: New York; London: Routledge, 2016. | Series: Routledge advances in film studies; 47 | Includes bibliographical references and index. | Includes filmographies.
Identifiers: LCCN 2015040499
Subjects: LCSH: Horror films—History and criticism. | Horror films—Psychological aspects. | Motion picture audiences.
Classification: LCC PN1995.9.H6 A383 2016 | DDC 791.43/6164—dc23
LC record available at http://lccn.loc.gov/2015040499

ISBN 13: 978-1-138-59961-1 (pbk)
ISBN 13: 978-0-415-74982-4 (hbk)

Typeset in Sabon
by codeMantra

This book is dedicated to my aunt, Isidora Aldana Rivero. *Porque tía solo hay una.*

Contents

List of Figures

Acknowledgements

I would like to thank Felisa Salvago-Keyes, Nancy Chen and Nicole Eno at Routledge for their editorial help, support of this project and substantial patience with my enquiries. I would also like to thank the four anonymous reviewers who provided feedback on a very early draft of this book and whose suggestions were incredibly useful in its final shaping.

In addition, I would like to thank all of the critics mentioned herein for their intellectual stimulus, especially Julian Hanich, Matt Hills, Anna Powell, Barbara Creed, Cynthia Freeland, Steven Shaviro and Noël Carroll. Their work has been foundational to my own thinking.

On a personal level, I would like to thank Sara Martín Alegre for her continued support of my work and for always being an amazing human being and role model.

I would also like to thank my family for all their encouragement and love: they really are a wonderful bunch and I am very lucky to have them.

Finally, I would like to thank Chris Barker for being there and for keeping me going. He is a superb companion.

Introduction

The Affective-Corporeal Dimensions of Horror

In 2005, the year of its theatrical release, I watched Eli Roth's *Hostel* for the first time. The experience is not one I will easily forget. At the time, I was not the seasoned Horror viewer I am today, hard to scare and aware of the major tricks of the genre.[1] I went to see the film mostly because it had been described as one of the scariest ever made and because Tarantino endorsed it. Perhaps for this reason, and because the film managed to affect me in a way that many others have not, I can remember my response to it very vividly, and it was multi-layered. Affectively, the film managed to do things to my body: I was on edge for its last half hour and some of its scenes were truly hair-raising. I was startled and disgusted, and I felt anxiety for Paxton (Jay Hernandez) when he tries to escape the building where Elite Hunting carry out their sick business. Representationally, the film did not make me aware of gender in ways that, say, the films of Dario Argento had in the past; I was mostly shaken by its cruelty, and especially, by its explicit scenes of torture. Emotionally, the film "hit" me just as effectively: I was horrified by the thought of the plausibility of its premise – to make things worse, *Hostel* claimed to be based on true events – and the possibility that people, somewhere in the world, would be mad enough to pay money to kill or torture someone they did not know for the mere pleasure of seeing someone suffer and die. This aspect of the film stayed with me for a few days, as I pondered not just about the ethics of the characters' actions but also my own involvement and role as consumer of violent spectacles: had I enjoyed the film? If so, did that make me complicit in the torture-for-sale business at the heart of the film? Was I in some way responsible for the carnographic spectacles I had witnessed? And worst of all, why did I want to carry on watching Horror?

In an attempt to deal with these questions as thoroughly as I possibly could, and with my interest piqued by the lack of work carried out in the area of affect and Horror, I embarked on a Ph.D. The doctoral dissertation *Consuming Mutilation: Affectivity and Corporeal Transgression on Stage and Screen* was completed in 2013 and got as close to an answer as I could muster at the time.[2] My main argument, that affect in Horror has a strong dramatic anchoring in performance and theatre, especially in graphic and horrific drama such as the plays of the *grand guignol,* was one that I still

maintain, but in that study I was more interested in looking for origins and legitimising the intellectual value of the experiences I have recounted than in expanding on the various implications of being affected by Horror. I was particularly concerned in reaching out for a model of Horror viewership that did not rely on psychoanalysis, a critical approach that I found opaque and which did not account for the feelings I consciously experienced when engaging with Horror.[3] A year before the submission of my doctoral thesis, I published an article on the subject, entitled "Beyond Psychoanalysis: Post-millennial Horror Film and Affect Theory" (Aldana Reyes 2012), which argued vehemently for the need to consider affect as a serious approach through which to analyse Horror film in general and, more specifically, post-millennial or contemporary Horror. Although I still stand by many of the ideas I put forward in that article, in this book I abandon the article's more philosophical framing.[4] The reason for this is, simply, that I do not find it necessary anymore and that, if one is to detract from models of Horror study that complicate the experience to the point where the ordinary viewer may no longer be able to understand the film's dynamic, then the alternative better be based on real, live corporeal experiences that are recognisable and intuitive.

Figure I.1 The intensity of the attacks on the body in *Hostel* (2005) can stay with viewers even days after being exposed to the film.

In this sense, the present book is intended as the culmination of my current thinking around the ambiguous and ever-shifting creature that affect has become in academia and as an acknowledgement of the important work being carried out by more rational and empiricist approaches to the study of cinema and Horror, such as cognition and phenomenology, by critics like Steven Shaviro, Julian Hanich or Matt Hills. However, since Affect Studies

is made up of an incredibly wide-ranging number of approaches, some of which contradict each other (they even use the word "affect" to describe different phenomena), my other anchoring point is the body, especially the moment of visceral contact between the viewer's and the character's, as foregrounded in examples of graphic Horror, mutilation or torture. This cinematic moment, largely under-theorised, is, for me, the epitome of the moment of affect: the point at which our bodies may be moved by those we see on the screen. The processes that take place at this point, and which deflect classical models of identification, neatly collect both the main emotional aim of Horror – to scare the viewer – and the complex process whereby viewers may be negatively affected by cinematic "attacks". Thus, instead of vouching for the usefulness of any one given approach, *Horror Film and Affect* turns instead to my interest in the body, which has led to outputs that have consistently highlighted the significance of corporeality to Horror film and Gothic literature (See Aldana Reyes 2013b, 2014, 2015a, 2015b). The main goal is to thereby provide a broad introduction to the various ways in which Horror uses bodies in order to affect ours and how corporeal threat lies at the heart of the moment of Horror. But first, it is necessary to assess exactly why such an intervention might be desirable.

Horror Film and Affect

Horror criticism is probably at its healthiest. The once-neglected history of Horror has, in the twenty-first century, been consistently explored and recast in a number of broad historical overviews, such as those written by Paul Wells (2000), Peter Hutchings (2004), Rick Worland (2007), Colin Odell and Michelle Le Blanc (2007), James Marriott (2007), Brigid Cherry (2009), Winston Wheeler Dixon (2010), Jonathan Rigby (2011) or Bruce F. Kawin (2012). The interest has been such that landmark studies, such as those by Charles Derry (1977), Kim Newman (1985) or David Pirie (1973), have been expanded and republished under different titles (Derry 2009; Newman 2011[5]; Pirie 2007). These, together with increasing numbers of Horror guides or film must-sees (Newman and Marriott 2006; Schneider 2009b; Sumner 2010) and the publications of niche presses, such as those by Headpress, which focus on trash, exploitation, cult and Z-budget films, have guaranteed that very little horrific filmic ground now remains unearthed or obscure.[6] The development of Horror specialist distributors like Arrow Films and the free availability and illegal circulation of previously hard-to-find VHS tapes or DVDs as digital video files on the Internet has made completist studies even more feasible. Publications on specialist subgenres that are either distinctively twenty-first century or have blossomed critically since the turn of the century have also begun to appear, with volumes on Gothic horror (Bell 2013; Botting 2008; Hopkins 2005; Rigby 2015), torture porn (S. Jones 2013; Kerner 2015; Wilson 2015), found footage Horror (Blake and Aldana Reyes 2015; Heller-Nicholas 2014) or snuff (Jackson et al. 2015;

Kerekes and Slater 2015).[7] Alongside these, studies on perennial figures such as the zombie (Russell 2005; Silver and Ursini 2014; Waller 2010) or the vampire (Gelder 2012; Weinstock 2012), when not taken together as the "undead" (Hunt et al. 2013; Waller 2010), have continued to proliferate. With the rise of auterism, it is also now common to find monographs on the work of well-known practitioners such as George A. Romero (Paffenroth 2006; Wetmore 2011; Williams 2003), Dario Argento (Cooper 2012; Gracey 2010; A. Jones 2012) or Guillermo del Toro (Davies, Shaw and Tierney 2014; McDonald and Clark 2014). Such is the popularity of the genre and the amount of criticism that it has generated that readers aimed at students and writers in the field have sprung up and now collect some of the main arguments and trends.[8]

In terms of specific approaches to Horror, the influence of social activism from the 1960s onwards, especially feminism and the women's movement, Queer Studies and post-colonialism, has translated into a number of publications that continue to explore these concerns in twentieth century cinema and up to the present. Both constructions of gender (Coulthard 2015; Short 2006) and of sexuality (McGlotten and Jones 2014) are mined for meaning or else taken as the subject of studies that seek to understand their relevance and import to the genre. In terms of race, Robin R. Means Coleman (2011), for example, has foreground blackness and argued for the liberating role of Horror as a genre that offers representational spaces to black people and can transform into radical challenges to more established forms of cinema. New approaches that have been particularly popular in the twenty-first century, or that had not received considerable attention before this, now include the turn to national cinemas, especially those of America and Japan, in order to explore the socio-political intricacies of their outputs.[9] Key to these writings has been the argument that the recognisable and international language of Horror cinema allows individuals and nations to speak of, channel and work through the traumatic legacy of recent history (Lowenstein 2005; Blake 2008).[10] Even more recently, Horror's position within the entertainment industry has been revalued and its films read alongside the market flows and laws of supply and demand that dictate their look and numbers (Bernard 2014; Nowell 2014; Walker 2015).[11]

Affect, on the other hand, has not preoccupied Horror critics excessively, especially if one takes into account the considerable amount of space that has been dedicated to the other big psychological approach, psychoanalysis, since the 1970s and, more steadily, since the 1980s.[12] Of course, this is, to a certain extent, to be expected, since psychoanalysis has had many incarnations and not all psychoanalytic approaches abide by the same rules or even follow the same writings. Having said that, it is definitely possible to distinguish patterns in psychoanalytic approaches to Horror (the return of the repressed or the role of the uncanny being two of the favoured ones (Hills 2005, 46–54)) and to name Sigmund Freud, Carl Jung, Jacques Lacan and, more recently, Slavoj Žižek as the main influences. It is harder to do the

same with affect because there is no one affect theory that has predominated and because Affect Studies is not a totemic or even cogent school of thought adhering to a given number of precepts. Although work that centres on affect tends to turn to the writings of philosophers Gilles Deleuze, Baruch Spinoza, Friedrich Nietzsche and Henri Bergson, it is far from clear that a reliance on their ideas is necessary in order to develop affect-based approaches. More importantly, a lot of work that has been published under the labels "cognitivism" and "phenomenology" could be termed affective in its intended outcomes but has not been understood as such for methodological reasons. What then is affect and how has it been used in Horror Studies?

Affect, as a term defining the physical process whereby the body is affected by an external prompting, has been described in incredibly abstract ways, no doubt because theorisations often rely on sometimes opaque philosophy and because the term – in places, "affection" – has become general currency in approaches to cinema that rely on it.[13] For Brinkema, for example, affect is that which:

> *disrupt[s], interrupt[s], reinsert[s], demand[s], provoke[s], insist[s] on, remind[s] of, agitate[s] for: the body, sensation, movement, flesh and skin and nerves, the visceral, stressing pains, feral frenzies, always rubbing against: what undoes, what unsettles, that thing I cannot name, what remains resistant, far away (haunting, and ever so beautiful); indefinable, it is said to be what cannot be written, what thaws the critical cold, messing all systems and subjects up.*
>
> (Brinkema 2014, xii, italics in original)

It is hard not to notice here how affect is already being granted a radical or transgressive edge that resonates with the deterritorialising and liberating language of post-structuralism and with the deconstructive ethos that has permeated critical writing since the turn to Derrida in the Humanities. Although this work, which I term Affect Theory, is important, it can sometimes obfuscate meaning in its desire to theorise a feeling or reaction that, because it is complex and difficult to define, should be treated with almost scientific specificity and not rendered an asubjective, free-floating, flowing construct. To further complicate matters, there are at least eight approaches to affect, all of which vary depending on angle and discipline (see Gregg and Seigworth 2010, 8–9). Thankfully, where Horror has turned to affect, it has done so almost universally from a phenomenological point of view and thus taken it at its emotional and somatic levels. This is not to say that the field of Horror Studies has necessarily done this consciously, namely, that it has sought to define Horror or to pin it down in a critically productive way, but that it has turned to affect in the search of a language that describes the way Horror films do things to viewers and their bodies. It is with this last meaning in mind that I have myself used "affect" in the past (Aldana Reyes 2012; 2015b), where I have very distinctly separated it from the

more rational and cognitively engaged emotions. Although I maintain this fine-tuning is important, I find it practical to refer to affect as an umbrella term that collects, as Plantinga has suggested, not just somatic responses, or "body responses", but also emotions and moods (Plantinga 2013, 95). In other words, my use of affect in this book consciously collapses, like a lot of literature (Carroll 1999; Hanich 2010; Wetherell 2012), cognition, somatics and phenomenology without proposing at any point that these are necessarily co-terminous or that affect is exclusively subject to emotional biases. This terminological point needs further expansion, as it forms the core of the structure of this project.

As Carroll has explained, part of the problem in attempting to define emotions as affects stems from the fact that, in ordinary parlance, mind-based responses to film are generally deemed "emotional responses" (1999, 21). Like him, I subscribe to the idea that emotions might be best understood as *"cognitive emotions"* (21, italics in original), as eminently processual and construal-based, and thus are best separated from the affective response, that is, the hard-wired reactions commonly known as reflex and which may be provoked by the startle effect. Plantinga, who refers to emotions as "concern-based construals" (2009, 29), takes a similar stance when he differentiates them from the "cognitively impenetrable" "feelings or sensations" (29) that the word "affects" covers. Thus, "moods, reflexes, mimicry, and felt physiological and bodily responses are affect, while fear, suspense, and pity, for example, are emotions" (57).[14] The main hindrance to this methodology is that moods are more complex than mere bodily response and fear is a complex emotion often made up of various concerns and, at times, a mixture of these and of bodily responses. My approach in this book, therefore, falls somewhere between the two. In order to make my usage of these concepts as clear as possible and to avoid any methodological confusions, I do two things. Firstly, I refer to cognitive emotions as simply "emotions" yet separate them, where necessary, from even more complex cognitive processes that require an evaluation of a subject's (a viewer's, in this case) reaction to the images they are watching.[15] Secondly, I refer to affective responses like reflexes as somatics or somatic responses, and to both somatics and emotions as affect. This is not just to avoid the terminological confusion that arises from terming emotions "affects", but also because, in this way, I can refer to both somatic responses and emotions (of varying complexity) as affects and to their study as Affect Studies. This book, therefore, is not concerned with Affect Theory but with Affect Studies, namely, with the phenomenological and empiricist aspects of affect rather than with their philosophical theorisations and implications for lived body experience or even as ontological tools.[16] In other words, I am concerned with affect because it allows me to engage with the ways in which I "experience fear to explore the outer limits of knowledge and of cinematic representation itself" (Gledhill 2008, 352).

I have said that Horror has not been particularly interested in affect and, until recently, this was largely the case. The works that I survey are testament to the fact that, where affect has been considered in Horror, it has generally been as part of wider considerations of the role and experiential qualities of the onscreen body, in the first instance, and of the body of the viewer, in the second. Although landmark critical studies in Horror, especially the volumes by Carroll (1990), Clover (1992) and Creed (1993), which will be covered throughout this book, made significant contributions to these areas by virtue of their interest in theorising female representation, the cognitivist side of Horror or the role of the viewer within the cinematic exchange, none of them can be said to professedly turn to affect (neither do they mean to do this).[17] It would not be until 2005 that Matt Hills and Anna Powell would make strong cases, from different angles, for the study and legitimisation of affect. Drawing strongly on Deleuze's understanding of "affection", Powell makes a case for the "primacy of corporeal affect" (2005a, 2) and its help-fulness in the process of determining the value of Horror beyond the purely allegorical. Her project, however, is more concerned with applying Deleuze, by using his writings as a theoretical toolbox, to the reading of films. It puts affect into the heart of the Horror experience but runs the risk of granting dogmatic value to the philosopher's writings. In other words, Powell's discussion of films such as Clive Barker's *Hellraiser* (1987) manages to pro-vide an enticing reading of the film as a reflection or exemplification of the concept of the body-without-organs (2005a, 83–8) but with the proviso that one buy Deleuze's ideas wholesale. This is a particularly difficult thing to do when his understanding of affect shifts from the neuronal to the intensive, and remains vague at best.[18]

More in tune with my use of the term affect in this book is Hills' prac-tical plea for "an affective theory of the genre" as a solution to what he sees as the shortcomings of cognitivism, which, for him, fail to account for feelings like "anxiety" or "moods" in their preconceptions that Horror must be object-directed (2005, 24). His proposed affective approach takes fear to be more of an affect, or feeling state, and proposes that the temporality of Horror is not punctual. Instead, we can think about how moods and ambi-ences can pervade a text and see that emotions appear alongside specific narrative events (25). This inclusive model takes in the breadth of the aes-thetic experience that is Horror and accounts for the effect of the "objectual indeterminacy" (26) of films like *The Blair Witch Project* (Eduardo Sánchez and Daniel Myrick, 1999), which never shows its source of fear and may not even offer confirmation of its actual existence. Whilst I agree with Hills in the need to provide accounts for the overarching moods and ambiences that come together into the Horror experience, I think it is possible to see how these are coloured by narrative effects themselves.[19] In other words, moods can be created not just through music, lens filter effects, camera angles, lighting or performances, but through the cumulative effect that a series of narrative moves can have on viewers.

In short, cognitive theories need not negate the work of affect, but affect should simply be extended to cover all the elements that have an influence on viewers' perceptions of given scenes and of entire films (representation, but also the use of special effects, the cinematic tricks I just referred to) and the ways in which films generate both emotional states and somatic responses.[20] In a sense, what is needed is an inclusive approach that expands affect to cover the techniques that film and filmmakers deploy in order to move viewers – a means of neo-formalism that links anticipated effects with filmic techniques, whether the latter be somatic, emotional or cognitive in their impact on the viewer and regardless of their positioning within the Horror film (i.e., anticipatory, immediate and lasting responses).[21] This is what Julian Hanich's work (2010) has developed, through a phenomenological lens, for Horror.

Since Hanich has had a big influence on my thinking around affect, and his thoughts on cinematic emotion will be explored in other parts of this book, it seems unnecessary to expound on the specifics of his research at great length in this introduction. However, his ideas and development of a phenomenology of Horror have significantly advanced thinking in the field, and it becomes necessary to, at least, briefly mention how the connections he has identified between the workings of film and the somatic and emotional body have shed light on previously neglected aspects of Horror. Refining or completing the Deleuzian work that I have mentioned before, Hanich has gone on to assess, very convincingly, how it is possible to read Horror through everyday experiences, through the language that we ordinarily use when referring to the way we perceive and live in the world through our bodies. This has focused the attention on previously overlooked layers of experience such as somatic empathy, covered in Chapter 3, which was previously misunderstood and felt to be of little interest to study. His work has managed to both reinstate the importance of the lived body and made a case for the turn to cinematic effects as a way of reading meaning into film. Beyond his typology of cinematic fear (Hanich 2010, 81–218), which draws up necessary distinctions between shocks, dread, terror and direct and suggested horror, Hanich's suggestion that somatic responses like those produced by the startle effect return us to our lived body and to a form of self-awareness that is embodied and organic (2012: 586) is a principle that permeates this study. Although I do not pledge allegiance to one specific approach – this is one of the benefits, as I see it, of Affect Studies – my own development is akin to the phenomenological methodology developed by Hanich. In many ways, this study seeks to expand and reflect on some of the conclusions that may be drawn from a phenomenological understanding of Horror by returning to previous work in Horror Studies and paying attention to possible misunderstandings or concepts that have become givens but which deserve a more nuanced experiential analysis.

The aim is not to thereby problematize the well-honed theories of Creed or Carroll, but to see where these thoughts can be developed, through

an affective focus, into a model that, like Hanich's, accounts for viewer's experience of extreme moments of engagement, such as that of witnessing torture or corporeal harm, and places the body at the centre of critical attention at the representational, emotional and affective levels. I do not purport to offer a collection of affects or even to apply previous affective approaches to Horror, but simply to study the ways in which Horror affects viewers, especially through the use of the body, on more than one level simultaneously. Bringing together work on abjection and disgust allows me to consider the representational aspect of the body on screen and, taken together with the emotional and affective dimensions of the experience of Horror, to show that an affective-corporeal approach is not simply desirable but more honest in its acknowledgement of the general aim of Horror, the intention of its makers and the disturbing experience viewers expect from the genre.

Horror Film and the Body

The contemporary subject is now, more than ever, an "embodied one", as cognitivist Shaun Gallagher (2005, 3) put it, and the human body is seen to "structure" and "shape the human experience of self, and perhaps the very possibility of developing a sense of self" (3). This corporeal turn has brought with it a thorough rejection of Cartesian models of thinking that previously rendered the body a "mere material handmaiden of an all-powerful mind, a necessary but ultimately discountable aspect of cognition, intelligence and even affectivity" (Sheets-Johnstone 2009, 2).[22] Rather than universalise emotions, though, the acknowledgment of the material genesis of the act of feeling has shifted the focus towards the particularities of thinking through our flesh. Lisa Blackman writes of the "somatically felt body" as a form of "aliveness or vitality that is literally felt or sensed but cannot necessarily be articulated, reduced to physiological processes or to the effect of social structures" (2008, 30). This foregrounding of the living and organic body is one that has had a clear repercussion on how we understand life and the human subject. The somatic import of the flesh does not reduce us to meat, but it does bring with it a certain awareness of the vulnerability and transience of the same body that in previous centuries was seen to transcend the material.[23] Scientific and philosophical studies have probed the very incapacity for articulation that Blackman identifies as concomitant to our apprehending of the lived body. The acknowledgement that not everything we experience can be explained through logical reasoning has had an undeniable impact on how we view cognition and its relation to our constitution as sentient subjects.[24] For example, it is now widely accepted that cognition is marked by psycho-motor processes that we cannot always control and which are prior to a psychological awareness of any fact; that is to say, there is scientific evidence that "indicates that one's body anticipates one's conscious experience" (Gallagher 2005, 237). Film Studies have been quick to catch up with these philosophical, ontological and scientific advances.

Corporeal approaches to Film are not exclusive to the past twenty-five years, but it is safe to say that it was not until the late 1990s and 2000s that a strong and sustained stream of publications by phenomenology-influenced scholars started making a case for the need to appreciate the position and value of the human sensorium within the filmic experience and to celebrate the sensual nature of the viewer-film encounter. From Sobchack's notions of the film's body (1992, 164–8, 203–47) and cinesthetic subject (2004, 53–84) to Laura Marks's haptic visuality (2000, 162–4) and Jennifer Barker's visceral engagement (2009, 120–44), to the so-called "affective turn" in the social sciences (Ticineto Clough 2007), the body has received consistent attention and gradually become a force to be reckoned with in the Humanities. For Horror, this has not translated directly and, until recently, Horror had not been studied through approaches that would account for the immediacy of its viscerality. In fact, discussions about the role of the body to Horror began as an appreciation of the excesses of 1970s and 1980s Horror during the latter decade, especially as a result of the popularity of body Horror and what William Paul would call the gross-out movie (1994).[25]

In 1983, Philip Brophy coined the word "horrality" (1986, 5) to refer to the growth of special effects in Horror and their particular convergence into a form of cinematic realism used to depict the thorough destruction of the body.[26] Refusing the psychological in favour of the physiological, block-busters like *The Hills Have Eyes* (Wes Craven, 1977) or *The Evil Dead* (Sam Raimi, 1981) were described as cinematic carnival rides that would "tense your muscles, quicken your heart and jangle your nerves" (Brophy, 1986, 5). Corporeality was seen to have taken over the genre, privileging the "act of showing over the act of telling" and galvanising cinematic and physical transgressions (2). Similarly, in 1986, Pete Boss was also remarking that contemporary Horror had "an unquestionable obsession with the physical constitution and destruction of the human body" and that this could be read as "a closing-off or reduction of identity to its corporeal horizons" (1986, 15, 16). For Boss, this was also the reason the 1980s saw a rise in medical Horror and Horror where the body is the victim of disaster. This materialist and empiricist outlook is one which I have explored at length in *Body Gothic* (Aldana Reyes, 2014) and, whilst there would be little point in re-rehearsing my arguments there, it is important to note that I do not find Horror's turn to the body a necessarily troubling affair – rather, a natural one that stems from changes to perceptions about corporeality – and neither do I think the body was the exclusive province of the 1980s.[27]

If it is true that body Horror and the slasher genre, both of which had peaked by the time of the appearance of Brophy's article in *Screen*, did con-tribute to the gradual increase in levels of onscreen gore, one could argue that such had been the fare of Horror for a long time. Before the endless slaying and sexual indulgence of the *Halloween* (John Carpenter, 1978) and *Friday the 13th* (Sean S. Cunningham, 1980) franchises, the films of Herschell Gordon Lewis had already caused a stir due to their visual excesses in the

early 1960s.[28] Before them, the now celebrated Hammer Horror brought gore into the age of Technicolor: the organs in formaldehyde that pepper Frankenstein's laboratory in *The Curse of Frankenstein* (Terence Fisher, 1957), as well as the scene where the monster is shot in the eye and bleeds profusely, were some of the goriest images audiences had ever seen. The blood that spatters on the Count's coffin in the credit sequence for *Dracula* (Terence Fisher, 1958) would further establish a gorier aesthetic that would very quickly be picked up by the controversial Anglo-Amalgamated "sadist" trilogy composed of *Horrors of the Black Museum* (Arthur Crabtree, 1959), *Circus of Horrors* (Sidney Hayers, 1960) and *Peeping Tom* (Michael Powell, 1960).[29] Even the Frankenstein monster of the first Universal Horror production, James Whale's *Frankenstein* (1931), can be perceived as a major corporeal breakthrough in terms of its highly accomplished and realistic portrayal of a reanimated corpse. In a sense, then, regardless of specific filmmaking contexts – for example, the heavy use of special effects and prosthetics in the 1970s and 1980s – the body has always remained an important part of Horror. Images of corporeal harm are more ubiquitous, graphic and explicit because the genre has evolved and because such images now encounter less stringent censorship laws.[30] The number and intensity of violent and explicit scenes has also grown because of changes in our perceptions of human subjects and our experience of the world, as well as the gradual secularisation of the West. The body, in many ways, has become more evidently somatic and phenomenologically present.

The understanding of horror as a genre that recuperates the "organic life" in us as "neglected" and "marginalized" by the mainstream (Morgan 2002, 2–3) is the genesis for the work of Jonathan Lake Crane on cinematic Horror. In *Terror and Everyday Life* (1994), he notes the pleasure to be found in the experience of visceral enjoyment of the body and suggests that injuries sustained by the onscreen body might be experientially transferrable to the viewer. Although he does not provide an actual methodology, Crane is concerned with the nature of "simple narratives that seem to exist solely to showcase the latest leap forward in stomach-churning special effects" (29, 2) and examines them precisely for that value. Interestingly, a lot of the characteristics that Crane already ascribed to the "new horror" of the late 1980s are also present, even more strongly, in post-millennial Horror: a bleak sense of nihilism, a further pull towards the human dimension of the genre, the use of special effects to create realistic evisceration and the lack of a clear resolution (8–10). This book concretises some of Crane's vaguest ideas, that is, how film might actually simulate "harm" for the potential viewer. In a sense, this work also challenges Crane's notion that blood and realistic detail work as markers of the Horror experience at an aesthetic level. Instead, I contend that it is the capacity of certain Horror films to present corporeal threat as real (and not necessarily in a way that creates aesthetic distance, and thus, potential appreciation) that proves a basic requisite in the creation of affect. Mutilation is not necessarily attractive because it is

aesthetically pleasing – although this is possible in a different contemplative context – but because it is capable of affecting the body of the viewer.

This is a view that was well-established by the early 1990s. Aside from Crane's, work, Steven Shaviro's *The Cinematic Body* set up a "paralogical strategy" (1993, 266) for understanding the cinematic apparatus and its "symbiotic and parasitic interpenetration" (264) with the body. Shaviro's theory is based around affect and champions a "counteraesthetics grounded in shock, hilarity, relentless violence, delirious behaviourism, contagion, tactile participation, and aimless, hysterical frenzy" (103). This "psycho-physiology of cinematic experience" (53) is the beginning of a project that aims to explore how images and film might amplify subjectivity or corpo-real sensation. In other words, Shaviro's is a "materialistic semiotics" (51) that draws upon Walter Benjamin's "tactile appropriation" (51) whilst, like the phenomenologists, it shifts the focus to the body of the viewer and its inner workings. According to Shaviro, mass media, the digital age and our technological relation to the world have had different consequences from those commonly considered in assessments of postmodern culture. Rather than drive us away from reality and into a world of simulacra and hyperreality conducive to the waning of affect, these images have put us in direct contact with the fibre of life. They have shown, and continue to show us, how the body "mutates into new forms, and is pushed to new thresholds of intense, masochistic sensation" (138–9), how we might understand "visceral immediacy as an *effect* of simulation" (5). Modern Horror films are affect machines that exalt, enthral, "manufactur[e] and articulat[e] lived experience" (2). In Shaviro's influential account, Horror operates by "destroy[ing] customary meaning and appearances, ruptur[ing] the surfaces of the flesh, and violat[ing] the organic integrity of the body" (102). The contact between the filmic reel and the flesh is, thus, a physical one. For Shaviro, the cinematic experience can foreground abjection precisely because the body it depends on is itself "at once captivating and violently repulsive" (260). Horror brings this contingency out into the open as it forces bodies, both filmic and fleshly, into contact with one another. Horror, especially of the graphic type, attempts to reinscribe the body into the film/text and thus aims to short-circuit the distinction between thought and body.

Although Horror criticism seems to have largely shied away from the body in the 2000s in favour of socio-political studies, there have been a few recent attempts to grapple with the legacy of the work of critics like Crane and Shaviro, even if not strictly presented as such, in the 2010s. I have already mentioned Julian Hanich's phenomenology of Horror (2010), which has indeed been the most influential, thorough and comprehensive study to pick up on the biological qualities of Horror and its viewers, but other scholars have also attempted to analyse the links between Horror and embodiment and even the possibility of what has been termed "the horror sensorium" (Ndalianis 2012).

Larrie Dudenhoeffer, in his *Embodiment and Horror Cinema*, picks up these debates and argues for the need to take into consideration all our "organs, members, and fluids" (2014, 3), for "*the condition of embodiment, in some way or other, is what makes the horror film horrifying*" (5, italics in original). His points about Horror breaking corporeal boundaries echo the thoughts of other critics, especially Shaviro, and his intention to dig deeper into the psychosomatic aspects of Horror aligns him with the other theorists I have covered. Unfortunately, beyond his general plea for a closer engagement with embodiment, the ideas he develops are not particularly illuminating and, in some cases, either feel counterintuitive or are difficult to prove. Arguing that critics like Jay McRoy or Jennifer M. Barker concentrate "mainly on the surface of the skin rather than on the deep tissue structures or the anatomic miscellanea of the organ systems that it conceals" (2014, 3), Dudenhoeffer proposes, instead, "*an anatomo-hermeneutics* of horror cinema" (14) that will assess how certain films are "creative or figurative re-elaborations of the organs, vessels, cells, or other aspects of subjective embodiment" (14). He goes on to suggest that Horror films, especially body Horror films, although both categories seem to collapsed into one another insofar as all Horror is body Horror, exemplify the use of one of four tissue types, muscular, connective (fibrous and cartilaginous), nervous and epithelial (14–5). This taxonomy allows Dudenhoeffer to draw analogies between the cinematographic qualities of film and those of the human body and to argue that some Horror films foreground one of these tissues by providing clues (presumably aesthetic ones). However, why a precisely analogical-corporeal approach to Horror is beneficial in order to apprehend the genre is never made entirely clear, or indeed, why certain films would be interested in prioritising a type of biological analogy over another. More importantly, Dudenhoeffer's approach appears to confuse the awareness of corporeality that Horror elicits (via its use of cinematography, camera work, colour palettes) and the specific intricacies of the psychosomatic processes thereby encouraged. In other words, I am not entirely sure how useful it is to propose that certain Horror "resembles the cells, fibers and matrixes of connective tissue, or the fats, tendons, cartilage and submucosa that support, separate and enclose different organs in their respective systems" (18). The inclusion of blood in *The Amityville Horror* (Jay Anson, 1979), used as an illustrative example, strikes me as much more connected to the potential emotional and affective purpose of the film than to a desire to emulate the vascular nature of the human system. Similarly, it would be difficult to argue that we feel Horror film with our muscular systems in a conscious way. What seems at stake, then, is not whether Horror uses the body in its narrative or cinematographic intent but how the body in Horror (the anatomies onscreen or diegetic bodies) are employed in order to produce affect.

Ndalianis's concept of the Horror sensorium feels more intuitive and empirical. For her, the sensorium "refers both to the sensory mechanics of

the human body and to the intellectual and cognitive functions connected to it" (2012, 1). It "is a space where the medium and the human body collide; where they meet and affect each other in very real ways that play themselves across and deep into the mind and body of the spectator" (3). Contending that contemporary horror, New Horror, as it is called, has focused on "sensory encounters" (4). Ndalianis contends that there has been a general drive towards foregrounding corporeality both inside and outside of the film, meaning that its "violence continues to be played out offscreen and across the body of the spectator" (5). For Ndalianis, the unforgiving nature of films like *Wolf Creek* (Greg McLean, 2005) or the remake of *The Hills Have Eyes* (Alexandre Aja, 2006) is echoed in the films' destruction of human bodies. In other words, bodies in New Horror are strategically exploited to put forward very specific messages about an apocalyptic society in decay or, in the case of *Hills*, to make a point about nuclear testing in America (2012, 17, 22–3). For these films, "the spectator's understanding of the ideological issues is reliant on targeting the spectator through the senses" (39). However, exactly why the makers of Horror films would be interested in putting forward any specific politics, or that doing so would make certain films better or more interesting examples of the genre, seems unfair. Could it not simply be the case that Horror is now more graphic and that some films also happen to contain strong political metaphors or even direct messages? In any case, I find it more productive to think that one does not rely on the other, although creating a bleak atmosphere and mood is necessarily conducive to greater affect. The history of Horror is, to a certain extent, inextricable from both the constant overexposure and attack of the body and the advances in techniques that may have rendered its injury, dismemberment or other forms of physical distress believable. Adriana Cavarero has recently reminded us that the term "horror" comes from the Latin verb *horreo*, which refers to the "hair-raising" quality (the bristling of gooseflesh) of that type of fear (2009, 7). Whilst it is true that post-millennial Horror appeals to the lived body by turning the visceral and the bloody into intense forms of interactive participation with moving images (with or without explicit political messages), this could be argued of Horror in previous decades. The corporeal scope of Ndalianis's analysis also ends here, as the sensorial engagement between the film and the viewer's body is limited to Brigitte Peucker's work on the materiality of the viewer to the image (2007) and her own borrowings from Sobchack.

Useful as they no doubt have been in re-sparking wider debates about Horror, the contributions of Dudenhoeffer and Ndalianis also have, like some of their 1990 predecessors, failed to engage with the wider implications that the turn to the body has for an understanding of the genre. Logically, the focus lies elsewhere in these studies – Dudenhoeffer is more interested in analysing body-film analogies; the scope of Ndalianis's work covers other forms of media, such as video games and even paranormal romance, and she is also interested in the social critiques behind the violence – but the connections between biology (the emotional and somatic levels of Horror) and

Figure I.2 It is not necessary to understand the political messages in *The Hills Have Eyes* (2006) to be cinematically affected by the film.

the Horror experience still remain vague, especially as far as direct harm – that is, attack, torture and mutilation of human bodies – is involved. How, precisely, does Horror work on the body? Can we simply reduce effects to feelings, or should these be qualified? For example, experientially, seeing a body being tortured is very different from watching a scene where a character enters into a dangerous place and puts their body in danger. Beyond the particularities of feeling, it is important to explore the links between representation and affect. Why is the body such an important avatar for responses and reactions to the horrific in film? How does perception, the way we interact with the world and anticipate emotions and feeling, result in our capacity for empathy, somatic or otherwise?

Horror is an unashamedly bodily genre (Williams 1991) that often revels in the creation of a direct corporeal rapport between text and viewer, and it thus has become the prime locus for situating the playful transgression of the body in cinema. A focus on the ways in which the body is used to affect the viewer – what I am calling the affective-corporeal model – should thus shed light on the specifics of the experience of Horror.

This Book

In order to account for (a) the corporeal ways in which viewers are generally affected by Horror and (b) the specificity of the corporeal encounter where the onscreen body comes under direct harm or attack or a sense of corporeal threat, I focus on what I see as the three main levels of the affective encounter between film and viewer.

In Chapter 1, I account for the representational value of certain images, particularly those connected to the internal body. Since the main

approach to discussions of images of corporeal harm has tended to develop from psychoanalytic concepts, especially from applications of Julia Kristeva's notion of abjection in her *Powers of Horror* (1982), and, in the most significant and influential cases, has been permeated by a strong feminist bias, I begin by considering the connection between the body, abjection and gender through the work of Barbara Creed. I take issue, as many other critics have done, with the potentially reductive monstrous-feminine model and propose a challenge to the idea that all onscreen bodies in Horror are heavily gendered and cause fear, in the case of women, by virtue of characteristics that are perceived as female. Arguing for the continued need for studies that highlight gendered representations, I propose instead that the body in Horror, as far as its affective powers are concerned (and here I mean their capacity to scare and horrify, not to titillate sexually, which is not a general intention of most Horror) is largely ungendered. Drawing on recent scholarship on the nature of disgust, I suggest that we understand abjection, still useful as a construct that articulates the immediate rejection of certain images, as a form of fearful disgust based on corporeal vulnerability and the human capacity to assess the pain and danger in physical harm. This rethinking of abjection allows me to argue for a more inclusive, although not strictly universal, view of images of mutilation, which have great affective powers and which do not rely on the viewer's reading of a body's gender or its concomitant functions. In order to illustrate these ideas, I turn to *Ginger Snaps* (John Fawcett, 2000), a feminist film, and distinguish between the film's conscious use of the monstrous-feminine body to make a point about, in this case, female puberty, sexuality and coming of age and its use of images of mutilation (or abjection, as it is understood here) in order to appeal to the viewer's sensorium. I also look at how the same is true of another film in which the female body is strongly abused, Pascal Laugier's *Martyrs* (2008).

In Chapter 2, I continue my exploration of the affective side of Horror by turning to its emotional dimensions, namely, how Horror generates emotional states in viewers. Starting with a deep and detailed engagement with the cognitive work of Cynthia Freeland and, more importantly, Noël Carroll's development of "art-horror" (1990), I argue for both a need to expand the latter's object-directed theory of emotions to encompass sources of threat that are not direct or even seen. This leads me to propose that Horror can be generally defined by the emotional state of threat, of feeling either directly attacked by the film (in the startle effect) or by extrapolation via alignment with the body on screen. My contention is that corporeal threat is by far the most common affective experience in Horror and that a more rounded understanding of how Horror seeks to make the viewer experience fear is necessary. The case study of found footage and, more specifically, of the Spanish film *[●REC]* (Jaume Balagueró and Paco Plaza, 2007) shows how this aim is generally patent in a film's form, marketing campaign and cinematography. So as to show that corporeal threat need not rely on the moment of direct horror or the startle effect,

I turn to dread as a crucial emotional experience that is both object-directed (insofar as the moods or atmospheres in the film work in tandem to generate fear of something), and yet, until the reveal (when there is one) has no direct object. I also consider the qualitative difference between dread and the emotion that follows the awareness of the characteristics and reach of the threat, which I term "survival suspense". Finally, in the last sections of the chapter, I consider the importance of ethics and morals to the viewing of corporeal mutilation, as guilt, shame and a sense of unhealthy complicity in the exchange amplify our engagement with given images and scenes. I show how certain films, *Snuff-Movie* (Bernard Rose, 2005) being a case in point, exploit this cognitive process of self-assessment to generate additional affect on viewers.

In the third and last chapter, I attempt to do two interconnected things. First, I account for the most somatic side of affect, the bodily, automatic responses that cannot be said to be cognitive and only vaguely emotional. The startle effect, as the most obvious cinematic instance where the physiological body of the viewer is appealed to directly, is therefore explored in some detail. Beyond collecting what has been said about the startle effect (or cinematic shock), I follow Hanich in his valuing of this reflexive experience as one that leads to a moment of re-apprehension of the somatic body. I then look at cinematic examples of Horror that could be said to be strongly, and even predominantly, somatic, like 3D Horror. *My Bloody Valentine 3D* (Patrick Lussier, 2009) serves as the backbone for a brief exploration of some of the affective techniques used by this type of Horror in generating affect. Second, this chapter turns to somatic empathy, which is mentioned elsewhere in the book. Surveying the main identificatory models proposed in the past, I show that empathy, like the concept of abjection I develop in Chapter 1, does not depend on sympathy or the specificities of the body in question, but on corporeal intelligibility. Hanich's work on the forms of mimicry that comprise somatic empathy is also useful in determining the moment of encounter with images of mutilation as an instance of sensation mimicry. Drawing on work from Pain Studies, I argue that it is the naturally non-transferable, yet universally understood, sensation of pain which articulates these moments of viewing discomfort. In other words, scenes that abuse mutilation have a corporeal and somatic underpinning that relies on the human capacity to comprehend pain and physical harm, especially its potential sensations and effects. I also propose that viewers naturally align themselves with the harmed or tortured body almost independently of sympathetic allegiances.[31] Torture porn, and *Hostel*, more specifically, provides a good example of how Horror is complicit in the affective nature of the affective-corporeal engagement between viewing and intradiegetic bodies. Highlighting the role of alignment in two key scenes, as well as their relevance within very precise narratives, I argue that a number of contemporary Horror films are particularly invested in affecting the viewer as strongly as they can, and that, in order to do so, they will consistently choose the

treatments that favour affective and emotional responses. This might mean a combination of shots that favour both the source of threat and the intradiegetic victim and, in some cases, attack the viewer directly.

Finally, a word is needed on my choice of texts. As should be evident, all the case studies in this book are of twenty-first century films, and, with a few exceptions of canonical texts that have been key to Horror discussions before this contribution, I stick to the post-millennial. This contemporary bias is not necessarily motivated by recent history or its specific socio-political makeup. The type of arguments I make about the affective side of Horror do not preclude or negate traumatic approaches to the genre, and logically, the present shapes the nature and look of Horror and the anxieties it channels. However, socio-political context rarely become the focus of my attention here because my point is that affect, as I understand it, is a lot more direct, corporeal and somatic than it is context-dependent. In other words, whilst thematically, the context shapes the content of the film and, in found footage, even its look, the dynamics of engagement and exchange between the bodies of viewers and those of the film and its characters remain largely constant. Although films may lose their affective powers as they age, this is not so much a result of a change in our interaction with films as of the development of new and more verisimilitudinous cinematic techniques, as well as our acquaintance with the genre and cinema more generally. As the choice of films from different countries (America, England, Canada, Spain and France) shows, neither am I particularly interested in the idiosyncrasies of national frameworks. The reality is that this book could have used canonical examples throughout, or films from many other countries, and have come to the same conclusions. However, to stay true to the momentousness of the study I want to (a) break new ground rather than return to well-worn texts and (b) show that the approaches and theoretical fine-tuning in *Horror Film and Affect* can be relevant to our analysis of films today. Additionally, since contemporary Horror, by virtue of its contemporaneity, is able to show more, and its spectacles on the whole are less censored than they have been in the past, they present good examples of affective cinema. Although the six films studied in detail here orchestrate the discussions in the three chapters, these are by no means the only ones mentioned. The chapters include multiple references to other relevant films where scenes or aspects in them serve to illustrate my more general points or in order to provide evidence for my main arguments.

Finally, to return to my aim, this book is intended as an expansion of the work of cognitivists, phenomenologists and Horror theorists. By bringing together and refining, or rethinking, some of the key elements in the affective-corporeal exchange between viewer and Horror, it provides the first comprehensive approach to affect and Horror film. As such, it seeks to advance knowledge in this field and to reinstate a critical approach that is intuitive, clear, more experientially measurable and useful in the thinking around the effects of Horror and its relation to human corporeality.

Notes

1. Throughout this book, I use the capitalised version of the word "horror" to refer to Horror as a genre, its general traits and tenets, as opposed to the feeling of being horrified. In a sense, this follows Carroll's distinction between horror and art-horror in his *The Philosophy of Horror* (1990), which was a great influence on this book and is studied in detail in Chapter 2.
2. See Aldana Reyes (2013a).
3. I favour the term "viewer" over "spectator" in this book to emphasise the move away from the universal, programmatic understanding of the intended audience that early Film Theory, especially semiotics and psychoanalysis, proposed. The term is meant to refer not to a single type of viewer, a means of avatar that magically covers everyone, but rather the potential "'cooperative' viewers [...] who allow the film to do its intended emotional work" (Plantinga 2009, 97). In other words, "viewer" is intended to acknowledge the flexibility of disposition of the varied subjects that constitute the public for Horror as well as the fact that genre filmmakers often have a target audience in mind.
4. The framing of the article was largely driven by Deleuze and Guattari's formulation of the body-without-organs in *A Thousand Plateaus* (1987).
5. Newman's book had already gone through three editions by the end of the 1980s, two published in America (1985; 1989) and one in Britain (1988). In the interests of space, I am not including publishing details for these various editions in the bibliography.
6. See, for example, King (2005) or Ziemba and Budnik (2013). There has even been a Horror cinema coffee table book (Penner and Schneider 2008) that was reprinted in 2012. The success of the Horror guides can be gauged from the fact that some of them have yielded updated and revised editions. Newman and Marriott's *Horror* (2006), for example, was updated and republished in 2010 and 2013.
7. The book by Kerekes and Slater is not new, but a new and expanded edition of their 1993 book of the same title.
8. See, for example, those by Bloom (2007), Gelder (2000) or Jancovich (2002).
9. For studies of American Horror, see Briefel and Miller (2012), Hantke (2010) and Kevin J. Wetmore (2012). For Japanese Horror, see Balmain (2008), Harper (2008), McRoy (2005; 2007) and Wee (2013).
10. Transnational frameworks have also been usefully applied to discuss these issues. See Choi and Wada-Marciano (2009), Khair and Höglund (2012), Och and Strayer (2013).
11. The industry approach has not limited itself to post-millennial cinema. It has also been applied to the retrospective study of important periods of Horror-making, such as the Horror productions of Universal Studios (Mallory 2009), and of cycles, such as the slasher films of the late 1970s and early 1980s (Nowell 2011). Audience research has also started to become a focus of academic interest, especially fan practices (see Conrich 2010; Hills 2005, 71–108).
12. See, among others, Creed (1993), Heller (1987), Schneider (2009a), Twitchell (1987) and Wood (1978; 1980).
13. See, for example, Powell (2012), Rebecca Coleman (2011), del Río (2008), Kennedy (2000) and, especially, Massumi (2002, 23–46; 2015), although the latter does not focus on cinema but on affect more generally. For some

applications of Deleuze to Horror film see Powell (2005a; 2005b), Lockwood (2009), McRoy (2010) or Aldana Reyes (2012).

14. The view that sees general feelings as affects is by no means reducible to Plantinga. See also Mazzarella (2009, 291).

15. This is what, in psychological literature, is called the complex emotions or "emotions of self-assessment" (Taylor 1985).

16. Although, in a sense, my point will be, like Hanich's (2012), one that seeks to prove that engagement with affect – studying Horror affectively – necessarily makes an ontological point insofar as the lived body is reinstated in the moment of horror, especially of startle effects.

17. Creed's contribution can be traced back to 1986, as her book expands ideas rehearsed in her article for *Screen* that year.

18. See Powell (2005a, 210). Another aspect that I find unconvincing is the face in close-up as epitome of the affection image, as close-ups of wounds can be just as a/effective. The primacy of the facial close-up has also been dealt with by Powell elsewhere (2005b).

19. For more on moods and pre-figuring, see Leffler (2000, 177–89).

20. Hills makes a similar point when he argues that Horror "involves an interplay between 'affect' and 'emotion' as these are defined by cognitivists, with cognitive speculations transforming affects into emotions, while such evaluations can also be challenged or textually complicated" (Hills 2005, 28). Crucially, for me, affects, understood as somatic responses, need not be transformed into emotions, although they necessarily condition them, but are free-standing and form part of the experiential affective realm of Horror. Similarly, I do not think emotions can be turned into affects (28), although I concur that emotional states or moods can intensify certain affects or encourage them.

21. Such an inclusive approach can produce, but is not limited to producing, studies or aesthetic analyses that catalogue these possibilities, like the ones by Cherry (2009, 52–94) and Sipos (2010). I do not understand pre-conditioning that happens outside the film (seeing the film alone, being particularly scared of a given film) as anticipatory responses. I mean, specifically, anticipatory sensations within the film, such as dread. Pre-conditioning is no doubt crucial to viewer response but, since it varies from viewer to viewer, it is harder to analyse in more systematic terms.

22. The term "corporeal turn" was coined by Sheets-Johnstone (1990).

23. See MacCormack (2012).

24. Even reasoning has been shown to be ultimately shaped by the body. See Lakoff and Johnson (1999, 4, 16–7).

25. For more on body Horror see Grant (2008) and Aldana Reyes (2014, 52–74).

26. The article appeared originally in the spring issue of the Australian journal *Art and Text* in 1983.

27. For another view that sees the body in the 1980s as relevant, not because it offers transcendence of the body but because it offers transcendence "through" it, see Badley (1995, 5–38).

28. See Crane (2004), Curry (1999) and Palmer (2006).

29. For more on this trilogy, see Hutchings (1993, 3–23). The only significant precursor for this type of explicit Horror is perhaps *Terror Is a Man* (Gerardo de León, 1959), an adaptation of H. G. Wells' *The Island of Dr. Moreau* (1896) which includes a very brief close-up of a scalpel cutting through flesh. The

film included a bell warning to ensure audiences would have time to look away, if they so desired.
30. Sexual violence is still an important bone of contention for censors in countries like Britain (see British Board of Film Classification, 2013). Horror history can also be read alongside the history of censorship, but again, this is not the place for that discussion. Instead, see Egan (2007) and Petley (2011).
31. This argument is a little more complex than I can put forward here. For a more detailed discussion, see the "Corporeal Identification: Somatic Empathy" section in Chapter 3.

Bibliography

Aldana Reyes, Xavier. 2012. "Beyond Psychoanalysis: Post-millennial Horror Film and Affect Theory". *Horror Studies* 3.2: 243–61.

———. 2013a. *Consuming Mutilation: Affectivity and Corporeal Transgression on Stage and Screen*. Doctoral thesis. Lancaster University.

———. 2013b. "Gothic Horror Film, 1960–Present". In *The Gothic World*, edited by Glennis Byron and Dale Townshend, 388–98. London and New York: Routledge.

———. 2014. *Body Gothic: Corporeal Transgression in Contemporary Literature and Horror Film*. Cardiff: University of Wales Press.

———. 2015a. "Gothic Affect: An Alternative Approach to Critical Models of the Contemporary Gothic". In *New Directions in 21st-Century Gothic: The Gothic Compass*, edited by Lorna Piatti-Farnell and Donna Lee Brien, 11–23. London and New York: Routledge.

———. 2015b. "Mobilising Affect: Somatic Empathy and the Cinematic Body in Distress". In *Corporeality and Culture: Bodies in Movement*, edited by Karin Sellberg, Lena Wånggren and Kamillea Aghtan, 35–46. Aldershot, UK: Ashgate.

Badley, Linda. 1995. *Film, Horror, and the Body Fantastic*. London and Westport, CT: Greenwood Press.

Balmain, Colette. 2008. *Introduction to Japanese Horror Film*. Edinburgh: Edinburgh University Press.

Barker, Jennifer M. 2009. *The Tactile Eye: Touch and the Cinematic Experience*. London, Los Angeles and Berkeley, CA: University of California Press.

Bell, James, ed. 2013. *Gothic: The Dark Heart of Film*. London: British Film Institute.

Bernard, Mark. 2014. *Selling the Splat Pack: The DVD Revolution and the American Horror Film*. Edinburgh: Edinburgh University Press.

Blackman, Lisa. 2008. *The Body: The Key Concepts*. Oxford and New York: Berg.

Blake, Linnie. 2008. *The Wounds of Nations: Horror Cinema, Historical Trauma and National Identity*. Manchester, UK: Manchester University Press.

Blake, Linnie, and Xavier Aldana Reyes, eds. 2015. *Digital Horror: Haunted Technologies, Network Panic and the Found Footage Phenomenon*. London and New York: I. B. Tauris.

Bloom, Clive. 2007. *Gothic Horror: A Guide for Students and Readers*, 2nd ed. Basingstoke: Palgrave Macmillan.

Boss, Pete. 1986. "Vile Bodies and Bad Medicine". *Screen* 27.1: 14–25.

Botting, Fred. 2008. *Limits of Horror: Technology, Bodies, Gothic*. Manchester, UK: Manchester University Press.

Briefel, Aviva, and Sam J. Miller, eds. 2012. *Horror after 9/11: World of Fear, Cinema of Terror*. Austin, TX: University of Texas Press.

Brinkema, Eugenie. 2014. *The Forms of the Affects*. London and Durham, NC: Duke University Press.

British Board of Film Classification. 2013. "An Official Afterword: The BBFC Responds to the Launch Issue of the Cine-Excess eJournal". *Cine-Excess eJournal* 1. http://www.cine-excess.co.uk/bbfc-response.html. Accessed 1 December 2014.

Brophy, Philip. 1986. "Horrality: The Textuality of Contemporary Horror Films". *Screen* 27.1: 2–13.

Carroll, Noël. 1990. *The Philosophy of Horror: Or, Paradoxes of the Heart*. London and New York: Routledge.

———. 1999. "Film, Emotion, and Genre". In *Passionate Views: Film, Cognition, and Emotion*, edited by Carl Plantinga and Greg M. Smith, 21–47. London and Baltimore, MD: The Johns Hopkins University Press.

Cavarero, Adriana. 2009. *Horrorism: Naming Contemporary Violence*. Chichester, UK, and New York: Columbia University Press.

Cherry, Brigid. 2009. *Horror*. London and New York: Routledge.

Choi, Jinhee, and Mitsuyo Wada-Marciano, eds. 2009. *Horror to the Extreme: Changing Boundaries in Asian Cinema*. Honk Kong: Honk Kong University Press.

Clover, Carol J. 1992. *Men, Women and Chain Saws: Gender in the Modern Horror Film*. Princeton, NJ: Princeton University Press.

Coleman, Rebecca. 2011. "'Be(come) Yourself only Better': Self-Transformation and the Materialisation of Images". In *Deleuze and the Body*, edited by Laura Guillaume and Joe Hughes, 144–64. Edinburgh: Edinburgh University Press.

Conrich, Ian. 2010. *Horror Zone: The Cultural Experience of Contemporary Horror Cinema*. London and New York: I.B. Tauris.

Cooper, L. Andrew. 2012. *Dario Argento*. Urbana, Springfield and Chicago, IL: University of Illinois Press.

Coulthard, Lisa. 2015. "Uncanny Horrors: Male Rape in *Twentynine Palms*". In *The Dread of Difference: Gender and the Horror Film*, edited by Barry Keith Grant, 2nd ed., 488–508. Austin, TX: University of Texas Press.

Crane, Jonathan Lake. 1994. *Terror and Everyday Life: Singular Moments in the History of the Horror Film*. London and Thousand Oaks, CA: Sage.

———. 2004. "Scraping Bottom: Splatter and the Herschell Gordon Lewis Oeuvre". In *The Horror Film*, edited by Stephen Prince, 150–66. New Brunswick, NJ: Rutgers University Press.

Creed, Barbara. 1986. "Horror and the Monstrous-Feminine: An Imaginary Abjection". *Screen* 27.1: 44–71.

———. 1993. *The Monstrous-Feminine: Film, Feminism, Psychoanalysis*. London and New York: Routledge.

Curry, Christopher. 1999. *A Taste of Blood: The Films of Herschell Gordon Lewis*. London: Creation Books.

Davies, Ann, Deborah Shaw and Dolores Tierney, eds. 2014. *The Transnational Fantasies of Guillermo del Toro*. Basingstoke, UK: Palgrave Macmillan.

Deleuze, Gilles, and Félix Guattari. 1987. *A Thousand Plateaus: Capitalism and Schizophrenia*, translated by Brian Massumi. Minneapolis, MI: University of Minnesota Press, 1987.

del Río, Elena. 2008. *Deleuze and the Cinemas of Performance: Powers of Affection*. Edinburgh: Edinburgh University Press.

Derry, Charles. 1977. *Dark Dreams: A Psychological History of the Modern Horror Film*. London: A. S. Barnes and Co.

———. 2009. *Dark Dreams 2.0: A Psychological History of the Modern Horror Film from the 1950s to the 21st Century*. Jefferson, NC: McFarland.

Dixon, Wheeler Winston. 2010. *A History of Horror*. New Brunswick, NJ: Rutgers University Press.

Dudenhoeffer, Larrie. 2014. *Embodiment and Horror Cinema*. Basingstoke, UK: Palgrave Macmillan.

Egan, Kate. 2007. *Trash or Treasure? Censorship and the Changing Meanings of the Video Nasties*. Manchester, UK: Manchester University Press.

Gallagher, Shaun. 2005. *How the Body Shapes the Mind*. Oxford and New York: Oxford University Press.

Gelder, Ken, ed. 2000. *The Horror Reader*. London and New York: Routledge.

———. 2012. *New Vampire Cinema*. London: British Film Institute.

Gledhill, Christine. 2008. "The Horror Film". In *The Cinema Book*, edited by Pam Cook, 347–54. London: British Film Institute.

Gracey, James. 2010. *Dario Argento*. Harpenden, UK: Kamera Books.

Grant, Michael. 2008. "Body Horror". In *The Cinema Book*, edited by Pam Cook, 355–60. London: British Film Institute.

Gregg, Melissa, and Gregory J. Seigworth, eds. 2010. *The Affect Theory Reader*. London and Durham, NC: Duke University Press.

Hanich, Julian. 2010. *Cinematic Emotion in Horror Films and Thrillers: The Aesthetic Paradox of Pleasurable Fear*. London and New York: Routledge.

———. 2012. "Cinematic Shocks: Recognition, Aesthetic Experience, and Phenomenology". In *Amerikastudien/American Studies* 57.4: 581–602.

Hantke, Steffen, ed. 2010. *American Horror Film: The Genre at the Turn of the Millennium*. Jackson, MS: University Press of Mississippi.

Harper, Jim. 2008. *Flowers from Hell: The Modern Japanese Horror Film*. Hereford, UK: Noir Publishing.

Heller, Terry. 1987. *The Delights of Terror: An Aesthetics of the Tale of Terror*. Urbana and Chicago, IL: University of Illinois Press.

Heller-Nicholas, Alexandra. 2014. *Found Footage Horror Films: Fear and the Appearance of Reality*. Jefferson, NC: McFarland.

Hills, Matt. 2005. *The Pleasures of Horror*. London and New York: Continuum.

Hunt, Leon, Sharon Lockyer and Milly Williamson, eds. 2013. *Screening the Undead: Vampires and Zombies in Film and Television*. London and New York: I.B. Tauris.

Hopkins, Lisa. 2005. *Screening the Gothic*. Austin, TX: University of Texas Press.

Hunter, Leon, Sharon Lockyer and Milly Williamson, eds. 2013. *Screening the Undead: Vampires and Zombies in Film and Television*. London and New York: I.B. Tauris.

Hutchings, Peter. 1993. *Hammer and Beyond: The British Horror Film*. Manchester, UK: Manchester University Press.

———. 2004. *The Horror Film*. Harlow, UK: Longman.

Jackson, Neil, Shaun Kimber, Johnny Walker and Thomas Joseph Watson, eds. 2015. *Snuff: Real Death and Screen Media*. London and New York: Bloomsbury Academic.

Jancovich, Mark, ed. 2002. *Horror: The Film Reader*. Abingdon, UK, and New York: Routledge.

Jones, Alan. 2012. *Dario Argento: The Man, the Myths and the Magic*, 2nd ed. Guildford, UK: FAB Press.

Jones, Steve. 2013. *Torture Porn: Popular Horror after Saw*. Basingstoke, UK: Palgrave Macmillan.

Kawin, Bruce F. 2012. *Horror and the Horror Film*. London and New York: Anthem Press.

Kennedy, Barbara M. 2000. *Deleuze and Cinema: The Aesthetics of Sensation*. Edinburgh: Edinburgh University Press.

Kerekes, David, and David Slater. 2015. *Killing for Culture: From Edison to Isis. A New History of Death on Film*. London: Headpress.

Kerner, Aaron Michael. 2015. *Torture Porn in the Wake of 9/11: Horror, Exploitation, and the Cinema of Sensation*. New Brunswick, NJ: Rutgers University Press.

Khair, Tabish, and Johan Höglund, eds. 2012. *Transnational and Postcolonial Vampires: Dark Blood*. Basingstoke, UK: Palgrave Macmillan.

King, Richard. 2005. *Twisted Visions: No-Budget Horror Movies and the People Who Make Them*. London: Headpress.

Kristeva, Julia. 1982. *Powers of Horror: An Essay on Abjection*, translated by Leon S. Roudiez. Chichester, UK, and New York: Columbia University Press.

Lakoff, George, and Mark Johnson. 1999. *Philosophy in the Flesh: The Embodied Mind and Its Challenge to Western Thought*. New York: Basic Books.

Leffler, Yvonne. 2000. *Horror as Pleasure: The Aesthetics of Horror Fiction*. Stockholm: Almqvist and Wiksell International.

Lockwood, Dean. 2009. "All Stripped Down: The Spectacle of 'Torture Porn'". *Popular Communication: The International Journal of Media and Culture* 7.1: 40–8.

Lowenstein, Adam. 2005. *Shocking Representation: Historical Trauma, National Cinema and the Modern Horror Film*. Chichester, UK, and New York: Columbia University Press.

MacCormack, Patricia. 2012. *Posthuman Ethics: Embodiment and Cultural Theory*. Aldershot, UK: Ashgate.

Mallory, Michael. 2009. *Universal Studio Monsters: A Legacy of Horror*. New York: Universe Publishing.

Marks, Laura U. 2000. *The Skin of the Film: Intercultural Cinema, Embodiment, and the Senses*. London and Durham, NC: Duke University Press.

Marriott, James. 2007. *Horror Films*. London: Virgin Books.

Massumi, Brian. 2002. *Parables for the Virtual: Movement, Affect, Sensation*. London and Durham, NC: Duke University Press.

———. 2015. *The Politics of Affect*. London: Polity.

Mazzarella, William. 2009. "Affect: What Is It Good For?" In *Enchantments of Modernity: Empire, Nation, Globalization*, edited by Saurabh Dube, 291–309. London and New York: Routledge.

McDonald, Keith, and Roger Clark. 2014. *Guillermo del Toro: Film as Alchemic Art*. London and New York: Bloomsbury Academic.

McGlotten, Shaka, and Steve Jones, eds. 2014. *Zombies and Sexuality: Essays on Desire and the Walking Dead*. Jefferson, NC: McFarland.

McRoy, Jay, ed. 2005. *Japanese Horror Cinema*. Edinburgh: Edinburgh University Press.

———. 2007. *Nightmare Japan: Contemporary Japanese Horror Cinema*. Amsterdam: Rodopi.

———. 2010. "'Parts Is Parts': Pornography, Splatter Films and the Politics of Corporeal Disintegration". In *Horror Zone: The Cultural Experience of Contemporary Horror Cinema*, edited by Ian Conrich, 191–204. London and New York: I.B. Tauris.

Means Coleman, Robin R. 2011. *Horror Noire: Blacks in American Horror Film from the 1890s to Present*. London and New York: Routledge.

Morgan, Jack. 2002. *The Biology of Horror: Gothic Literature and Film*. Carbondale, IL: Southern Illinois University Press.

Ndalianis, Angela. 2012. *The Horror Sensorium: Media and the Senses*. Jefferson, NC: McFarland.

Newman, Kim. 1985. *Nightmare Movies: A Critical History of the Horror Film, 1968–88*. New York: Proteus Publishing.

———. 2011. *Nightmare Movies: Horror on Screen since the 1960s*. London and New York: Bloomsbury.

Newman, Kim, and James Marriott. 2006. *Horror: The Complete Guide to the Cinema of Fear*. London: Andre Deutsch Ltd.

Nowell, Richard, ed. 2011. *Blood Money: A History of the First Teen Slasher Film Cycle*. London and New York: Continuum.

———. 2014. *Merchants of Menace: The Business of Horror Cinema*. London and New York: Bloomsbury Academic.

Och, Dana, and Kirsten Strayer, eds. 2013. *Transnational Horror across Visual Media: Fragmented Bodies*. London and New York: Routledge.

Odell, Colin, and Michelle Le Blanc. 2007. *Horror Films*. Harpenden, UK: Kamera Books.

Paffenroth, Kim. 2006. *The Gospel of the Living Dead: George Romero's Visions of Hell on Earth*. Waco, TX: Baylor University Press.

Palmer, Randy. 2006. *Herschell Gordon Lewis, Godfather of Gore: The Films*. Jefferson, NC: McFarland.

Paul, William. 1994. *Laughing Screaming: Modern Hollywood Horror and Comedy*. Chichester, UK, and New York: Columbia University Press.

Penner, Jonathan, and Steven Jay Schneider. 2008. *Horror Cinema*. Cologne, Germany: Taschen.

Petley, Julian. 2011. *Film and Video Censorship in Modern Britain*. Edinburgh: Edinburgh University Press.

Peucker, Brigitte. 2007. *The Material Image: Art and the Real in Film*. Stanford, CA: Stanford University Press.

Pirie, David. 1973. *A Heritage of Horror: The English Gothic Cinema, 1946–1972*. London: Gordon Fraser.

———. 2007. *A New Heritage of Horror: The English Gothic Cinema*. London and New York: I.B. Tauris.

Plantinga, Carl. 2009. *Moving Viewers: American Film and the Spectator's Experience*. Berkeley: University of California Press.

———. 2013. "The Affective Power of Movies". In *Psychocinematics: Exploring Cognition at the Movies*, edited by Arthur P. Shimamura, 94–112. Oxford and New York: Oxford University Press.

Powell, Anna. 2005a. *Deleuze and Horror Film*. Edinburgh: Edinburgh University Press.

———. 2005b. "'The Face Is a Horror Story': The Affective Face of Horror". *Pli: The Warwick Journal of Philosophy* 16: 56–78.

———. 2012. *Deleuze, Altered States and Film*. Edinburgh: Edinburgh University Press.

Rigby, Jonathan. 2011. *Studies in Terror: Landmarks of Horror Cinema*. Cambridge, UK: Signum Books.

————. 2015. *English Gothic: Classic Horror Cinema 1897–2015*. Cambridge, UK: Signum Books.

Russell, Jamie. 2005. *Book of the Dead: The Complete History of Zombie Cinema*. Guildford, UK: FAB Press.

Schneider, Steven Jay, ed. 2009a. *Horror Film and Psychoanalysis: Freud's Worst Nightmare*. Cambridge, UK: Cambridge University Press.

————. 2009b. *101 Horror Movies You Must See before You Die*. London: Cassell.

Shaviro, Steven. 1993. *The Cinematic Body*. London and Minneapolis, MN: University of Minnesota Press.

————. 2011. *Post-Cinematic Affect*. Ropley, UK: Zero Books.

Sheets-Johnstone, Maxine. 2009. *The Corporeal Turn: An Interdisciplinary Reader*. Upton Pyne: Imprint Academic.

Short, Sue. 2006. *Misfit Sisters: Screen Horror as Female Rites of Passage*. Basingstoke, UK: Palgrave Macmillan.

Silver, Alain, and James Ursini. 2014. *The Zombie Film: From* White Zombie *to* World War Z. Milwaukee, WI: Limelight Editions.

Sipos, Thomas M. 2010. *Horror Film Aesthetics: Creating the Visual Language of Fear*. Jefferson, NC: McFarland.

Smith, Murray. 1995. *Engaging Characters: Fiction, Emotion, and the Cinema*. Oxford: Clarendon Press.

Sobchack, Vivian. 1992. *The Address of the Eye: A Phenomenology of Film Experience*. Oxford and Princeton, NJ: Princeton University Press.

————. 2004. *Carnal Thoughts: Embodiment and Moving Image Culture*. London, Los Angeles and Berkeley, CA: University of California Press.

Sumner, Don. 2010. *Horror Movie Freak*. Iola, WI: Krause Publications.

Taylor, Gabriele. 1985. *Pride, Shame, and Guilt: Emotions of Self-Assessment*. Oxford: Clarendon Press.

Ticineto Clough, Patricia. 2007. "Introduction". In *The Affective Turn: Theorizing the Social*, edited by Patricia Ticineto Clough and Jean Halley, 1–33. London and Durham, NC: Duke University Press.

Twitchell, James B. 1987. *Dreadful Pleasures: Anatomy of Modern Horror*. Oxford: Oxford University Press.

Walker, Johnny. 2015. *Contemporary British Horror Cinema: Industry, Genre and Society*. Edinburgh: Edinburgh University Press.

Waller, Gregory A. 2010. *The Living and the Undead: Slaying Vampires, Exterminating Zombies*. Chicago, IL: University of Illinois Press.

Wee, Valerie. 2013. *Japanese Horror Films and Their American Remakes: Translating Fear, Adapting Culture*. London and New York: Routledge.

Weinstock, Jeffrey. 2012. *Vampire Film*. Chichester, UK, and New York: Columbia University Press.

Wells, Paul. 2000. *The Horror Genre: From* Beelzebub *to* Blair Witch. London: Wallflower.

Wetherell, Margaret. 2012. *Affect and Emotion: A New Social Science Understanding*. London and Thousand Oaks, CA: Sage.

Wetmore, Kevin J. 2011. *Back from the Dead: Remakes of the Romero Zombie Films as Markers of Their Time*. Jefferson, NC: McFarland.

————. 2012. *Post-9/11 Horror in American Cinema*. London and New York: Continuum.

Williams, Linda. 1991. "Film Bodies: Gender, Genre, and Excess". *Film Quarterly* 44.4: 2–13.

Williams, Tony. 2003. *The Cinema of George A. Romero: Knight of the Living Dead.* Chichester, UK, and New York: Columbia University Press.

Wilson, Laura. 2015. *Spectatorship, Embodiment and Physicality in the Contemporary Mutilation Film.* Basingstoke, UK: Palgrave Macmillan.

Wood, Robin. 1978. "Return of the Repressed". *Film Comment* 14.4: 25–32.

———. 1980. "Neglected Nightmares". *Film Comment* 16.2: 24–32.

Worland, Rick. 2007. *The Horror Film: An Introduction.* Oxford and Malden, MA: Blackwell.

Ziemba, Joseph A., and Dan Budnik. 2013. *Bleeding Skull! A 1980s Trash-Horror Odyssey.* London: Headpress.

Filmography

Amityville Horror, The. 1979. USA. Directed by Stuart Rosenberg. American International Pictures, Cinema 77 and Professional Films.

Blair Witch Project, The. 1999. USA. Directed by Eduardo Sánchez and Daniel Myrick. Haxan Films.

Circus of Horrors. 1960. UK. Directed by Sidney Hayers. Lynx Films Limited.

Curse of Frankenstein, The. 1957. UK. Directed by Terence Fisher. Hammer Film Productions.

Dracula. 1958. UK. Directed by Terence Fisher. Hammer Film Productions.

Evil Dead, The. 1981. USA. Directed by Sam Raimi. Renaissance Pictures.

Frankenstein. 1931. USA. Directed by James Whale. Universal Studios.

Friday the 13th. 1980. USA. Directed by Sean S. Cunningham. Georgetown Productions Inc. and Sean S. Cunningham Films.

Ginger Snaps. 2000. Canada. Directed by John Fawcett. Copperheart Entertainment and Water Pictures and Motion International.

Halloween. 1978. USA. Directed by John Carpenter. Falcon International Productions.

Hellraiser. 1987. UK. Directed by Clive Barker. Cinemarque Entertainment BV, Film Futures and Rivdel Films.

Hills Have Eyes, The. 1977. USA. Directed by Wes Craven. Blood Relations Co.

Hills Have Eyes, The. 2006. USA. Directed by Alexandre Aja. Dune Entertainment and Major Studio Partners.

Horrors of the Black Museum, The. 1959. UK. Directed by Arthur Crabtree. Anglo-Amalgamated and Carmel Productions.

Hostel. 2005. USA. Directed by Eli Roth. Revolution Studies and Beacon Pictures.

Martyrs. 2008. France. Directed by Pascal Laugier. Eskwad, Wild Bunch and TCB Pictures.

My Bloody Valentine 3D. 2009. Canada. Directed by Patrick Lussier. Lionsgate.

Peeping Tom. 1960. UK. Directed by Michael Powell. Anglo-Amalgamated.

[•REC]. 2007. Spain. Directed by Jaume Balagueró and Paco Plaza. Filmax International and Castelao Productions.

Snuff-Movie. 2005. UK. Directed by Bernard Rose. Capitol Films.

Terror Is a Man. 1959. USA and The Philippines. Directed by Gerardo de León. Lynn-Romero Productions and Premiere Productions.

Wolf Creek. 2005. Australia. Directed by Greg McLean. FFC Australia, Film Finance Corporation, South Australian Film Corporation et al.

1 Representation
Abjection, Disgust and the (Un)Gendered Body

It could be argued that psychoanalysis, in its various incarnations, has kept the body at the centre of its theories. From Freud's work on the unconscious and the formation of the ego to Lacan's thinking about the acquisition of language or the mirror phase, the body – as constitutive of the speaking subject, in its role within the realm of the symbolic – has been significant to its major thinkers, albeit sometimes only obliquely.[1] However, because psychoanalysis is invested in totemic understandings of, for example, psychosexual development and is often connected to abstract notions related to the mind or to social-organisational principles, it has been perceived as an "acorporeal" critical approach within the context of Cultural and, more specifically, Film Studies. Whilst it was, at one point, the favoured methodology in the Humanities, recent work has, unsurprisingly, aimed to recuperate it.[2] Whilst psychoanalysis, as a discipline, continues to be used and studied, there has been a major drive towards the application of poststructuralist theories that celebrate plurality and the significance of the specificity of the individual to the analysis of cultural texts. Among these, the work of Deleuze and Guattari, especially their powerful challenge to Freud in *Anti-Oedipus* (1977), has contributed to the perception of psychoanalysis as potentially outdated and even ahistorical.[3] Although this has naturally translated into Horror Studies, with recent publications unpacking the benefits of alternative approaches like phenomenology, critics in the field still borrow from psychoanalysis.[4]

In this chapter, my intention is not to make claims about the validity and the corporeal nature of psychoanalysis but to show how one of its main applications to Horror, the notion of abjection as defined by Julia Kristeva (1982) and developed by Barbara Creed (1986; 1993) has become crucial to the genre and its interest in issues of corporeal representation. More particularly, my focus is on the ways in which the abject female body has laid at the heart of debates that have both legitimised the study of Horror and complicated its construction of female villains as disgusting through a focus on their excessive corporeality. Turning to the maternal body, I suggest it is possible to recast it as a representational zone of affect because of its transgression of the inner/outside body dichotomy, rather than, as has been argued, because it is inherently linked to any universal forms of detachment and rejection of the mother on the part of the child. In essence, what

I propose in this chapter, beyond establishing a new understanding of abjection as fearful disgust, is that representation can be usefully rethought by focusing on the disturbance of corporeal boundaries. Since these boundaries are strongly culturally and socially inflected, emphasising the ways in which the female body is portrayed in specific films becomes necessary to ascertain how the latter continues to be articulated as a source of fear.

This first step towards considering the relevance of the body to Horror and to affect engages with the way in which certain corporeal images – the most widely discussed being the abject female body – can arouse feelings in audiences because of commonly shared ideas of what may constitute a disgusting, undesirable or disruptive body, or because of the foregrounding of certain bodily discharges connected to femininity, such as menstruating blood. Whilst the specific conclusions I reach may not strictly apply to other forms of horrific representation (since the abject female body, maternal or otherwise, is neither the sole nor the principal source of horror in Horror), the backbone of my argument may be extrapolated: besides acting as the catalyst for the type of more instinctive reactions connected to the vicarious experience of imagined pain, the body can be a source of affect at a representational level when it dares to transgress the neatly delineated boundaries of inside and outside.

I begin this chapter by considering Creed's application of Kristeva's abjection to the realm of Horror and showing how some of her more general thoughts on the female body fail to account for the ways in which corporeal affect is actually mobilised. A case study of *Ginger Snaps* (John Fawcett, 2000) allows me to analyse the difference between a film's use of gender at an explicit thematic level and the way in which a much less gendered body could be said to elicit affect. In this chapter, I also challenge the primacy of the maternal body as principal guide or indicator of abjection. I focus on the problems that such an essentialising model proposes to illustrate how reductive readings of Horror's exploitation of the maternal body ignore its nature as a disturbing genre more interested in affecting the viewer.[5] More generally, my consideration of fearful disgust as a possible alternative through which to understand the impact of images of abjection helps me illustrate how abjection can be distanced from its more universal and archetypal implications and appropriated for Affect Studies. I illustrate this through a case study of a film that very explicitly abuses the female body and abounds with images of abjection, Pascal Laugier's *Martyrs* (2008). As I will show, the film's affective work is not necessarily connected to the thematic one, even if both can feed off each other.

Gender, Abjection and the Limitations of the Monstrous-Feminine Model

Gender has been one of the most important and productive areas of debate in Horror Studies since the 1980s, when Horror started gathering

critical momentum.[6] Not only did it help shift interest towards an until then much-maligned genre, in some cases it even purported to present it as potentially radical. For example, Stephen Neale argued that the monster in Horror is produced by male fear of castration and that, by displaying the misconception that women are castrated, it potentially lays bare the problems of the patriarchal order (1980, 44–55). Similarly, in her influential article, "When the Woman Looks", film scholar Linda Williams invested the act of looking at monsters on the part of female characters (and, by extension, viewers) with a subversive and dangerous power that explained its compulsive punishment and repression on the screen.[7] Basing her reading on a masochistic-sadistic model that relied on psychoanalysis, Williams was already laying the groundwork for the potential application of this discipline to studies seeking to discuss the politics of gender representation. Although some publications in the mid-to-second half of the 1990s would avoid psychoanalysis completely (most notably those by Judith Halberstam (1995) and Rhona J. Berenstein (1996)), two canonical works, Carol J. Clover's *Men, Women and Chain Saws* (1992) and Barbara Creed's *The Monstrous Feminine* (1993), would do much to institute it as a key approach in the analysis of the female body in Horror.[8]

Clover's rethinking of Laura Mulvey's (1975) argument about the cinematic identification of viewers with the sadistic male gaze depended on principles that are effectively Freudian. Her ground-breaking proposition that the pleasures of identification with the often androgynous final girl of the slasher film are premised on the adoption of a masochistic viewing position inevitably takes us back to pre-Oedipal stages. Similarly, Creed's own theorisation of the monstrous-feminine develops from Julia Kristeva's psychoanalytically-inflected work on abjection.[9] Both studies focus on the female body and draw from psychoanalysis in order to articulate their arguments. Not only are they an important indication that, as I suggested in the introduction, the body has remained at the heart of the major debates on the purpose and workings of Horror, but they also, crucially, point towards the ways in which representations of the transgressed onscreen body continue to generate affect by (ab)using its vulnerability. Since my focus in this chapter remains corporeal representation, I centre primarily on Creed's theses in order to assess their validity to the possible construction of viewing affect through representational channels. I will, however, turn to Clover later in this study when I consider the role of viewer positioning in Chapter 3.

Barbara Creed's hypothesis, at least initially, is simple enough: female monsters abound in popular culture and, especially, in Horror. Purporting to investigate the neglected figure of the woman-as-monster (instead of the more commonly investigated woman-as-victim), Creed proposes the term "monstrous-feminine" to refer to her, as it emphasises the fact that gender and sexuality are essential to the construction of her monstrosity.[10] She proposes that the monstrous-feminine is a "phantasy" of castration created by the male and therefore directly linked to sexual desire.[11] As a result, monstrous-feminine figures are either *femmes castratrices*, castrating mothers or figures

who incorporate (when they do not symbolise) the image of the *vagina dentata*. Her other main contention is that, when represented as a monster, Horror often exploits woman's "mothering and reproductive functions" (1993, 7). Since this is a key and complex aspect of Creed's theory, I will devote a separate section to it later in this chapter and focus, first, on the ways in which the monstrous-feminine body is seen as a source of abjection.

According to Kristeva, abjection's social work is to separate out the human from the non-human and demarcate the boundaries between the fully and the partially constituted subject. As a dark "revolt [...] of being", the abject is "opposed to *I*" and "settles me within the fragile texture of a desire for meaning [...] [It] draws me towards the place where meaning collapses" (1982, 1–2). Although Kristeva's subsequent discussion of food muddles things somewhat, her proposition that the corpse is upsetting and a form of abjection because it does not, like the encephalogram, "*signify*" death (instead, it *shows* death, what is "permanently thrust aside in order to live") is significant (3, italics in the original). The former allows for reflection or acceptance, whilst images of abjection (the corpse, a "wound with blood and pus", or, if applied to the olfactory sense, "the sickly, acrid smell of [...] decay") puts one "at the border of [their] condition as living being[s]" and "disturbs identity, system and order" (3–4). In a long list, Kristeva proposes a number of possible examples of abjection that is perhaps too inclusive and does not seem to compare reasonably with the image of the corpse or the workings of abjection as she has previously described them. Here, abjection is "[w]hat does not respect borders, positions, rules. The in-between, the ambiguous, the composite. The traitor, the liar, the criminal with a good conscience, the shameless rapist, the killer who claims he is a saviour" (4). Her attempt to further define the term does not do much to delineate its boundaries, something which is only complicated by her use of poetic language. Abjection, thus, effectively becomes anything "immoral, sinister, scheming and shady: a terror that disassembles, a hatred that smiles, a passion that uses the body for barter instead of inflaming it, a debtor who sells you up, a friend who stabs you" (4).

The most comprehensive and viscerally-inflected definition of abjection, which is the one that interests me most in this study, has been provided by Rina Arya, who describes it as "a complex theoretical concept and a pervasive cultural code" which is also:

> a vital and determinative process in the formation of the subject. On a psychic level (in the sense of psychoanalysis), the experience of abjection both endangers and protects the individual: endangers in that it threatens the boundaries of the self and also reminds us of our animal origins, and protects us because we are able to expel the abject through various means. For Kristeva, abjection originates as a psychic process but it affects all aspects of social and cultural life.
>
> (Arya 2014, 2)

The abject, that which endangers the self, is expelled (abjected) and thus its threat reduced or contained. Abjection has been seen to originate in the infantile rejection of the mother's body, an important, yet problematic, point that is developed in some detail below in relation to Creed's own application of the concept to her study of the monstrous-feminine. Despite its obvious challenge to the stability of the subject, or perhaps because of it, the abject cannot be objectified: it is neither object nor subject itself, but has properties of the two; it lies "at the boundary of what is assimilable, thinkable" (Kristeva 1982, 18).[12] This means that the abject is similar but other, an "other" (Arya 2014, 4), in fact, which lives within ourselves and must be rejected in order to protect the borders that constitute us: "[i]t is something rejected from which ones does not part, from which one does not protect oneself as from an object" (Kristeva 1982, 4). As we can see, abjection and the abject are incredibly complex and very abstract notions that are highly speculative and poetically described. Unsurprisingly, they have been applied to a number of disciplines and studies, but the approach that concerns me here, due to its influence and the durability of her arguments, is Creed's own use of Kristeva.

Creed's notion of the monstrous-feminine draws mainly on three aspects of abjection: its preoccupation with borders, the nature of the feminine body and, crucially, the mother-child relationship, as I will show later. For Creed, Horror illustrates the work of abjection representationally, by featuring a host of images of abjection that include, predominantly, the corpse (partial or full) and bodily wastes ("blood, vomit, saliva, sweat, tears and putrefying flesh" (1993, 10)). The latter substances, especially because blood can be associated with menstruation, are often connected to the monstrous-feminine, a figure which also encapsulates, by its very nature, the crossing of borders and categories.[13] In psychoanalytic terms, she threatens the stability of the symbolic order by breaking a clearly defined border between what constitutes the proper or clean body and the polluted or improper one.[14] Creed, *pace* Kristeva, acknowledges the role of ritual and religion in the delimitation of what constitutes these borders and, thus, the formulation of the abject female body. For her, constructions of the monstrous-feminine in modern Horror have a grounding in ancient religion and, especially, in what it considers abominable, that is, "sexual immorality and perversion; corporeal alteration, decay and death; human sacrifice; murder; the corpse; bodily wastes; the feminine body and incest" (Creed 1993, 9). It is not surprising, then, she argues, that cannibalism, the abominable and living corpse or bodily disfigurement are recurring images in this genre.

The basis for her readings of films such as *The Exorcist* (William Friedkin, 1973), *The Brood* (David Cronenberg, 1979), *The Hunger* (Tony Scott, 1983) or *Carrie* (Brian De Palma, 1976) is that, thematically, they are always primarily about the "exploration of female monstrousness and the inability of the male order to control the woman whose perversity is expressed through her rebellious body" (34). Thus, demonic possession, telekinesis and other

psychic phenomena, or blood-sucking are only conduits for a broader filmic analysis of the representation of women that no longer reduces them to victims and places them at the centre of the act of representation. Some of the insights provided by Creed's application of abjection illustrate how, in these landmark films, Horror could be seen to stem from challenges to gendered behaviour – women's "break[ing] with [their] proper feminine role[s]" – or culture's grotesque treatment of the pregnant body and of female reproductive functions (42, 58, 83). Creed's study is significant because it is one of the first to point out that well-known Horror is problematic in its construction of femininity as a form of threat. With her, the representational dimensions of Horror suddenly gain an additional meaning that purportedly forces us to rethink both our viewing position (as subjects who understand, and are therefore complicit in, the construction of the body of woman, especially of the mother, as monstrous) and the models of femininity available to women in this genre (victims or monsters). Creed's theorisation of Horror seeks to show that representation re-presents, that the monstrous-feminine is informed by processes of abjection carried out socially and culturally.

Before I set out to re-appropriate abjection as a theoretical tool through which to understand the affective impact of certain corporeal images, it is important that Creed's complex study of the configuration of the monstrous-feminine, as well as its limitations, is given due consideration. Her reliance on essentialist biology is crucial for a de-gendering of the abject and its repositioning as a source of fear due to its vulnerability. Thus far, I have provided only a partial account of abjection, because, for Kristeva and therefore for Creed, abjection and the monstrous-feminine develop through the maternal figure. It is her body that is key to, first, understanding the extent to which representation is connected to cultural and social assimilation, and, second, the extent to which such a position ignores the actual workings of the abjected body as an image.

The female body, because of its maternal functions, can be seen to acknowledge what Kristeva calls its "debt to nature" (1982, 102), something the symbolic body should bear no indication of, and which, for this reason, makes it more likely to be a source of abjection. More specifically, however, the mother is directly responsible for an actual instance of abjection which is seminal to the formation of the subject, is situated in the pre-Oedipal stage and is seen as a pre-condition for narcissism. The struggle that ensues between the child who wants to break away from its mother and the mother who holds it back and will not let it enter into, and attain its position within, the symbolic world is for Kristeva, fundamental to the inscription of the maternal body as a zone where conflicting desires mingle. The eventual entry into the symbolic necessitates the repression of the mother and what she signifies (her authority). Defilement rites, argue Kristeva and Creed, are responsible for "point[ing] to the boundary between the maternal semiotic authority and the paternal symbolic law" (Creed 1993, 14), the former being connected to the pre-verbal dimension of language and

the corporeal drives of the child. If one follows this reasoning, the maternal body is abject in adult life because it is naturally linked to this phase in the psychological development of the subject. In some Horror, the maternal body is thus doubly abject when present: not only is it naturalised as abject by patriarchy, but it is also made explicitly monstrous (its features rendered grotesque or macabre). In a correlative move that I will problematise below, both aspects – the representational and the real – are connected in order to place the maternal body at the heart of Horror. As Creed's final and totalising statement puts it, "every encounter with horror, in the cinema, is an encounter with the maternal body *constructed* (I am not arguing that woman is essentially abject) as non-symbolic by the signifying practices of patriarchal ideology" (166).

Creed focuses on *Alien* (Ridley Scott, 1979) to illustrate the way in which abjection materialises in Horror, although she proposes that other examples may be found in films such as *Invasion of the Body Snatchers* (Philip Kaufman, 1978) and *The Thing* (John Carpenter, 1982). For her, the presence of the archaic mother – "the parthenogenic mother, the mother as primordial abyss, the point of origin and end [...] the image of the mother as sole origin of all life" – is there in the text's representation of the Freudian primal scene, through recurring images of blood, darkness, death and monstrous birth (the "facehugger" and "stomach-burster") and, perhaps more importantly, through the alien, who is "fetish-object of and for [her]" (Creed 1993, 17, 18).[15] The iconography and settings are reminiscent of the womb and female genitals, she claims, as is the mother-ship *Nostromo*, also referred to as "Mother", and the vaginal openings of the unknown space-ship where the hatching alien eggs are found. Importantly, however, Creed feels the need to distinguish between the semiotic mother that preoccupies her in most of *The Monstrous-Feminine* (Kristeva's "mother of the semiotic chora") and the archaic mother, who is "generative" and "pre-phallic" (20). Although she never explains how the two would be distinguished in terms of their representation within the film – presumably they coalesce – she does suggest that the alien, as a castrating and all-incorporating monster, can be understood via fetishism to be "a form of doubling or multiplication of the 'phallus'" (23).

Creed's drawing on Roger Dadoun's work on Count Dracula (1989) to conclude that the alien symbolises the archaic mother's fetishised phallus and that its "razor-sharp teeth" are yet another representation of the castrating "all-incorporating mother" (23) seems not just pure abstract speculation but actually counterintuitive.[16] In fact, what this critical move suggests is precisely the limitations of psychoanalysis as a discipline through which to study the workings of fear: it highlights the need to remove abjection from its psychosexual bed and into the arena of social interactions. At the risk of sounding excessively prosaic, when the alien finally appears in the scene where Brett (Harry Dean Stanton) is looking for his cat, the source of affect is not the thought of the *vagina dentata* but the fact that the alien is a

direct threat to the rather harmless and unarmed technician. The connection between the alien's mouth and the *vagina dentata* is one that works only by analogy (and not necessarily in as clear or unproblematic a way as is suggested) and one that fails to deal with the affective specificities of the scene. The role of sound, of lighting and the way in which the film has anticipated, but not shown, the grown alien are all missing from Creed's reading. More importantly, shock (or fear) is not articulated via representation only, but through the piercing of Brett's body. The shot where the mouth is seen opening up and revealing a small head is followed by another where the latter propels and pierces something (the image is flashed too quickly for the object to be discerned with any clarity) and, then, by a shot where Brett is seen screaming and his head bleeding.

Surely, even if we were prepared to acknowledge that, representationally, the alien stands in, psychoanalytically, for the repressed "nightmare image of the archaic mother, constructed as a sign of abjection" (Creed 1993, 24), this does not account for the way in which the scene uses both bodies to create a sense of threat. In other words, what is lacking here is an explanation of the processes whereby something that is potentially abject at a symbolic level (not in the psychoanalytic sense, that is, but at the level where it metaphorically symbolises something) acts upon the body of the viewer. If it could be argued, as Creed does, that *Alien* is preoccupied with "the notion of the fecund mother-as-abyss" and that its "deepest terror" is "the cannibalizing black hole from which all life comes and to which all life returns" (Creed 1993: 25), this still does not explain how the film expresses that preoccupation. Such propositions, problematic as they are (is the film not, at least on a superficial level, about a predating alien that takes over a ship?), only help us speculate about what the film could be about on an abstracted dimension far removed from its structure, as well as from the way in which viewers might experience, for example, the film's use of startle effects. It is also premised on the principle that viewers will pick up and understand the connections between the alien, the background and the archaic mother – which was not necessarily the case for this viewer the first (or the last) time that he watched *Alien*. Although the counter-argument could be that the reason these connections might not be readily obvious is that they rest on deep psychological structures, I still find them unsatisfactory in order to determine how horror functions on a practical level.[17] To put it simply, the alien is also scary or disgusting because it oozes acid, has no obvious eyes, looks and is prefigured as aggressive and dangerous, is obviously faster than humans and can easily kill them.

Other important examples are the gaping "voracious maw[s]" in *The Thing* (John Carpenter, 1982) and *Poltergeist* (Tobe Hooper, 1982), as well as the shark in *Jaws* (Steven Spielberg, 1975), all of which Creed sees as images of "the mysterious black hole that signifies female genitalia which threatens to give birth to equally horrific offspring as well as threatening to incorporate everything in its path" (Creed 1993, 27). It is this presence,

that of the "gestating, all-devouring womb of the archaic mother", which "generates the horror" (27). This reading of an image, or, in this case, a specific figure or part of a monstrous body, as an example of a primal image causing abjection is symptomatic of the type of psychoanalytically informed representational reading of Horror that confuses possible metaphoric readings with the narrative, visual, cognitive and affective workings of Horror. For one thing, the correlation between the voracious maw, even an actual man-eating womb like that of *The Thing*, and the abstract archetypal notion of the archaic mother's all-devouring womb, is never convincingly argued or justified. The analogy, or design of the womb, in *The Thing*, may well draw, visually, from the female womb and may even be a deliberate attempt to make that part of female anatomy monstrous. At worst, it may be a grotesque appropriation of the female body for affective purposes. However, it does not follow that this has been done with the intention to "signify" anything, least of all the archaic mother and her body, as this position would have to grant that the special effect designers, scriptwriters and director were aware of the concept itself in the first place. In the film, the womb is just another component of a bigger monstrous body, largely indescribable, although with traces of the human and made, at least in part, of flesh, that may not be ascribed with any ease to a specific gender. If, for the sake of argument, we were to overlook the above, we would still have to reject Creed's proposition on the grounds that the devouring womb does not generate horror because it signifies something else. If, indeed, it generates any horror at all – and, with the passing of the years, this may increasingly become less likely – it is because it is presented as a real threat to the intradiegetic characters and/or the viewer. The womb here is not solely horrific as a concept but as a material presence: it could literally eat you up.

This example, for me, is indicative of the type of shift that my reading of representation, and abjection, entails. Female bodies may well be presented as monstrous and horrific, but their appearance is a conscious decision made by the directors or screenwriters that does not sit, or indeed, act upon deep-seated structures of the human psyche. It may well be that these psychoanalytic ideas can be, afterwards, underpinned to the images or situations themselves, but such endeavours must necessarily remain speculative in nature and often fall through when contemplated within the affective and narrative context of the film. In the previous example, the choice of the "devouring maw" as a horrific image may be an indication of an inherent fear of the female reproductive system on the part of patriarchal, phallic society, but since the film is hardly interested in female reproduction otherwise, this seems far-fetched and unfair. It could be argued that, since the "thing" in the film represents an encounter with unknown forces that escape human understanding, images such as that of the maw may stand as metaphors for the mystification of female sexuality. But again, even if we choose to favour such readings, they do not account for the way in which the text affects readers directly.

At this point, it is necessary to turn to a contemporary example, especially one that specifically deals with gender issues and the monstrous female body, in order to establish the distinction between a gendered thematic concern a more general affective one. *Ginger Snaps*, a celebrated feminist film that actively parades, and comments on, the female teenage body, is perhaps the best choice.

Case Study 1: The Female Teenage Body in *Ginger Snaps* (2000)

The aim of this first case study is twofold: on the one hand, it seeks to disprove the notion that Horror's depiction of the monstrous-feminine always functions in the same negative way by showing how films in the genre can also draw on the female body in order to negotiate anxieties connected to adolescence and femininity. On the other hand, this study demonstrates that the source of abjection in films that are easily identifiable as contemporary texts where the monstrous-feminine takes central stage does not function through a reductive representational system producing horror through the dread of difference or through a twisted portrayal of female reproductive functions. To conflate the workings of Horror with the ways in which films present and question gender fails to realise that the representation of bodies works in multiple ways. Lastly, I analyse any possible instances of abjection, as I will define it, within the film and defend my contention that these are not gendered but, instead, appeal to corporeal intelligibility and the capacity to understand the intensity and consequences of pain. This does not demand a de-gendering of Horror, as *Ginger Snaps* has a clear feminist agenda. In it, gender is dealt with at a thematic level, so that the film is explicitly *about* it. Such a shift allows me to speak about the way in which Horror can actively challenge the type of biological essentialism that lies at the heart of Kristeva and Creed's abjection.[18]

Ginger Snaps is, quite possibly, one of the most gender-conscious films of the twenty-first century.[19] If the killer (human) female figures of *May* (Lucky McKee, 2002), *The Loved Ones* (Sean Byrne, 2009), *Excision* (Richard Bates, Jr., 2012) or *Stoker* (Park Chan-wook, 2013) embody concerns about adolescence that are not necessarily exclusive to girls, such as difficulties blending in at school, unpopularity or being rejected by potential idealised partners, the werewolf at the heart of *Ginger Snaps* is very obviously a gendered monster that seeks to update classic films such as *I Was a Teenage Werewolf* (Gene Fowler, Jr., 1957) or *An American Werewolf in London* (John Landis, 1981).[20] Like *Jennifer's Body* (Karyn Kusama, 2009), adolescence is largely coloured in *Ginger Snaps* by the onset of sexuality and the conflicted feelings it generates: it is a period of maturation that is painful and disconcerting, in which the body changes slowly but steadily and in unexpected ways but which may be ultimately seen to be attractive because it also empowers the subject. The premise of the film is simple: Ginger

Fitzgerald (Katharine Isabelle) is bitten by a werewolf on the night when she experiences her first period. Initially very close to her sister, Brigitte (Emily Perkins), the changes she experiences as she begins to morph into a wolf-human hybrid and, eventually, a gigantic wolf, inevitably drive the siblings apart. Her transformation coincides with her sexual awakening, so that her journey from girlhood to womanhood, contained metaphorically in her becoming-wolf, mirrors her need to sever her childhood ties (encapsulated by her young and not-yet menstruating sister) and become an independent adult woman.

These are no ordinary teenagers: the credits sequence reveals that the Fitzgerald sisters also have a morbid curiosity that manifests itself in strange practices, such as their taking pictures of their own staged deaths for a school project or discussing suicide. At the same time, however, they are also archetypally alternative: they smoke, they hate school and they do not care. The sisters are quite similar: Ginger is attractive and less shy than stern and mousy Brigitte, but they are still clearly separated during PE from the girls who wear make-up, are sportier and clearly have a greater preoccupation with their body image. In a way, then, the film is at pains to establish a sense of personality and identity premised on difference and alterity. These girls are, at least to their fellow students, "freaks". All of this changes for Ginger when she hits puberty. She then starts noticing boys – even those she had previously feared were "checking [her] out" – wearing lipstick and wanting to experiment with her body by, for example, getting piercings. This homogenises Ginger, as if the experience of becoming-woman were necessarily tied up with being accepted as a "normal" (normative) gendered and sexual subject. Her sister, who is still a girl, cannot fit into this world and continues to be perceived and treated as "other". Despite this, the film does not side with Ginger or the gendered and socialised girls. In fact, since Ginger's transformation inevitably leads to her death, it could be argued that her transformation reflects the ways in which becoming a sexual subject is fraught with complications, expectations and disappointments. Ginger becomes a species of blueprint for the traumatic experiences of female adolescence, so that her process, her painful metamorphosis, can be read as a metaphor for the universal ordeal of coming of age. Since the film is centred on the lives of the two girls, *Ginger Snaps* chronicles this key moment in the development of humans specifically from a woman's point of view, albeit that of a girl who is experiencing no ordinary adolescence.[21]

Early on, as she begins suffering from a backache that will later be connected to her first period, Ginger is singled out as the one who looks like "she's good to go" and as the "redhead" with the "rack". Her mother (Mimi Rogers) recognises her daughter's pain for what it is and celebrates it because she is, like Brigitte, three years late menstruating. The passage is completed narratively by the attack of the werewolf on a full moon, who is attracted by Ginger's menstrual blood, and her double-cursing.[22] This scene signals Ginger's final step into adolescence, which, in the guise of small lycanthropic

changes, begins to alter her body almost immediately. Pain and self-loathing or disgust of one's own body is highlighted throughout: from the tampon shopping trip, where Brigitte feels the need to ask Ginger if she is sure she just has cramps, to Ginger's rather offhand remark, upon noticing wolf fur sprouting out of her claw scars, that she cannot afford to have a "hairy chest", these instances of corporeal surprise and shock are significant. They create a strong link between the visceral reality of becoming a woman by, for example, showing the disgusting process of suddenly haemorrhaging copiously on the floor, or including a mini-lecture on the types of menstrual flows Ginger should expect for the next thirty years. In fact, the discomfort of ovulation becomes virtually indistinguishable from, although not equated with, her body's reaction to the infection, a point driven home by an earlier scene where a video about "meiosis" is being shown in class, a cellular process whereby the intruder/invader body consumes and destroys its host. Microscopic images are connected to Ginger, who, during the screening, lets her head bang against her desk in either agony or exhaustion.

Figure 1.1 Ginger's transformations in *Ginger Snaps* (2000) are not affective because they rely on a specifically feminine body.

As I have mentioned, the film is also interested in showing adolescence as an exciting period of excess and experimentation. When Jason (Jesse Moss) suggests to Ginger that she smoke a joint in order to take the edge off her pain, her response is that she likes "her edge". Jason then uses this remark to dare her to try the weed and prove she is not a "chicken". This moment kick-starts a new phase of self-discovery and confidence that sees Ginger shaving, getting highlights and wearing clothes that show off her slender figure. After a sneaky smoke-up in a van, Ginger kicks Trina's (Danielle Hampton) Doberman, a sign that she is finally standing up for herself and

is stronger, quite literally, than before. Her rebellion, her appropriation of her own body and, in this case, her budding monstrosity, is set in contrast with the overly positive and highly posed world of the middle-aged women (represented by her mother and the school nurse (Lindsay Leese)), who respond to her questions and discomfort with smiles, cakes and matter-of-fact advice like "I'm sure it feels like a lot of blood – it's a period!" or "[e]veryone seems to panic the first time". Ginger is also distanced from the traditional expectations and constructions of womanhood by being the active party in her relationship with Jason. In the car scene, Jason challenges her forwardness by asking her "[w]ho is the guy here?", to which she responds by pinning him down and biting his chest.

For all that *Ginger Snaps* is a film about the passage from girlhood to womanhood, about the horrors and insecurities of adolescence, it is also, as we are reminded throughout, on another level, simply a werewolf film.[23] Upon seeing Ginger run to the bathroom after kicking Trina's dog, Brigitte remarks that the problem is not just about her "being female" and proceeds to explain that she was indeed bitten and has been possibly infected. Ginger herself, after a scene where she rejects her mother's excitement over her first period, feels the need to make it clear that the fact that she is "butt-ugly" does not make her a "monster". The car scene is even more poignant, because, although it may gain further meaning later, when it is revealed that Ginger's decision not to use protection passed the curse on to Jason, it rejects easy metaphoric impositions. The temptation is to read the scene as a comment on the risks of not wearing protection when having sex and, thus, of contracting STDs, but the film specifically tells us that this is not the case. A shot that concentrates on Ginger's pointy spine – an image we recognise from Brigitte's discovery of her tail – makes it clear that her urges are connected to her infection. Furthermore, Ginger actually explains, when talking about what has happened, that she felt an "ache" that she thought "was for sex, but it's to tear into fucking pieces". This is a crucial point. Although the film uses lycanthropy as a trope through which to discuss the hormonal and psychological changes connected to growing up, it does not conflate them. Ginger is both a teenager and a werewolf; her pains are both related to growing up and to becoming a wolf. If the lines between both are blurred, adolescence and werewolfism never truly collapse into each other. It is, of course, productive to read Ginger's transformation metaphorically – this is one of the film's distinctive aspects and which makes it stand out as a potentially feminist film – but to argue that the film is about the female body would be to essentialise it at a thematic level. It would also ignore the narrative's affective dimensions, which does not rely on hybridity, and only rarely on abjection.

In *Ginger Snaps*, Ginger's body is shown as a source of disgust and the biological processes which are explicitly menstrual only scare her: the target audience is obviously aware that what she is going through is connected to menstruation but can also understand that certain of her changes have little

to do with it (that it is, for example, unusual for teenagers to grow sharp canines or a little tail, like Ginger does). As the film advances and Ginger's metamorphosis speeds up, this becomes even more obvious: the claw sticking out of her foot, her dirty and animal-looking fingernails, changing eye colour, pronounced brow, saggy skin with doglike tits and snarly, deep voice.[24] Her physical becoming-monster runs parallel to our estrangement from her as a likable character. As she starts blaming Brigitte for her mistakes and is shown feeling no remorse for her actions or their consequences (Jason's state, Trina's death, in which she played a role), it is difficult to continue to feel sympathy for her. Her turning into a grotesque and gigantic monster, one who does not look at all like Ginger used to, is mirrored by her loss of ethical and moral qualms and, thus, humanity. Inherent to this change is a self-loathing that manifests in sadness over her own condition ("I can't be like this!") and a botched attempt to remove her growing tail, a token of her otherness. Yet, Ginger's body does not become a source of abjection. It is presented as a curiosity, as a spectacle that is also unexpected – we are never entirely sure what is going to happen to her next, and previous werewolf films, such as *The Company of Wolves* (Neil Jordan, 1984), are of little help. Ginger is only truly horrific when she becomes utterly "other". When that happens, however, all figurative traces of Ginger are gone and whatever fear the creature may cause is a result of its monstrous qualities (size, feral look, aggressive attitude, capacity to kill) and these are not specifically associated with femininity of female sexuality.[25] There is, in fact, little attention directed to the gender of the final werewolf creature: she is scary because she is a gigantic, violent beast.

A scene that flirts with abjection, but does not fully channel it, comes at the beginning of the film. After the girls have made a pact to die together and discussed their potential suicide, the scene shifts to a lateral pan of a white picket fence that very soon reveals an impaled Ginger, two bloodied planks of wood sticking out of her stomach and her face smudged and with a vacant stare. The editing here creates a natural causal deduction: Ginger is dead and her death looks recent; the girls went ahead and killed themselves. When it becomes obvious, only seconds later, that the scene is staged and that their previous discussion was, quite possibly, connected with their photography project, it becomes impossible to feel any strong fear or disgust towards the scene. At that point, we know it to be "fake" even intradiegetically and may even criticise its effectivity after Brigitte exclaims "[t]oo much blood! And I can see your gonch!" But even before this, the score and the camerawork present the scene as a tragic resolution, one that should potentially awaken a sense of pity and disappointment because the character appeared to be quirky and interesting, and not one of fearful or disgusting affect. The fact that the corpse is only marginally gory – all we see is painted blood – and looks only marginally dead, works against any other prevailing feelings, so that shock and pathos are more likely than fear and disgust. Ginger's impaled body does not, then, strictly qualify as an image of abjection due to the treatment it receives in this particular scene.

A better example of a sequence that toys with abjection comes when Ginger tells Brigitte about her sexual episode with Jason. Brigitte's attempt to save her sister are important to the story, as they link it strongly to the werewolf genre. Monkshood, a plant connected to wolfsbane, is eventually proven to be a successful antidote but, before that, the sisters try to use silver. The scene in particular sees Brigitte piercing Ginger's navel with a long and sturdy needle as Ginger reacts to the pain. Although not strictly an instance of abjection, since there is no blood, viewers are manipulated into an emotional state that arouses similar feelings and which will be discussed more thoroughly in Chapters 2 and 3. The tearing of the skin in Ginger's navel creates a form of somatic empathy that allows the viewer to empathise with her apparent pain and which reminds us of the vulnerability of the body. Since the scene works viewers up to the moment of the piercing by prefiguring it (Brigitte asking "ready?" as she gets her gloved hands closer) and the negative effects it will have (Ginger is seen holding on to the bars of her bed), there is a certain anticipation: the piercing will be painful, especially since no anaesthetic is being used. The fact that a strong, loud sound can be heard when we see the needle penetrate the skin, a shot followed by a countershot of Ginger reacting with a convulsion and a scream, help frame the moment as affective. The action is repeated several times, with Ginger convulsing ever more violently and the music rising to meet the anxious occasion. The scene does not quite fall into the realm of abjection, since we do not see the inside of the body or its contents, but it relies on similar affective methods by breaking the barrier between the corporeal outside and the inside.

Figure 1.2 One of the very few scenes in *Ginger Snaps* that uses abjection does not actually rely on the exclusive feminine quality of Ginger's body.

Because *Ginger Snaps* is largely a melodrama with supernatural elements, there is a lack of explicit body Horror or gore. In fact, the film only becomes truly horrific in its last third, when it begins adopting the imagery and cinematography that we have come to associate with the genre. The scene with the dead school teacher (another source of abjection is his recent corpse, which has big claw marks over the shoulder and parts of his ear missing) is the turning point. After this, Ginger is seen following a bleeding and screaming janitor through an empty and badly lit corridor (the lights, appropriately, flicker for additional effect). Her presence is threatening, she walks behind the man slowly, sure that her crawling prey has no chance of escape. The music has moved from the more melancholy tones of the opening scenes to an atmospheric and claustrophobic score more in tune with the generation of fear. The scene ends, unsurprisingly, with Ginger sticking her hand inside the man's stomach and pulling it back out as she notes how much she enjoys killing. Ginger's final transformation is also presented in typical Horror language: fast editing closing in on specific parts of her body as they contract, enlarge and change, is combined with sparse lighting – the light coming from the lampposts in the street as the van she is in drives past them – which only allows for glimpses of what is taking place. The music, shrill and unnerving, complements the camera work. But, as elsewhere, whatever fear may be generated here, it has nothing to do with Ginger's body as specifically female. The brief scene is comparable to that in other werewolf films such as the aforementioned *An American Werewolf in London*, where the bodies are male.

All of this is not to say that *Ginger Snaps'* resorting to representation does not betray a lack of awareness of the ways in which the monstrous-feminine is constructed, but quite the opposite. This is a film that subverts expectations and plays with the female body so as to create fear and attraction *consciously*. We do not need to stop and think about whether gender is of thematic importance because *Ginger Snaps* does this job for us: the constructed nature of gender is present in the narrative and dialogue as well as in the representational sphere. As Sue Short has suggested, *Ginger Snaps* can, in fact, be read as forming part of a trend in mid-to-late 1990s cinema where "[t]he cruelty of adolescence, particularly in terms of bitchy girls and sexually manipulative boys [...], [t]he difficulties of establishing female solidarity, and the greater tendency to depict women in competition with one another" (2006, 89) all become major and prominent themes.[26] The film includes scenes where the mother tells Brigitte and Ginger "what men want" (presumably, although this is never spelled out, to have sex), and explains that they are all the same. Later, Ginger herself claims that women can only be "a slack, bitch, tease or the virgin next door". Fear may well be constructed around the female teenage body, a grotesque version of corporeality that exploits difference and emphasises sexuality and the female reproductive system, but this is not what elicits abjection in the film. The premise of the fear caused by the monstrous-feminine is used for other purposes: to

declaim the impossible beauty canons that women are subject to, to show that sexuality still plays a pivotal role in the construction of feminine identity, especially in the context of school life, that virginity and innocence are still contrasted to promiscuity and licentiousness in a perpetuation of the angel of the hearth against the whore dichotomy. But abjection, where it appears, is purely corporeal and does not reach out for fearful disgust in the specificity of the female body or the monstrous-feminine.

Abjection Without Psychoanalysis

As I proposed in the Introduction to this book, a full understanding of any scene in Horror must account for the three levels of affective articulation here discussed. In order to successfully unpack how scenes are scary, frightening or disturbing, then, we need a complex reading that goes beyond the purely representational – what is figured as threatening and why – as well as the areas of contact between it and the emotional and somatic levels of filmic interaction. Since representation is what concerns me in this chapter, what I want to consider is if, and how, abjection, whose core work I still find valid as an attempt to theorise the formulation of shocking and disgusting images, can be developed outside its psychoanalytic remit. My contention is that this shift involves a redrafting of the boundaries of what exactly is being attacked by the invocation of the abject so that it is no longer the self as subjective construct that becomes the crux of the matter (its abstract social and even mental construction) but rather the very physical limits of the body. One of the possible reasons for a neglect of the ways in which the latter impinges on elaborations of the abject is that it is seen as belonging in the realm of the base corporeal, of what constitutes the abject as opposed to what it challenges.

To see the body in distress, under threat, as the key to representations of abjection is, on the one hand, quite a radical move, as it entails a rethinking that de-psychologises and de-genders a theoretical approach grounded in psychoanalysis. However, this break is methodological and not necessarily concerned with principles. Whilst I would continue to challenge the validity of theories that depend on rather shaky notions of childhood psychosexual development and "archaic" notions of femininity, it is undeniable that the bodies of women have indeed been exploited by Horror for affective purposes that go beyond the illicit and into monstrous territory.[27] Research into this area has, as I have noted, been pivotal in Horror Studies: it has led to some of the most interesting, political and sophisticated work in the field, and it has been a significant milestone in feminist criticism, especially in its consideration of women as more than simply victims. Thanks to it, it has been proven that the representations and constructions of different female bodies are essentially social and cultural (especially religious) and that they often draw on female sexuality, especially the possibility of its excess, on female reproductive organs and on the substances they expel.[28] However, to reduce the workings of Horror, even the type of Horror that specifically

plays with the female body, to the way in which gendered and female archetypes are socially produced is to ignore at least three key implications. First, the socio-cultural construction and social inscription of bodies is liable to change and is therefore not dependent on a fixed schematic, mythical construction of woman (whether as Mother-Goddess or as "other"). Second, to argue that the monstrous-feminine is scary because it is grotesquely female does not allow for forms of corporeal monstrosity that do not rely on gender. In fact, it collapses all forms of representational fear into the bodies of women which, in cases, are not scary or disgusting purely, or even mainly, because they are female, maternal or otherwise reminiscent of their gender or reproductive functions. Third, to see examples of the primal scene and traces of the archaic mother in such general and symbolically complex substances as blood, is potentially a task that is as reductive as the models of female subjectivity allegedly avowed by the films criticised of abusing them.

It is thus necessary to revise abjection by, in the first instance, recuperating it as a theoretical approach that places corporeal threat at the heart of the experience of Horror. In order to do so, work on the area of disgust is invaluable in determining the limits and systematic processing of disturbing forms of corporeal representation. Through some examples and a case study, I will turn to some of these ideas to propose that these contemporary texts may be read through a lens that is not exclusively tinted by gender-based concerns.

Many of the problems with abjection come from its almost exclusive connection to the monstrous-feminine and, more specifically, the maternal body, it stems from psychoanalytic propositions that lack scientific evidence and which have been challenged over time. For example, Creed's reliance on Kristeva's proposition that the maternal body is linked to "universal practices of rituals of defilement" (Creed 1993, 12) and thus to the excremental has no sound basis in reality beyond the fact that mothers have a substantial role in toilet training processes and the mapping out of what a clean and proper body constitutes. Although I am, in the interests of space, simplifying ideas here, the equation of abjection with the maternal body is problematic on another level: not only does it not account for instances of abjection where the bodies are not feminine or maternal, but it also confuses the representational with the emotive levels of Horror viewership.[29] Even if we took Creed's account to mean purely that the maternal body is one source of abjection among others (a prospect she seems to undermine when she claims that scenes of blood and gore point "to the fragility of the symbolic order in the domain of the body where the body never ceases to signal the repressed world of the mother" (1993, 13)), this still would not explain how abjection is responsible for our feelings towards a specific sequence where that body is responsible for affect in ways that are not only connected to defilement or border-crossing. Let us look at a specific instance where abjection falls short in its attempt to explain the affects of a specific text.

In *Slither* (James Gunn, 2006), an alien invasion takes over a small town following the collision of a meteorite. One of its most effective scenes features local girl Brenda (Brenda James) who, having been fertilised by her

infected lover (Michael Rooker), is discovered locked in a barn and having ballooned up to ridiculous proportions. Following a quick survey of the barn, which shows she has been feeding on raw meat to satiate her hunger, she explodes and releases hundreds of alien slugs. In a sense, we could argue that this scene parades the maternal body in a grotesque, inflated manner, that is both monstrous (because grotesque) and abject (because the source of its representational horror is the female, maternal body). However, this does not explain the actual dynamics of the scene, which generates dread and shock via the anticipation of Brenda's explosion and, later, her tearing apart. The one explicit emetic moment, where a man runs outside retching, is kick-started by either the discovery of the dead possum on the floor or the prospect of its being eaten raw (or maybe a combination of both), and not necessarily by Brenda's body. To argue that abjection works, in this case, via recourse to a subjective challenge that involves the disruption of the self within the realm of the symbolic seems counterintuitive and actually sidesteps the particulars of its narrative structure. As will become clear, this is the case because Horror often affects viewers on more than one level. So, whilst the generation of direct affect here is partly tied up with notions of female representation (women's reproductive system, their capacity to host life, the unpredictability of that life, the biological disruption it causes), it is also dependent on other emotions (the atmosphere generated; the alignment with the police officers) and on the somatic level (the use of sound, the scale and orchestration of the explosion). Similar arguments could be made for other infamous horrific birthing scenes, such as those in *The Fly* (David Cronenberg, 1986) or *Species II* (Peter Medak, 1998).

Figure 1.3 The affective horror of the birthing scene in *Slither* (2006) attempts to shock the viewer through Brenda's bursting body.

The pregnant body, which, as I showed, has been understood to be at the heart of the moment of abjection, can also be easily proven to be both foundational to Horror and yet far removed from the type of fearful disgust that I see as the intended outcome of images of abjection. It is true that pregnancy itself, a biological process that disrupts the inside/outside boundaries of the female body in very visceral ways, has been the basis for a number of pregnant Horror films – most notably *Rosemary's Baby* (Roman Polanski, 1968) and *The Brood* – and that horrible childbirths have appeared in a number of films in this genre – I have mentioned *Alien*, *The Fly* and *Species II*, but also the spectacularly excessive birth scenes in *Xtro* (Harry Bromley Davenport, 1982) and *Baby Blood* (Alain Robak, 1990) or the self-managed caesarean extraction in *Prometheus* (Ridley Scott, 2012). However, their link to abjection has nothing to do with their treatment of the maternal body. Pregnancy, as a concept, can be scary, because the characters in Horror either carry a form of life within them that is either extremely "other" (the son of Satan, alien life) or else a threat to their body and that of humanity (chestbursters, giant larvae). The period of pregnancy itself may be portrayed, like adolescence in *Ginger Snaps*, in horrific terms as a way of analysing the type of life-changing experience these corporeal processes signify for women, but it is rare for this to happen explicitly (the exceptions are *Breaking Dawn – Part II* (Bill Condon, 2011) and *Devil's Due* (Matt Bettinelli-Olpin and Tyler Gillett, 2014), although the former is not strictly Horror). When it does occur, gestation is a source of fear and not of abjection as, barring gory childbirth scenes, Horror tries to externalise (in the body of the mother) how something is wrong with what is inside it (generally, the womb). Otherwise, whatever is being incubated in the mother's body, especially if it has the capacity to infect (slugs in *Slither*) or destroy mankind (the demon-human hybrids in *Pro-Life* (John Carpenter, 2006) or *Stranded* (Roger Christian, 2013), the Antichrist twins in *Blessed* (Simon Fellows, 2004)), is the obvious thing to fear. Only on very rare occasions is the main character a victim who must protect her child at all costs, as in *Inside / À l'intérieur* (Julien Maury and Alexandre Bustillo, 2007).

Abjection can be reframed in terms that do not depend on psychoanalysis or Kristeva/Creed's formulation of the maternal body in order to provide a first step into a theory of the type of figures, images and situations that generate affects connected to Horror. This does not so much entail a somatic or emotive breakdown of the types of engagement with them but an understanding of how they aim to create sensations or feelings because of specific associations. Whilst Chapters 2 and 3 explore emotions and somatics, the remainder of this chapter focuses on how abjection might be discussed as a form of fearful disgust. This allows me to both hold on to abjection's emphasis on transgressive images and infuse them with a less abstract and more intuitive *modus operandi*.

We can adopt a "psychodynamic" approach to the use of representation in Horror by focusing on "viewer's motives and interests in watching horror

films and on the psychological effects such films have" (Freeland 1996, 195). Let me qualify this statement. What I propose is not a derivation that continues the work of psychoanalysis. Instead, it is possible to provide readings that weave the "intra-filmic" (Freeland 1996, 204) aspects of Horror – its structure and narrative, the representational practices deployed – with approximations of how images, bodies and situations aim to arouse certain feelings in their potential receptive target audiences. Similarly, since this approach entails an engagement with the time-place coordinates of texts (their social and cultural specificity), it is aware of the political and historical contingencies that affect the treatment and exploitation of objects/subjects of representation and of the history of the genre itself without reducing affect to subsidiary meaning. In short, rethinking abjection in terms of Horror's resorting to a number of images, both recurring and new, with the intention to horrify, shock or provoke revulsion can help us ascertain how it affects viewers representationally. This has the benefits of freeing abjection from its problematic psychoanalytic trappings.

Despite her reliance on a representational model that is not dynamic or changing, Creed does acknowledge, if briefly, that abjection is connected to the function of Horror in *The Monstrous-Feminine*.[30] As I have been arguing, this is possibly the most useful part of her argument, not only because it understands Horror to have a cathartic quality that helps explain its apparently paradoxical appeal (why would we be interested in being presented with images that will affect our sense of selfhood and subjective integrity?) but also because it gives an indication of how moments of abjection may actually work on audiences. Her suggestion, brief and schematic as it is, begins to tread the ground between a close reading of images of abjection (what they are, where they come from and how they relate to the social and cultural construction of "woman") and the ways in which Horror helps viewers negotiate them in a productive way. In her words:

> In terms of Kristeva's notion of the border, when we say such and such "made me sick" or "scared the shit out of me", we are actually foregrounding that specific horror film as "a work of abjection" or "abjection at work" – almost in a literal sense. Viewing the horror film signifies a desire not only for perverse pleasure (confronting sickening, horrific images/being filled with terror/desire for the undifferentiated) but also a desire, once having been filled with perversity, taken pleasure in perversity, to throw up, throw out, eject the abject (from the safety of the spectator's seat).
>
> (Creed 1993, 10)

Taking on the function that religion once had, Horror helps purify the abject "through a descent into the foundations of the symbolic construct" (Kristeva, qtd in Creed 1993, 14). For Creed, Horror "attempts to bring about a confrontation with the abject (the corpse, bodily wastes, the monstrous-feminine)

in order to finally eject the abject and redraw the boundaries between the human and the non-human" (1993, 14). Key to this process is, as we have seen, the figure of the mother and her reproductive functions, as they threaten the stability of the symbolic order. Yet, in spite of the limitations of the model that I have outlined, the basic ground of this premise can be critically recuperated for a theory of representational affect.

The Importance of Physical Threat

I have gone to great lengths thus far in this book to prove theoretically a move that, in a sense, might already have taken place at a practical level. After all, a number of critics who have recently relied on abjection do not necessarily adopt its psychoanalytic basis, but instead have appropriated the label for their own uses. For instance, the Social Sciences have started developing the notion of "social abjection", "a more thoroughly social and political account of abjection" which centres on "what it means to be (made) abject, to be one who repeatedly finds herself the object of the other's violent objectifying disgust" (Tyler 2013, 4). In Gothic Studies, Judith Halberstam has also drawn on its political and social connections, made by Kristeva herself in her later study of Céline in *Powers of Horror*, to show how certain bodies (for example that of the Jew), are "gothicised or transformed into a figure of almost universal loathing who haunts the community and represents its worst fears" (Halberstam 1995, 18).[31] Tyler and Halberstam's uses of abjection illustrate how "abjection" has become another word for identifying the situation of social outsiders, whatever grounds that otherness is premised upon, as well as the process of their casting off.

In the discipline that concerns me here, Film Studies, and, more specifically, Horror, similar steps have already been taken, although not necessarily through a dissatisfaction with the underlying structures of abjection. The most obvious example, Tony Magistrale's *Abject Terrors* (2005), a survey study, clearly exposes in the introduction that his use of the term "abject" is an appropriation that connects it more seemingly with monstrosity. The monster, according to him, either embodies the abject ("in the otherness of their bodies or actions") or projects it onto viewers (2005, xvi). Drawing on his reading of Kristeva, then, via the work of Cook and Bernink, Magistrale formulates the abject as a means to discuss "a wide-ranging construction of otherness that threatens and disrupts the processes of life" and which is "located in sexual perversity, gender ambiguity, torture, incest, bodily wastes, murder, death, and the feminine body" (2005, 15–6). Abject terrors thus become "the core disruptions of the social order and paternal norm set in motion by the monster", and they "invoke the response of terror, confusion, disgust, or perverse association in other characters on the screen as well as in the audience watching the film" (Magistrale 2005, xvi). Although the "paternal norm" is noted here as an important factor, the analyses in the book take issue with social rules (laws, conventions) that we could argue are

paternal only insofar as they are articulated by a predominantly patriarchal Western society – the one that produces the majority of its film releases. In other words, Magistrale's critique does not limit itself to a study of the ways in which the "law of the Father" is disrupted in Horror, but it more generally surveys the ways in which monstrosity in Horror disrupts and challenges human convention and social structures.

Whilst my recuperation of the abject for the purposes of the generation of affect is quite close to Magistrale's, my concern does not rely on the processes whereby the monster transgresses order and decorum, but rather on how Horror uses certain bodies – as well as the organic substances connected to them – to create a horrific sensation in the viewer. In other words, I am not interested in the ways in which a very specific and crucial character, the monster, channels anxieties at the heart of which lay cultural codes. It is equally important that, at a representational level, situations themselves, say, the traps in the *Saw* films (2004–10), can generate abjection. As I see it, the work of abjection brings together the representational with the emotive and the somatic in a way that foregrounds the vulnerability of the body. The subject or object at the heart of the moment of horror needs to be posited as threatening, whether in him/herself (their bodies) or their aggression (their attack of other characters or of the camera), so that fear is not purely generated by the categories and conventions the figure of the monster challenges or the form of "otherness" it embodies, but is a result of the cinematic techniques used to turn representation into actual instances of threat. After all, if the monsters are disrupting but not convincing to the viewer, due to either a change in conceptions of the monstrous or the fact that the special effects or cinematography are so outdated as to appear artificial, viewer engagement with those images may vary and could even lead to the very opposite reaction: laughter.[32]

In order to establish corporeal threat as one of the key elements at the representational level of Horror, it is necessary to return to Creed's remarks on the dual quality of its deployment of abjection: on the one hand, Horror abounds with images of abjection; on the other, it itself utilises and exploits the workings of abjection – that is, the ways in which we are shaken or disturbed (especially disgusted) by certain images, actions or thoughts – for affective reasons. The two processes, although related, are necessarily different and require their own separate and careful analyses. As Rina Arya has noted, there is a crucial distinction to be made between "abjection" as a noun and therefore concept (images of abjection), and the "operation of abject-ing" (2014, 4), taken here as a cultural ritual of purification that restores social stability and which Horror could be seen to participate in. The catalogue of images of abjection is extensive, so it is best to deal with them separately and begin with the process of abjecting.

The interaction between the image or action of abjection and the viewer of Horror relies on the self-evident nature of the former, perceived as such through social acculturation or, in the case of somatics, as I will argue, the

work of instinctive reaction and reflexes that are proprioceptive and act either contiguously with, or even prior to, the cognitive processes that allow us to assess images and actions qualitatively. It could be argued that, since abjection in this process is strongly, although by no means exclusively, linked to convention and tradition (culture and religion, for example), its origin in psychoanalysis is confusing and the term altogether inappropriate. Quite the opposite is true: abjection is useful as a theoretical concept because it explicitly links feeling and representation and, more precisely, because it acknowledges that its corresponding images generate precise effects – in Kristeva and Creed, almost instinctively or even universally.[33] My refinement here is important. What I am suggesting is that abjection works in two ways: firstly, it creates a specific form of affect – fear as connected to disgust – through reliance on discourses around the body, its social representation and that of its components (organs and expelled substances). These are ultimately cultural constructions, regardless of how closely they have been aligned with common sense. A perfect example is that of parturition, which, when presented in all its visceral and bloody glory, as in *Baby Blood*, can become a source of abjection. Although this aspect of abjection is important, it is intimately related to bodies and their constituting substances and not to discreetly gendered identity.[34]

Secondly, abjection also works on a more primeval level. Images of abjection are connected to the frailty and vulnerability of the body, and are affective because they remind us instinctively of our mortality and the possibility of pain or extensive damage. A perfect example, although a complex one, is the close-up of a wound: it is not the symbolic transgression of the outside/inside corporeal boundaries delimited by skin that carries the affective import, but its symptomatic association with illness, infection, pain and, in extreme cases, death. The advantage of such a recasting of abjection is that it works on both the real and the representational spheres: the same substances or body parts may affect the viewer when encountered in real life. For example, the sight of wounds, unless one is accustomed to them via their studies or profession, or else, has developed a (sometimes) pathological desire for them, is normally accompanied by either hissing noise, concern or revulsion. Not only is the wound abject, but our capacity to vicariously imagine a similar pain (as I explain in Chapter 3) can generate affective experiences. In both cases, the concomitant attraction that Kristeva identifies in abjection is also apparent: scopophilic and experiential curiosity may be at the heart of our continued engagement with images of abjection. The filmic experience is, necessarily, quantitatively different from the real one as, even though empathic alignment and suspension of disbelief can mean that we can feel something akin to what the characters are feeling, this always happens at a remove. It is crucial for this engagement with the image to be clearly fictional to the viewer, as films that play with real images of abjection – the branding wound scene in *The Bunny Game* (Adam Rehmeir, 2010) – or pretend to pass for the real thing – the disembowelling in *August Underground's*

Mordum (Jeremi Cruise et al., 2003) – also rely on other forms of cognitive affect that involve the viewer at a moral level.[35]

This version of abjection is substantially different from those that have been proposed before, not only because it entails a reframing of the abject body, but because it questions the role of identification (and subsequent rejection) of the image of abjection. For example, Arya claims, via Kristeva, that abjection may be understood as a process whereby "the threat of abjection (of being abject) gives rise to the operation of expelling the abject and thus restoring stability, albeit for a period of time" (2014, 4). For her, the "expelled part does not disappear – it is the perpetual remainder – and continues to threaten the boundaries of the self and society, thus activating the need for the operation of abjection" (Arya, 2014, 4). Whilst the second part of her argument is very valid, namely, that images of abjection may arouse a specific feeling or a set of them that can be vanished either narratively (by being put to an end within, and by, the film) or by short-circuiting the viewer's engagement with the film or the specific image or action (choosing to look away, forgetting what has been seen or reducing the anxiety by, for example, making fun of one's own reaction), identification with the characters or their abjected qualities should not be seen as the key to abjection's power.

Instead, being able to empathise with either an action or substance that involves a form of threat to an intradiegetic character or, if a first person POV (point of view) film, the camera, ensures that the subject feels threatened and may feel shock, dread or disgust. The threat may be momentarily vanquished, but since to be human and, thus, to have a body of flesh and bone is to be vulnerable, the threat of being hurt or killed is perennial and can be exploited. Whether the action, figures or substances are a direct threat – say a close-up of skin bitten by one of the rabid, infected humans of *28 Days Later* (Danny Boyle, 2002) – or merely a potential, even figurative, threat – the flesh-eating water of *Cabin Fever* (Eli Roth, 2002) – what kick-starts the process of abjection is not a process of identification but of recognition of the image of abjection (the damaged body) and the exact threat it poses. When this danger is one external to the body, say an object or an animal, cognitive and causal processes are necessary in order to connect the image with its potential result. Crucial here would also be the cinematographic accompaniment (score, make-up, acting) that frames the image.

Let us look at an example. The image of Carrie White (Chloë Grace Moretz) covered in pig blood in Kimberly Peirce's *Carrie* (2013) – an image reminiscent of her first period earlier in the film – does not require the viewer to identify either with Carrie as a character or to accept her potential metaphoric encapsulation of all menstruating women. Whilst being able to empathise with the plight of the main character at some level is definitely part and parcel of how sympathy, empathy and engagement work in Horror and, more generally, in film, it is important that we distinguish images of abjection from the various feelings and emotions with which they can work contiguously. Carrie does not automatically symbolise all

womanhood, although her plight may well signal this and, in any case, it is not the source of horror in this particular scene. What causes fear here is her unbridled attack on her fellow students as a revenge for her humiliation. If fear is generated in the sequences that follow her humiliation, these are premised on the deaths of the students themselves, and not on Carrie's corporeality as a token of the defiled feminine body or of the archaic mother in its linkage to the reproductive system. Menstruation, then, does not generate abjection in this film; it is merely the catalyst for carnage. Its symbolic import can well be examined, but it does not provide a clear insight into the workings of the scene. At most, the image of Carrie covered in blood can be scary by association – because we know it is connected to the menstrual blood that has ruined her already precarious school life – but it does not, in itself, constitute an instance of abjection.[36] By contrast, the scene where her mother, Margaret (Julianne Moore), is trying to escape the praying room by attempting to force open a vertical incision on the door encapsulates the work of abjection perfectly. Within it, there is a brief shot that consists of a close-up of Margaret's mutilated fingers as they are rubbed against wood splinters. The fingers are very bloody, show long and deep cuts and even strips of loose skin. The image that causes fearful disgust in this instance is not connected to female sexuality or motherhood but stands out as affective because it is corporeally intelligible and connotes pain.

Figure 1.4 Fearful disgust may be experienced in the scene in *Carrie* (2013) where Margaret tries to pry open the door to a locked room with her bare hands.

Of course, none of the above claims regarding a representationally affective theory of abjection are intended to be essentialist in nature. There are no universal images of abjection, at least not in the same way that instinct and reflex processes (moving a hand away from fire) are universal human

traits.[37] What do exist, however, are recurring images – blood, open wounds, bloodied organs – that are consistently exploited for affect in Horror and appeal to humans' instincts of self-preservation. The cross-cultural and trans-national quality of pain allows us to think about abjection in a way that, unlike the psychoanalytic model, does not require a totemic construction of the female and the maternal bodies. This means that we do not rely on gender or the social and convention-driven rules of patriarchy to explain its workings. Although similarly constructed, images such as the open wound do not depend on a symbolic or metaphoric meaning, but on an analogical or even causal one: viewers are aware that these images are normally a token indicating our bodies are either in danger, dying or dead. So what are they, more specifically, and can we distinguish them from the different cultural ideas associated with them? Also, since we are dealing with substances such as blood, which can generate disgust, how does this rethinking of abjection distinguish it from the latter?[38] We can begin to answer these questions by tracing fearful disgust back to the body. Since Kristeva's own definition of disgust is unclear (she only mentions that "disgust" is a symptom of abjec-tion, but how or why is left to reader to imagine (1982, 11)), I draw primarily on recent work in Cultural Studies, Anthropology, Sociology and Film Studies.

Abjection As Fearful Disgust

Representational disgust draws from real disgust, which, as has been argued, is a physical response, or series of them, that humans developed in order to ensure self-preservation and well-being.[39] As a general visceral, "quasi-automatic ('instinctive')" aversive emotion, "one of the most violent affections of the human perceptual system", disgust has been defined by Winfried Menninghaus as "the violent repulsion vis-à-vis [...] a physical presence or some other phenomenon in our presence [...] which at the same time, in various degrees, can also exert a subconscious attraction or even an open fascination" (2003, 2, 1, 6). Although it is strongly connected with consciousness, self-reflection and the human, disgust for certain things and our levels of tolerance towards it is not something we are born having a clear awareness of, but rather involves cognition and is a result of the effects of acculturation, tradition, education and practical training.[40] Rather than helping us define isolated instances of boundary-crossing, disgust, as Martha C. Nussbaum has suggested, shapes our daily routines and moments of inti-macy, as it structures social relations and even plays a role in the passing of laws (2004, 72).[41] If abjection explores the boundaries of corporeality, disgust explores those of the clean, pure and proper, which are often articu-lated by the desire to deny or reject the primal, that is, our animality. Thus, substances, objects and acts/actions that are a source of disgust are generally linked to contagion, assimilation or infection. This is also why touch, smell and taste, the "tactile" senses, are seen to have a stronger connection to disgust than then the more distanced hearing and sight.[42]

The experiential structure of disgust has been discussed along similar lines from a phenomenological, pre-reflective point of view. Julian Hanich proposes that disgust in film is an example of "cinematic synaesthesia" (2009, 295), that is, of the ways in which film can engage more than one sense simultaneously, and argues for four main distinguishing characteristics. Firstly, disgust, whether its source be an object or a situation, is marked, following Kolnai, by its "closeness" and "proximity" (Hanich 2009, 294). This feeling may be amplified by cinematic techniques such as the close-up, which bring the object or action closer to viewers and focus their attention, accentuating its potential affect. Secondly, disgust brings about a moment of "*constriction* of the viewer's lived body" which accounts for the need to reject the object of disgust and thus achieve "a more expansive state of being" (Hanich 2009, 295). Disgust, through it closeness, also induces a series of distancing or aversive strategies that can range from closing one's eyes to looking away or giggling. Finally, disgust is premised on a "precarious intertwinement" (Hanich 2009, 298) between viewer and film that, if distressing, may be broken at any point, something which does not necessarily take place when one experiences the same emotion in real life. Inherent to all the negative emotions laid out here are a number of positive ones that let us understand why disgust may be enjoyed and even sought after as a cinematic experience, chiefly, that it satisfies cognitive interest, via the prodding of taboos or by allowing viewers to get experientially close to images or actions that are not normally part of their day-to-day life, and that it provides somatic pleasure. Horror can ensure that a scene or sequence is particularly disgusting by resorting to certain techniques that draw on its basic characteristics. These can include anything from the aforementioned close-ups to choice and combination of disgusting objects or images, and even manipulation of feelings via somatic empathy and sympathy.

For the purposes of this study, then, it is important to distinguish disgust strictly from abjection, which I am arguing is a form of fearful disgust, especially since these aversive emotions are normally taken to belong together.[43] Kolnai, in his foundational book on the subject, speaks of a form of disgust "that on the physical side is tuned more towards the shudder than any actual vomiting (disgust which is closest kin to fear, usually aroused by visual impressions)" (2003, 35), although he does not give it a name. It is as such that I propose we understand abjection outside the psychoanalytic remit, as a form of fearful disgust.[44] Colin McGinn has done a very good job of differentiating fear and disgust experientially and conceptually. To begin with, fear is a "prudential emotion" that "operates to protect the person (or animal) from danger" and the natural expression of which is "self-protection – against damage to the self by the feared object" (McGinn 2011, 5). His claim that "[a]voidance of contact is an instrumental aspect of fear, not its essence" is crucial in establishing disgust as a different emotion.[45] The latter is, by contrast, an "aesthetic emotion" whose primary focus is "the *appearance* of its object, not what that object can do or has done in the way of

harm"; in other words, it is "appearance-sensitive" (McGinn 2011, 6, 10, italics in original).[46] For this reason, as we saw, the natural reaction caused by disgust is one of "*avoidance*", of wanting to "avoid contact with it" (6, italics in original). Whilst fear may be conjured up by disgust if the object or substance threatens to harm the body, "[p]hysical harm is not the aversive stimulus where disgust is concerned" (11). Abjection as I have been invoking it in this chapter could, however, be best understood as a form of fearful disgust. At heart, it is a prudential emotion too, since it makes viewers aware of their corporeal vulnerability and potentially scared for their health and/ or that of the character whose body is on display. Unlike fear of objects or subjects that can damage the physical body (externally or internally), however, it relies on a series of images connected to the human body itself that threaten integrity and trigger instincts connected to self-preservation. As such, abjection is also appearance-sensitive, something fear alone is not, yet is not "motivated by ideational factors", as disgust is: images of abjection, as I move on to show, do not rely on the "origin of the item and its social history" (Nussbaum 2004, 88) but rather on corporeal awareness and intelligibility.

To illustrate how disgust works differently from abjection, let me turn to a key scene in *Dread* (Anthony DiBlasi, 2009) that very consciously sets out to exploit disgust, and only disgust, for viewing affect. In this film, as in the short story (1984) by Clive Barker that it is based upon, Quaid (Shaun Evans), a student working on a school project, takes his experiments on fear too far. Drawn to what makes people afraid and to whether it might be possible to force people to overcome that feeling, Quaid starts forcing human subjects to face their worst nightmares. The tests take the form of direct torture. In the case of Joshua (Jonathan Readwin), his partial deafness as a child has made him scared of that condition, so Quaid fires a gun close to his head and shatters his eardrums. Joshua consequently goes insane. Abby (Laura Donnelly), who is terrified or her birthmarks being seen by others, is also tortured, albeit psychologically. Footage that shows her undressing and about to have sex is broadcast all over campus, something that drives her to scrub her skin off with bleach. But the film's *pièce de résistance* is undoubtedly Cheryl's (Hanne Steen) confinement, which relies on the "live or die – make your choice" premise of the *Saw* films. Unable to even bear the smell, Cheryl is kidnapped and placed in a locked room with a slightly salted and cooked beef steak as her only possible means of nourishment. Quaid waits for a week until Cheryl becomes desperately hungry and eats what, by then, is a thoroughly rotten, fly-infested piece of meat.

The rotten steak in *Dread* is clearly meant to generate disgust via an object (putrefied meat) that, in its utter decay, encourages the type of aversion and rejection that defines the emotion. If fear is at all part of the scene, then this is a fear for the potential consequences of eating the steak, especially as the scene is protracted and plays with the possibility of Cheryl giving in when she gives it an initial and reticent bite a few days in. It is a reflexive

moment that relies on cognition and reflection – shock itself is avoided by the fact that her eating of the steak is anticipated and becomes inevitable.[47] The viewer is, thus, not shocked or surprised by the outcome but expects it and can brace him/herself for it accordingly. When she eventually bites into the blackened meat, viewers are likely to experience disgust (imagining the taste) and pity, since they potentially empathise with Cheryl's predicament. The film has shown us that Cheryl is a vegetarian not out of moral choice but due to traumatic associations between meat and childhood abuse – her rapist dad worked in a meat-packing plant. When she is forced by Quaid to eat meat, viewers may naturally side with her and feel helplessness and anger.[48] Fear, however, is not essential to this scene as, even though her predicament can be vicariously experienced by extrapolation ("what if I was in her position?"), the threat is not one that concerns the direct vulnerability of the body to external attack. Adult humans know that eating rotting or rotten food is potentially bad for their bodies and that this can lead to illness, but this does not pose a direct threat to their physical integrity in the way that an object thrown at them does.

My specific focus in this chapter is the human body and fearful disgust, so how can we differentiate the latter from disgust more broadly?[49] Rejected or excretory fluids such as faeces, urine, sweat, pus, vomit or phlegm, as well as nourishing or reproductive fluids such as breast milk or semen, have all been connected with abjection but, as should be clear, they fall more firmly with the realm of the disgusting, since, regardless of the potential ubiquity or universality of their revulsion, a real or fictional encounter with them rarely is conducive to fear.[50] Instead, where they may evoke a visceral reaction, it might be closer to the gag reflex, whether physical or psychological. Their construction as disgusting images, especially when the substances belong to somebody else and are therefore not part of one's own body, is partly moral and conventional in the sense that more-or-less homogenised rites of purity and hygiene govern the social and, more largely, human interaction in the Western societies that produce the majority of Horror. One could argue that images such as somebody else defecating are rejected insofar as cubicles have been developed to avoid its witnessing in public spaces, but this is not tantamount to arguing that their representation conforms to general parameters of abjection. Additionally, although a substance such as faeces could be seen to be dangerous to life because it poses serious threats of infection or because it signifies filth or dirt (themselves conducive to illness and even death), the connections established here are inferred and not self-evident, as theorists such as Georges Bataille have argued.[51] Similarly, menstrual blood can only be a source of abjection when it is displayed in a scene as a source of fear in the first place. In Brian De Palma's *Carrie*, Carrie's (Sissy Spacek) shower scene, where she wrestles with her first period, is coded in this way so her bodily fluid may thus be recast as an image of abjection. In other words, whilst menstrual blood would largely be the source of disgust, it can be presented in contexts where concern for the character's integrity or safety

is accentuated. However, I would argue that, in such instances, it is the more general use of blood as substance indicating corporeal vulnerability that elicits feelings of disquiet and that its menstrual quality is secondary to the production of abjection.

Principal Images of Abjection Understood As Fearful Disgust

As I pointed out earlier, the abject has been theorised as neither object nor subject: a sort of concept that hovers between the two and which we cannot assimilate or else incorporate or ingest (Anya 2014, 5). According to this idea, the abject should be a concept – perhaps an abstract one – and yet, it is easily located by Kristeva in, for example, the "skin on the surface of milk" (1982, 2). Given that part of my goal here is to rethink abjection so that it becomes material and practical, I would be inclined to propose that the abject can indeed be aligned with the broken body, or with images that depict it bleeding or torn open. As a result, I propose that "abject", as an abstract term, be replaced with concrete "images of abjection", that is, images connected with the organic body and its various fluids, as this has the advantage of emphasising the difference between an encounter with, to go back to my recurring example, a real wound and the fictional close-up of one.[52] It is the encounter with these specific images in the context of Horror, where they are often presented to affect viewers, which leads to the moment of fictional abjection: a form of fear close to disgust (but not synonymous with it) and which is premised on the vulnerability of the body. To return to Arya's definition of abjection, certain images pose a form of fictional danger to the viewing subject – and I use the word "subject" here to mean very much the emotional and psychosomatic viewer – by virtue of their underlying connection to the frailty of corporeality, something that reminds us of our animality or, for an even clearer term, materiality.[53] I would also propose that, whilst some of the reactions to specific images, such as the type of disgust based on impurity/defilement that may be generated by being exposed to menstrual blood, are largely socially constructed, it is also true that we relate to the psychical reality of our bodies from birth and instinctively learn to react to images that are conducive to pain in ways that are not strictly cognitive but experiential and, in the first instance, have a somatic origin.

At this point, it is vital that the main images of abjection in Horror be identified and differentiated from substances that have been ascribed to abjection but which clearly belong in the territory of disgust. Similarly, since disgust is an important part of abjection, but it is by no means coterminous with it, it is vital to both define and segregate it and its related substances and actions from the world of abjection. It is easy to see how, for example, faeces would have been mistaken for a source of abjection since, like images of abjection, images that provoke disgust appeal to humans via recourse to their biology – the body and its functions. However, faeces cause disgust

because they have been constructed thus socially and because they are seen as alien; that is, because they have left the body and thus are external and foreign.[54] Images of abjection are much more elemental, they appeal to the somatic and/or instinctive body, and do not rely on internal/external dynamics in the same way. They can be fearful precisely because they stand at the border of the liminal quality of the body, drawing attention to its vulnerability. Although Nussbaum has seen the "type of vulnerability that we share with other animals, the propensity to decay and to become waste products ourselves" (2004, 92) as central to disgust, this is, for me, a better definition of the work and purpose of abjection. Whilst in disgust the emphasis remains decay and waste, in abjection pain and vulnerability are the central catalysts of anxiety.

Bodily fluids have often been connected to abjection because they are rejected and expelled physically, socially and culturally. However, they are more readily understood as generating fearful disgust. According to this rethinking of abjection, the main bodily fluid that can generate feelings of fear in Horror within the context of the integrity of the body is flowing blood. I am, naturally, referring to blood in this passage as a secular substance, even though I realise its symbolic and metaphoric plurality.[55] In fact, film may often use blood for its symbolic ascriptions in order to generate further outrage via, for example, desecration. My concern is with blood as an image that can affect viewers so strongly that some of them might faint as a result. The capacity for the blood to appear "real" is important (we do not react in the same way to blood that looks "fake" either because of its bright colour or its consistency), as is the context in which it is presented (the histrionic bloodbaths in a film such as *Braindead* (Peter Jackson, 1992) are often coded as humorous and also desensitise the viewer via accumulation). It is also crucial that the blood be flowing from the body, rather than old or dry (served in a glass, as in *Interview with the Vampire* (Neil Jordan, 1994)). Blood puddles may well be a sign of danger or a cue to viewers that an even worse image/scene is about to appear or take place.[56] Blood flowing from a body, however, immediately triggers a sense of concern and fear, as humans know that profuse bleeding is generally dangerous. In a sense, then, flowing blood as a source of abjection works by analogy with the sight of blood in real life. For some, the experience of encountering it is harrowing enough that they may faint as a result. Often, the same viewers, who know their limits in this respect, prefer not to engage with such images at all. For the same reason, cuts, when presented in close-up, can also be a source of abjection, especially when followed by shots of ensuing blood, as the sensation and situation is one that most viewers will have experienced at some point in their lives and can empathise with. In all these circumstances, it is very difficult to separate the image of abjection (the cut) from the action itself (being cut by something or someone), which is also an intelligible one that can be processed in similar ways but which entails bigger levels of empathy. Blood in itself, when connected to a suffering body, has an almost natural

capacity to affect us in ways that are not strictly culturally coded and which, instead, rely on corporeal awareness. This awareness is connected to, for example, the identification of potential threats, whether inanimate (sharp objects, fire) or animate (dangerous animals, other human beings), and is a crucial survival skill.

Corollary images of abjection include wounds, infected or otherwise open, bloodied organs and viscera or body parts (severed arms or heads, for example) and, perhaps, skin.[57] Wounds are openings of the body that viewers can readily understand, because they will have experienced similar instances of bodily harm such as cuts, the import of which their minds and bodies can readily recognise. They are also a source of anxiety because their openness, the tearing of the protective layer that is our dermis, leaves the body exposed to infection and contagion. Although the particularities of the wound may have a supplementary symbolical meaning (a castrated man, in *Teeth* (Mitchell Lichtenstein, 2008)), its basic materialism ensures that a physiological reaction can be triggered. Although subject-specific responses to images of wounds will necessarily vary according to conditions such as previous exposure to them or having grown accustomed to their consumption, it is fair to propose that, when Horror closes up on wounds, it generally does so to generate a specific type of feeling on the viewer. When the camera statically follows Jigsaw's (Tobin Bell) improvised emergency cranial surgery, with shots of Lynn (Bahar Soomekh) sawing a piece of his skull off and then accessing his brain in *Saw III* (Darren Lynn Bousman, 2006), the effect the film seeks to accomplish in this scene is not quite summarised by the terms fear or disgust, but by an amalgam of the two: abjection. A typical reaction to them, sometimes externalised in a hissing noise, accompanied by a narrowing of the eyes and/or a slight recoil so as to push oneself away from the image/action, can be a mixture of fear for the well-being of the character(s) (which, as I will show in Chapter 3, does not rely on identification with them), of a vicarious sense of vulnerability via somatic empathy and of fearful disgust at seeing parts of the body that would normally remain invisible (muscular tissue, cartilages, organs).

The final key image of abjection that is crucial to Horror is that of the recently diseased corpse. As a concept, the corpse is something that, as I noted above, was already key to Kristeva's formulation of abjection and remains relatively unproblematised by Creed. Although I agree that the corpse can engender a form of existentialist crisis, I do not think it is necessarily one that is categorical or subjective in essence. There are various ways in which corpses generate affect, and the ways in which they work in Horror varies according to a number of possibilities. Vital, in the first instance, is a distinction between types of corpses: those that are presented in a relatively well-preserved state do not generally arouse feelings of fear and disgust, and may often appear for other purposes, such as to generate pity for the plight of a particular character. Contrastingly, the heavily rotten, suppurating, smelly corpse, especially when thriving with insect or scavenging

life, is a better example of abjection.[58] The more decayed and corrupt, the more likely it is that it might elicit feelings of fearful disgust, as it acts as a *memento mori*; if, on the contrary, the corpse is reduced to its bare, clean white bones, the feelings can be more complex and vary greatly according to treatment.[59] The more recent corpse, bloodied, with gashes, gangrenous or in bits, is abjection territory: it showcases spilled/spilling, fresh blood, wounds and exposed organs and tissues. Where bones appear in abjection, they protrude to contrast with living, torn muscle or skin.

Consider the difference between Sookie's (Anna Paquin) discovery of her dead grandmother Adele (Lois Smith) in the TV series *True Blood* (2008), clearly meant to generate shock but not fear, and that of Norma Bates in *Psycho* (Alfred Hitchcock, 1960). Although the latter is mummified and therefore not strictly a visceral corpse, Mrs Bates is missing her eyes and her intimidating, yet smiling, rictus, provoked by the fact that she no longer has any lips covering her teeth, are clearly meant to horrify. The film's score, as well as the reaction cue provided by Lila (Vera Miles), who proceeds to back off (hitting the bulb in the room) screaming at the top of her voice, help to frame the scene in this way.[60] In the case of *True Blood*, the music also peaks upon the discovery of the corpse, but its presentation is different: the first shot shows Sookie's grandmother in a pool of blood from a medium-low angle that also includes Sookie's arm and therefore aligns us with her. The following shot, a very quick, low-angle one from the floor, brings us closer to the corpse in a humane way: the image focuses on grandma's head, help-lessly gazing into the distance, and on her hand, which, although blurred, seems to stretch out and ask for help. The scene's framing as shock, and not fear, is further emphasised by a return, in the last shot, to Sookie's face as she assimilates what she and the viewer are seeing. This is not an abject corpse, but one that will be missed and that neither her nor the viewer were expecting to see dead at this point in the series.

The corpse can also be a source of abjection because it is alive (the zombie) or because it "appears dead", yet is not. The first case, that of the undead body or walking corpse, is quite complex and exceeds the repre-sentational. In the main, zombie bodies experience all forms of corporeal decay whilst still alive. This means that viscera, blood and wounds are a basic part of their physiognomy and that fear driven by disgust epitomises them. One of the reasons, vampires, another type of undead monster, have been received more positively is precisely that they do not usually corrupt and decay. Their capacity to stay pristine and untouched by time has, in fact, had a crucial impact in their mainstreaming and in the popularity of the teenage vampire lover in films such as *Twilight* (Catherine Hardwicke, 2008). Although it is not impossible for zombies to be romanticised along similar lines – R (Nicholas Hoult), the only ever-so-slightly rotten teenage zombie in *Warm Bodies* (Jonathan Levine, 2013), is perhaps the most notable example – the corporeal dereliction that they stand in for makes this process more difficult. Due to their status as corpse, zombies move and, in almost every

instance, pose a "real" threat to the viewer, and this has its own cognitive repercussions. The resulting affect is better understood as an emotion-based form of threat.

Finally, a model example of the type of living corpse that I have mentioned is the "sloth" scene in *Seven* (David Fincher, 1995). After breaking into an apartment that looks disused, smells badly and is full of dust, detectives Mills (Brad Pitt) and Somerset (Morgan Freeman) discover the emaciated body of a man that shows no signs of life strapped to a bed. The skin has needle marks, burns and boils, some of them clearly infected, and the pale flesh has an unhealthy bluish hue. His lips also seem to have receded from his mouth, revealing the teeth in a Batesian grin. Since the previous "gluttony" scene had introduced us to a corpse, the new victim shows all signs of having been tormented and his body is immobile, the viewer is likely to assume that the man is dead. As one of the officers looks closer with a torch and whispers "you got what you deserved", the body comes to life and starts coughing. The man was, it appears, either slumberous or in some catatonic state from which he is awakened. Although the primary feeling here might be shock, rather than fear, for the corpse comes alive unexpectedly, the scene also channels abjection via the decayed imagery and the prospect of a man living in, and through, a body so damaged as to have been mistaken for dead.

All of the substances and images connected to abjection that I have glossed in this section produce fearful disgust via their instinctive connection to the vulnerability of the body and the ease with which it can be broken, torn open and placed under threat. The representational abuse of the body, especially anything that signifies a transgression of its neatly separated inner and outer dimensions, can be a source of abjection. Importantly, however, these very images are not *always* and ineluctably so. Their treatment in Horror, which tends to exploit them for affect and works by analogy with the feelings they potentially encourage in real life, is responsible for reifying them as such. Their main trait is the generation of fear, but a specific type of fear that is mixed with disgust and which derives from the organic nature of the body. Physical vulnerability is capable of generating the latter, but it alone is not enough to constitute abjection.

Before moving on to a couple of case studies that will exemplify the workings of abjection as a representational method which affects the body of the viewer, I should like to emphasise that abjection, as I understand it here, only constitutes a threat to the subject because the body of the viewer is naturally sentient and cognitively engaged. In other words, the move that I have proposed is one that shifts away from psychoanalytic modes of under-standing subjectivity dependent on deep set structures moulded by our psy-chosexual development (themselves moulded by the world of the symbolic and its concomitant patriarchy) and towards a more visceral understanding of the subject. In other words, I am concerned with how certain images of abjection draw from our capacity to apprehend danger and pain. The devel-opment, then, takes us closer to a formulation that would run something like

"this affects me because it threatens my sense of physical integrity (health, life), because it is a threat to my body and thus myself (my self)". The preoccupation is, thus, not with the constitution of selfhood as a self-aware, social process, but with a more primal, embodied sense of oneself. This is not to deny that the former exists, or even that it does not inflect our reception of complex images of abjection or disgust, but rather that it is not the socially and culturally constructed sense of self that is threatened by abjection, but a much more basic and psychosomatic one.

This means that the female body in Horror is not necessarily abjected because of its status as "female" or, as Creed argues, because it is connected to some instance of primal maternal rejection. It might be that femininity is used as the basis of monstrosity (women's reproductive functions given monstrous qualities) or that socio-cultural notions connected to femininity or girlhood are transgressed, but it does not translate that the female body is, in itself, a *de facto* source of abjection. In *The Exorcist*, Regan's (Linda Blair) violent masturbation scene where she/a devil impales her vagina with a crucifix is more morally reprehensible and shocking than an instance of straightforward abjection. This is the case because little is shown (the piercing sound of the crucifix is much more brutal than the image, which does not expose genitals and merely shows her white dress stained with blood), but the moral implications are significant: the scene shocks because it violates the body of a girl, generally associated with virginity and innocence, and because it does so by desecrating a key symbol of Christian religion. Insofar as this could be a source of abjection for viewers, its power relies on the capacity to create a form of somatic empathy between it and Regan's body, so that the viewer can vicariously imagine the pain such an instance of abuse could generate.[61]

Comparably, the transformative body of the teenager can become the arena in which anxieties related to growing up and subjectivity are canvassed (*Ginger Snaps*, *Carrie*). These anxieties may well be connected with feminine corporality because they explore such inalienably female concerns as menstruation, but this should not lead to the conclusion that menstruation, in itself, should be a natural image of abjection. Woman, as a representational category, is not necessarily "othered" in Horror but, rather, her congenital reproductive and sexual specificity is either negotiated metaphorically or else exploited for affect. Furthermore, to argue that the monstrous-feminine is always articulated by such significant psychoanalytic constructs as the image of the castrating mother is to ignore the ways in which castrating fears may be explored literally or not at all. These monstrous-feminine bodies, according to this rethinking of abjection, are not fearful because they posit an intrinsic fear of the gendered other and, therefore, need to be treated as complex texts in themselves. Although I will not deny that a number of Horror films are potentially misogynistic, and inexcusably so, the difference of the monstrous-feminine body can be incidental or, in some cases, part of a larger feminist project seeking to engage with female worries

and problems. Let me turn to a problematic example in order to tease out the last concomitant implications of my argument.

Case Study 2: Abjection As Fearful Disgust in *Martyrs* (2008)

Martyrs is a well-known exponent of what has been called the New French extremity, a term that refers to a number of twenty-first century films, not all of them Horror, which exploit gore, nudity, sex and violence, and which include *Trouble Every Day* (Claire Denis, 2001), *Switchblade Romance / Haute tension* (Alexandre Aja, 2003), *Sheitan* (Kim Chapiron, 2006) or *Inside / À l'intérieur* (Julien Maury and Alexandre Bustillo, 2007).[62] *Martyr*'s use of violence and brutality is, as the name of the movement indicates, extreme, something which was, as the director himself has explained, volitional to the point where *Martyrs* ended up being about these issues itself (Laugier, qtd in Francis, Jr. 2013, 171). More recently, the source of an American remake, the film became a cult success in Europe and the subject of some controversy in France, where the graphic nature of the film led to it being given an 18 rating, something which would have limited its release and subsequent TV airing (Austin 2015, 283). This classification was ultimately revoked by the Minister of Culture in July 2008, and gave the film an additional sense of danger that did not do it any harm. I have chosen it here both because it is an example of extreme cinema – or, at least, of cinema that has been considered extreme by journalists and critics – and because it very specifically uses the bodies of women in its exploitation of images of abjection. It serves as a good example of the ways in which films that make interesting points about gender need not rely on a gendered approach to affect. As I will show in a final example, although gender is important in the film, it plays a very small role in the articulation of affective scenarios.

The popularity of the New French Extremity has come hand-in-hand with a host of scathing reviews that see no value in it. As a representative example, it is worth quoting James Quandt's lengthy definition in the first article to grant the movement significant attention. For him, New French Extremity is

> a cinema suddenly determined to break every taboo, to wade in rivers of viscera and spumes of sperm, to fill each frame with flesh, nubile or gnarled, and subject it to all manner of penetration, mutilation, and defilement. Images and subjects once the provenance of splatter films, exploitation flicks, and porn – gang rapes, bashings and slashings and blindings, hard-ons and vulvas, cannibalism, sadomasochism and incest, fucking and fisting, sluices of cum and gore – proliferate in the high-art environs of a national cinema whose provocations have been historically formal, political, or philosophical (Godard, Clouzot, Debord) or, at their most immoderate (Franju,

Buñuel, Walerian Borowczyk, Andrzej Zulawski), at least assimilable
as emanations of an artistic movement (Surrealism mostly).
(Quandt 2004, 127–8)

Although this is not the place for a consideration of the value (or lack thereof)
of the New French Extremity, it is important to note that, as is evident from this
passage, it has been the subject of similar debates as other explicit Horror sub-
genres, most notably, torture porn. In fact, a number of New French Extremity
films can, and have been, studied as part of the torture porn trend. Whether
these films are politically engaged – or indeed whether it is important that they
be so – has been of interest to academics, especially since critics like Quandt
have seen in their "shock tactics" (2004, 128) a reflection of contemporary soci-
ety.[63] In other words, like all other Horror, *Martyrs* is susceptible of political
and social readings and, of course, of readings that highlight its gender politics,
although these will inevitably face the difficulty of having to argue against what
I take to be quite a strong act of ungendering of the body in the finale of the film.

Martyrs centres on the bad fortune of Anna (Morjana Alaoui), who falls
prey to the actions of a sect which believes torturing innocent women and
bringing them to the brink of corporeal existence, as close to death as is
humanly possible, will allow them to have an exclusive insight into the after-
life or, as is suggested, into the possibility that there is nothing beyond the
material world other than the void. Escaping in 1971 from a previous incar-
nation of the sect's torturing grounds in the Chamfors industrial zone, where
she suffered from malnutrition, dehydration and mild hypothermia, Lucie
(Mylène Jampanoï) grows to be a damaged, self-harming girl bent on revenge.
Anna, who has stood by her during her childhood, is phoned by Lucie after
the latter has killed an entire, apparently innocent, family who she claims
were her torturers and whom she identified through a newspaper article. After
this rather long preface, which includes the discovery that Lucie is haunted
by the ghost of a girl she left behind during her escape from imprisonment (a
ghost which only she can see and is clearly the embodiment of her guilt), the
film begins – or begins again. As it turns out, Lucie may not have been mis-
taken, for Anna uncovers a secret basement hosting a woman who has been
subjected to an even worse treatment than Lucie was. After trying to help
the ailing woman, a group of strangers arrive, shoot the victim and imprison
Anna. The second half of the film chronicles Anna's own sufferings at the
hands of what appears to be a merciless, impersonal group led by a woman
known as the Mademoiselle (Catherine Bégin). Anna's ordeal mimics that of
Catholic martyrdom and, more specifically, that of St Bartholomew when,
towards the end, she is flayed alive. Her final revelation to the Mademoiselle is
nihilistic enough that the latter chooses to shoot herself during a gathering of
the secret society where the truth about the afterlife was going to be revealed.

As a film that exploits the female body in a very gender-explicit way – the
Mademoiselle explains that young women are preferred for torture because
they are more "responsive to transfiguration" – and does so in quite a brutal,

merciless and graphic way, *Martyrs* has polarised critics, with detractors accusing it of insensitivity and pointlessness. The image of the martyr, which is the epitome of transcendence in suffering and which brings to mind, in its female context, images of Joan of Arc in all its aestheticised close-up glory in *The Passion of Joan of Arc / La Passion de Jeanne d'Arc* (Carl Theodor Dreyer, 1928), is replaced here with a gritty, gory and bleak version of a victim of apparently absurd violence. This is precisely the opinion voiced by Henry Bacon when he asks whether the alleged spiritual justification for the torture in the film can be said to have any validity:

> One may well ask whether *Martyrs* is a continuation or exploitation of the Catholic mystery of suffering. Renaissance religious art does offer some extremely horrific images. But while suffering might possibly have an ennobling effect on a person, it is highly questionable whether watching suffering, in still or moving images, could possibly have the same effect. The excessive verisimilitude of the cinematic image, the sense of a human being, one of our kind, being subjected to merciless torture, very likely appeals even more strongly to our lower instincts than contemplation of still images of tortured saints looking forward to heavenly bliss.
> (Bacon 2015, 127–8)

Again, this position potentially confuses the affective drives of the film (to scare, unnerve and affect the viewer with images of brutal and merciless violence visited upon a helpless victim) with its thematic concerns, which may or may not be linked to gender issues or to religious practices of transcendence.[64] The fact that the film is seen to be exploiting specifically female bodies has led critics, journalists and general viewers to call the film "hypocritical" (Parkinson 2009) and "misogynistic" (Laugier, undated). In fact, it is possible to argue, as Ruth McPhee has done, that quite the opposite is true and that the final image of Anna, skinless and beatified in her flayed body, could be read as an "ungendered, inhuman and transcendent" (2014, 50) image and that the film may represent "a strong feminist strain of Gothic [Horror]" (Hogle 2014, 74).

But regardless of the value of its themes, of whether we see the depiction and predicament of the women in the film as progressive or not, *Martyrs* seems remarkably intent on affecting viewers in the most direct ways irrespectively of the gender of the onscreen character. In order to do this, it deploys, very effectively, a number of cinematic tricks (the startle effect in the attack of the creature (Isabelle Chasse), the close-up slicing of Lucie's back) and, most importantly, a number of images of abjection that, although presented through and on the bodies of women, are affective regardless of a specific gender. The scene where Anna encounters the tortured woman, Sarah (Emilie Miskdjian), in the basement of the secret chamber offers a good example through which to illustrate this point. The woman is indeed naked, but it seems inconceivable that her nudity could be a source of titillation:

not only is she emaciated and her skin covered in sores and scar tissue, her lips are chapped and dry, and she has bald spots where a head contraption has hindered the growth of hair. If the vision of this woman is meant to be arousing, then it is most definitely not so in the normative meaning of sensuality or sexuality.[65] Neither is this an exponent of the monstrous-feminine, since the potential threat Sarah poses when first encountered soon fades as the viewer, and Anna, realises that the woman is another prisoner. A sympathetic reaction is encouraged by the inclusion of the torture chair, which had already featured in the pre-credits sequence, and a big chain that restrains Sarah. More likely, when one takes into account the cinematic elements that constitute her presentation, the scene seeks to affect the viewer negatively. Sarah is intended to arouse fearful disgust, particularly when her head contraption is removed. In fact, the Horror here is premised on the slow reveal of the extent of the woman's torment and disfigurement so that it could be argued that the threat she poses is a visual one: what am I about to see and can I stomach it? This initial moment of abjection is soon disavowed as Anna starts caring for the woman, tending to her wounds and even bathing her. At this point, when we know the supplicant is simply another victim, our feelings are likely to be moved to pity and compassion. The change in musical register punctuates this change. However, as Anna starts removing the metal hoops that anchor Sarah's helmet to her head, abjection returns: blood streams down, the woman begins screaming and her forehead is bloodied. There is an obvious appeal here to the visceral as source of fearful disgust, especially where internal tissue is exposed. A subsequent scene where Sarah knifes her own wrists gives a final visceral touch to the sequence.

Figure 1.5 Anna's encounter with another imprisoned victim in *Martyrs* (2008) premises its affect on a viscerality that transcends gender and is connected to pain.

Other notable examples that employ similar images include the scenes featuring the ghost and Anna's flaying towards the end of the film. In terms of the former, the editing of the shots that display the creature's (again, naked) body are so fast and syncopated that it is difficult, in fact almost impossible, to discern a specific gender. Covered in blood that masks her anatomy, with one white eye, veins mapping her face and an open mouth that shows clear signs of having been sewn shut in the past – all evidence of torture – her threatening presence is accompanied by unsettling music, the thumping sounds as the creature moves from the floor to the bath and by its feral screaming. The creature's blood is clearly not menstrual but a result of torture, as we have strong reasons to suspect, by this point, that the monster may be an instance of psychological trauma connected to the girl Lucie could not save. Additionally, and as I have mentioned, her body is both naked and ungendered for the purposes of the scene. The creature scares not because she is an embodiment of the monstrous-feminine but because she poses a direct threat to Lucie and/or the viewer. We cannot even say that her female traits are what make her scary: she would be just as scary if she was a naked man. What is at stake for the viewer here is the corporeal threat she entails to Lucie and, by extension, the viewer. The creature is also used to quite literally jump us; the bath floor sequence aligns Lucie's vision with ours so that, by the time the creature opens her mouth in a violent growl, the viewer is allowed little experiential distance and may, therefore, be particularly shaken by the vision. Here, images of abjection – the woman's hurt and hurting body – are used alongside traditional Horror techniques to scare the viewer.

Anna's flaying is even more significant because all her skin is removed and the camera lingers on the underlying muscles and ligaments. An image that should conjure up total abjection in its bringing of the inner body into the outer world, it is actually more likely to elicit disgust or pity. Since the previous twenty minutes have charted Anna's progressive descent into a largely immobile, bruised up and swollen victim, an image that recalls images of concentration camps, viewer sympathy and rapport have had a chance to evolve. It is virtually impossible, if the cooperative viewer has been following the film as it intends to be followed, that her pain and torture are experienced as anything other than morally censorious, disgusting and constricting. Like Anna, the viewer wants the violence to end. This is why, when it is announced that she will undergo the last stage of her martyrdom, her skinning alive may come as a form of relief. The design and extent of her torture are finally revealed and we know that there will be an end to suffering, however horrible it shapes up to be. Anna's flayed body, degendered in the removal of her breasts and mere intimation of genitals, is largely reduced to its flesh, to its nature as a body made out of muscles, arteries and cartilage. Her strapping to the cruciformic metallic bed that keeps her propped up is also presented solemnly, against a nostalgic music that connotes sadness and pity rather than fear. The moment when it is

announced that she has transfigured, things change somewhat. It is made clear that the fact that Anna is alive is almost inconceivable; this is followed by a high angle shot that focuses on her out-of-body stare. The unnerving music returns, the back lighting changes to black and her body has grown more viscous, gooey and blood red. All these elements have a direct effect on our perception of what is, in essence, the same image. For these reasons, I would argue this shot is more evidently one that relies on abjection.

Scenes like this one indicate that, whilst images of abjection naturally arouse fearful disgust (and it is, indeed, difficult to supress this feeling when watching her skinless feet touch the floor), the cinematographic treatment is as important as the image itself. Music, lighting, composition, narrative positioning and character allegiance can come together in making certain sights less apprehensive. The fact that all blood has been removed from Anna's body, so that she appears like a textbook anatomical model, also creates further affective distance. The film wants to encourage this distancing because the effectivenes of the ending depends on our capacity to see through Anna's eyes – quite literally. The scene where the camera enters the pupil of her eye and then zooms back out is incredibly powerful and moving, and reminds us that Anna's transcendence leaves the material body, gender included, behind.

Figure 1.6 The flayed body of Anna in *Martyrs* becomes an evident source of ungendered fearful disgust towards the end of the film.

A problematic scene, by comparison, is Anna's previous beatings at the hands of a dispassionate security guard, although these are not scenes that use images of abjection beyond Anna's bleeding from the bludgeoning and her inevitable bruising. Anna's helplessness, mixed with the feelings of empathy and sympathy that may be generated by out realisation that she is

underserving of this treatment, is significant in making us feel for her safety. The scene relies on cognitive and emotional links forged with her throughout the first half of the film, where she has shown herself to be a true friend, a do-gooder (she helps the fallen mother (Patricia Tulasne)) and a survivor. The scene does more than simply provide a realistic and crude instance of violence – Anna is repeatedly stricken by the man several times, with no compassion or, at this stage, apparent motives. As Steve Jones has noted, it is not simply a question of how much violence is shown on screen either. Although the quality of this violence is itself stronger because the empathic and sympathetic links are stronger, the treatment the violence receives and its pace are significant, as "[c]adence [also] impacts on how effectively these sequences convey the characters' suffering" (Jones 2013, 71). The crudity of the scene is also a result of its "episodic nature", which gives "the impression of gratuitousness", and of the unusual lack of dialogue (71). The scene could be read for its gender import and, if taken to be an allegory for domestic violence, could be even more effective for its loathsome presentation.[66] However, the scene, like the rest of the film, does not rely on these principles to affect the viewer. The gendered reading is an additional one that may be appositional to the more obviously emotional, cognitive and affective experience of the film, and acts as a further source of anxiety for the viewer. Ultimately, *Martyrs* is an effective exercise in negative affect, and manages to be so regardless of the gender of its main characters. Instead, brutal violence and images of abjection, which are largely ungendered, become the source of affect throughout.

Conclusion: The Relevance of Representation to an Affective-Corporeal Model of Horror

In his 1872 study *The Expression of the Emotions in Man and Animals*, Darwin already suggested that horror is elicited by observing scenes of torture or pain.[67] This chapter has gone some way towards suggesting how this might be taking place at a very basic representational level with images that encourage a sense of threat connected to our corporeal vulnerability and capacity to read certain images as conducive to pain, harm or imminent death. This has helped me to move away from problematic gender-centred models of representation which, despite their significant work in highlighting the ways in which the female body is portrayed as monstrous in Horror, run the risk of essentialising gender and reducing the female body to its maternal qualities. As I have proposed, whilst it is productive, indeed necessary, to see how Horror helps articulate social and cultural anxieties, some of the most important being gender and sexual constructions as well as their abuses and exploitation, we should not conflate this cultural work with a text's affective ones. Some Horror is misogynistic; some Horror is feminist in its intent and message; other Horror is ambivalent or does not express gendered views at all or purposely.[68]

To let negative images of femininity organise Horror's affective production is to give primacy to archetypal structures of psychology and sexual development that rarely have a direct relevance for viewers or the film's narrative. It has been fundamental to map out these distinctions in new films that could be said to continue the tradition of the monstrous-feminine as propounded by Creed. My reading of the texts has separated the cultural work that the films could be said to do – how the teenage female or the maternal body are portrayed as monstrous – from the ways in which fearful disgust is actually articulated via recourse to images of the damaged and bleeding body. Because my approach entails a de-gendering of images of abjection, this means that the nature of affect needs to be theorised regardless of the gender or sexuality of the viewer and characters, and rather in terms of viewers' acquaintance, tolerance and enjoyment of images of abjection.

At a corporeal level, my analysis of abjection as a concept that is separated from psychoanalytic models of representation initiated my analysis of the various levels on which the body can be said to orchestrate the generation of fear. Although inseparable from the emotive and the somatic, the representational (in my specific use of the term throughout as the recourse to certain images of abjection) allows us to think about the specific, near-instinctive connotations that certain images of corporeal damage convey. To concretise abjection is to demystify it, to stop using it as a construct premised on a vague sense of transgression, of boundary-crossing, and which remains impossible to define other than through the capacity to resist the process of definition itself. A theory of abjection that returns to representation and anchors it in corporeality can help us position a sentient and visceral body at the heart of the Horror experience and corporeal intelligibility as a key and complex notion through which to understand it. Its main benefit is that it is at a remove from notions of the constitution of selfhood which, whilst important, might not necessarily impinge as strongly on actual viewing experiences for many viewers.[69] Its demystification is not coterminous with a refusal of the notions and ideas that have been connected to abjection: the importance of taboo (cannibalism, murder, rape) in Horror, at a moral level, or the fact that the bodies of women are sometimes exploited according to facets that return to the female specificity of their bodies.

The move away from archetypal constructions of bodies and towards a phenomenological, empirical and rational approach that looks at the specificity of the use of images of abjection in given scenes is productive because it rethinks some of the main problems with the way in which abjection, as a theoretical construct, has been used in Horror criticism. Firstly, the "[f]ear of the other" (Arya 2004, 7) that is so central to Creed's application of abjection is rendered problematic: it is found lacking in its engagement with cultural and historical specificities of gender or sexuality. Secondly, the reduction or alleged expulsion of the abject, whether metaphoric or

physical, becomes difficult to justify on any level. Curiosity, by opposition, is a very palpable, and sometimes deciding, factor for Horror viewers. Finally, a theory of abjection that explains fear and disgust as a return to a primal moment in our psychological (semiotic, symbolic, linguistic) development, what Kristeva terms the "thetic phase" (1982, 43), inevitably short-circuits the dynamics, structure and cinematography that the images themselves are surrounded and inflected by. Abjection may have been of incredible import in claiming the need for theories of Horror that encompass female bodies and their monstrous renderings and, as I have shown in my reading of *Ginger Snaps*, it is possible for filmmakers to consciously produce feminist films by drawing on the same pool of clichés about femininity and womanhood that has given rise to the monstrous-feminine.

And yet, Horror is more actively concerned with generating fear and fearful disgust than with elaborate discursions about the nature of motherhood. This is not to deny that it cannot do so effectively or that it cannot reappropriate a mythical figure for feminist purposes, or indeed, in order to explore the reality and hardships of the human body. What I am contending, instead, is that Horror's interest in representation is usually more coloured by fear and the elicitation of physical discomfort – how fictional bodies are used to generate affect – than in the nature of gendered bodies. My reading of abjection allows for an enjoyment of images of abjection that need not derive from a strictly social and cultural understanding involving all human beings or premised on speculative ideas about the loss of the self that seem difficult to ground in phenomenological and empirical terms. Those driven to images of abjection are so, in most cases, because they like encountering them within the context of Horror (let us remember that not all Horror is explicit and that some viewers prefer subtle Horror that very patently does not deal in such graphic terms). The potential pleasures derived from the consumption of images of abjection are many, but the main ones, as I see them here, are the experimentation of a safe, because at a fictional remove, experience of threat and corporeal destruction, and the satisfaction of a morbid curiosity about the limits and boundaries of the body. Obviously, images of abjection are rarely found in isolation and form part of larger films. The much-lauded exploding head scene in *Scanners* (David Cronenberg, 1981) can most certainly be enjoyed independently from the wider film and may well have been a major selling point for it initially, but its abjective power gains fuller import and significance, other layers of affect, when viewed as part of a totality. This means that the work of this chapter is one based on the isolation and identification of images that normally appear within a given context. At the same time, I have attempted to show how their precise workings are also dependent on treatment and purpose.[70] Although effect may not be fully achieved, or may erode as changes in cinema make the images less believable or convincing, their intention should be emphasised, since Horror consistently attempts to move bodies in specific, often negative, ways.

Notes

1. See Freud (2003) and Lacan (2004).
2. See Diamond (2013), Lemma (2014) and Piotrowska (2015).
3. The number of significant publications that have drawn on the work of Deleuze in the last ten years is vast. I would point the interested reader towards specialist series, such as Edinburgh University Press's Deleuze Connections, or to specialised journals, such as *A/V Journal: Deleuze Studies*, run by Manchester Metropolitan University.
4. For more on horror and phenomenology, see Chapter 3 in this book. For an example of recent scholarly work to use psychoanalysis, see Dumas (2014).
5. Most recently, Arnold (2013).
6. The most notable works of Horror criticism came from Robin Wood, who produced a series of articles on 1970s and 1980s Horror that were eventually reworked and expanded into a chapter of his influential book *Hollywood from Vietnam to Reagan* (1986). See also Wood (1984). The legacy and relevance of gender to this genre can be seen in the later publication of edited collections such as Grant (1992; rev. edn 2015), and monographs such as Pinedo (1997).
7. Linda Williams (1984) also argues that the horror film creates an affinity between female victim and monster. Whilst it is true that other published works had touched on gender in Horror either before (Lenne 1979) or around the same time (Hogan 1986; Twitchell 1985), they would come under heavy criticism in the 1990s due to their lack of academic rigour or dismissal of female monsters (see Creed 1993, 3–5).
8. It is important to note that both Clover and Creed's thoughts on these monographs had already been rehearsed in articles published in 1987 and 1986, respectively. Some of these ideas, therefore, technically belong to the previous decade.
9. Creed explains that her analysis in this book also "necessitates a rereading of key aspects of Freudian theory, particularly his theory of the Oedipus complex and castration crisis" (1993, 7).
10. This, she argues, is not the case with the male, who is not sexed or gendered in the same way by virtue of his monstrosity, and whom she terms "male monster" (1993, 3).
11. Creed prefers to use the term "phantasy" (1993, 6) to "fantasy" in order to make her alignment with Freud more evident. He uses it to refer to the engagement of the subject with the activity of wish fulfilment.
12. Kristeva calls the abject a "twisted braid of affects and thoughts" (1982, 1).
13. A corollary of her discussion, which veers off into similar territory, considers how female monsters often take the guise of castrators or psychotic mothers or else appear in images reminiscent of the *vagina dentata* (Creed 1993, 87–166). Since my focus remains abjection, and this is abandoned as a methodological tool in exchange for Freudian theories on castration anxiety, I am not including Creed's ideas on these subjects in this study. However, my warning regarding the dangers of privileging readings that focus on metaphoric or psychologically-invested images as a way to explain their affective import still stands for the conclusions reached there.
14. See also Douglas (2002), who made very similar arguments from an anthropological perspective.

15. See also Creed (1993, 24–30). For Freud's theory of the primal phantasies, see Freud (2001a, 205–26; 2001b). Creed also claims, although without any real or conclusive evidence for the correlation proposed, that the archaic mother is always present in Horror as the figure of "death" (1993, 28).

16. I would make a similar case for the need to challenge the reading that sees the Count's fangs as an image of the *vagina dentata*.

17. Other critiques have been levelled to Creed's study from feminist Film Studies, especially her reliance on gender essentialism, something she shares with Kristeva, and its totalising approach to the application of feminist theory and psychoanalysis. For a detailed account of these objections, see Freeland (1996, 198–202).

18. *Ginger Snaps* has been read by Creed as an example of the "*femme animale*" (2015, 180, italics in the original), a type of the monstrous-feminine. Creed argues that the female werewolf is an "abject being" because "her body is even more unstable that that of the male" (2015, 188), and focuses on menstruation, sexuality and the tail of the she-wolf, which is read as a "furry phallus" (185).

19. For the most thorough exploration of gender in the film, especially as it intersects with sexuality, see Mathijs (2013, 53–84).

20. Films that explore similar territory from the point of view of boys are easy to find. Think, for example, of *The Final* (Joey Stewart, 2010) or *Scar* (Jed Weintrob, 2007). *Hard Candy* (David Sleade, 2005) is perhaps the obvious exception here, but this text belongs more clearly to the rape-revenge tradition.

21. I am not taking into account here the fact that the director is male, as I do not believe this has any bearing on my reading. However, lest the film be accused of putting forward a male construction of female sexual awakening, it is worth noting that the script was written by Karen Walton.

22. Ginger refers to her menstruation as the "curse" straight after she feels blood running down her legs and feels the need to explain to her sister that she is not contagious. The significance of the moon here, connected to menstruation, is also noteworthy.

23. Peter Hutchings makes this point brilliantly when he suggests that the film "can credibly be interpreted in a manner that does not centre on female biology" and warns against the dangers of "prob[ing] beyond the surface detail [...] in order to discover significance, or to render that detail symptomatic of something other than what is ostensibly appears" (2015, 167). For such a reading, one that focuses on the nationality of *Ginger Snaps*, see Rothenburger (2010).

24. The only way she can pass for "normal" during the later stages is by either hiding parts of her body or by pretending she is wearing a costume.

25. I am expressing doubt about the beast's capacity to generate fear because I find the monster slightly disappointing and unconvincing.

26. See Short (2006, 88–110) for a longer consideration of this point. See also Linda Ruth Williams (2001).

27. For some of the main challenges to Freud, see the articles collected in Dufresne (2007). I realise I am collapsing a number of psychoanalytic studies here, including Kristeva's, but universal and archetypal notions of femininity have been challenged more generally in Film Studies since, at least, the 1980s.

28. Missing from this is, of course, the way in which race and nationality are also part of the construction of the female abject.

29. I am aware that the argument that would be made for the validity of this equation is that the substances in themselves are symbolically feminine and maternal and thus abject, regardless of the body they are produced in. I still find this limiting in that excrement is also naturally male. Moreover, the bracketing off of women as possessing a form of maternal "authority" that is opposed to "paternal laws" perpetuates stolid familiar structures that are no longer relevant, especially in a society that now strongly includes single parents and gay couples.

30. Creed started her representational work in 1986 and expanded it in 1993. She further explored the subject in 1995 and 2005. However, she has not to my knowledge produced an account that focuses on the process of consumption of the body-monstrous.

31. Horner and Zlosnik commented in 2014 on the "creative" ways in which abjection continues to be used by Gothic scholars in this way, as well as to "throw [...] off [...] fundamental instabilities and multiplicities" (2014, 58).

32. I am thinking more specifically about the way in which scenes that would have previously been coded as horrifying in German expressionism can be seen as histrionic or "camp" by contemporary audiences due to changes in, for example, cinematic conventions.

33. What I mean by this is that abjection starts with the rejection of the maternal body at a stage where cognitive processes have not started taking place. For Kristeva and Creed, the abjection of the female and maternal bodies is naturalised, in other terms, it is internalised to the point where it becomes self-evident and, in psychoanalysis, universal.

34. Birth is not just a source of abjection because the maternal, birthing body has been culturally pushed to the side (barely ever present in social media unless sanitised). Blood and the disruption of the inside/outside boundaries are also significant. The vicarious feeling of pain via the suffering mother is also important and is cognitive in essence.

35. By making viewers ask themselves "why am I watching this?" and "am I complicit in the violence for watching this?" In the case of *Mordum*, additional questions the viewer may ask are "is this real?" or "how can I differentiate the real from the staged violence?" Admittedly, this is one of the possible pleasures of watching the film.

36. The initial shower scene, where the shots alternate between medium close-ups of Carrie extending her bloodied hand towards the camera and shots of either one of the students or the PE teacher being stained by the blood, could be seen as one of disgust, but not as one of abjection. There is not enough flowing blood to sustain the possibility that Carrie may be in real danger and, by this point, we know Carrie to be merely experiencing her first period.

37. Not even these are "universal", since a person who had damaged nerve endings or certain pathologies, such as congenital insensitivity to pain, may not react to a fire in the same way. I am, however, assuming these to be exceptions to the rule, since instincts and reflexes are things we share with animals and which have been evolutionarily developed in order to guarantee survival. Finally, it is important to note that, since abjection is an extreme form of feeling that makes us aware of our own bodies, this means a number of people decide not to engage with related images fictionally and that others cannot cope with them at all.

38. Some critics, such as Ahmed (2004, 84–9), have considered abjection and disgust to be one and the same thing.

39. See Korsmeyer and Smith (2004, 1). Disgust should not be confused with distaste, which is innate and biological, and which non-human animals also display.
40. See, for example, Angyal (1941), and Rozin and Fallon (1987).
41. For more on the relationship between disgust and the law, see Nussbaum (2004, 75–87, 115–23).
42. See Kim (2001).
43. See Kolnai (2003, 93–109). I disagree with Miller (1997, 26) that Horror is simply "fear-imbued disgust". Horror, as I will show in Chapters 2 and 3, actually encompasses a host of emotions such as dread, shock or, as I am showing here, fearful disgust.
44. Arya proposes that "abjection" is a "proper subset of disgust": "they have the same presentations and phenomenology but different theoretical rules" (2014, 39). As is clear from my discussion in this chapter, I think of abjection as an intermediate emotional experience between fear and disgust.
45. McGinn proposes "adverse economic circumstances or revelations that might destroy one's reputation" (2011, 5) as examples of concepts that can cause fear yet are not related to the vulnerability of the body. However, this proposition fails to acknowledge that these concepts are scary because their adverse results *can* lead to bodily damage (malnutrition, because one cannot feed oneself as a result of having no money or having been sacked). If the feeling experienced is connected merely with a worsening of the quality of life (having to live on a strict budget), then "worry", "preoccupation", "concern" or "stress" strike me as better options.
46. For Menninghaus, disgust is an experience that, like fear, puts the subject in "a state of alarm" and is responsible for "an acute crisis of self-preservation". However, unlike in fear, where the self-preservation instinct is excited by the potential damage of an external threat, in disgust it is "the face of an unassimilable otherness, a convulsive struggle" (2003, 1).
47. For more on anticipatory disgust, see Hanich (2011, 14–8).
48. I have no space here to consider moral or ethical disgust, as these processes are cognitive and related to narrative and plot rather than specific images. For more on moral disgust, see Kass (1997), Schnall et al. (2008) and Kelly (2011, 101–36).
49. Abjection, via sympathy and empathy, can also be felt towards the animal body, especially the closer it is, analogically, to the human body. Most likely, however, damaged animal bodies will be a source of pity or sadness or, if an evil, irredeemable animal, relief and excitement. It is crucial to note, however, that disgust is always a response to "biological, not inanimate, objects" (McGinn 2011, 53).
50. This is the case unless the specifics of the scene make those substances scary for other reasons. It is technically possible to make virtually every object or substance frightening through use of light, music or cinematography. These substances have the added complication of being arousing for some, especially when used in fetish pornography. I would add to these substances human hair, which is organic, but does not normally have any fleshy qualities and is thus perceived as disgusting. I am excluding tears, because they are more obviously connected with the feeling of sadness.
51. See Bataille (1986, 57–8).
52. The close-up of a wound in texts that rely on the documentary, such as medical programmes which show the procedures followed in certain operations,

follow the same premise as instances of real abjection, since the images may be experienced as mediated yet real or not staged.

53. Arya's reliance on the animal is necessarily tied to the abject's social and cultural work, since abjection threatens subjectivity and subjectivity is human and rational. I, however, feel that we can think about abjection as a return to the materiality of the body, a materiality that need not be connected to a loss of reasoning. This denial is also borne of my dissatisfaction with the idea that the subject is somehow lost in the encounter with the abject only to be returned later once the former has been expelled. We cannot escape the self by means other than loss or manipulation of consciousness (through, for example, consumption of psychotropic substances), sleep or death. The abject could also be perceived as simply another part of the subject, a repressed one that must be rejected, but I find this theory even less plausible and even more speculative. My engagement with the body is a very phenomenological and empiric one that understands it as purely material and driven by consciousness.

54. This is the reason why, as Nussbaum explains, saliva can be seen as disgusting when one has spat on one's own glass but not when it is in our own mouths (2004, 88). Expelling bodily substances turns them alien and, potentially, into sources of disgust.

55. For more on the symbolic significance of blood see Camporesi (1995) and Hill (2014).

56. Some people even take these cues as an opportunity to look away, especially audiences who cannot cope with strong images.

57. Bloodied skin with flesh remnants, as in Leatherface's borrowed skin mask in *The Texas Chain Saw Massacre* (Tobe Hooper, 1974), could be a source of affect and of abjection but, on its own, removed from the body and even dried or cured, as in *Jeepers Creepers* (Victor Salva, 2001), it is more likely simply a source of either disgust or fear. For the ways in which skin is connected to disgust, see Miller (1997, 52–3, 54).

58. See McGill (2011, 13–4), who argues for the importance of decomposition, as "[i]t is clearly not fear that prompts such an aversion, since we generally are not afraid of what a dead body might do to us; rather, it is the sensory appearance of the decaying body that revolts and disturbs" (14).

59. See Miller (1997, 179–205) and Rozin, Haidt and McCauley (2008). For the way in which death is more obviously expelled or rejected socially, see Becker (2011, 11–24). For the feelings skeletons elicit, see McGinn (2011, 17).

60. There is, of course, the concomitant horror of realising that Mrs Bates was dead the whole time, which further confuses the viewer until, seconds later, Norman (Anthony Perkins) appears dressed as his mother.

61. The impact of this may well differ according to the viewer's gender, but I would argue that, since having our body penetrated by a piercing object is a form of pain we can readily recognise, viewer engagement with the image would not be terribly different at this level. Morally, it could well be that this scene is seen as offensive and therefore received differently. For example, feminist readings of *The Exorcist* might complain about the ways in which the body of a little girl is desecrated via rape, and thus phallocentrically, and by a mythical character portrayed as masculine (the Devil).

62. James Quandt, who coined the term, has remarked that the New French Extremity was never meant to designate a conscious cinematic movement

and that it initially conflated Horror "with its art-house confraternity" (2011, 210–1).

63. For an overview of some of these debates, see Palmer (2011, 67–70). For a general introduction to New French Extremity, see McCann (2013, 280–3).
64. The fact that the film shows the *Hundred Pieces* torture, which appeared in Georges Dumas' *Nouveau traité de psychologie* (1930–43) is an obvious reference to Georges Bataille, who, in his *The Tears of Eros*, describes the scene as allowing him to "reach [...] the point of ecstasy" (1989, 206). The information regarding the picture in the film, as offered by Mademoiselle, is obviously a fabrication.
65. The only concession to explicit sexuality is a brief kiss between Anna and Lucie that the latter quickly rejects.
66. The link to domestic violence is spelled out by the film later, when Anna is showed a picture of an abused wife as an example of someone who transcended pain and became a martyr.
67. Darwin (1873, 304–7).
68. All horror expresses gender views insofar as, like any other type of cinema, it is a product of its time. My point is that Horror is only sometimes *explicitly* about gender dynamics.
69. It also means moving away from language as constitutive of abjection. Abjection, for me, is ultimately an affective encounter with images.
70. An example I do not have time to cover here is that of "splatstick", a hybrid genre, halfway between splatter and comedy, and which plays with the boundaries of abjection, disgust and laughter. For an introduction, see Aldana Reyes (2014, 55–6) and Russell (2011).

Bibliography

Ahmed, Sara. 2004. *The Cultural Politics of Emotion*. Edinburgh: Edinburgh University Press.

Aldana Reyes, Xavier. 2014. *Body Gothic: Corporeal Transgression in Contemporary Literature and Horror Film*. Cardiff: University of Wales Press.

———. 2015a. "The *[•REC]* Films: Affective Possibilities and Stylistic Limitations of Found Footage Horror". In *Digital Horror: Haunted Technologies, Network Panic and the Found Footage Phenomenon*, edited by Linnie Blake and Xavier Aldana Reyes, 149–60. London and New York: I.B. Tauris.

———. 2015b. "Reel Evil: A Critical Reassessment of Found Footage Horror". *Gothic Studies* 17.2: 1–15.

Angyal, Andras. 1941. "Disgust and Related Aversions". *Journal of Abnormal and Social Psychology* 36.3: 393–412.

Arnold, Sarah. 2013. *Maternal Horror Film: Melodrama and Motherhood*. Basingstoke and New York: Palgrave Macmillan.

Arya, Rina. 2014. *Abjection and Representation: An Exploration of Abjection in the Visual Arts, Film and Literature*. Basingstoke: Palgrave Macmillan.

Austin, Guy. 2015. "Contemporary French Horror Cinema: From Absence to Embodied Presence". In *A Companion to Contemporary French Cinema*, edited by Alistair Fox, Michel Marie, Raphaëlle Moine and Hilary Radner, 275–88. Oxford and Malden, MA: Wiley-Blackwell.

Bacon, Henry. 2015. *The Fascination of Film Violence*. Basingstoke: Palgrave Macmillan.

Bataille, Georges. 1986. *Eroticism: Death and Sensuality*, translated by Mary Dalwood. London: Athlone Press.

———. 1989. *The Tears of Eros*, translated by Peter Connor. San Francisco, CA: City Lights Books.

Becker, Ernest. 2011. *The Denial of Death*. New York: Souvenir Press.

Berenstein, Rhona J. 1996. *Attack of the Leading Ladies: Gender, Sexuality and Spectatorship in Classic Horror Cinema*. Chichester, UK, and New York: Columbia University Press.

Camporesi, Piero. 1995. *Juice of Life: The Symbolic and Magic Significance of Blood*. New York: Continuum.

Clover, Carol J. 1987. "Her Body, Himself: Gender in the Slasher Film". *Representations* 20: 187–228.

———. 1992. *Men, Women and Chain Saws: Gender in the Modern Horror Film*. Princeton, NJ: Princeton University Press.

Creed, Barbara. 1986. "Horror and the Monstrous Feminine: An Imaginary Abjection". *Screen*, 27.1: 44–71.

———. 1993. *The Monstrous-Feminine: Film, Feminism, Psychoanalysis*. London and New York: Routledge.

———. 1995. "Horror and the Carnivalesque: The Body-Monstrous". In *Fields of Vision: Essays in Film Studies, Visual Anthropology and Photography*, edited by Leslie Deveraux and Roger Hillman, 127–59. London, Berkeley and Los Angeles, CA: University of California Press.

———. 2005. *Phallic Panic: Film, Horror and the Primal Uncanny*. Melbourne, Australia: Melbourne University Press.

———. 2015. "*Ginger Snaps*: The Monstrous Feminine as *Femme Animale*". In *She-Wolf: A Cultural History of Female Werewolves*, edited by Hannah Priest, 180–95. Manchester: Manchester University Press.

Dadoun, Roger. 1989. "Fetishism in the Horror Film". In *Fantasy and the Cinema*, edited by James Donald, 39–61. London: British Film Institute.

Darwin, Charles. 1873. *The Expression of the Emotions in Man and Animals*. New York: D. Appleton & Co.

Deleuze, Gilles, and Félix Guattari. 1977. *Anti-Oedipus: Capitalism and Shcizophrenia*, translated by Robert Hurley, Mark Seem and Helen R. Lane. London: Viking Penguin.

Diamond, Nicola. 2013. *Between Skins: The Body in Psychoanalysis*. Oxford and Malden, MA: Wiley-Blackwell.

Douglas, Mary. 2002. *Purity and Danger: An Analysis of Concepts of Pollution and Taboo*. London and New York: Routledge.

Dufresne, Todd, ed. 2007. *Against Freud: Critics Talk Back*. Stanford, CA: Stanford University Press.

Dumas, Chris. 2014. "Horror and Psychoanalysis: An Introductory Primer". In *A Companion to the Horror Film*, edited by Harry M. Benshoff, 21–37. Oxford and Malden, MA: Wiley-Blackwell.

Francis, James, Jr. 2013. *Remaking Horror: Hollywood's New Reliance on Scares of Old*. Jefferson, NC: McFarland.

Freeland, Cynthia A. 1996. "Feminist Frameworks for Horror Films". In *Post-Theory: Reconstructing Film Studies*, edited by David Bordwell and Noël Carroll, 195–218. London and Madison, WI: University of Wisconsin Press.

Freud, Sigmund. 2001a. *The Standard Edition of the Complete Psychological Works of Sigmund Freud: Jensen's "Gradiva" and Other Works, vol. IX (1906–1908)*, translated by the Institute of Psycho-Analysis. London: Vintage.

———. 2001b. *The Standard Edition of the Complete Psychological Works of Sigmund Freud: An Infantile Neurosis and Other Works, vol. XVII (1917–1919)*, translated by the Institute of Psycho-Analysis. London: Vintage.

———. 2003. *An Outline of Psychoanalysis*, translated by Helena Ragg-Kirkby. London: Penguin.

Grant, Barry Keith, ed. 2015. *The Dread of Difference: Gender and the Horror Film*, 2nd ed. Austin, TX: University of Texas Press.

Halberstam, Judith. 2000. *Skin Shows: Gothic Horror and the Technology of Monsters*. London and Durham, NC: Duke University Press.

Hanich, Julian. 2009. "Dis/liking Disgust: The Revulsion Experience at the Movies". *New Review of Film and Television Studies* 7.3: 293–309.

———. 2011. "Towards a Poetic of Cinematic Disgust". *Film-Philosophy* 15.2: 11–35.

Heller-Nicholas, Alexandra. 2014. *Found Footage Horror Films: Fear and the Appearance of Reality*. Jefferson, NC: McFarland.

Hill, Lawrence. 2014. *Blood: A Biography of the Stuff of Life*. London: Oneworld Publications.

Hogan, David J. 1986. *Dark Romance: Sexuality in the Horror Film*. Jefferson, NC: McFarland.

Hogle, Jerrold E. 2014. "History, Trauma and the Gothic in Contemporary Western Fictions". In *The Gothic World*, edited by Glennis Byron and Dale Townshend, 72–82. London and New York: Routledge.

Horner, Avril, and Sue Zlosnik. 2014. "Gothic Configurations of Gender". In *The Cambridge Companion to the Modern Gothic*, edited by Jerrold E. Hogle, 55–70. Cambridge: Cambridge University Press.

Hutchings, Peter. 2015. "The She-Wolves of Horror Cinema". In *She-Wolf: A Cultural History of Female Werewolves*, edited by Hannah Priest, 166–79. Manchester, UK: Manchester University Press.

Jones, Steve. 2013. *Torture Porn: Popular Horror after* Saw. Basingstoke, UK: Palgrave Macmillan.

Kass, Leon R. 1997. "The Wisdom of Repugnance: Why We Should Ban the Cloning of Humans". *New Republic* 216.22: 17–26.

Kelly, Daniel. 2011. *Yuck!: The Nature and Moral Significance of Disgust*. Cambridge, MA: Massachusetts Institute of Technology.

Kim, David Haekwon. 2001. *Mortal Feelings: A Theory of Revulsion and the Intimacy of Agency*. Ph.D. dissertation. Syracuse University.

Kolnai, Aurel. 2003. *On Disgust*. Peru, IL: Open Court.

Korsmeyer, Carolyn, and Barry Smith. 2004. "Visceral Values: Aurel Kolnai on Disgust". In Aurel Kolnai, *On Disgust*, edited by Carolyn Korsmeter and Barry Smith, 1–25. Peru, IL: Open Court.

Kristeva, Julia. 1982. *Powers of Horror: An Essay on Abjection*, translated by Leon S. Roudiez. New York: Columbia University Press.

Lacan, Jacques. 2004. *The Four Fundamental Concepts of Psycho-Analysis*, translated by Alan Sheridan. London and New York: Norton.

Laugier, Pascal, quoted in Rob Carnevale. Undated. "Martyrs – Pascal Laugier Interview". *IndieLondon.com*. http://www.indielondon.co.uk/Film-Review/martyrs-pascal-laugier-interview. Accessed 1 December 2014.

Lemma, Alessandra. 2014. *Minding the Body: The Body in Psychoanalysis and Beyond*. London and New York: Routledge.

Lenne, Gérard. 1979. "Monster and Victim: Women in the Horror Film". In *Sexual Stratagems: The World of Women in the Horror Film*, edited by Patricia Erens, 31–40. New York: Horizon.

Magistrale, Tony. 2005. *Abject Terrors: Surveying the Modern and Postmodern Film*. New York: Peter Lang.

Mathijs, Ernest. 2013. *John Fawcett's* Ginger Snaps. Toronto: University of Toronto Press.

McCann, Ben. 2013. "Horror". In *Directory of World Cinema: France*, edited by Tim Palmer and Charlie Michael, 276–309. Bristol and Chicago: Intellect.

McGinn, Colin. 2011. *The Meaning of Disgust*. Oxford: Oxford University Press.

McPhee, Ruth. 2014. *Female Masochism in Film: Sexuality, Ethics and Aesthetics*. Farnham, UK: Ashgate.

Menninghaus, Winfried. 2003. *Disgust: Theory and History of a Strong Sensation*. Albany, NY: State University of New York Press.

Miller, William Ian. 1997. *The Anatomy of Disgust*. London and Cambridge, MA: Harvard University Press.

Mulvey, Laura. 1975. "Visual Pleasure and Narrative Cinema". *Screen*, 16.3: 6–18.

Neale, Stephen. 1980. *Genre*. London: British Film Institute.

Nussbaum, Martha C. 2004. *Hiding from Humanity: Disgust, Shame, and the Law*. Oxford and Princeton, NJ: Princeton University Press.

Palmer, Tim. 2011. *Brutal Intimacy: Analyzing Contemporary French Cinema*. Middletown, CT: Wesleyan University Press.

Parkinson, Michael. 2009. "Parky at the Movies: In Cinemas 26/03/2009". *The Oxford Times*, 26 March, not paginated.

———. 2011. "More Moralism from That 'Wordy Fuck'". In *The New Extremism in Cinema: From France to Europe*, edited by Tanya Horeck and Tina Kendall, 209–13. Edinburgh: Edinburgh University Press.

Pinedo, Isabel Cristina. 1997. *Recreational Terror: Women and the Pleasures of Horror Film Viewing*. New York: State University of New York Press.

Piotrowska, Agnieszka. 2015. *Embodied Encounters: New Approaches to Psychoanalysis and Cinema*. London and New York: Routledge.

Quandt, James. 2004. "Flesh and Blood: Sex and Violence in Recent French Cinema". *Artforum* 42.6: 126–32.

Rothenburger, Sunnie. 2010. "'Welcome to Civilization': Colonialism, the Gothic, and Canada's Self-Protective Irony in the *Ginger Snaps* Werewolf Trilogy". *Journal of Canadian Studies* 44.3: 96–117.

Rozin, Paul, and April E. Fallon. 1987. "A Perspective on Disgust". *Psychological Review* 92.1: 23–41.

Rozin, Paul, Jonathan Haidt and Clark R. McCauley. 2008. "Disgust". In *Handbook of Emotions*, edited by Michael Lewis, Jeannette M. Haviland-Jones and Lisa Fieldman Barrett, 757–76. New York: Guildford Press.

Russell, Jamie. 2011. "The Gore the Merrier: Slapstick, 'Splatstick' and Body Horror". In *Flesh and Blood*, vol. 2, edited by Harvey Fenton, 80–8. Godalming, UK: FAB Press.

Schnall, Simone, Jonathan Haidt, Gerald L. Clore and Alexander Jordan. 2008. "Disgust as Embodied Moral Judgement". *Personality and Social Psychology Bulletin* 34.8: 1096–109.

Short, Sue. 2006. *Misfit Sisters: Screen Horror as Female Rites of Passage*. Basingstoke, UK, and New York: Palgrave Macmillan.

Twitchell, James B. 1985. *Dreadful Pleasures: An Anatomy of Modern Horror*. Oxford and New York: Oxford University Press.

Tyler, Imogen. 2013. *Revolting Subjects: Social Abjection and Resistance in Neoliberal Britain*. London and New York: Zed Books.

Williams, Linda. 1984. "When the Woman Looks". In *Re-Vision: Essays in Feminist Film Criticism*, edited by Mary Ann Doane, Patricia Mellencamp and Linda Williams, 83–99. Frederick, MD: University Publications of America.

Williams, Linda Ruth. 2001. "Blood Sisters". *Sight and Sound* 11.6: 36–7.

Wood, Robin. 1984. "An Introduction to the American Horror Film". In *Planks of Reason: Essays on the Horror Film*, edited by Barry Keath Grant and Christopher Sharrett, 107–41. London and Metuchen, NJ: Scarecrow Press.

———. 1986. *Hollywood from Vietnam to Reagan*. New York: Columbia University Press.

Filmography

Alien. 1979. UK and USA. Directed by Ridley Scott. Brandywine Productions.

American Werewolf in London, An. 1981. UK and USA. Directed by John Landis. PolyGram Filmed Entertainment and the Guber-Peters Company.

August Underground's Mordum. 2003. USA. Directed by Fred Vogel, Kiljoy, Cristie Whiles, Jerami Cruise and Michael Todd Schneider. Toetag Pictures.

Baby Blood. 1990. France. Directed by Alain Robak. Partner's Productions.

Blessed. 2004. UK and Romania. Directed by Simon Fellows. Syndicate Films, Andrew Stevens Entertainment and K/W Productions.

Breaking Dawn – Part II. 2011. USA. Directed by Bill Condon. Sunswept Entertainment and Temple Hill Entertainment.

Brood, The. 1979. Canada. Directed by David Cronenberg. Canadian Film Development Corporation.

Bunny Game, The. 2011. USA. Directed by Adam Rehmeier. Death Mountain Productions.

Cabin Fever. 2002. USA. Directed by Eli Roth. Black Sky Entertainment.

Carrie. 1976. USA. Directed by Brian De Palma. United Artists.

———. 2013. USA. Directed by Kimberly Peirce. Misher Films.

Company of Wolves, The. 1984. UK. Directed by Neil Jordan. Palace Productions.

Devil's Due. 2014. USA. Directed by Matt Bettinelli-Olpin and Tyler Gillett. Davis Entertainment.

Dread. 2009. UK. Directed by Anthony DiBlasi. Midnight Picture Show and Matador Pictures.

Excision. 2012. USA. Directed by Richard Bates, Jr. BXR Productions.

Exorcist, The. 1973. USA. Directed by William Friedkin. Hoya Productions.

Final, The. 2010. USA. Directed by Joey Stewart. Agora Entertainment.

Fly, The. 1986. USA. Directed by David Cronenberg. Brooksfilms and SLM Production Group.

Ginger Snaps. 2000. Canada. Directed by John Fawcett. Copperheart Entertainment, Water Pictures and Motion International.

Hard Candy. 2005. Directed by David Slade. Vulcan Productions.

Hunger, The. 1983. UK. Directed by Tony Scott. Metro-Goldwyn-Mayer and Peerford Ltd.

Inside / À l'intérieur. 2007. France. Directed by Julien Maury and Alexandre Bustillo. BR Films and La Fabrique de Films.

Interview with the Vampire: The Vampire Chronicles. 1994. USA. Directed by Neil Jordan. Geffen Pictures.

Invasion of the Body Snatchers. 1978. USA. Directed by Philip Kaufman. Allied Artists Pictures.

I Was a Teenage Werewolf. 1957. USA. Directed by Gene Fowler, Jr. Sunset Productions (III).

Jaws. 1975. USA. Directed by Steven Spielberg. Zanuck/Brown Productions and Universal Pictures.

Jeepers Creepers. 2001. USA. Directed by Victor Salva. Myriad Pictures, American Zoetrope and Capitol Films.

Jennifer's Body. 2009. USA. Directed by Karyn Kusama. Fox Atomic.

Loved Ones, The. 2009. Australia. Directed by Sean Byrne. Ambience Entertainment and Insurge Pictures.

Martyrs. 2008. France. Directed by Pascal Laugier. Eskwad, Wild Bunch and TCB Film.

May. 2002. USA. Directed by Lucky McKee. 2 Loop Films.

Paranormal Activity. 2007. USA. Directed by Oren Peli. Blumhouse Productions and Solana Films.

Passion of Joan of Arc, The / La Passion de Jeanne d'Arc. 1928. France. Directed by Carl Theodor Dreyer. Société générale des films.

Poltergeist. 1982. USA. Directed by Tobe Hooper. SLM Production Group.

Pro-Life. 2006. USA. Directed by John Carpenter. Starz Productions, Nice Guy Productions and Industry Entertainment. TV.

Prometheus. 2012. UK and USA. Directed by Ridley Scott. Scott Free Productions, Brandywine Productions and Dune Entertainment.

Psycho. 1960. USA. Directed by Alfred Hitchcock. Shamley Production.

Rosemary's Baby. 1968. USA. Directed by Roman Polanski. William Castle Productions.

Saw. 2004. USA. Directed by James Wan. Evolution Entertainment and Twisted Pictures.

Saw III. 2006. Canada and USA. Directed by Darren Lynn Bousman. Twisted Pictures.

Scanners. 1981. Canada. Directed by David Cronenberg. Canadian Film Development Corporation, Filmplan and Victor Solnicki Productions.

Scar. 2007. USA. Directed by Jed Weintrob. Norman Twain Productions.

Se7en. 1995. USA. Directed by David Fincher. Cecchi Gori Pictures, Juno Pix and New Line Cinema.

Sheitan. 2006. France. Directed by Kim Chapiron. 120 Films, La Chauve Souris and StudioCanal.

Slither. 2006. USA. Directed by James Gunn. Gold Circle Films and Strike Entertainment.

Species II. 1998. USA. Directed by Peter Medak. Metro-Goldwyn-Mayer and FGM Entertainment.

Stoker. 2013. UK and USA. Directed by Park Chan-wook. Scott Free Productions and Indian Paintbrush.

Stranded. 2013. Canada and UK. Directed by Roger Christian. Gloucester Place Films, International Pictures, Three, Minds Eye Entertainment and Moving Pictures Media.

Switchblade Romance / Haute tension. 2003. France. Directed by Alexandre Aja. EuropaCorp and Alexandre Films.

Teeth. 2007. USA. Directed by Mitchell Lichtenstein. Pierpoline Films.

Texas Chain Saw Massacre, The. 1974. USA. Directed by Tobe Hooper. Vortex.

Thing, The. 1982. USA. Directed by John Carpenter. David Foster Productions and Turman-Foster Productions.

Trouble Every Day. 2001. France. Directed by Claire Denis. Arte France Cinéma, Canal+, Centre national de la cinématographie, Dacia Films, Messaouda Films and Zweites Deutsches Fernsehen.

28 Days Later. 2002. UK. Directed by Danny Boyle. DNA Films and the British Film Council.

Twilight. 2008. USA. Directed by Catherine Hardwicke. Temple Hill Entertainment, Maverick Films, Imprint Entertainment and DMG Entertainment.

Warm Bodies. 2013. USA. Directed by Jonathan Levine. Mandeville Films.

Xtro. 1982. UK. Directed by Harry Bromley Davenport. New Line Cinema.

2　Emotion
Cognition, Threat and Self-Reflection

I have, thus far, considered images of abjection in ways that do not rely on psychoanalytic inscriptions of the subject and I have made a case for their understanding as representational triggers of fearful disgust. However, focusing on individual images is not enough to entertain how Horror involves cognitively complex emotions such as dread, which can be incited via actions and situations that demand a specific viewing involvement or via specific scenes that make use of cinematic elements that are not strictly image-driven. Think, for example, of the use of editing, rhythm and music in the seminal shower murder in Alfred Hitchcock's *Psycho* (1960). Although I open with a more general survey of the ways in which Horror makes us feel – the emotions that surround the moment of mutilation – the body in distress within the specific context of Horror will concern me later in this book. The current chapter, then, seeks to extend my previous contentions on the role of images of abjection and the import of threat and corporeal attack by also analysing the implications of a genre that often seeks to involve the viewers in morally and ethically complex ways. In a sense, the affect that images of violence may have on viewers can be undermined, overwritten or emphasised by moral implications connected to viewer interpellation. Horror, as a genre that has often been criticised for its titillating exploitation of violence, can play with viewer emotion in order to excite concurrent feelings of shame and guilt and, thus, increase the impact of a given action, situation or image.

Before exploring the ways in which instances of cinematic mutilation may complicate matters by manipulating the viewer into specific viewing alignments or by eliciting participatory guilt, it is important to understand both how Horror has been seen to connect to emotions and how more recent approaches to its study may have advanced our thinking regarding the role of emotions in the process of Horror viewing. Whilst cognitive approaches to Horror have not been strictly corporeal in essence, the work of Noël Carroll does rely on a sense of threat that I see as vital to Horror and offers an initial account of our fictional encounter with it that has been vital to the field. Focusing on the potential limitations of this model, theoretical shortcomings that derive from understanding Horror as a genre defined by the presence of a monster, allows me to make a case

for the need to consider the role of corporeal threat in the emotional states it seeks to elicit.

Some Cognitivist Approaches to Horror: Acknowledging Emotions

Some critics have seen an early precedent of cognitivist film theory in Hugo Münsterberg's *The Photoplay: A Psychological Study* (1916), yet cognitivism more widely developed through the work of David Bordwell in the 1980s and that of Noël Carroll, Murray Smith, Ed Tan, Joseph D. Anderson and Torben Grodal in the 1990s.[1] Perhaps better understood, as Gregory Currie suggests, as a "program rather than a specific theory", due to the variety of models and theories that their main exponents use (as well as the lack of one fixed doctrine), cognitivism is interested in how our perception of film is coloured by the "perceptual resources [...] we deploy in the project of making sense of the real world" (Currie 1999a, 106).[2] Our responses to film, then, are "rationally motivated and informed attempt[s] to make sense of the work" at various levels: "sensory stimulus in light and sound, narrative, and object charged with higher-order meanings and expression" (106). As I say, no one doctrine predominates, but there is a clear methodology that relies on cognitive science, mainly, "theories of perception, information-processing, hypothesis-building, and interpretation" and on a "science-oriented" philosophy interested in rational argument (106). Cognitivism is both interested in the perception of film, the ways cinema, and narrative in particular, creates meaning, and the processes whereby emotions are generated. Although cognitivism is a bit of an umbrella term that can refer to psychological processes of both a "nonconscious (that is, automatic) and a conscious nature" (Barratt 2008, 531), I am specifically evoking here the conscious and complex ones. Somatics, which will be discussed in Chapter 3, can thus be seen as partly cognitive, but the fact that some reactions are not cognitively processed sets them apart from others that require rational evaluation or complex thinking.[3]

Cognitivism was fundamental to the development of approaches to cinema that, like phenomenology, rejected "Grand Theory" and deep psychology models of viewership that did not take into account the narrative impact of film or the ways in which film audiences may be seen as active participants in the cinematic encounter.[4] In a sense, cognitivism made possible a focus on the ways individuals actually experience cinema and paved the way, in part, for future audience research and the development of Reception Studies. Aside from recognising the positive value of emotions and of cognitive processes in writing about cinema, cognitivism has also been particularly interested in genres and in movement, and has yielded scholarship on documentaries, women's film and the avant-garde, among others.[5] The genre to receive the greatest attention by far, however, is Horror, which has been the subject of at least two significant monographs, by Carroll (1990) and by

Freeland (2000), and the subject of a number of scholarly articles and book chapters, the most notable of which will be covered below. It is important to notice that neither Carroll nor Freeland's work has relied on the type of empathic scenarios that will be studied in Chapter 3 and that the type of relations established with Horror in their work are premised on other emotive processes – hence, their being analysed under the label "cognitivism". These studies do not focus on the body, or indeed, on Horror that contains graphic scenes, but they begin to make a case for the need to consider the emotive impact of Horror on the body of the viewer. Instead of beginning with Carroll, the most influential of these critics, I consider his art-horror theory last because it grants more space.

Cognitive approaches to Horror have, in part, been interested in defining Horror and its appeals (or potential pleasures).[6] Cognitivism begins to position the viewing body at the centre of Horror, even if some of its conclusions depend on generalisations about audiences and their viewing pleasures that have been proven to be dubious. For example, Torben Grodal itemises the various possible reactions of viewers ("shiver[ing], trembl[ing], mak[ing] vaso-motor contractions") and argues that horror proposes "a compromise between an active and a passive position" and that it "represents a 'negative' way of activating the viewer's awareness of his [*sic*] body" (1997, 172). His proposition is interesting because it allows viewers an active position, one where they may "model [...] the reactions of fear and possible defence" and where the "fictional structure" facilitates the "creation of strong psychosomatic reactions" (172). However, Grodal's model is based on the assumption that Horror has to necessarily be hedonistically re-evaluated, namely, that a "positive evaluation" (172) is ultimately sought for. Horror cannot be premised purely on negative emotions but must, eventually, be transformed into a positive feeling. Its viewers are also naturally young and, for this reason, Grodal argues, Horror allows them to contemplate "the problems of corporeal delimitation *vis-à-vis* the Other (that is, the other sex) in puberty" (173).[7] Similarly, although Grodal sees in Horror "a desire for cognitive and physical control" (246–52), his conclusions regarding cognitive dissonance and the application of top-down hypotheses and choice of schemata seem alien to the much more obvious experience of physical threat.[8]

More nuanced is the work of Freeland, who, in her study of Horror's construction of evil (and its import for feminism), also seeks to investigate how Horror is "structured so as to stimulate both our emotional and our intellectual responses" and is "designed to prompt *emotions* of fear, sympathy, revulsion, dread, anxiety, or disgust" (2000, 3). Like Grodal, Freeland's viewers are actively engaged: they think, reflect and make judgements and evaluations as they "follow features in the film that guide [...] emotional response[s]" (2000, 3). Comparing the work of horror to Greek tragedy, Freeland focuses on its main paradox, that is, its capacity to be pleasurable whilst either incorporating predominantly negative feelings or images that evoke pain (5). Although she writes about a plethora of films and considers

anything from vampire films to the Horror of David Cronenberg and the slasher film, it is perhaps her chapter on "Graphic Horror" that best articulates her thoughts on how this might take place. Graphic Horror, as a label, is here used to refer to modern cinema (1970s onwards), which she sees as, if not anti-intellectual, "mainly physical and psychological" and dependent on "remarkable spectacles of horrific force and power" (Freeland 2000, 242).[9] Some of the films that Freeland discusses under this category have been, more or less successfully, subsequently studied as slasher films.[10]

To begin with, Freeland makes a distinction between treatments of the body in Horror that is also relevant to my own here. Horror often exploits the body to extremes that, because of their histrionics, may bring it into contact with comedy and "gross out" Horror or "splatstick".[11] The reactions and responses that these uses of the body may arouse in viewers vary radically from those where the body is meant to have a negative affect more obviously connected to fear. In order to illustrate this difference, Freeland turns to the *Hellraiser* films (1987–2011). As she explains, the violent "numbers" in the first instalment (Clive Barker, 1987), most notably the regeneration of Frank (Sean Chapman/Oliver Smith) from drops of blood in the attic, can have an important affective impact, yet serve crucial narrative purposes.[12] Others, such as the one-minute flashback sequence where Frank explains to Julia (Clare Higgins) how he first came into contact with the cenobites, can have an emotionally enhancing effect by teasing viewers, creating a sense of dread and even hinting at possible future displays of carnality (Freeland 2000, 258). By contrast, a film like *Hellbound: Hellraiser II* (Tony Randel, 1988), as a sequel, plays with expectations, subordinate narratives and spectacle. Its numbers, the transformation of Dr. Channard (Kenneth Cranham) or Julia's bloody return from the mattress where she died, can, Freeland argues, take over and "*become* the narrative" (262), an end in themselves as visual displays. This is possible because, when viewing sequels, viewers can "switch from involvement in a film's plot to a meta-level sort of aesthetic appreciation based on special knowledge and interests" (262). Thus, the visceral spectacles of *Hellraiser II* allow fans to discuss and study the films and their cinematic qualities, especially the use of special effects and the extremity of the violence (as the films try to outdo themselves in that department). Their potential intertextuality or cross-referencing, as well as their employment of wit and parody, can also be a source of delight and excitement (263).

Similar cases could be made for more recent films, especially the *Saw* series (2004–10). The first instalment, *Saw* (James Wan, 2004), is rather viscerally mooted and presents itself as more of a suspense-driven narrative with shades of the police procedural, aspects that got it compared to dark thrillers and dystopian films such as *Se7en* (David Fincher, 1995) or *Cube* (Vincenzo Natali, 1997). The stories of *Saw II* (Darren Lynn Bousman, 2005) and, especially, *Saw III* (Darren Lynn Bousman, 2006), by contrast, meander through mini-tests that involve groups of people and act as tangential or

appositional narratives which eventually come into contact with the main plot, Jigsaw's life: his illness, oeuvre and death. Because of this, subsequent films in the series become more concerned with the tests and the traps themselves, and their gruesome effects on victims, than on Jigsaw himself.[13] They also, most importantly, push the graphic envelope by having very explicit sequences that do not imply or suggest but, instead, show graphic deaths.[14] This different approach to Horror is best epitomised in the difference between the climax of *Saw*, where Dr. Gordon (Cary Elwes) severs his own foot, and the cranial surgery scene in *Saw III*. In the former, the moment is not shown by the camera directly. Instead, the scene portrays Dr. Gordon's reaction and connotes pain via focus on facial expression, acting, sound effects and score. This is the case despite the fact that the severing of the foot is the most anticipated scene in the film: it, or a similar escape route, becomes necessary for the narrative and for the achievement of a happy ending. In *Saw III*, the removal of a piece of Jigsaw's cranium is offered in painstaking detail in a prolonged scene whose main purposes are to create tension and fearful disgust and not necessarily to advance the narrative.[15] Similarly, the tests in these sequels are not provided after the fact (as a number of them are in *Saw*, although they do indulge in brief, syncopated and suggestive flashbacks) but are experienced in the film's intradiegetic time. They emphasise tension, dread and disgust, and they also mobilise the Hobson's choice ethos of the series, as well as trigger concomitant "what would I do if I were in that position? What could I have done to avoid that ending?" cognitive scenarios.

Figure 2.1 The visceral number is crucial to *Saw III* (2006) and its various trap scenarios.

The application of Freeland's approach tells us more about the nature of graphic Horror – what constitutes it and the role that numbers play within

it – than the actual cognitive workings of the pleasure derived from them. Her attempt to dissect the nature of this apparently dichotomous situation, in fact, collapses what I think are intrinsically divergent processes: affection (the act of being affected by something) and appreciation (the cognitive process that helps us understand its role and value). Freeland proposes that Horror that is "dominated by graphic spectacle" (2000, 256) is bound up in a paradoxical situation – what Carroll names the "paradox of the heart" (Carroll,1990) – whereby what would "ordinarily feel painful and disgusting" (Freeland 2000, 256) can become pleasurable. This is the case because, on the one hand, "the graphic spectacles contribute to the plot and to the cognitive-emotional content of horror films" (256). On the other hand, viewers may take delight in "cinematic creativity"; these are "aesthetic pleasures that have to do with the audience's knowledge and appreciation of the genre" (257).

Two critiques of this contention need to be levelled at this stage: firstly, graphic spectacles need not contribute to the plot, but this does not mean that they can only be rescued by fans or through an awareness of the genre or of the series being watched. The numbers in the *Saw* films are largely perfunctory to the wider narrative (it matters little that what kills police informant Michael (Noam Jenkins) is a Venus fly trap contraption in *Saw II*), and yet, they can arouse strong feelings of dread and need not be self-referential or require any kind of previous knowledge (the expository Jigsaw video takes care of this). In fact, due to the episodic nature of the trap scenes, they can potentially be consumed or experienced in isolation and still produce strong affects and emotions via somatic empathy and a limited degree of sympathy. Secondly, the direct processes of affection that are connected to, for example, "dread, fear [or] empathy" (Freeland 2000, 257) are of a different order from the aesthetically, and therefore experientially detached, appreciation of gore or of violent titillation.[16] Whilst both are not mutually exclusive, it is difficult to feel them simultaneously and, I would argue, one necessarily precedes the other and will probably be informed by its effectiveness.[17] In other words, the depth of cognitive involvement is greater and more removed from the affective purpose of the film when we are admiring it aesthetically than when we are fully immersed in its affective work. For this reason, but mostly because I am concerned with the negative affects that generate a sense of threat, I do not consider the contemplative and appreciative aspects of Horror's spectacles in any more detail.[18]

So far, I have provided a short survey of two influential cognitive approaches that have gone some way towards situating the relationship between Horror, the body and emotion. The most influential of cognitivist studies of Horror, however, is undoubtedly Noël's Carroll development of the notion of "art-horror" in his landmark study *The Philosophy of Horror: Or, Paradoxes of the Heart* (1990). By turning to it in the next section of this chapter I seek to begin answering the questions "how does horror work on the mind (and thus body)?" and "how does its use and abuse of

corporeality enter the viewing equation?" Before I can propose a cognitive approach to the apprehending of pain on screen that involves the emotion of threat, it is necessary to begin by laying down the principles that make the affective exchange different from a similar one in real life. Although Carroll's theory of art-horror has some limitations, which will be duly noted, it has represented, and continues to represent, a theoretically-sophisticated and useful springboard into the symbiotic areas between Horror aesthetics and corporeality.

Art-Horror and Carroll's Thought Theory of Emotions

Carroll's book was the first sustained attempt, through analytic philosophy, to put together a working and comprehensive emotional theory of Horror, that is to say, one that "presume[d] that the genre is designed to produce an emotional effect" and purported "to isolate that effect" and "show how the characteristic structures, imagery, and figures in the genre are arranged to cause the emotion [...] *art-horror*" (1990, 8). This is significant because, unlike the work that had come before it and which had given privilege to deep structure psychology, psychoanalysis and cultural context, Carroll's account focused exclusively on Horror's "intended capacity to raise a certain *affect*" (1990, 14).[19] Like mystery and suspense, and unlike Westerns, Horror takes its name from the predominant emotion, or emotional state, it seeks to engender in viewers. Although Horror as an affect is a rather imprecise construction and, as this book proves, it does not work at an exclusively emotional level but also at a somatic and representational one, Carroll's repositioning of Horror within an experiential realm that, additionally, is concerned with the general usage of the word in ordinary parlance is crucial for what it allows him to deduce.[20]

"Art-horror" is "cross-art" and "cross-media" (Carroll associates it with literature, film, drama, ballet, television, radio and fine art) and it is different from real-life or "*natural*' horror" (1990, 12). Art-horror works by analogy with the intradiegetic characters and, most importantly, their emotional states, which will be affected by the monsters in the film. The state of "abnormal, physically felt agitation" that is generated as a consequence is a result of the "thought" of the object of "art-horror" – its possible being or existence – and the related "evaluative thoughts" (28) of its potential threat at physical, moral and social levels. Carroll relies on what has been called the "object-directed theory of emotions" (challenged, in later years, by "the feeling theory of emotions") to propose that emotions should be identified with feelings and that they do not rely on a "formal object of emotion" (28).[21] This object can be a thought: the thought of the object and of the effects it could have on us.

Relevant to Carroll's theorisation of art-horror, and perhaps the most controversial and problematic of his propositions, is that the formal object of emotion of art-horror are monsters: non-human "being[s] not believed

to exist now according to contemporary science" (27), namely, disturbing or insterstitial, and that, unlike the creatures in fairy tales, are perceived as "disturbances of the natural order" (16).[22] These monsters are at the heart of the affective experience, because their "breach [of] the norms of ontological propriety" (16) generates Horror in the intradiegetic characters and, vicariously, in viewers. Most importantly, monsters must be both threatening and "impure", as the exclusion of either would not generate art-horror, and usually cause a need for distanciation.[23] Using the example of the Count in Bram Stoker's *Dracula* (1897), some of the ensuing reactions to this character may include recoiling, nausea, screaming, running away or avoiding contact. The behaviour of the characters, then, provides emotional blueprints for the audience who, as in *The Fly* (Kurt Neumann, 1958), will feel horrified by the reveal of the human-fly hybrid (David Hedison) partly because they follow, or parallel, the emotional cues (responses) provided by a screaming Helene (Patricia Owens). Because monsters in Horror are dangerous, they are frightening. Important to this notion of the monster is its capacity to signify uncleanliness and impurity, which Carroll sees as basic to disgust and, alongside fear and other emotional reactions, composes the "occurrent emotional state" (24) of art-horror.[24]

When making a case for the role of monsters, Carroll points out the importance of their "inconceivable", "unclean and disgusting" (21) elements, harking back to Mary Shelley's *Frankenstein* (1818) and focusing on the work of Lovecraft or Clive Barker. His conclusions here are that these examples

> indicate that the character's affective reaction to the monstrous in horror stories is not merely a matter of fear, i.e. of being frightened by something that threatens danger. Rather, threat is compounded with revulsion, nausea, and disgust. And this corresponds as well with the tendency in horror novels and stories to describe monsters in terms of and to associate them with filth, decay, deterioration, slime and so on. The monster in horror fiction, that is, is not only lethal but – and this is of utmost significance – also disgusting.
>
> (Carroll 1990, 22)

I have shown, however, that disgust is not crucial to Horror. In fact, the fact that a monster is disgusting can have more than one effect: it can be the source of laughter, depending on treatment (the monsters in the horror-comedy *Basket Case 2* (Frank Henenlotter, 1990)), or it can enhance the sense of threat by, for example, evoking fears related to contagion and infection (the rabid humans/zombies of *28 Days Later* (Danny Boyle, 2002)). Neither is disgust exclusive to the monster, especially if we take the word's more complex meaning in the context of a moral situation or of one's involvement with it. Carroll's understanding of disgust does not allow, either, for the fearful disgust that preoccupied me in Chapter 1, where the sense of threat

is corporeally intelligible. Similarly, his suggestion that a monster needs to be impure or else it would only produce the emotion of "fear" (28) makes little sense: not only is the concept of impurity vague (is this physical or moral impurity, or both? And if the latter, then, surely there must be gradations to that perception?), some monsters can appear to be pure or even generate some sympathy (Hayley (Ellen Page) in *Hard Candy* (David Slade, 2005)). The startle effect, which is still one of the most important scaring techniques in Horror, renders the physical or moral impurity of the monster irrelevant in affective terms. In some cases, as the iconic scene in *Paranormal Activity* (Oren Peli, 2007) shows, Horror need not be premised on a monster but might be, merely, and instance of shock.[25]

Although Carroll's understanding of Horror is wide enough to encompass a strand of Gothic novels, forms of Horror that do not include a monster or, indeed, a non-human monster such as the serial killer are also excluded from his definition.[26] Most contentiously, this leads him to argue that the work of a writer like Edgar Allan Poe is best understood as terror because it plays with "abnormal psychologies" (15). Apart from the fact that such an approach is contradictory – since Carroll's definition relies on affects and not on the origin of that affect – it fails to account for films such as *Saw*, where the moment of horror is not instigated by a human monster but, rather, by the punitive machinery that Jigsaw sets up and which operates almost independently from him. Carroll's model is also limiting because it does not allow for a truly progressive understanding of Horror whereby the source of the affect can be seen to change historically and culturally according to specific developments in literature and film.[27] Why, specifically, it is useful to separate Poe's form of Horror from the work of Ann Radcliffe, Charles Brockden Brown or Washington Irving is not immediately clear and, at an affective level, poses more questions than it answers. The workings of terror are, in essence, the same as those understood as art-horror. Terror, especially in the first wave Gothic novel (1764–1820), may well explain its horrors away, but this does not mean that the affect writers sought to conjure up was qualitatively different from those in, say, the work of Matthew Lewis of Charles Robert Maturin.[28] If anywhere, the difference between terror and horror resides in the resolution: whilst terror ultimately takes the edge off the moment of horror, Horror intensifies it.[29] This, to me, is a narrative and structural difference that does not feel significant enough to either deny the inclusion of psychological terror in Horror or to argue for a generic difference between the two.

Bar the need for monsters, the most significant of Carroll's propositions is his acceptance that the moment of horror is both "physical" and "cognitive" (1990, 24), a similar distinction to the one I have been establishing between somatics and emotion. Whereas the physical dimension of an emotion "is a matter of felt agitation", a "sensation or a feeling" and a "sense of physiological moving"; it "involves some kind of stirring, perturbation, or arrest physiologically registered by an increase in heartbeat, respiration, or the

like" (24). As he remarks, to be in an emotional state is to be moved, to be taken out of what we could call the "normal" state of emotive affairs and to move into an "agitated" one (24). The sensations that recur in art-horror, then, include: "muscular contractions, tension, cringing, shrinking, shuddering, recoiling, tingling, frozenness, momentary arrests, chilling [hence 'spine-chilling'], paralysis, trembling, nausea, a reflex of apprehension physically heightened alertness (a danger response), perhaps involuntary screaming" (24). The other side of the emotion, the cognitive one, is determined by "beliefs and thoughts about the properties of objects and situations" that are not purely factual but also "evaluative" (26). He calls this view the "cognitive/evaluative theory" of Horror. According to it, "an occurrent emotional state is one in which some physically abnormal state of felt agitation has been caused by the subject's cognitive construal and evaluation of his/her situation" (27).

The problem with this account is that, whilst some emotions (if not all) are coloured by affects and physical reactions, emotions are not crucial, to my mind, to the generation of certain physical reactions that are reflex-based.[30] Carroll's account seems to collapse the two in a way that, whilst useful, confuses two effectively different processes: the somatic and the emotional. In my understanding of affect, a "feeling" is also too complex to fall neatly into the category of somatic affects. In other words, Carroll's distinction between the two sides of the emotion works best as that, an explanation of the two sides of the horror emotion: the physical one, which is connected to somatics and informs feeling, and the cognitive process, which involves emotive states and reflection. It, however, on its own, cannot account for the entirety of the Horror experience, which is also, as I have argued, not strictly cognitive or emotional. In his discussion, he speaks of a possible thought experiment in which the "physical agitation" (Carroll 1990, 27) that one would feel upon seeing a truck headed in one's direction (and being nearly run over by it) could be artificially stimulated by it. Carroll's point, that he would not wish to say that, under these circumstances, he was "afraid" (27), does not prove anything other than emotions have a physical basis.[31] We could, however, argue that, in this situation, he is being put through physical reactions that, taken together, or separately, are constitutive of the emotion of art-horror. Whilst it is important to acknowledge that emotions are corporeal in essence, it is also useful to distinguish between an emotional state that is cognitive and a somatic one which is instinctive or reflexive, as they are both part of Horror. To feel horrified is by no means a uniform experience, but it can be profitably aligned with a series of feelings and reactions that are characteristic of it.

How, then, does Carroll's cognitivist approach allow for the functioning of art-horror? Carroll starts with the basic questions that all fiction poses: how is it possible to feel for characters who viewers know do not exist in real life? For art-horror, this translates into the need to account for how the thought of the monster can be both dismissed and entertained

at the same time: the viewer needs to be able to suspend disbelief in their knowledge that the monster does not exist whilst, at the same time, being cognitively moved by the situation and the potential threat it supposes. In order to solve this conundrum, Carroll goes through three possible theories of fiction: the illusion, the pretend and, his own, the thought theory of emotional responses. The first, which proposes that audiences are duped by the illusionistic powers of cinema to believe that they really are in the presence of certain monsters, is dismissed on the grounds that viewers would very likely leave the room if they thought they were *actually* in danger. The postulation of suspension of disbelief is also challenged because the cognitive process thereby entered does not appear to be one that can be willingly started or that can account for emotional investment. The second theory, initially laid down by Kendall Walton, develops the notion of "quasi-fear" (1978a; 1978b) as an emotion both psychological and physiological and which allows for a degree of pretending: a recognition of our engagement with fiction makes it possible for viewers to then engage in pretend fear. Carroll notes some obvious problems with pretend theory: it presupposes a conscious feeling of make-believe, it seems to deny genuine fear in art-horror and it does not answer for the vicarious feelings we experience for intradiegetic characters (being scared for somebody else's well-being) or the general fearsomeness of the monster. Carroll then argues that art-Horror "requires existence beliefs" (1990, 77) and draws on the work of Peter Lamarque to propose a thought theory of emotions.

Carroll's proposition is straightforward: we are not moved into art-horror by the belief that the monster (Horror object) exists but merely by the thought of it and, most importantly, its content. This move shifts the attention from the object itself to its onscreen representation, or the idea of it, and permits Carroll to recuperate genuine emotion because thoughts need not be believed in order for them to be entertained.[32] According to thought theory, the Elder God Cthulhu in *The Call of Cthulhu* (Andrew Leman, 2005) may art-horrify audiences if the thought content of it, the idea of a powerful, mind-boggling winged, tentacled, dragon-like monster who eats its followers and defies the laws of geometry and human logic, is found to be scary. Of course, it might be the case that only a few of these characters are found to be fearful and this would be enough. If, on the contrary, such a monster is too fantastic to arouse emotions of fear, the system is short-circuited. Similarly, if the treatment or the cinematography are found to be unrealistic or distracting, an equivalent effect may take place: the monster will be found defective. This might well be the case with *Cthulhu*: the film is shot in black and white and is a silent film. It, thus, intends to replicate the look of German expressionism, which was roughly contemporary with the writing and publication of Lovecraft's story in 1926 and 1928. This concession to style might well alienate some viewers or force them to experience the film differently: viewers may appreciate the attempt to create a film that looks like the type of adaptation that could have been made in Lovecraft's

time. They might also like to highlight the acting, the idea for the script or the execution, especially if these precluded art-horror from taking place ("it was not scary, but it was an interesting attempt to adapt Lovecraft"). Ultimately, Carroll would argue, the capacity for that film to horrify would rely on its monster. If the Cthulhu in this film is felt to look fake or simply not scary – and this has certainly been something that has been pointed out by my students during screenings – then the film will not succeed as Horror for those viewers. The thought theory of emotions, then, seems to account for art-horror's capacity to work (or not) depending on audience's perception of the monster.

But even for this more flexible theory, art-horror continues to be an object-directed emotion aimed at specific characters and not, as Carroll explains, to "the fiction as a whole" (1990, 84). This is problematic, as it is sometimes the thought(s) that derive from watching a film that stay(s) with us. In the examples of the *Saw* films, I remember being distinctly shaken by ideas such as "how horrible would it be to find myself in a similar situation?", a vicarious positional emotion. In the Introduction, I already mentioned my reaction to Eli Roth's *Hostel* (2005). Art-horror was not, in this case, premised on the monsters in the fiction, which are largely interchangeable, but on the thoughts of a lucrative punishment system and the possibility that other human beings who know nothing about me would be prepared to pay money to torture me to death for their sadistic pleasure. Both films were marketed as Horror, however un-graphic *Saw* may have been in comparison to its sequels, and sought to arouse precisely negative emotions. They were distinctly not somatic affects, although the latter, also present in my experience of the films, probably helped in preparing me for the deeper, reflective processes that I underwent afterwards. It would be difficult to locate a monster in either film, even by Carroll's killer-qua-monster standards, and they both were specifically corporeal experiences as opposed to uncanny moments of art-dread: my fearful thoughts and "what if" quandaries were, in both instances, premised on the vulnerability of my body and the thought, and effects, of the violence depicted. They also were not, at least on a conscious level, reactions strictly related to disgust. The thought processes here involved a situation where I could be harmed by the ideas of punishment in the film, where I could project myself onto the bodies of the victims and wonder about the intricacies of their torture and suffering.

As we can see, although Carroll's thought theory of emotions is relevant in helping us break away from suspensions of disbelief and pretend systems that do not encompass the real emotions inherent to art-horror, it does not successfully explain the emotions we feel in genre films where horror is not directly connected to a monster or its thought.[33] Missing from this is, I think, an acknowledgement of the corporality of the Horror experience which, as I have been arguing, has been implicit and yet largely absent from cognitivist approaches.

Finally, Carroll's thesis is also articulated by the paradox of the heart of its title: why would anyone be interested in what is, in essence, a potentially unpleasant experience? Carroll attempts to resolve this by giving his argument one last twist and suggesting that art-horror is not what determines the Horror experience. Instead, art-horror is "the price we are willing to pay" for the revelation of what is unknown, "of that which violates our conceptual schema" (1990, 186). Curiosity, fascination and an investment in the process of discovery and disclosure all lie at the heart of Horror and compensate for the unpleasant feeling of art-horror. Proof of this, he argues, can be found in the formulaic plots that generally gravitate around the appearance, confirmation and confrontation of characters with a monster. Naturally, as with the ideas exposed above, this theory does not account, for example, for the pleasure of experiencing fear for its own sake. Whilst I would never deny that curiosity is a key aspect of Horror, I would argue it needs to be recast as a morbid one: a curiosity that transcends a specific narrative (although it does not ignore it, as Horror often involves suspense) and relies on the experience of being horrified in a way that can be controlled. I also reject the fact that categorical indeterminacy is a basic aspect of the Horror experience; it is a premise that is only tenable if one follows an object-directed cognitive approach and reduces the monster to meanings that could be said to lie outside the direct experiential realm of the viewer. In short, when we are affected by a monster, it is not necessarily the thought of their interstitiality or of the taxonomic crisis they impose that scares us. At the risk of sounding excessively prosaic, I would propose that wherever monsters provoke fear – and I have made the point that I do not see them as crucial to Horror – they do so because we can think of them as a plausible danger within the fictional experience.

Carroll's account is partly concerned with establishing a clear division between what constitutes Horror and what does not. He therefore takes a lot of pains to distinguish it from suspense or art-dread in what are, in places, lengthy exercises in logical reasoning that end in the counterintuitive solutions and conjectures pointed out in this section. Since what exactly constitutes Horror as a genre (its various elements) is not something that preoccupies me here, and a fully fledged answer would require an entire study, I will not take issue with the question of its generic delimitation. The type of corporeal engagement that is at the heart of my study can appear in other films, thrillers or police procedurals, most obviously, but this does not change the essence of my larger contention: Horror is premised on the emotion of threat, an emotion that is often, but not exclusively, shared via imagination and somatic empathy with intradiegetic characters and, most importantly, their bodies. Films such as *Seven*, which use this type of emotion constantly, but not as graphically as, for example, the *Saw* films, can therefore be seen as either Horror or dark thrillers with horrific moments.[34]

Carroll's cognitive work has helped me begin answering the question of how it may be possible for human beings to be scared by Horror, especially

when they know that the events and figures in films cannot, by their nature as inventions, constitute a *real* threat. A revisited thought theory of emotions which acknowledges that emotions need not be object-directed (connected to a monster) but point towards the importance of the threatening content of a thought (the idea) is, therefore, important when assessing the degree to which Horror could be said to affect its audiences. The monster is not the marker of the emotion of horror, but, as I have shown, a mere catalyst that can be replaced by events, situations, objects and even the mutilation or dismemberment of the body in isolation. If we can explain the bodily reactions to startles as instinctive and borne of our motor-reflexes, it is harder to account for complex emotions that involve cognition. Whilst the former do not necessitate an emotional involvement with the text or its narrative, purely with the audio-visual nature of film, the latter are inherently psychological. As I move on to show below, corporeality, that of viewers and that of the film (especially the characters' own bodies but also the body of the film, that is, the many audio-visual aspects that come together to make a scene affective), is key to assessing corollary feelings that might colour our viewing experiences. Horror, therefore, appears as a dispositional and bodily state that we are constantly having to negotiate, can be altered and which one can attempt to short-circuit at any point. Developments in cognitivism and the workings of perception can help us unravel the workings of this cinematic experience.

Physical Threat As Horror's Defining Emotional State

At the end of his brilliant introduction to Horror, Mark Jancovich suggests that "[i]f there is any feature which all horror texts share, it is probably the position of the victim – the figure under threat" (1992, 118). His larger point is that Horror is concerned with oppressive forces that threaten the individual and with "the workings of power and repression in relationship to the body, the personality, or social life in general" (118). Although the connections between power structures and repression of trauma have consistently been shown to play a crucial role in the thematic shaping of Horror, I, however, want to expand on the notion that the victim under threat, a victim that most obviously encompasses the viewer, is its most significant core characteristic.[35] What this means, in essence, is that my approach to this genre is not aesthetic or tropic, but affective: I focus, like Carroll, on the feelings that Horror is supposed to arouse through close analysis of the film's narrative and use of special effects, sound and music.[36] Such an approach necessarily fails to encompass actual audience experiences, because this is not a sociological project, and does not account for fan practices and engagement or how repeat viewings of a film might change its original intention, or indeed, that of individual scenes.[37] All of these are interesting and relevant considerations, but they lie outside the remit of this study, which is theoretical and wishes to look at the way Horror ideally affects viewers. As

such, I rely both on filmic elements and advertising campaigns, as the latter are often concerned with selling the film as a limit experience.[38] Horror is designed and marketed to engender a series of specific feelings that are aroused by creating a sense of fictional threat which, despite its fictional quality, can feel partially real to viewers.

The theory of threat also disregards the fact that Horror entails identification with the source of threat, as such an empathic connection seriously endangers the emotional dynamics of the genre.[39] In fact, I would go as far as to argue that a semblance of identification with the source of threat is only possible where sadistic pleasure is gained from the exacting of revenge and, even then, we are likely to align ourselves experientially, and exponentially, with the victim as well. For example, it could be argued that, in the remake of *I Spit on Your Grave* (Steven R. Monroe, 2010), viewers are likely to sympathise with Jennifer (Sarah Butler), since she is raped and mistreated by the four men she later systematically hunts down and kills. The film takes great pains to present Jennifer as an interesting and good character, and we will therefore be sympathetic to her plight. However, the killings of the men, graphic and horrible as they are, would be experienced very differently if we simply identified with Jennifer. Instead, the film codes these scenes as moments of horror, regardless of the ethical or moral dilemmas that may be raised by them, and guilt and morbid curiosity are appealed to in order to enhance and amplify the experience. This fact does not change if we consider that, technically, the initial threat is constituted by the four men, and their killing is therefore a narrative resolution reinstituting the status quo. At the point at which Jennifer starts killing, regardless of the fact that we have been following her suffocation via focalisation, she becomes a threat, and because identification no longer relies on character-specific qualities, we are likely to empathise with the bodies of her victims too. This is to say that, even in instances like this one, where it could be proposed that alignment with the source of threat is palpable in the second half of the film, the body of the victim will remain an empathic source of feeling regardless of whether it is felt that the men deserve their comeuppance.[40] It is possible to still feel corporeally under threat and remain morally on the side of the source of threat, because the emotions we feel almost inevitably gravitate towards the body of the victim and because the film will give the images a specific, horrific treatment.[41]

Choices of title often belie Horror's interest in exploiting the links between characters, their ordeals and viewers. In fact, the titles of films such as *You're Next* (Adam Wingard, 2011) address the potential viewer directly. Others, such as *Choose* (Marcus Graves, 2011) or *Would You Rather?* (David Guy Levy, 2013) show their debt to the "what would you do?" scenarios popularised by the *Saw* series, putting the viewer, if only nominally, in the place of the victim(s). In these cases, the alignment between viewer and suffering body is established even before the action begins. Films such as *[•REC]* (Jaume Balagueró and Paco Plaza, 2007), which I will consider at length below, even go as far as to spell out their intent: one of their promotional

taglines in trailers was "experience fear", a message that intensifies the alignment between viewer and camera that the film constantly encourages. Finally, others, such as *It Follows* (David Robert Mitchell, 2014), have titles that generate curiosity and the potential thrill of fear: what follows? If "it" follows, if that is its function, surely "it" can follow me too? Titles are one way in which the emotional state of threat is privileged in Horror and viewers exhorted to feel.

Advertising and marketing campaigns are also revealing in what they suggest about the viewer/victim connection. I have already mentioned the "will you survive?" message in one of the official theatrical trailers for *Saw 3D*, which also showed cinemagoers being strapped to, and by, their seats and having flying saws fired at them. Other films, such as *Paranormal Activity*, opt for a completely immersive and extra-cinematic approach. Its official trailer begins by showing a number of people queuing up for a premiere whilst the following information is presented: "[I]n September 2009 a screening was held in Hollywood, California. This audience was among the first to experience *Paranormal Activity*. This is what they saw ..." The trailer shows the film from the point of view of someone at the back of the theatre so that the heads of the other cinemagoers are on display. The images of the film are then intercut with meta-cinematic night vision feed of the audience as they react to the action.[42] The trailer then focuses on images that transmit fear and helplessness and, in a nutshell, on the reactions we connect with Horror-watching: men and women holding each other protectively, screaming, hiding part of their faces under their shirts, opening their mouths in awe or surprise, holding their faces or jumping out of their seats. These images are also edited alongside reviews of the film that highlight how *Paranormal Activity* is "one of the scariest movies of all time" and "genuinely horrifying", and explain that "the entire auditorium was freaked out of their minds ... People were physically shaken". The message "[e]xperience it for yourself" is also flashed towards the end. This trailer literalises the work of countless other Horror trailers: it emphasises the importance of the experience (as opposed to having the film told to you or seeing other people's reactions), prepares the viewer for sensory assault and, most importantly, creates a sense of excitement about being scared.

As we can see, Horror is underlined by the emotional state of being under threat at a fictional remove. It is necessary, at this point, to propose how this threat manifests and, most importantly, how it might work at a cognitive level. The first thing to note is perhaps the most obvious one: although the threat in Horror is a fictional one and is sometimes mediated (via the intradiegetic character), it relies on human threat detection skills. This is crucial, since studies have shown that threat detection does not rely exclusively on cognitive processes but also on perceptual and emotional factors (LaBoe 2014, 702). The perceptual features of threat would be, for example, the shape of the threat (the shadow of a wolf heading towards the camera). The cognitive aspect of threat means that knowledge or expectations of

Figure 2.2 Paranormal Activity (2007) showcases the main emotional and affective reaction expected from Horror, the recognition of threat, in its trailer.

that threat influence the way we react to it and to the others which may be derived from it. In the case of torture, our knowledge of pain at a low threshold is transferable to images of mutilation that we have never experienced through our imagination by extrapolation. Finally, the emotional aspect of threat is the feeling derived from the detection of fear, its processing and our reaction. Threat as an emotion relies on threat cognates to which we react with specific emotions and, in some cases, concomitant physical reactions. Fear-inducing stimuli are also the ones that most consistently capture human attention and for which there is most rapid target detection, a fact that is probably connected to evolutionary developments.[43] In Horror, the most natural reaction to threat is that of fear as it is expressed in some of the actions showcased in the *Paranormal Activity* example. Some of the physical reactions, such as jumping out of one's seat, are more obviously a reflex motor reaction and are not necessarily cognitive but others, such as protecting one another or hiding behind one's own clothes (or, indeed, looking at one's partner in fear, which has not been mentioned), are more obviously socially constructed.[44]

It is useful to note that, although it is intrinsically related to it, the type of corporeal threat I have been exploring here is not necessarily synonymous with the one developed by terror management theories.[45] The latter have focused on how an individual's worldview beliefs and buffering of self-esteem are a basic method of psychological self-defence on the face of the awareness and fear of death (S. Solomon, Greenberg and Pyszczynski, 1991). This is what is known as the mortality salience hypothesis. The psychological conflict that arises from having a desire to live but realising that death is inevitable is uniquely human and resolved by the development of social and

individual coping mechanisms. More generally, human culture (especially religion and philosophy) can be seen as attempts to address the moral and ethical implications of this realisation. Death thought accessibility, that is, anxiety over the thought of death, is easily engendered when an individual's systems of belief or defences are threatened by others, a process that also leads to aversive emotions.[46] This explains why, for example, practising Christians may find possession films such as *The Devil Inside* (William Brent Bell, 2012) or *The Last Exorcism* (Daniel Stamm, 2010) more difficult to watch, more objectionable and more emotionally affective than those viewers who do not believe in evil, Hell or possessions. Similarly, people who believe in ghosts might be naturally more emotionally involved in films that feature them, like *The Woman in Black* (James Watkins, 2012). This does not mean that the startle effects would shock them more than other viewers, since these do not rely on moral or cultural convictions but on physiological reactions (the scene where the ghost reaches out towards the camera from a dark corridor). What it does mean is that those viewers who have a specific religious conviction or cultural belief might find themselves even more pre-disposed to be scared and offended by certain films. A film's propositions might provoke stronger reactions because they provide a form of threat that goes beyond the corporeal and which, if only in subliminal ways, may remind us of the awareness of mortality that we seek to repress. Of course, it is likely that individuals for whom that type of experience would feel grossly uncomfortable, or even unbearable, would choose not to be exposed to the film in the first place.

Death primes, reminders of mortality that are often reflective in nature, have been used to test the validity of the mortality salience hypothesis and have shown that death thought anxiety increases exponentially in cases where subjects are exposed to such primes even when they are fictional.[47] Although a number of these experiments have been reflective in nature, that is, subjects were exposed to these stimuli and then tested for direct responses, a similar notion may be applied to the experience of threat at the heart of Horror. Where Horror goes beyond the physiological reaction, the sense of threat can manifest in a sense of atmosphere and mood, a build-up or crescendo of suspense or the generation of vicarious feelings of, for example, entrapment, claustrophobia or helplessness, as happens in *Captivity* (Roland Joffé, 2007). These all work towards creating a sense of corporeal vulnerability that relies on our knowledge of the precarious line between life and death and the many forms in which threat could easily translate into death. In the case of the above-mentioned traps in the *Saw* films, our emotional state is altered, not just by editing and cinematographic choices (disorienting speed, dislocating intercutting, dark lighting and flashes of light, a faded and grotty colour palette that feels stagnant) but by the inferences that the average viewer can cognitively draw from the death (or, as I will propose in the next chapter, pain) primes and their effects. Death or corporeal anxiety may thus be aroused and exploited by Horror in order to

create the emotions of fear and threat (of feeling under possible attack and, thus, scared and on edge). As I have already proposed, via Carroll, these emotions are "real" in their intensity but ultimately perceived in the awareness that they are fictive. The thought of the threat and its consequences generate fear and concomitant emotions such as dread.

A good illustration of this process is the reverse bear trap scene in *Saw*: its dynamic and syncopated look and feel are necessarily influenced by our knowledge that such a device would have terrible and, most importantly, fatal consequences when inserted in the mouth of a human being and pried open. Crucial to the assessment of this scene, then, are the cognitive processes that help us apprehend the bear trap as a physical threat that can endanger the life of the character onscreen and with whose body we empathise. The film emphasises these effects and ensures the connections are made by having Amanda (Shawnee Smith) watch a video where Billy the puppet showcases the consequences of the mechanism's trigger system. Although her face is partly covered by the contraption, it is still possible to sense her fear through facial expression, especially her eyes, which, as we know, provide affective clues for viewers. Billy's demonstration is included for two reasons: on the one hand, because Amanda survives and, therefore, viewers are not treated to the visual spectacle that has been set up by the scene.[48] The video acts as a palliative confirming the trap's deathliness and viciousness and to prompt those viewers who may be reticent (or incapable) of imagining the outcome to do so. On the other hand, it highlights Amanda's situation and her mortality, a message further emphasised by Jigsaw's live-or-die message. From here on, the viewer may experience the scene as it is presented: a race against time to escape the inevitability of a very painful death. Amanda's almost instinctive reactions are edited alongside shots of the trap's timer ticking away and bringing her closer to death. The result is a mix of threat-based fear and suspense that, if not intrinsically horrific because it may also be present, in a similar form, in genres such as the thriller, is very common in Horror. In the case of the *Saw* series, it is also present in circumstances that are not coded as merely suspenseful but as very obviously horrific.[49]

Predisposition to the identification of a form of threat also has a direct effect on our capacity to detect it and shapes our possible reactions to it.[50] The act of going to watch a Horror film, especially one that has been advertised as an extreme Horror experience, prepares us psychologically for what is to come and, since we are particularly open to the idea of threat, we are likely to read ambiguous situations suspiciously or negatively.[51] Not only are we more alert than we would normally be to the perception of threat in real life or in the watching of a film that is not Horror, we will also be predisposed to react in more accentuated ways.[52] In other words, our emotions are heightened and stimulated. Viewers can also consciously psych themselves up for these moments and actively participate in their amplification. Thus, for example, some viewers may choose to dim the lights when watching a

film at home in order to create the right atmosphere: darkness allows us to concentrate our attention on the screen more effectively and is felt to be "creepier". It is possible that the same viewers may also choose to view these films at night, which has its own connotations of danger and is traditionally the setting of a number of dangerous scenarios in Horror film and fiction. Similarly, sound may be turned up because we are aware of its important role in the generation of shocks (or startle effects) and some viewers choose to use headphones to make the experience more intense and involved. In some cinematic cases, the threat may be a literal one, namely, it may manifest itself physically. Think of, for example, William Castle's use of gimmicks, such as *Emergo*, the flying skeleton lunging at the audience at the end of *House on Haunted Hill* (1959), or *Percepto*, the vibrating motors under cinema seats that gave the impression that the titular creature in *The Tingler* (1959) had taken over the viewer's body.[53] In short, the threat transaction may be courted by Horror itself, but it may also be sought from outside by viewers who, recognising the desired effect, seek to magnify or strengthen it.

Finally, threat defines other types of corporeal feelings that are directly connected to, and derived from, it. The anticipation that can be felt prior to the attack or reveal of the threat is best understood as "dread" and its complexities deserve a separate section in this chapter. Similarly, the emotional reactions that ensue after the acknowledgment (it need not be revealed) and discovery of the threat, what has been called "terror" but may be more intuitively called "survival suspense", often relies on the flight or fight mode.[54]

To summarise some of my contentions up to this point, physical threat lies at the heart of the Horror experience and, where it is not working at a purely somatic level, it is necessarily connected to concomitant threat-processing cognitive and emotional states that come together to generate what we call fear. Horror films often foreground this experiential aspect of the genre and work in ways that seek to create dispositional emotional states of fear via awareness of corporeal vulnerability and of human mortality. Films can do this via alignment with characters who are put under threat, often regardless of our specific feelings for them, or by creating atmospheres or moods that elicit vigilance and increase our capacity for threat-detection. Viewers of Horror generally enjoy this experience and return to it because, at least partially, it allows them to relive the moment of feeling physically threatened at a fictional remove. The various ways in which our bodies and minds pick up threat-inducing phenomena are exploited to shock or create longer states of emotional arousal. The capacity to fear a specific thought, the source of threat but also, crucially, a specific scenario, is what effectively dictates the treatment and definition of Horror, which, in turn, becomes the driving or overriding affect governing the genre and making it distinctively horrific. Turning to the ways in which Horror seeks to generate scenarios where threat and, thus, where escape or defence become the teleological emotive drive, can give us a sense of (a) both how Horror does not necessarily rely on thematic constraints but on affect as modulating sensation and

emotion and (b) of how corporeality and the positioning of the viewer are crucial to Horror, even more so than its political or social messages.[55] More largely, this entails a move away from an object-directed theory of emotions to one that acknowledges dispositional states and threatening situations and cognates as essential to the generation of fear.

Case Study 1: Experiencing Fear, or How *[•REC]* (2007) Works

At this point, it is useful to provide a more extensive illustration of the cognitive processes at play in Horror by focusing on one filmic example that is representative of the contemporary, largely post-millennial, trend commonly known as "found footage".[56] *[•REC]* should not stand here for *all* found footage films, especially since, as I have argued elsewhere, found footage is not, technically, a subgenre but a framing device that may be applied to different subgenres, including the monster feature (*Cloverfield* (Matt Reeves, 2008)), the haunted house/building film (*Paranormal Activity*, *Grave Encounters* (The Vicious Brothers, 2011)) or the possession film (*The Devil Inside*).[57] However, as an especially successful example of found footage that garnered very positive reviews and the popularity of which led to, among other things, three sequels in Spain and two American remakes, a study of its narrative, the cinematic tools it uses and the effects it aims to produce, should give a general sense of how Horror can rely on threat-related emotional and cognitive processes in order to articulate extremely affective stories and yet remain practically plotless. The roller-coaster ride, an image that has been connected to Horror in the past, is achieved in *[•REC]* through its exploitation of the affective possibilities of found footage framing. This point was made quite clear in the promotional campaigns, which positioned the film as a threatening adventure in "total immersion" that would guarantee, among other things, the possibility of "experienc[ing] fear".[58] Similarly, the Spanish trailer addressed potential viewers and aligned them with the main characters by including commands such as "run", "escape" or "survive".

[•REC] also presents itself as "real-time" Horror, a premise it tries to maintain for the majority of its running time by imitating the look of unmediated or "live" feed.[59] Hence the opening scene with Ángela (Manuela Velasco), a TV reporter for the fictional programme *Mientras Duermes* (*While You're Sleeping*), and her cameraman Pablo (Pablo Rosso) carries no credits (the only concession to the film as fabrication is the "Filmax" logo flashed before the first scene) and makes no attempt to position the film as fictional.[60] This stylistic choice, which it shares with other films and is most notable in the faux snuff Horror subgenre, creates a sense of unease: the viewer is constantly expecting the acknowledgement of the text's own fictionality, a moment that is postponed until the very end.[61] The scene takes place outside a real fire brigade station and moves on to chronicle the everyday activities of those inside, who are also real fire fighters. The tour of the

installations, meant to introduce the viewers of *Mientras Duermes* to the intricacies of the job during an ordinary night shift, is therefore real insofar as the video is virtually indistinguishable from what the actual programme would look like. The main difference is that the bad takes are not edited out in order to maintain the illusion of immediacy and to build further character development. They also serve to make the film look like a found document: as the action progresses and the film becomes more of a survivor's log through which to potentially challenge the official version of events, the distinction between final and test takes is lost. The images become a form of unmediated, raw access to the action, the relevance of which keeps being reinstated by Ángela's constant demands that Pablo "keep recording". Verisimilitude and involvement, then, are engendered by the nature of the camera and the presentation of a situation that "could" be real. This is different, however, from proposing that the events in the film are perceived as happening in "real time".

Figure 2.3 The immersive immediacy of *[•REC]* (2007) is partly accomplished by its pretend live feed look and fast editing.

Because screenings of the film took place in actual cinemas, which, with the exception of live transmissions of famous plays, almost systematically project material that has been recorded prior to the screening, the film was necessarily consumed as fictional. Since *[•REC]* also has obvious cuts, which appear at moments where the camera is either willingly turned off (because other characters demand this), or else, it hits the floor and blacks out, the idea that the feed could be being watched in real time, like in the TV film *Ghostwatch* (Stephen Volk, 1992), is untenable; *[•REC]* does not aim to be received as "real time" television but merely to look and feel like it. This hybrid approach sustains the illusion of reality for the purposes of

the film: to affect audiences. It has very little interest in its concept remaining believable so long as the immersive effect is not threatened.[62] In other words, belief in the credibility of the events is sacrificed to the overall affective effect. The reason *[•REC]* is particularly attractive, more so than similar films such as *Evil Things* (Dominic Perez, 2009), *Reel Evil* (Danny Draven, 2012) or *Unfriended* (Leo Gabriadze, 2015), is that the framing system stays strong and is legitimised by the characters. Shot in what appears to be one very long take, albeit interrupted, on the same night, the film exploits the first-person camera to generate a sense of emotional involvement that had previously only been achieved with comparable success in *The Blair Witch Project* (Eduardo Sánchez and Daniel Myrick, 1999). Unlike that film, and unlike other films that acknowledge their own mediation of events, such as *Diary of the Dead* (George A. Romero, 2007), *[•REC]* allows for the viewer to truly step into the action by having a cameraman – Pablo – who is really little more than an avatar: he is never seen (apart from his hand, very briefly) and hardly heard at all. The fact that his reactions to the various threats around him also seem quite natural and logical – to run away, to drop the camera when help is needed – means that it is easier to step into his shoes and experience the film as one more character in the story. In other words, from the relatively restrictive point of view of the film, *[•REC]* allows for a level of viewer interaction that is more easily identifiable with first-person video games.[63] The general aim, as director Jaume Balagueró put it, was to create a "purely digital-video horror film that could be more direct and hyper-affect the audience by being told in that cinema vérité way [...] using YouTube language" (Balagueró, qtd in Jones (2008)).

The premise of the plot is simple enough: a distress call received by the firemen leads the protagonists into what has been called the "terrible place" (Clover 1992, 30–1), in this case, a block of flats in Barcelona city. Once inside, a series of accidents make it clear that unusual occurrences are afoot, especially after the building is cordoned off and put under quarantine. The film chronicles the happenings that take place inside the building and which lead to the decimation of its inhabitants. This includes the incessant filming of the various attacks that take place, from the initial chewing of the police chief's throat (Vicente Gil) to the fall of one of the firemen down the stairwell and, eventually, to the turning of the victims into rabid human beings haunting the houses and corridors of the building. Running out of spaces in which to hide or protect themselves from the monsters, the characters end up in the top flat, which had been previously introduced as the locked-up property of a man from Madrid who no longer lives there. It is here that the most horrific encounter takes place: the *niña* Medeiros (Javier Botet), an alleged victim of demonic possession, is set free and attacks both Ángela and Pablo. The latter receives a hammer blow to the head and is presumably killed. The former is carried away by the ghoulish and feral child, who has grown into a lanky and nightmarish adult.

Ángela's fate is uncertain and only revealed in *[•REC]2* (Jaume Balagueró and Paco Plaza, 2009). Most notably, the film is seen exclusively through Pablo's camera, which becomes a document proving the unfairness of the treatment him and Ángela have received: how they have not been told the truth and have been left to die. Regardless of its potential political meaning as alternative, counterstate evidence, the presence of the camera throughout scenes of intense horror is thus cleverly justified. But why is this such an interesting choice?

The hand-held camera framing is important on more than one level: perceptually, it can create a sense of physical discomfort such as motion sickness or disorientation and limit our visual field to elicit a feeling of claustrophobia (as happens in the last scene, where the line of vision is reduced to a floor-level shot which enhances the sensation of vulnerability) or to underscore the effects of the startle effect. For example, the opening of the attic trapdoor leads to a slow, surveying circular pan meant to assess the potential danger of the room. As the camera is about to come full circle, a small, rabid child (Víctor Massagué) suddenly manifests where, previously, the camera had only recorded empty space. The close proximity of the image, plus the swift direction of the scene and anticipation of the moment – it is obvious, from the build-up, that something horrible is likely to happen – means that it is difficult not to react physically to the scare. Horror often resorts to this type of close-up reveal, generally with the addition of strong extradiegetic sound, in order to amplify feelings of fear. Found footage allows for the perceptual sensation of closeness, since the POV framing can bring objects closer and means that the human eye-line is maintained. When it is dark, the camera's light also helps focus the action on the area that it can illuminate, which, itself, provides for a number of shocks from characters hiding in the shadows. POV shots also ensure that the actions are experienced in a manner that, with natural limitations, tries to replicate more faithfully human vision than films which present the action omnisciently. The use of night vision also accentuates the eeriness of the situation and, in the last scene, makes the characters appear even more helpless: viewers can see Ángela as she struggles to find a way out, herself incapable of seeing as she crawls on the floor.[64]

On an emotional level, the descent into darkness, which is gradual but steady, as the film travels from light outside to the inside of a building and, in the last scene, total darkness, colours responses and predispositions accordingly. The first emotions viewers may experience are those of curiosity, especially if we follow Ángela's interest in finding out more about what is happening. The potential tedium of this initial exposition scene, which lasts around seven minutes, is not simply a question of taste: Ángela herself asks Pablo to cut out the potential bits that might be a *coñazo* (Spanish for "a drag") after spotting that their fireman guide is not particularly engaging. This initial lapse in action sets up expectations for what is to come: even though the viewer does not know that the action will soon relocate

to a much darker and threatening building, the scenes are still taking place at night and our protagonists are often shown on their own. The huge and instant mobilisation of the personnel upon hearing the alarm (the sounding of which is foretold by Ángela, who expresses her desire to hear it) is potentially exciting, too: the action has begun. The arrival at a flat in the middle of Barcelona begins to change the tone of the film. The conversation between the neighbours is confusing, and the police cars outside the building indicate that the situation "might be worse than it appears", as Ángela puts it. The secrecy advocated by the various police officers who question the presence of the camera and the right of Pablo to keep recording also prepares us for the revelation of secrets. As the building is sealed off and escape routes consistently blocked off, the feeling of claustrophobia is enhanced, as are fear, suspense and, since we have already been exposed to the zombie creatures, threat. It is clear by the time the old, crazed lady (Marta Carbonell) is introduced that the intradiegetic situation is both severe (the police have proven ineffective), dangerous (hence the sealing off of the building) and one that prompts despair. A significant part of the film features a long escape scene from one part of the building to another as the various inhabitants are bitten and transform. Emotionally, the film encourages vicarious threat: we both feel for the safety of Ángela and Pablo and, thus, for our own (since we share their visual and, to a certain degree, experiential space).

Figure 2.4 In *[•REC]*, the viewer shares the same affective experiential space as the camera, an immersive first-person POV.

Cognitively, there are few thought processes at work here, other than those that allow us to put ourselves in the place of the bodies of the characters (Ángela's, mainly, but also the disembodied space occupied by Pablo's

camera) and which allow us to identify the threat. On the one hand, it is possible that viewers are keen to find out about the mystery and that, since all escape routes are barred, the path which Ángela and Pablo follow feels "natural" and is not actively questioned. On the other hand, because the film seamlessly aligns the viewer with Pablo's (the camera's) POV, the emotional investment in escaping and hiding from the threat is greater. *[•REC]*'s relentlessness, a characteristic highlighted by its short duration and intense action-packed scenes, ensures that there is little time for questioning the narrative or the intentions and desires of the characters beyond the moments when the film makes such concessions. An example is a long seven-minute interlude scene showing interviews of the surviving tenants. The answers given by Mari Carmen (María Lanau) and her daughter, Jennifer (Claudia Silva), serve to inform sharp audiences about the effects of the initial onset of the infection, as Jennifer is sick with the virus that has transformed the others. Similarly, the interview with the physician's assistant (Carlos Vicente) recaps the situation and ensures that the serious state of the victims is both assessed medically and its importance reinforced. However, there is little character development in these exposition scenes and their purpose is largely narrative. They provide some respite from the tension and impress on viewers the despair of characters who are incommunicado, quarantined and in danger. Even the last exposition scene, where Ángela and Pablo go over the documents found in the accursed flat while they play a tape that explains the infection mutates and has transmission patterns like those of the common flu, does little but reinstate what viewers already know. The information on the various newspaper cuttings is also only glanced at, so that the details cannot be absorbed on a first viewing.[65]

To go back to the problem with Carroll's object-directed theory of Horror, I would argue that what makes this film horrific is not the nature of its monsters, which remain largely unexplained and ambiguous, although not in the interstitial, impure way that is suggested. In fact, by the end of *[•REC]*, we know little more about them than we did at the start of the film: the little girl (*niña* Medeiros) was clearly possessed and her blood is sampled and studied, but there is no real explanation for the outbreak or for the existence of the speedy, zombie-like creatures. In fact, the zombies in *[•REC]* are not too dissimilar from the rabid humans in *28 Days Later*, insofar as it could be argued that they are not really zombies at all but merely infected humans. Although this would appear to do little in terms of rebuking their categorical impurity – the creatures would still be disgusting because they are infected and infectious; knowledge of the actual specificities of their condition is not crucial. Their "otherness" is indeed emphasised by their screeching, groaning and squealing, more appropriate of animals (the sounds are, in fact, amplified recordings of animal sounds), but the moment of horror does not occur because these creatures are hybrid or remarkably inhuman. The film does not give the viewer enough time, or indeed clues, to put the pieces together: what has caused or is causing

the problem (its origins), how it can be exterminated, or indeed, a possible solution. The only thing that is crystal-clear to the potential viewer is what is clear to the characters: the monsters' reactions, their ferocity and rapaciousness, the fact that they attack (by biting) and act violently. This is more than enough to posit them as a threat. Because they are established as dangerous and examples of their capacity to infect are given, fear is made possible. The film is Horror because it follows the dynamics of the genre and not because it includes zombie-like characters. The lack of context for these monsters, in fact, adds to their creepiness: their attacks can be more effective because we have no real sense of what they are or what is guiding them.[66]

In conclusion, even a cursory look at the workings of the film reveals that [•REC] does not work representationally but seeks to create a heightened and suggestive emotional state (the gory scenes and its zombies are not seen in much detail) that it pairs with affective showers. These include constant startles and a general feeling of trepidation and of never being quite safe amplified by the use of POV and found footage framing. The film, thus, exploits threat in order to create an immersive experience that is closer to survival video games than to previous found footage Horror.[67]

Anticipation and Reaction to Threat: Dread and Survival Suspense

As the case of [•REC] has made clear, if corporeal threat lies at the heart of the emotional hold of Horror, it actually manifests in a number of interconnected ways. As the infected eventually crystallise as the main horrific threat – the police and health authorities surrounding the building are too vaguely presented to become a threat in the same sense – the horror continues through tense scenes of escape and temporary barricading.[68] In other words, whilst threat continues to dominate, the particularities of its provenance and of its possible avoidance become sources of pleasurable fear and even structure the action that follows. In this section, I turn to dread because it demands a complex emotional and cognitive engagement and because it also privileges the body of viewers and their capacity for suggestion. Focusing on the methods used by Horror to engender a sense of anticipation imbued with fear allows me to expand my proposition regarding the privileging of the emotional state in Horror. Dread, understood as the anticipatory emotion that leads to the realisation that one is in danger, is both necessary and defining for an affective theory of Horror. As I have shown, in the case of found footage Horror, the end product, the creation of dread and, thus, of a sense of being vulnerable, may even shape the look and structure of a film. Dread, like threat itself, is not the exclusive province of Horror and it manifests in many other films, especially thrillers; its main existence, or even prevalence, does not guarantee genre specificity. However, its dark, prolonged and anxiety-creating treatment in Horror, especially since the famous build-up to the bus startle scene

in *Cat People* (Jacques Tourneur, 1942), has been a classic, almost basic, component. It appears with remarkable consistency, alongside the startle effect, in paranormal or ghost stories and is generally connected to subtlety despite the fact that it is used almost indiscriminately in the genre as a whole.[69]

Before I move on to differentiate between the two main forms of dread at play in Horror, it is important to note that my use of this term differs from that of other critics. As I have pointed out, Carroll's thoughts on what he calls "art-dread" are self-professedly "underdeveloped"; the term is mainly brought up to avoid the non-inclusion in art-horror of Horror stories that lack monsters and that are connected to the "uncanny", to "unease and awe, perhaps of momentary anxiety and awe" (Carroll 1990, 42), as sparked by an encounter with unknown and inexplicable forces. In this category are included stories such as Robert Louis Stevenson's "The Body Snatcher" (1884), W. W. Jacobs "The Monkey's Paw" (1902) or episodes from the TV series *The Twilight Zone* (1959–64). But this understanding of dread seems to subsume the entire story to one affect and does not allow for the inter-action of dread with other feelings, such as those of perplexity and horror at the end of "The Body Snatcher". It also unhelpfully collapses dread into cosmic fear or fear of the paranormal (thematic preoccupations indicative of subgenres) with a feeling that (as I have explained) may be found in other genres (science fiction, in the case of *The Twilight Zone*, which often, unsurprisingly, ventured into horrific territory). Robert C. Solomon proposes a similar definition, where dread is understood to be a source of the unknown and "shares with fear a sense of imminent danger, though it shares with anxiety the obscurity of its object" (2003, 243). As in Carroll, this account sees no object in dread (it could be argued that Carroll develops the notion to account for non-monster-related Horror) and, inexplicably, does not lead to imminent danger. The problem with both approaches is that they fail to understand that dread is a crucial part of Horror and, therefore, hard, or even impossible, to dissociate from it. I see dread as one of the techniques Horror uses in order to scare and not as a strictly discrete emotion *per se*. In fact, dread is more obviously an emotional state of suggestion in which fear is made possible and imminent.

Refining both the work of Carroll and of Solomon, Freeland establishes a connection between a wave of new films around the turn of this century – such as M. Night Shyamalan's *The Sixth Sense* (1999) and *Signs* (2002), the aforementioned *The Blair Witch Project* and *The Others* (Alejandro Amenábar, 2001) – and the understated Horror of Val Lewton.[70] For Free-land, the horror in these films is "subtle and lingering", as they rely on "uneasy suspense" and on creating "a vague sense of impending doom and disaster" (2004, 189). This distinguishes them from other contemporary horrific manifestations, such as the post-modern slasher better represented by *Scream* (Wes Craven, 1996). Dread, for Freeland, then, is similar to fear in that it involves a sense of danger but, ultimately, is different because it is "looser and less focused on a particular object" (2004, 191). In this respect,

it is closer to anxiety for, in her words, "dread involves a threat that is not only unidentified and powerful but also unnerving because it is deeply abhorrent to reason" (191). However, why specifically dread must originate from "something dangerous and hugely evil [...] yet not well-defined or well-understood" (191) is not immediately clear. The distinction between an ill-defined threat and a very physical one (a letter with potential anthrax versus a monster, in her example), seems to me to pose a problem of gradation: the latter is more eminently and directly horrific but the difference resides in the final response to the threat, not in the anticipatory state prior to it.[71] In any case, the latter would depend on the specific treatment of a scene: the incorporeal death, a form of threat that is not physically embodied, in the *Final Destination* series (2000–11) is an obvious case in point.[72] Let us look at this example more closely.

The shower scene in *Final Destination* (James Wong, 2000) manages to create a sense of dread by turning the most common objects (a dripping tap) into a source of threat by virtue of its use of camera lens and music. Prior knowledge, or intention, of the logic of the film – characters who avoid meeting their end via the prophetic vision of Alex (Devon Sawa) will have to pay for having escaped death's plans – is also decisive in conjuring up a sense of dread that has nothing to do with the physicality of the threat itself (or, at least, only insofar as it is constituted by physical objects that can be touched) and everything to do with expectations. In this particular instance, the viewer awaits the dreaded end in a mixture of empathic emotions related to the safety of the character ("will he be able to escape his fate?"), the horribleness of the potential outcome ("how far will the film go? How much will it show and in what way?") and the process ("exactly what will happen to this shower to make it deadly?"). Admittedly, as the series advances, the dread also morphs: by the time we reach the laser eye scene in *Final Destination 5* (Steven Quale, 2011), we are certain that Olivia (Jacqueline MacInnes Wood) will not survive the surgery and are therefore attentive to the series of chain reactions that will cause the inevitable. The dread in this particular scene is connected with its potential gruesome factor and, as Olivia is freed from the contraption that appeared sure to kill her, with working out what worse fate awaits. The fact that the film provides clues as to the deaths of its characters – Olivia's actions in the film bring her in contact with objects that either point to her eyes or conjure up the dislodged eye at the end of the scene – means that the type of dread is specifically morbid, since we know that the most likely outcome will include an optical attack. As should have become obvious by now, we are in need of a theory of dread that acknowledges its emotional content.

Julian Hanich, in his accomplished and perceptive *Cinematic Emotion in Horror Films and Thrillers* (2010), has come closest to a functioning set of characteristics for dread as I understand it here, namely, as an emotional state concerned primarily with anticipation of threat. Although I find some

Figure 2.5 In *Final Destination 5* (2011), dread is created through the certainty that an ordinary situation, such as laser eye surgery, will end up killing the character.

of his conclusions and subdivisions slightly counterintuitive, since his theory of dread is an important springboard for my own, it needs to be discussed at some length. For Hanich, the epitome of dread is the "alone-in-the-dark" scenario where viewers are rooting for a character entering, often slowly and with apprehension, a dangerous, dark or otherwise threatening place. The source of the threat (knowing what it is) is less important, then, than the outcome, which is that it is very likely that the character will come into contact with the threat very soon. Dread ends in horror or in the startle effect (shock, in Hanich's taxonomy) but, importantly, does not include those feelings themselves, so that dread could be said to be "intense but quiet" (Hanich 2010, 156). Unlike what he terms "direct horror" (81–107), dread is separated by its temporality and intentionality.[73] Regarding the former, despite its happening in the present moment, it always points towards the future, whereas direct horror is experienced when the threat materialises. Regarding the latter, Hanich argues, the object of dread is "less coherent and more complex" than in direct horror; in dread "[w]e feel afraid of a prospecting, largely unknown and sometimes even amorphous danger" (157). This, too, is significant if, I would argue, not necessary for the dread scene. Knowledge of the exact threat, if viewers and/or intradiegetic characters have it, will guide the form of the threat in ways which are different from the cases where that knowledge is not to hand. The quality of those experiences might well have a distinct level of intensity, mainly because, in the cases where little is known about the threat, individual imagination is activated and this can be very powerful. Ultimately, I would contend that the emotional state being encouraged in these situations is one and the same: the anticipation of an encounter with a form of threat that will be harmful, quite

possibly on a physical level, regardless of how much we know about its origin or explanations. Let me turn to a couple of illustrative examples.

In *The Babadook* (Jennifer Kent, 2014), one of the most critically acclaimed post-millennial Horror films, the threat is prefigured very clearly and very early on.[74] Since the film is named after the fantastic character in *Mister Babadook*, a book that little Samuel (Noah Wiseman) wants to have read to him, the viewer is likely to pay close attention to the drawings that represent him and whatever descriptions of his behaviour or actions may be provided. When Amelia (Essie Davis) starts feeling a sinister presence in the house, the logical and expected process on the part of the viewer is to anticipate that the threat is Mister Babadook himself. Playing for ambiguity, as Horror often does, there are enough hints that Samuel might be responsible: putting glass in their dinner does not require the action of a supernatural being, and, as the doctor diagnoses him with a febrile convulsion, there is evidence that he might suffer from some form of psychological disturbance and from anxiety. The film reinforces the idea that the Babadook may indeed exist: the references to the text that Samuel makes ("don't let it in"), the return of the book, under a slight different fashion, after Amelia has torn it to pieces, the three sharp knocks following a rumbling sound that will help you "know when [the Babadook]'s around". The fact that the monster could have a psychological explanation based on the fact that Amelia might be losing her grip on reality due to the traumatic loss of her husband and her inability to deal with her son's behavioural problems is, naturally, important at the level of meaning-making and in terms of our decisions about what happened.[75] But these decisions are related to intent and not to the dynamics of the film. Whilst they have an important role to play on our general feelings about it, whether we find the Babadook a successful one or not, they do not colour the way dread is constructed in it.

In one of the key horrific scenes in the film, Amelia has gone to bed after making sure Samuel is asleep. A series of noises at night (dragging sounds, the dog barking) wake her up. A false sense of relief is created by the thought that the dog could have been responsible for the disturbance. When the noises continue and the door eventually opens, this has a very different effect and leads to a sense of awareness and of accentuated perception that is cognitive. It is obvious that something is going to happen; we are not entirely sure of what it will be or what it will result in (whether Amelia will be harmed or harm herself), but we do know that the Babadook, imaginary or real, is connected to the events. When his distinctive figure is finally glimpsed on the side of the door, this is confirmed. As Amelia hides under the covers, the camera positioned at eye-level, and the creature whispers the characteristic "Baba-dook-dook-DOOK!", the sense of dread is accentuated. The following shots continue to elaborate on the possible danger: Amelia's looking upwards is met by a high-pitched score and the appearance of a ceiling-crawling shadow with long claws. The moment of horror at the end subverts expectations, as the Babadook goes inside her mouth and Amelia

awakes. Whether we believe the Babadook to have taken over Amelia's body or whether we think the entire sequence was a nightmare, the experiential quality the first time it is watched is the same. A sense of threat is generated and fear is felt for Amelia's, and our own, safety. This type of threat is directed at an object we know relatively well and the effects of which we can imagine. Although we cannot anticipate what the Babadook is capable of, whether he might use his claws as a weapon or his sharp teeth, his sinuous and creepy movements are enough to present him as threatening, especially given the context (the middle of the night, a dark room, a disquieting score). The source of threat can even change within the same film, as Amelia becomes the "monster" and tries to kill Samuel. The effects of a dread scene can be more or less predictable but their affective workings remain similar.

Dread always requires a source of threat; no film can create a sense of dread without one. This is the case because the latter is basic to the creation of the emotional state in the first place. This is not to say, of course, that it is not possible to create a sense of dread that is not aimed at a direct object yet is situational or purely cinematic. *Inland Empire* (David Lynch, 2006) displays the director's trademark use of uncanny sounds for their indeterminate sense of dread in various places. Lighting, camera angles and vaguely threatening conversations can be enough to turn scenes such as the exchange between Nikki Grace (Laura Dern) and an enigmatic woman from Poland (Grace Zabriskie) into uneasy experiences that seem to signal danger, death or worse.[76] Although dread can remain relatively unexplained, films that do not provide enough exposition regarding the nature of their sources of threat can produce a feeling of frustration, as viewers may think that the filmmakers did not know how to resolve a set-up and, if the buildups are significant, that there was no real payoff. An illustration of this is *It Follows*, where dread is constructed around some form of curse, the exact nature of which is never revealed. All the viewer knows is that it transmits sexually, that it uses human bodies, that it walks (but does not run) and that it is deadly. These traits are enough to generate dread: human figures can become sources of dread, not because of their nature, but by virtue of the danger they can represent, as can the situation itself (knowing that one has to keep on moving, is never safe and might be forced to simply pass on the curse).[77] Even in films where the threat is amorphous or even invisible, as in *The Happening* (M. Night Shyamalan, 2008), where a cryptic neurotoxin released by plants causes a plague of suicides, dread is constructed out of both the horrific situation (being under threat of inhaling the toxin and killing oneself) and the victims who commit suicide. The latter end up posing real threats themselves as they jump off buildings. The emotional state of dread is thus object-directed in that it needs a source or sources of threat to activate the fear, but it is also thought-directed in that it can be situational or activated by specific moods or atmospheres. I now turn to the repercussions of this proposition.

Like Hanich, I believe that in dread "we both feel *for the endangered character* and fearfully expect a threatening outcome that promises to be shocking and/or horrifying *to us*" (Hanich 2010, 156), but, importantly, I do not see both events as involving a split intentional object. Following the work of Hermann Schmitz, Hanich argues that dread has both a "concentration section" and an "anchoring point", the latter "remain[ing] mostly present as a background assumption and rarely becom[ing] foregrounded" (156). The distinction is illustrated via the example of a dog running towards us (where concentration section and anchoring point coincide) and a visit to the dentist (where the concentration section is the dentist and his implements and the anchoring point the anticipated pain). However flawed this distinction may be in itself, when it is applied to cinema it translates into a division between the feelings of empathy we feel for the viewer and those we might feel for our own safety.[78] I want to acknowledge a more natural fusion between the two types of feeling/affect so that fear of the character's fate is not significantly, or even qualitatively, different from our own feelings regarding ourselves. Unlike the moment of the encounter with threat, where our reactions may exactly mirror those of the character, dread can be channelled differently through our contextual knowledge. However, dread as an emotional disposition that concerns the viewer is seemingly consistent: viewers feel fear for the integrity and future of the character(s); they might also derive a similar feeling from the situation in which the film is putting the character and the viewer. They are scared because, on the one hand, the character's situation is emotionally and experientially shareable and, on the other, because, unlike the character, viewers may also be affected by the film's use of the medium (partial occlusions, use of music, editing). We do not fear for the characters, and then, for ourselves, but we fear for ourselves *through* the characters and their situations and, most importantly, through the hunch and, in places certainty, that they are under threat.

For the same reason, I find the justification of dread as imbued by fear of the unknown, and the Burkean suggestion that our "psychic means of self-protection" (Hanich 2010, 159) may be exceeded, difficult to prove in practice. Whilst curiosity undoubtedly plays an important part, as does suspense ("what is hiding in the corner?" or, when we know the threat, "where from, and how, will it strike?"), in the dread scene, it is not the undecidability of the unknown, in some Lovecraftian or supernatural sense, that is at work. The uncertainty is a lot less abstract and much more related to the vulnerability and well-being of the character. I am not entirely convinced that "epistemic deficit" always prepares us for the worst, because there is a fear that the "as-yet unimaginable horror might overwhelm our rational selves" (159). Films very often guide viewer expectations and provide clues for what is to come.[79] I do not seek to deny the role of imagination in dread; it is important because suggestion accentuates our emotional involvement. The Babadook in the eponymous film is perhaps that much more horrifying because he is never fully shown.[80]

What I would like to point out, however, is the fact that our imagination is very much given a path to tread: whilst we do not know exactly what the Babadook looks like, we are aware of the type of threat it supposes, especially as the action advances. This threat is neatly delimitated and need not exceed the barriers of the conceivable (intradiegetically speaking). As in Lovecraft, where characters are faced with beings that the human mind cannot process or conceive of, the result of facing a dread of the unknown that threatens our psychic means of self-protection would be intolerable and seriously harmful. Viewers are normally good at determining what they can and cannot withstand: if dread (or fear) cut too close to the bone, they know they can look away, leave or else continue watching and suffer the consequences.

Morbid curiosity is also part of the dread sequence and, in extreme Horror, might be a selling point for the viewer. The type of visceral fear it engenders is awakened by both the forbidden quality of the images and the type of feeling of guilt that will be incurred in their watching. I will develop this notion in more detail in the following section but, for now, suffice it to say that, as evinced in the long torture scenes in *August Underground* (Fred Vogel, 2003), dread can stem from both the extremity of the actions and the lack of knowledge of where the film's limits or boundaries will lie. How far will the film go and how realistic will the violence look? In less extreme examples, we could argue that morbid curiosity is a necessary ingredient of the instances where characters are obviously heading towards a nasty death or attack. If anticipated to be a gruesome event or encounter, dread continues to be articulated by fear but is filtered through a voyeuristic lens that forces us to admit to being interested in the actual consequences. This may seem a negligible fact but it is, indeed, crucial. Our attitude towards scenes where we know the dread to be fatal – cues will have been provided by the film by, for example, making sure the character is perceived to be unnecessary or deserving of his or her fate – is intrinsically different from the ones where we are genuinely scared of the outcome. In the latter, we either root for the main characters and are, therefore, more obviously empathically connected to them, or else, genuinely worried about the uncertainty of the threat and its extent. In the former, we are geared for the inevitable and know that our engagement is somewhat sadistic (because we are deliberately watching pain being inflicted on a character for entertainment or because we are curious about that pain) and, mostly, masochistic (because we can still relate somatically to the body of the victim). Sometimes Horror subverts these expectations, especially in slasher films, in order to produce surprise or relief.

I mentioned previously that threat generates two subsidiary emotions. I have covered the first and, in what remains, I turn briefly to survival suspense. Survival suspense, which differs from suspense in non-horrific or mainstream thrillers (detective stories, gangster films) due to its treatment and the fact that fear is the reigning emotion, has sometimes been termed "terror" and is normally distinguished from direct horror. Solomon, for

example, proposes that, in survival suspense, the reaction is to flee and "often results in panic insofar as it is rarely reflective and often obsessive" (2003, 242). The moment of encounter with the threat, by contrast, "may be overwhelming, but there is no reason to panic because there is nowhere to flee" (242). Although I do not find this definition entirely plausible – the difference in the quality of the reaction is simply one of reaction and, in any case, is better captured by the word "panic", because it conjures up the idea of paralysis from fear – it is useful to identify survival suspense from dread: it is qualitatively different because the scenes normally follow an escape and chase scene and because, unlike dread, they are infused with speed, motion, loudness, syncopated editing and other cinematic techniques common to suspense. Survival suspense in Horror, as opposed to in thrillers, is more often interested in the aftermath of the encounter with threat or the events that take place after its manifestation, because it is more likely that their results will be gruesomely lethal or seriously harmful. This escape does not need to be linear. In the cases where the threat is static, as in the traps in *Saw*, the tension will increase as the characters try to escape the threat by deactivating the contraptions. Typically, however, this normally translates into the character's escape attempts and the tension and suspense that develop from them. I prefer the term "survival suspense" to describe this state of affairs because, whilst it is imbued with fear, the main emotion is anticipation about the outcome and not the feeling of being constantly horrified by the source of threat. Whilst the horrific threat might reappear constantly, and the film may even mix survival suspense with dread by making the source of threat hide and turn up unexpected various times in one scene (the house chase sequence with which *Halloween* culminates (John Carpenter, 1978)), the focus tends to be on the chances that the character has of remaining unharmed. This also means that, although the elements it uses to scare can sometimes be affective or aimed at creating somatic reactions – loud bursts of music, noises – survival suspense is largely emotional and premised on the well-being of the character(s).[81] In this respect, even if we know that the character is likely to be okay, survival suspense can be generated regardless: we might suffer, in fear, for his/her scarring or harming of characters and not necessarily his/her death.[82]

Let us contemplate an example of a scene that very obviously engenders survival suspense from a different angle, by positing the threat *inside* the character. *Prometheus* (Ridley Scott, 2012), largely a science fiction film, has a few scenes that return to the reproductive horrors of the original. The most memorable of these occurs when Shaw (Noomi Rapace) uses an automated surgery table to extract a squid-like being from inside her. The scene manages to induce a feeling of survival suspense that it mixes with images of abjection. In many respects, the scene works like an escape-and-chase sequence, since Shaw's life is at stake and the viewer is likely to feel for Shaw's safety. The sudden bumps that appear in the skin of her thorax are enough to suggest an anomaly: something alive may be seeking to

find its way out. Additionally, previous knowledge of the *Alien* films and the "chestburster" means that viewers are predisposed to be suspicious of moments that recall the aliens' birthing technique. In the scene, which follows an immediate laser caesarean, does not simply play with the empathic pain connoted by the open skin and the reaction shot of Shaw moaning, but also generates suspense: the accelerated editing, the momentous music and the alignment with Shaw's perspective all signal towards the scene's emotional investment. On top of it, once the squid creature is removed, it poses a strong threat: it is alive and (literally) kicking and Shaw is in close contact with it in an enclosed space, with her stomach still cut open. The next thirty seconds, then, feed off our hopes that she might get out relatively unharmed (this possibly becomes more plausible as her open wound is stapled together and the table starts reverting to its horizontal position) but also off the simultaneous realisation that the squid creature could prove deadly.

As should be obvious by now, survival suspense is narratively close to dread but experientially different in its use of cinematography, editing, pace and music. In it, the workings of dread continue to be exploited, namely through anticipation, anxiety, uncertainty and curiosity over the outcome, as well as preoccupation with the well-being of the character, but, unlike dread, the fear for one's survival takes precedence and the threat, now concretised, displays its potentially fatal consequences. Because survival suspense relies, like dread, on the moment of threat, it is often found in sequences that have previously exploited the spatial and temporal aspects of dread. Survival suspense is not necessarily more physical than dread but is more obviously premised on the deadly consequences of the source of threat.[83]

To summarise, if threat is crucial to the experience of Horror, dread often articulates the moments leading up to the encounter with its source and, in the cases where the encounter is not directly fatal, the scenes may morph into survival suspense and draw fear and anxiety from the safety of the character. Dread and survival suspense are complex emotional states where the intelligibility of the danger at hand and the vulnerability of the body of the viewer are essential, and where other cognitive processes, such as development of the narrative or empathic relationships with characters, may have an important role to play. Significantly, focusing on the ways in which threat works in Horror, as per my consideration of *[•REC]*, can help us understand the way the genre works from the point of view of emotional rapport and of the effects it seeks to provoke on viewers. Affect, which is the driving force of Horror, is generated by creating a strong link between the bodies of the characters and the viewers. Although its transferability will be explored in more detail in the third chapter of this book, it is important to first consider the implications of the most complex of cognitive processes produced by the encounter with threat, alongside its consequences. I am referring to the affective surplus constructed around self-reflection and, more specifically, feelings of shame and guilt over one's complicity with the violent or scary spectacle.

Complex Self-Reflective Cognitive Processes: Shame and Guilt

Thus far, I have been focusing on emotions connected to the corporeality of the Horror experience that could be termed simple, since dread and the feelings that derive from the awareness of threat need not be specifically reflective. However, Horror has always been concerned with the morbid curiosity it offers, as can be deduced from the "friendly" viewer warnings in films such as *Terror Is a Man* (Gerardo de León, 1959) and, most famously, *Frankenstein* (James Whale, 1931), which asked audiences if they were sure they wanted to "subject [their] nerves to such a strain". Later, films such as *Peeping Tom* (Michael Powell, 1960) would start turning the camera even further in the direction of the viewer, complicating the relation between viewing and complicit behaviours, and bloodier and more controversial films, especially in the 1970s and 1980s would, as Chas Balun put it, "provoke an examination of conscience and force [us] to reveal [our] hand" (1990, 169).[84] These premeditated attempts to instil self-awareness aim to generate emotional (affective) surplus by fostering feelings of guilt and shame over the realisation that one is viewing what s/he should not. These emotions are not strictly simple in that they require a sense of perspective and extraction from the film narrative. I am calling them "complex" here to acknowledge the fact that they involve cognitive processes and incite states that are not strictly connected to the intradiegetic events in films as they affect the characters individually. This is not to say that Horror does not point towards the impact and effects of its viewing: sometimes films use guilt to extend or amplify the horror of the specific events. Viewers might, thus, feel horrified by what they have seen *and* the thoughts and conclusions they derive from them, especially in connection to their own role as participants, and maybe even instigators, of the material in the first instance.

Because their direct objects are not the film itself or its characters and guilt and shame are reflective emotions, they have been referred to as "meta-emotions" (Plantinga 2009a, 73) or "emotions of self-assessment" (Taylor 1985, 1). Carl Plantinga explains that these emotions can range from the very positive "pride" or a "strong sense of self-satisfaction", to the negative ones, shame and guilt (2009a, 73). I am focusing on these here because they are more prevalent in Horror. Plantinga also suggests that these emotions may also refer to previous responses so that one feels shame for having been moved to tears or, for example, for having desired the death of a certain character. Unlike Plantinga, however, I see a significant difference in emotions that assess one's own feelings and emotions that assess responses from other viewers. Although both are cognitive in essence, and "meta" because they rely on a self-awareness and reflection that, ultimately, vary from subject to subject and exist outside of the film's narrative realm, emotions based on other people's responses are likely to be judgemental in a different way: we may assess the propriety of others' responses according to what we think the film was trying to do or the way in which we ourselves felt implicated. As such, guilt or shame are not monolithic: there is guilt or

shame for someone else, because, for example, we may disapprove of their
behaviour during a particular scene, or there is guilt or shame that we have
not reacted in a different way. In the first-case scenario, someone might
wolf-whistle or else show sexual arousal towards a particularly exploitative
scene (the Bathory scene in *Hostel: Part II* (Eli Roth, 2007) where a naked
young woman is made to bleed to death over another naked woman's body)
and we may disapprove of their behaviour and feel anger or shame for them.
In the second scenario, we may feel shame or guilt that we did not find a
particular scene moving when our partner did, especially if the scene was
meant to generate compassion (the beating scene in *Martyrs* (Pascal Laugier,
2008), where a woman is beaten to within an inch of her life for no appar-
ent reason). Regardless, these are reactions that, because they depend on
a context that I do not have the space to cover in this volume, namely, the
shared viewing experience of Horror in cinema theatres, I am concentrating
on guilt and shame as they are experienced individually in relation to the
viewing position that Horror naturally encourages. This enticement can be
non-volitional or volitional.

Non-volitional enticements are connected to the feeling or sense that a
film has overstepped the boundaries of decorum (even within the context of
Horror) but has not done so in order to draw attention to itself.[85] Volitional
enticements appear in Horror that, by including a series of cinematic tech-
niques that either reveal its artificiality or showcase reflective framing
techniques, make viewers aware of their own involvement in the viewing
experience. Tom Six's *The Human Centipede: First Sequence* (2009) and *The
Human Centipede II: Full Sequence* (2011) are both excellent illustrations
of the two ways in which Horror can generate feelings of shame or guilt.
In the case of the former, the viewer might feel ashamed or guilty that they
have watched a film that, in an exploitative vein, fetishises scatology. They
may also feel additionally guilty or shameful if they have enjoyed it or the
concept, even if they pretend otherwise to themselves or others. In any case,
these are meta-emotions because they involve a reaction to the subject matter
or images in the film and not an explicit move on the film's part to raise an
awareness to the viewing. The framing of the sequel, however, further prob-
lematises the issue and may provide grounds for a more deeply felt involve-
ment. In *The Human Centipede II*, Martin (Laurence R. Harvey) is seen
watching *The Human Centipede* and *then* engaging in the same acts the film
proposed (i.e., creating the titular human insect by grafting human beings
mouth-to-anus). The denouement, which reveals that the torture of twelve
individuals may not have taken place within the diegesis of the film, as the
scene returns to the moment when Martin is shown watching the film from
his office in a multi-storey car park, seems to suggest that watching the first
film led to the type of sick fantasies *The Human Centipede II* has gone on to
record in such detail.[86] In doing so, the film seems to pose questions about
the viewing of both *The Human Centipede* and its sequel: not only does it
propose that fans of the film may not be able to discern between fiction and

reality but that they might be driven to replicate the behaviour of the fiction they have consumed and enjoyed. As a result, it is difficult for viewers not to engage, on some level, with their own interest in watching the film and to feel shame or guilt about having been curious about its content. The fact that *The Human Centipede II* pulls out all stops (special effects that, in the first film, had not been possible due to a small budget) may contribute to that feeling.

Volitionally reflective Horror may also take a step further and even accuse the viewer directly for watching and, most importantly, for continuing to watch once their complicity has been raised and problematised. The ultimate example of a film that seeks to gain further affective impact by accusing its viewers of being complicit in its violence is the remake of *Funny Games* (Michael Haneke, 2007). This rather plotless film uses its main premise (two boys who terrorise rich families for no apparent reason) to explore and decry the effects of violent media and entertainment on viewers. At various points, the viewer is addressed directly via breaks of the fourth wall that are unexpected and particularly unnerving, as the film does not, at the beginning, acknowledge that this may take place. Some of these interruptions include remarks that illustrate the lack of care the murderers show towards their victims: "I mean, what do you think? You think they stand a chance? Well, you're on their side, aren't you? Who are you betting on, hmm?" Others underscore the perceived thirst for violence of the viewer. At one point, Paul (Michael Pitt) asks "[i]s that enough?", a question that is connected to the viewer's potential interest in plot over its consequences on human life (the next sentence is "[b]ut you want a real ending, with plausible plot development, don't you?") but also one which may also be challenging the viewer to admit they want to see more. After all, the shooting of a young child (Devon Gearhart) and his father (Tim Roth) and the drowning of the mother (Naomi Watts) is still to come, at this point.[87] The ultimate denial of the viewer's possible desire for vengeance and/or justification comes in two subsequent scenes: when, after managing to get hold of a rifle, Ann shoots Peter (Brady Corbet) and when, at the end, a knife that had been previously prefigured on the family's boat is not used by Ann to escape. In both instances, the film frustrates the viewer's potential wish for retaliation and justice. In the former, the action is simply rewound by Paul and, in the latter, the knife is kicked off and dismissed. Both actions, alongside the direct address of the viewer, encourage self-questioning so that we become, as Catherine Wheatley has suggested, a "scopophilic subject" (2009, 106) forced to develop intellectual and emotional responses to the material at hand.

All Horror could be said to instigate self-reflection insofar as the genre premises its products as experiences in fear and, often, challenges promising to test our limits. It, thus, potentially kick-starts the process of questioning our interest in entertainment via engagement with negative affects. The fact that Horror, more so than any other genre, has led to numerous writings and documentaries attempting to investigate and find a reason for its appeal,

Figure 2.6 Funny Games (2008) challenges its viewers by breaking the fourth wall and forcing them to question their moral involvement with the spectacle of torture.

painted as a paradox, is perhaps proof that this perception is not only academic in its grounding.[88] Vivian Sobchack explains that reflexive exercises surrounding violence in film (and in other fiction) have an "*ethical charge*: one that calls forth not only response but also responsibility – not only aesthetic valuation but also ethical judgement" (2004, 284). The brutal complicity activated by affective corporeal transgression establishes an even more direct rapport between viewers and mutilation, because the former are forced to consider the implications of their watching. In other words, Horror exploits the interrogation of viewer complicity and desire for this type of spectacle in the first place. It relies heavily, although not exclusively, on visceral attacks on the body that often do not pull away but instead chronicle the extent and particularities of what happens to the human body under attack. Unless the treatment is deliberately comedic or portrayed in an exaggerated manner that may lead to distancing laughter, as in the splatstick in some scenes of *Shaun of the Dead* (Edgar Wright, 2004), *Black Sheep* (Jonathan King, 2006) or *Drag Me to Hell* (Sam Raimi, 2009), these will be received as shocking, potentially fearfully disgusting and visceral.[89] This means that, where mainstream action films would stop showing or else depict death from a distance, Horror will close-up on it and even present it aesthetically. Horror also, as has been argued, tends to be creative in its depiction of murder and has its characters and/or monsters attack in ways that come across as more personal and experientially closer: knives, needles or red-hot pokers and other sharp objects are preferred to guns (Clover 1992, 32).

To give but one contemporary example, in the slasher *See No Evil 2* (The Soska Sisters, 2014), Tamara's (Katharine Isabelle) death by serrated knife to

the neck is presented in slow motion. As her neck gives in under the weight of her head, a spurt of blood that stains the pane of glass separating her from her friends crowns a moment that has no real narrative *raison d'être*. Neither is it possible to laugh at the scene, since the death of Tamara can come as a shock and even as pitiful, especially if the viewer has warmed up to her funny character or was partial to Isabelle's acting style. Similarly, a number of directors, most notably, Dario Argento and Takashi Miike, have garnered reputations based on their fetishized, and sometimes sexualised, presentation of murder. Watching the death scenes in their films need not force a sense of reflection for the fan or connoisseur, who may well be engaging in different ways with the images: assessing them aesthetically (as a thing of beauty), looking for a unique directorial touch or apprehending them as artistic exercises that need not be taken seriously. But, in other cases, especially where viewers might not have this cultural capital or fan investment, it is likely that reactions might vary from looking away to being horrified and/or shaken. Concomitant feelings of guilt and shame may then be triggered alongside others that place responsibility on what the film has done or dared to portray (anger, disbelief, outrage). The latter, when the viewer was not particularly interested in being engaged in the experience in the first place, can occur irrespectively of the former or even in their stead. It is not a surprise, for example, that the reviewers of torture porn films that ended up decrying their degradation and sickness were not, in the first place, interested in Horror or in the spectacles this subgenre offers viewers.[90] Whenever the body is attacked in detail and for scopophilic pleasure, it is difficult not to feel moved to question the purpose, intention and effects of such violence, even if these queries are quickly disavowed by a knowledge of the nature of the genre.

Emotionally, seeing the human body under attack after having suffered for its well-being (dread) can be particularly affective. Empathic ties that will be explored in the next chapter may make this moment painful in more ways than the somatic and go beyond the vicarious feelings of corporeal awareness that come with the realisation of threat. Mutilated, bleeding or otherwise harmed bodies are normally kept outside social display and isolated. Similarly, the dead are duly coffined and buried or else cremated: the sight of the corpse, like that of the physically harmed body, is one that we do not tend to encounter on a day-to-day basis (other than by accident or trade). When we do encounter them, other feelings that are considered human and humane, such as concern for the harmed person's well-being, life and future normally take precedence. This means that encountering mutilation or explicit and graphically-presented murder already breaks a major social and cultural taboo, that of witnessing visceral violence.[91] The feelings of helplessness and morbid curiosity causally instigated can therefore contribute to pity and shame about our moral and ethical complicity in the Horror spectacle. Where the narrative is self-avowedly sadistic, as in the plotless *Grotesque / Gurotesuku* (Kôji Shiraishi, 2009) or *The Bunny Game* (Adam Rehmeier, 2010), both of which concentrate on the systematic torture of defenceless

characters, it is veritably difficult to avoid sensing that one ought not to be watching and, as happened with *Guinea Pig 2: Flower of Flesh and Blood / Ginî piggu 2: Chiniku no hana* (Hideshi Hino, 1985), not to question the implication and reaction one should have towards the viewing experience.[92]

As I have argued, all Horror can be seen as encouraging self-reflection to some extent, but a large number of post-millennial films have begun to do this actively and directly. If films such as *Peeping Tom* or *Henry: Portrait of a Serial Killer* (John McNaughton, 1986) began aligning the viewer with their voyeuristic killers (Henry is famously seen unflinchingly re-watching his attack on a family), Horror films such as *The Last Horror Movie* (Julian Richards, 2003) go as far as threatening to punish the viewer for deciding to watch murderous exploits. In some ways, these films are levelling strong critiques to their potential audiences that mirror the accusations often made against Horror, and also exploit contemporary fears regarding new media and the increasing availability of images of murder and mutilation on the Internet. Horror, thus, illustrates the current status of mediated violence and challenges the limits of viewing comfort, as it draws on particular loci of social unease to propose a form of fear suited to the age of digital video streaming. Scopophilia can now take central stage thanks to the abundance of cheap and user-friendly visual recording devices (phone and digital cameras) and virtual interfaces (the Internet) that have affected the way we communicate, exchange information and perceive our bodies and their roles within that context. For this reason, post-millennial Horror has borrowed heavily from the visual possibilities of new media but also tended to construct its fears around them. It feeds off what has been called "mediated voyeurism", or the act of consuming "revealing images of and information about others' apparently real and unguarded lives, often yet not always for purposes of entertainment but frequently at the expense of privacy and discourse, through the means of the mass media and the Internet" (Calvert 2000, 2–3). Horror has drawn attention to itself as a medium by presenting its narratives through different forms of new media and found original ways of generating guilt and shame about the act of engaging in the consumption of violence. Horror is invested in an ethics of the voyeuristic image of fear and aims for further affective import. *Snuff-Movie* (Bernard Rose, 2005) is a perfect example of this type of Horror and a film that is useful in illustrating the uses to which guilt and shame are put by Horror to ensure further emotional rapport.

Case Study 2: *Snuff-Movie* (2005) and the Complicit Morbid Viewer

Unlike Horror that uses found footage framing or the faux snuff subgenre, snuff Horror – as characterized by films like *Snuff Killer / La Morte in Diretta* (Bruno Mattei, 2003), *Snuff 102* (Mariano Peralta, 2007) or *Terror Trap* (Dan Garcia, 2010) – rarely attempts to look or pass for a real snuff tape.[93] The viewing process it entails is, therefore, very different, as it often encourages

and challenges the type of complex cognitive and emotional reflective pro-
cesses of guilt and shame, alongside a self-awareness that can force viewers
to question their own involvement in the consumption and circulation of
violent or graphic material. Snuff Horror narratives tend to be more complex
and nuanced, since the camera is not bound exclusively to the here and now
of a murderous yielder. It also shows artistic and cinematographic detail, a
polished and high quality end product more characteristic of mainstream
cinema and which would be difficult to find in a home-made tape or digi-
tal recording. The use of deliberately poor quality, shaky or low-definition
sequences is only resorted to in the glimpses of intradiegetic snuff recordings
in them. Snuff Horror, thus, necessarily situates itself as both a mediated and
mediating product. In terms of its capacity to mediate violence, the images
of attack and murder it chooses to display are presented as intradiegetically
real. The characters react to them, but the material is delimited by the filmic
frame and its presentation within a larger narrative that is not an actual snuff
film or attempting to pass for one. With regard to its nature as a mediated
product, the Horror film about snuff is also presented as fictitious. *Snuff 102*,
for example, is marketed as fiction, and an investment in the veracity of its
images is necessarily precluded by various extra-cinematic elements like cap-
tions, inserts or even complex camera moves.

Horror's own involvement in the exploitation of violence is a situation
more generally explored in the film about snuff and its investigation of the
complicated process of watching such material. *Hardcore*'s theatre scene
(Paul Schrader, 1979), for instance, is composed of shots of Kirsten's father
(George C. Scott) watching the snuff film and countershots of what is being
played on the screen. This set-up allows the viewer to see the exact reac-
tions the images produce in the intradiegetic consumer, thus potentiating the
intended reaction in *Hardcore*'s own viewers. As I have mentioned, these
films also often challenge spectators more directly, breaking the cinematic
fourth wall and, in their admonition of affect, incriminating them. Of these,
Snuff-Movie, an independent UK film, uses the self-reflexive-yet-exploitative
nature discussed in order to critique the problematic relationship between the
mediation of violent images and corporeal attack – the process of its genera-
tion, transmission and reception – and the aesthetics and workings of Horror.

Snuff-Movie's interest in exploring the boundaries between reality and
fiction, between fabrication and mediated "truth", is evinced through its
meta-textual interplay of different narrative layers which undermine each
other and foreground the artificiality of the final, supposedly "real", film.
For example, *Snuff-Movie* opens with a voiceover from the director, Boris
Arkadin (Jeroen Krabbé), promising that what follows is the "most shock-
ing, most explicit, most terrifying" material he has ever made and that "all
the violence, all the suffering, the horror, all of it, will be real". This claim
to authenticity is, however, instantly disavowed through an introductory
episode which borrows aesthetically from Hammer Horror and features a
post-Caesarean mother coming back from the dead as an angry, childless

vampire. The film then moves on to another highly contrived sequence that potentially re-creates the killing of Polanski's pregnant wife, Sharon Tate, at the hands of the Manson family. The sequence stands out from the previous one because some of its shots look grainy and out of focus. Seeking to replicate the look and feel of watching images recorded on a hand-held camera, all sound is subsumed to the loud running of the filmic reel, which, once more, points towards *Snuff-Movie*'s desire to present itself as counterfeit. The murder of Mary Arkadin is followed by a documentary in which the reporter seems to voice the film's own concerns: "[e]ach year over a billion people go to the movies. For most, the two-hour escape ends when the lights come up, but for some, the line between reality and fiction blurs". It is then revealed that the teenagers who murdered Mary (Lisa Enos) had been watching the film presented in *Snuff-Movie*'s opening sequence, now appropriately named *Premature Burial* and shown to be starring the deceased Mary herself. The second sequence happens to be the footage for the snuff movie they were recording the night of the killing spree. If this were not confusing enough, the sequence also turns out not to be offering the spectator the final "real" film either. As the camera pulls away from the television set, a couple sitting on a sofa become its central focus. The rest of the film chronicles the fate of the woman, Wendy Jones (Lisa Enos), as she herself becomes an accidental participant in a snuff Internet website and, thus, echoes concerns about unregulated online consumption of graphic material by the general public.[94]

Peer-to-peer file-share networks and websites have often been contested for their potential complicity in acts of sadistic voyeurism and scopophilia. A site with shock content like Rotten.com, which specialises in pictures of dead people and fatal accidents, has been sued in the past by relatives of the deceased, and some newsgroups in the Usenet.com discussion boards were shut down by the police under accusations of child porn distribution.[95] Recent studies have also shown that extreme pornography is on the rise and that the availability of obscene and illegal material is also sometimes enforced onto the unknowing Internet user through fraudulent links to "shock sites".[96] Similarly, the plots of post-millennial Horror films like *FeardotCom* (William Malone, 2002), *The Poughkeepsie Tapes* (John Erick Dowde, 2007) or *Untraceable* (Gregory Hoblit, 2008), revolve around the possible misuses of new image recording and file sharing programmes.[97] Like torture porn, a subgenre with which they have a lot in common, films about snuff offer a window into the ways in which Horror negotiates social anxieties regarding the mediation of violence whilst simultaneously exploiting its affective qualities. *Snuff-Movie* is by no means the first film to venture into this area, taking its main premise from *My Little Eye* (Marc Evans, 2002). The latter, shot entirely through a CCTV system, already tried to generate horror through its literal application of the fears that surrounded the TV programme *Big Brother* when first broadcast in the late 1990s by featuring a series of contestants who are unaware of their participation in a snuff film. *Snuff-Movie* takes this premise one step further. What

starts as Horror – the intradiegetic director, Arkadin, makes it very explicit that his aim to "horrify" and "create intense fear" – soon turns into a digital nightmare. The rooms are monitored with cameras and a CCTV system that is directly connected to the Internet. The deaths are recorded in real time and streamed on Snuff-Movie.com. This website is shown on Google's search engine as "Boris Arkadin's latest masterpiece in progress", featuring "over 50 live cams of continuous horror".

In this way, *Snuff-Movie* proposes a traumatised man's vision of the perfect Horror film through a reality TV nightmare scenario facilitated by the Internet. When Mary questions the director about the unusual recording process of the film, he logically contends that the crew is "gone the way of all over-manned archaic technology, supplanted by machines, and the audience [is] hopefully still out there in the dark, watching". The cameras in this self-professed "house of death" can see the people, but also what they are seeing. This provides for the perfect voyeuristic experience and, as with the DVD version of *My Little Eye*, the audience is given the option of watching the moment of death from various possible POVs.[98] Accordingly, and in the interest of maximum affect, when a murder is anticipated, the system prompts the user to jump directly to the director's cut. The film seems to imply that this controlled version of the experience searches for the cameras and angles that will provide the most lifelike mediation of the moment of death. Once the victim has been "snuffed out", the free website automatically offers the user the possibility of a replay. Most controversially, the only website user in the film happens to be Wendy's own boyfriend (Alastair Mackenzie). He is portrayed searching for pornography prior to his search for Arkadin's project. The point is clear: we are all involved in the exploitation of other people's bodies and, if we continue to behave unthinkingly, it could well be our partners whose murder we accidentally click on next.

Snuff-Movie also emphasises the pornographic appeal of the website by literally undressing Wendy in her acting audition. During her interview, she is forced to strip down because "there is a nudity content in the film" and the director is more likely to choose her if he is sent a full-frontal shot. This video, edited so as to make Wendy appear more licentious, is then uploaded onto the snuff website without the actress's content. The link between both types of gaze, voyeuristic and morbid, is thus cemented. In this respect, the aforementioned sofa scene is intriguing for its suggestion that the type of scopophilia that leads to virtual snuff films is inseparable from new digital technologies. As the lovers start getting randy on the sofa, the shot cuts to a zoom-in of the green light of their DVD-player. The scene then cuts to a counter-shot framing the heaving figures of the lovers from the POV of the device – we know this because it is an iris shot. This scene does not have a direct bearing on the latter action because no one is revealed to have been spying. Instead, the scene would seem to have been added for the sole purpose of signalling that voyeurism lies at the heart of the digital world and of *Snuff-Movie*. Viewers are actively aligned with the cameras and the users of such entertainment by analogy.

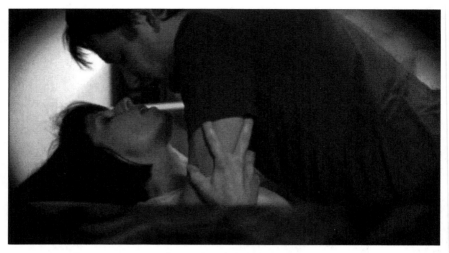

Figure 2.7 The viewer is complicity aligned with the hidden camera in this iris shot of *Snuff-Movie* (2005) and thus asked to question his/her own voyeuristic involvement.

The film acknowledges the types of unreflective affective spectacles digital technologies encourage because they necessarily culminate in a monitoring and policing of people by disembodied entities that may pose a very real threat to their lives. Snuff Horror exposes the danger that indiscriminate access to images and videos of all kinds might lead to deregulated exploitative ventures like Arkadin's. The rise of privacy settings in networking sites like *Facebook* and the mediation of events such as 9/11 would seem characteristic of an inextricable dependence on systems of image control in keeping with the logic of "control societies" (Deleuze 1995, 178). As Woodward has argued (2010, 230), in Western countries, where the installation and monitoring of security cameras is mandatory for most businesses, scopophobia, or the morbid fear of being watched by others, has come to define the contemporary subject. The computerization of trade through Internet shopping has also sparked interest in the possible culture of surveillance behind the boundless freedom and choice that such digital technologies seemingly promise. As Dean Lockwood has explained, "[c]omputer-tracked swipe card access and credit-card based consumption can also be considered a sort of electronic tagging, introducing openings and closings we can never guarantee" (2009, 45). Given this zeitgeist, the foregrounding of CCTV cameras in the *Saw* franchise, and the torture auctions in *Hostel Part II*, the ease with which an Internet snuff *Big Brother* can be created in *Snuff-Movie* is perfectly symptomatic of a digital age eager to question the moral involvement of viewers. These filmic examples declaim the potential misuse of monitoring systems and the ease with which Internet users can now upload and access real instances of violence such as Al-Qaeda's online beheadings or

the execution of Sadam Hussein in 2006 – not to mention the more directly participatory online experiences of death offered by some American prisons that support the death penalty.[99]

Horror thus challenges the viewer's involvement and their possible complicity in the audio-visual exchange but also benefits from it affectively. *Snuff-Movie* interrogates the logic and limits of the potential appeal of being a part of a self-avowedly voyeuristic experience. It is interested in the negotiation of the guilt inherent to the process of consumption of images of corporeal attack. By constantly aligning the viewing of violent images within the film (Wendy's husband's Internet practices) with the viewing of *Snuff-Movie* itself, the film manages to create a strange emotional state of confusion, self-awareness and, potentially, guilt and shame. *Snuff-Movie* is a hypocritically violent film, as, among other scenes of exploitation, Wendy is crucified in the nude. But it is also a film that self-deconstructs, especially when various deaths are revealed to be fake after the raiding of Arkadin's house. These events remind the viewer that what they have been watching is not real. This has two effects: to emotionally detach the viewer from the horror, as empathy is harder to sustain for suffering victims when it is made obvious that their suffering is feigned. Also, since expectations are constantly subverted in the film, it is possible that viewers are weary of its treatment of that violence. The second effect, thus, is the encouragement of a deep questioning of the violence that has been included. In other words, it is natural to reflect on the purpose of the film's revelation of the inner workings that could make it, potentially, more affective if kept undisclosed. *Snuff-Movie* offers the viewer a partial answer. As the report of Mary's murder inevitably leads to speculations about the motives and their connection to the killers' passion for Horror, the documentary explains that:

> people talk about horror films as [...] having a negative impact and [...] turning kids on to violence. I think what some people tend not to notice is that horror films, by definition, are the only genre films that encourage negative reaction to the violence that they depict.

Snuff-Film points to its own construction as affective product in order to draw attention, as I have suggested, to its potentially negative social impact. This type of post-modern artifice necessarily generates feelings of guilt and shame in the viewer, who is made morbidly complicit in the circulation of the images (by watching them) and, therefore, their production (these films would not exist unless there was an audience for them). Because it is difficult to carry on engaging with similar films if one does not purge, or at least attempt to deal with, the complicity thereby generated, it is likely that some of the frustration will be projected towards the film itself, which may be accused of being disingenuous about its treatment.

An example of this are reviews of *Untraceable*, which tackles a very similar topic. The reflective element of the film was fiercely condemned and

understood to be hypocritical. Carla Meyer complained about its mixed message.

> *Untraceable* condemns Internet voyeurism as it lingers on graphic images of a serial killer's victims being tortured. Somewhere in the movie is a topical commentary on modern technology encouraging unhealthy curiosity. But it's buried beneath too much hypocrisy.
>
> (Meyer 2008, not paginated)

It is this double-standard which, I suggest, makes for an unpleasant, because deeply involved, viewing experience. Unlike the relatively straightforward slashers, which may be left behind without excessive reflective involvement, the snuff Horror of *Snuff-Movie* seems to make the viewer part and parcel, as well as indirect subject matter, of the crime of deriving pleasure from images of corporeal attack, torture and death. Its capacity to generate viewing responsibility addresses the perennial question "should you be watching this and, more importantly, exactly what pleasure do you derive from it?" *Snuff-Movie* also asks "what does this film say about received and 'normalized' viewing practices of Horror?" Recent Horror has actively placed spectators in the challenging position of being both judges and victims, the torturers and the tortured. We have become reluctant mediators of the horror itself. This is evident from the critical reactions to the films, which signal a reluctance to accept the titillation inherent to their horrifying aspects. It is, in other words, an artistic pursuit that brings viewers too dangerously close to the material portrayed.

Snuff-Movie, like a number of other Horror films, is very aware of its mediating role in the affective-corporeal model. On the one hand, it uses new forms of media as the narrative elements that determine the end product and potentially make the film appealing in the first instance. The emphasis on new media can be explained as the prefiguring of verisimilitude as a selling point, because, if the film can successfully sell itself as a "real" event, this adds value to its affective qualities: it is experientially closer to the real thing and therefore can be more effectively disturbing and morally complicitous. *Snuff-Movie*, and Horror more generally, forces viewers to assess their own position as consumers of mutilation and death and as viewing subjects who enjoy being scared at the expense of the fictional suffering of others.

Conclusion: The Relevance of Emotion to an Affective-Corporeal Model of Horror

An excessive focus on representation might lead to conclusions that are purely pictorial and do not encompass the various kinaesthetic aspects of Horror: from the perceptual ones, such as the use and processing of motion, to the more complex ones, such as the ways in which certain scenes affect us emotionally because of what we know and what we have experienced.

The final scene in *The Blair Witch Project*, where Heather (Heather Donahue) returns to the basement to discover Mike (Michael C. Williams) facing a corner before dropping violently on the floor, relies on our knowledge of the film's background story, especially the specifics of the witch's murder, for full effect. At the point where we recognise Mike's position and the import of that meaning, we instantly recognise that Heather is in danger and are therefore likely to be even more afraid or apprehensive about the dropping of the camera and Heather's implied death. At an emotional level, *Blair Witch* seeks constantly to create moods and atmospheres that replicate the feelings of its characters: frustration, disorientation, threat-induced fear that is also largely imaginative or driven by suggestion. Turning to the ways in which Horror films actively seek to produce these states and how they can manage to do so successfully is important for various reasons. First, contrary to what is traditionally thought, it is difficult for Horror to be scary. Although it can rely on a number of stock formulas, these do not guarantee a reaction. In fact, since Horror audiences are often quite knowledgeable and savvy, the opposite is likely true. Focusing our attention on the shifts in, say, over-reliance and eventual exhaustion of one subgenre or set of emotional stimuli can be useful in determining the degree to which periods or eras in Horror do not simply represent contemporary anxieties or industrial pressures. An affective-corporeal approach acknowledges that creating Horror, generating a sense of vulnerability in threat, requires recycling and renewal of the cinematic elements and compositions that lead to this and concomitant emotions in new contexts and in new audiences. The exhaustion of torture porn and the return of the possession film could, thus, be read under these experiential and emotional coordinates.

Second, acknowledging the emotional import of Horror, the feeling of fear that develops from an awareness of physical threat, can be useful in demarcating the limits of the genre or exploring the fine line between genre products and films that only resort to the horrific at certain points in the narrative, like *Prometheus*. An affective-corporeal approach is, therefore, interested in the machinery of Horror and connects a cognitive-formalist approach with an emotional one that goes back to the text itself and the ways in which it seeks to affect its viewers. Although it cannot account for individual experiences of a given film, since these vary widely according to a number of factors, it can provide general patterns for the choices that were made at either aesthetic or compositional levels and suggest the ways in which the viewing body is not a passive subject in the filmic exchange.[100] In this respect, the approach can be said to be truer to the expectations of the genre and be more obviously connected to the reception and consumption of Horror. Whilst there are a number of reasons why people might choose to watch Horror, the desire to be frightened and experience fear is still a significant one and is equally determining for viewers who do not watch it because they have certain expectations of presumptions about what the genre will show or do to them. This is, most certainly, a more intuitive

way of finding value in Horror than proposing apposite readings about its transgressive qualities that, at times, depend on points of reference viewers might not share. Whilst socio-political readings of Horror are necessary, they hardly ever cover the experiential side of Horror. As I have suggested, this is problematic when, for fans and casual viewers, the latter may be more consciously present in the decision of watching a film in the first place.

Finally, emotion and cognition start to show that, while it is structurally useful to separate forms of horrific affect for the purpose of dealing with the areas of corporeal experience they more readily exploit, these are clearly intertwined and work together to create an emotional-affective canvas that is often difficult to separate into its constituents. However, being aware of the filmic experiences that require cognition and emotional input is helpful in determining the specific reasons for which a certain scene might, or not, be scary or create, for example, somatic empathy.

I have been particularly preoccupied in this account with the ways in which situations and thought can be emotionally contagious: threat situates us and the characters on a similar experiential level so that what we feel when we watch effective scenes of dread or survival suspense is not exactly what the characters feel, but something tantamount to it. The following chapter traces the intricacies of the connections we make with the bodies of the characters and their predicaments and also moves on to consider the instances where our body is directly attacked by the film alongside, or in lieu of, that of the characters. Considering somatics, then, does not so much constitute a break from emotion but an extension of work that focuses its attention on the physicality of corporeal attacks, the vulnerability of the body and the human capacity to understand pain and its neurophysiological consequences.

Notes

1. See Anderson (1996), Bordwell (1985), Bordwell and Carroll (1996), Carroll (1988; 1990), Grodal (1997), Münsterberg (2004, 48–56), Smith (1995) and Tan (1996). See also Plantinga and Smith (1999). I am not including Carl Plantinga's work here because I take it to be more concerned with affect, but I am aware that, in his writing, affect and cognition are imbricated and even interchangeable terms. See, for example, Plantinga (2009b).
2. Some of these theories, such as Anderson's (1996), are also not interested in filmic instances but in the meaning-making process of film more widely.
3. I am aware of the fact that, as Prinz has argued, all emotions can be said to be "embodied appraisals" (2004, 52–78), that is, that we cannot usefully separate emotions themselves from bodily reactions.
4. For more on the rejection of "Grand Theory", mainly psychoanalysis, semiotics and ideology, see Sinnerbrink (2011, 13–27). The most significant of the works that challenged these theories is Carroll (1988).
5. See Currie (1999b), Leibowitz (1996), Carroll (1981/2) and Peterson (1996).
6. For an overview of the other issues, see Smuts (2014, 4–11).

7. Another potential complication of Grodal's model is that its workings do not allow for a sufficient distance between Horror and the thriller. Although both have areas of contact, I would argue that the corporal encounters in them, especially in explicit Horror, are qualitatively different.

8. Part of the problem is that the cognitive processes being proposed require a general and, I would argue, holistic, understanding of a film, a task which might not become possible until the film has been viewed in its totality.

9. Freeland says that modern Horror includes scenes of "over-the-top, ever-escalating graphic violence and gore (or 'FX' [effects] as the fans say). It is common to witness gross bloody dismemberments, piles of internal organs, numerous corpses in stages of decay, headless bodies, knives or chain saws slashing away at flesh, and general orgies of mayhem. In these films, flesh becomes meat, the inside becomes the outside, blood pours out, skin is stripped off, viscera exposed, heads detached. People die in a number of creatively disgusting ways" (2000, 242).

10. The films are *The Texas Chain Saw Massacre* (Tobe Hooper, 1972), *Halloween* (John Carpenter, 1978) and *A Nightmare on Elm Street* (Wes Craven, 1984), among others.

11. See Paul (1994). "Splatstick", as a mix of comedy and Horror, will sometimes rely, in some scenes, in the corporeal workings of Horror, but it is likely to mix these up with higher doses of disgust and black humour. Perfect examples are *The Evil Dead* (Sam Raimi, 1981) or *Braindead* (Peter Jackson, 1992).

12. Freeland defines numbers as "sequences of heightened spectacle and emotion" that are not necessarily strictly connected to the narrative of the film (although they can serve that purpose too). They typically involve "[v]isions of monsters and their behavior or scenes of exaggerated violence" (2000, 256). For me, the numbers are instances of cinematic threat and need not include a monster. Sequences that create dread, or indeed the ever-so-powerful startle effect, need not derive in violence or feature a monster and could still be considered numbers. The cat in the cupboard sequence in *Alien* (Ridley Scott, 1979) is a good example.

13. Although all films feature Jigsaw, he is expendable enough to die in the third (of seven) films. The punitive system he encourages, and which enables the trap-victim-test scenarios, is largely independent and can be activated by a number of subjects or disciples. Featurettes in the DVD releases also, importantly, were often dedicated to the traps and not the characters. For more on this, see Aldana Reyes (2016).

14. The difference is best epitomised in the treatment of the climax of *Saw* (where Dr. Gordon (Cary Elwes) severs his own foot, a moment the camera does not show directly) and that of *Saw III*. In the latter, Jigsaw's cranial surgery is shown in close-up and as part of a prolonged sequence the main purpose of which is to create tension and fearful disgust.

15. I am not suggesting that the scene is completely irrelevant but that it does not fulfil a significant narrative purpose. Jigsaw still dies at the end.

16. Freeland's points about the "participatory graphic" or "perverse sublime" are similarly problematic in the relatively uncomplicated identificatory proposition and statements of fan tendencies that rely on repeated exposure and even acclimatisation to the genre. Her reliance on the notion that viewers necessarily identify with the "forces of destruction" and "celebrate evil" (2000, 243) feels antithetical to the genre, and indeed, a hard statement to prove. It is not

necessary to identify with Leatherface (Gunmar Hansen) in *The Texas Chain Saw Massacre*. In fact, this is actively discouraged by the narrative, which aligns the viewer very strongly with Sally (Marilyn Burns), especially in the latter part of the film. Similarly, the celebration of Leatherface is not actively championed and may well depend on subsequent viewings or a previous knowledge of the film and its characters. The film, however, clearly positions Leatherface as a threat, as a figure to fear.

17. The same would hold true for the histrionic, comedic excess of the splatstick sequence, where its extremity might be one of the aspects by which the success of the film is measured.

18. For more on the paradox of pleasurable pain in film and art, see Smuts (2007; 2009).

19. For previous significant psychoanalytic and materialist historicist accounts, see Grixti (1989), Jones (1971), Tudor (1989), Twitchell (1985) and Wood (1978; 1980).

20. Neither can we speak, at a strictly experiential level, of "horror" as a feeling or, at least, not without conceiving of that emotion as composed of other emotions such as dread, fear and shock.

21. For more on the difference between the object-directed theory of emotions and the feeling theory of emotions, see Whiting (2009).

22. For some key responses to Carroll, see Feagin (1992), Gaut (1993), Hills (2003), Neill (1992), R. Solomon (1992) and Vorobej (1997). For newer work that attempts to restore significance to the monster as part of the "purpose" of Horror, see Ochoa (2011).

23. If only threatening, the feeling would be fear and, if only impure, the feeling would be disgust (Carroll 1990, 28). Why fear is being separated from horror here or why it would not, in its own right, be sufficient as a source of art-horror is not entirely clear.

24. As opposed to a "dispositional emotional state" like "undying envy" (Carroll 1990, 24). It is important to note that "art-dread", which Carroll coins in order to explain the type of feeling generated by uncanny events or monsters, does not rely on disgust (42). A fully-fledged theory of dread is not provided, although it is suggested it creates an engagement with the realisation that "anxiety" and "foreboding" through "unavowed, unknown and perhaps concealed and inexplicable forces rul[ing] the universe" (42) and that this separates it from art-horror. Not only is this counterintuitive (Horror, as it is used by its readers and marketers, covers "art-dread"), but this intellectual sleight of hand also, as happens with shock, separates it from art-horror unnecessarily. Both are, to my mind, parts of the cognitive experience of horror and, regardless of the explicit cause of the threat, tend to generate similar results. The difference is one of treatment: whilst dread plays with anticipation and buildup, the attack of the monster can exploit shock, fear, surprise and disgust.

25. I am not suggesting this instant, on its own, is sufficient to grant the film the appellative "Horror". *Paranormal Activity* also evokes other Horror-connected emotions such as dread.

26. In replies to criticism of his theory, Carroll justifies his take on the serial killer or, for example, the monstrous beast (the shark in Steven Spielberg's *Jaws* (1975)), by suggesting that, although not strictly monsters, they act and are perceived in the same way. See Carroll (1992).

27. In this example, Poe could be understood as a game-changing writer who had a huge impact on the psychological turn of Horror in the late eighteenth century.

28. On the "explained supernatural", see Clery (1995, 106–14). For the difference between terror and horror, see Radcliffe (1826).

29. See Geary (1987).

30. Carroll acknowledges that "shock is often involved in tandem with art-horror" (1990, 36) and neatly separates it from the latter because it is a reflex. However, it is not entirely clear why the resulting effect is different from the physical correlates that he sees in emotion or why they should not be part of art-horror. His more general point is, of course, that it is possible to be art-horrified without feeling shock, but this position seems to unnecessarily create a schism between "a well-known scare tactic" (36) and the workings of art-horror. My view is that both are different aspects of the corporeal experience of Horror.

31. In fact, the truck-heading-for-you scenario could be said to rely more on the self-preservation instinct, which is not exclusively human, than on emotion.

32. In other words, we do not need to believe in the existence of the Count in *Dracula* in order to be scared by him. See Carroll (1990, 81).

33. See for, example, Freeland (2000, 267), who sees the monster as the centre of the spectacle of Horror's numbers.

34. In any case, if the film does not strictly feel like Horror, I would argue that this is because the deaths of the victims are often encountered after the fact (post-mortem) and that the focus relies on the investigation. Like *The Silence of the Lambs* (Jonathan Demme, 1991), its belonging to Horror is a question of personal opinion and will depend on what one believes to be characteristic of the genre.

35. For more on the connection between trauma, power and contemporary Horror, see, among others, Blake (2008, 123–86), the essays in Hantke (2010) and Briefel and Miller (2012), and Wetmore (2012). For more on the position of the body, see Aldana Reyes (2014).

36. I have laid out a similar approach to the Gothic in "Gothic Affect: An Alternative Approach to Critical Models of the Contemporary Gothic" (Aldana Reyes 2015b).

37. For audience research in Horror, see Weaver and Tamborini (1996), although it should be noted that the essays in this study are out of date and do not cover the post-millennial period. For an introduction to fan practices and their engagement with Horror, see Hills (2005, 71–108).

38. Hence recurrent messages daring the viewer to watch and even "survive" the experience, as in the theatrical trailer for *Saw 3D* (Kevin Greutert, 2010).

39. Some critics have seen this, as well as the allure of power connected to it, as a crucial element of Horror. See Shaw (2001).

40. This is not the case, I would argue, if the bad characters were to be killed swiftly or in little detail. It is the focus on torture and painful death that kick-starts the moment of horror in this film and not the appearance of threat, which is malleable and shifts throughout *I Spit on Your Grave*.

41. This is assuming that, in the fictional world of the film, viewers are ok with the concept of corporeal punishment and even murder as effective revenge tools. These are, for some, unjustifiable punishment methods and may, for that reason, make a sympathetic connection with the killer/monster impossible or difficult.

42. It is obvious that the image has been altered and that the film stock has been added in post-production, although this does not alter the way the trailer is potentially consumed.

43. See Öhman, Flykt and Esteves (2001).

44. I am not denying that animals hide when they feel under threat (they do) but rather that the action of partially hiding one's face or of looking away when faced with images that elicit a sense of threat is human and, at least partly, culturally coded.

45. See Greenberg, Pyszczynski and Solomon (1986), who base their theory on the work of cultural anthropologist Ernest Becker.

46. See Arndt, Cook and Routledge (2004) and Webber et al. (2015).

47. See, for example, Greenberg et al. (1994) and Webber et al. (2015).

48. Arguably, this disappointment is the reason why the trap returns constantly in the series and is finally seen in all its visceral glory in *Saw 3D*. It is also interesting that the scene offsets this limitation by having Amanda eviscerate a living man.

49. Treatment and intent are, therefore, crucial in determining the differences between the reverse trap scene I have been discussing and, for example, the laser beam scene in *Goldfinger* (Guy Hamilton, 1964), which is not coded as horrific in the same terms.

50. See LaBoe (2014).

51. Morton (2013, 41) makes a similar point when talking about how someone who is predisposed to fear spiders will naturally read their moves as attacks or threats.

52. This is why, sometimes, the impact of a scene that uses threat in non-genre films can be even more affective. It is less expected and thus can shock us more vehemently. Similarly, Horror tends to mix cold and hot showers and some-times interrupts scenes of apparent quiet with a moment of sudden horror that is all the more powerful because there has been no buildup.

53. See Worland (2007, 81–2).

54. I say it is more intuitive because "terror", if we are to follow its development as a term developed in consonance with the Gothic novel, is traditionally connected to the "supernatural explained" of Ann Radcliffe and the sublime or, at any rate, evokes the encounter with the unknown or with unexplained phenomena. See Aldana Reyes (2015a).

55. Although, as with *Cloverfield*, it is very possible that what could be termed political fears surrounding terrorism flavour and inflect the depiction of the source of threat.

56. For introductory approximations to found footage, see Blake and Aldana Reyes (2015), Heller-Nicholas (2014), Hoover (2014) and Zimmer (2015). See also Benson-Allott (2013, 167–202), although she calls it "faux footage horror".

57. Aldana Reyes (2015c).

58. Both captions are from the international trailer, which also asked viewers to "be ready".

59. The most obvious exception is the scene, twenty minutes in, where the image is rewound, something which suggests an external agent tampering with the footage and which interrupts the almost seamless flow of the action.

60. The choice of Manuela Velasco as Ángela is also not accidental, as she famously worked on Spanish TV for a number of years and would have been

recognisable from her participation in long-running programmes such as *Del 40 al 1.*

61. For more on the use and mediation of violence in the snuff genre, see Aldana Reyes (2015d).
62. As I have argued (Aldana Reyes, 2015c), the critical and fan failure of *[•REC]3: Genesis / [•REC]3: Génesis* (Paco Plaza, 2012) partly stems from the fact that this illusion is shattered when the first-person camera switches to the more general omniscient one.
63. The filmmakers had previously, in interviews, acknowledged the influence of video games in the type of visual experience they were trying to achieve. Unsurprisingly, 2013 saw the release of *Outlast*, the first video game almost exclusively played through a video camera and using night vision.
64. For more on night vision in Horror, see Soltysik Monnet (2015).
65. A desire to read this information is, presumably, what led to its eventual inclusion in the official book about the quartet. See Tato Reig (2014).
66. Further instalments in the series may choose to resolve some of these issues but this does not affect this particular film. In fact, that the apparent zombies turn out to be subjects psychically controlled by the host in the *niña* Medeiros was definitely disappointing for me, since it introduced a degree of supernatural involvement that made the zombie-like creatures less interesting and primal.
67. Even *The Blair Witch Project* was a lot more subtle in its scares, and the moments of shock are less frequent.
68. The moral ambiguity introduced by the dubious team and health authorities, plus the fact that the police seem to be as much in the dark as the other characters, means that they cannot be feared in the same way as the feral zombie creatures. If anything, they are perceived more as a restraint or inconvenience.
69. I would argue that this (mis)connection has cemented as a result of the fact that successful films that have relied on prolonged scenes of anticipatory dread which do not lead to a reveal have often been perceived as more accomplished than those which "show". The best example is the ending of *Night of the Demon* (Jacques Tourneur, 1957), which received heavy criticism for revealing the monster it, for the most part, subtly implies.
70. See Freeland (2004, 189).
71. Freeland's collapse of dread with Edmund Burke's notion the sublime (2004, 192) only complicates matters further, as Burke's own account is particularly loose and all-encompassing and more interested in sources than in emotional processes.
72. It is also important not to confuse dread, in the sense in which I am using it here, with premonition or uncanny scenes (Freeland 2004, 193).
73. In direct horror, the main emphasis is the concrete and direct event.
74. Similar cases could be made for films like *Insidious* (James Wan, 2010) or *Sinister II* (Ciaran Foy, 2015).
75. The most important of these are her hallucinations: her seeing the Babadook's clothes at the police station and even the signature pencil-shadowed hands on the police agent (Adam Morgan) who tries to help her, and, most tellingly, a cockroach infestation that is not there. We know these visions are not real because other human beings do not react to them. However, it is entirely plausible that she is being haunted and that these hallucinations are created by the Babadook.

76. Another example is the scene in which various women are dancing to "The Locomotion", where background noise and flashes of light are coupled with countershots of Nikki's confused reaction. It is hard to say, however, to what extent dread manifests here or whether the scene is meant to create unease and confusion more generally, given that the film is structurally complex and, as a whole, more obviously avant-garde than Horror.

77. I say can because, as happens a couple of times, characters are confused as to the "evil" nature of some people who walk towards them. In one specific case, the walk of a character is exploited for dread but the feeling ultimately refuted when the person turns out to be "normal".

78. Surely, the difference (if there is one) between the dog and the dentist examples is related to duration and not to quality. The anchoring point in the case of the dog is also the anticipation of pain or even worse. It is not that the two conflate (Hanich 2010, 157) but that they take place closer to each other in time. It is also unclear if the anticipation of pain in the case of the dentist is connected to fear of the anaesthetic wearing off, which would be a different type of dispositional fear and one we are unlikely to feel vicariously in film.

79. Another case entirely is whether they do so successfully or whether they work on individual viewers with different backgrounds, experiences and knowledge of the genre.

80. I am deliberately not discussing whether the Babadook is a metaphorical embodiment of trauma, as that is a meaning-making process that exceeds the situational circumstances of the moment of dread itself.

81. Hence, in part, the survival horror genre in video games, which, in turn, influenced Horror. For more on this topic, see the essays in Perron (2009).

82. As I have explained, the morbid curiosity that drives scenes where the character is sure to die is slightly different, as the suspense is not comparable. The viewer will not fear for the safety of the characters but might still feel suspense over the specificity of their death and the way in which it will be represented as spectacle. Surprise is also important, as viewers might not necessarily know exactly when the character will be killed or what will trigger their death.

83. Hanich makes a similar point in *Cinematic Emotion* (2010, 203–5, 216–8).

84. Balun is referring to films such as *Last House on Dead End Street* (Roger Watkins, 1972), *Fight for Your Life* (Robert A. Endelson, 1977), the original *I Spit on Your Grave* (1978) and *Maniac* (William Lustig, 1980).

85. I am not including here splatstick or other forms of extreme Horror that include comedy, since the latter has a direct effect in the way we receive affect and can even diffuse what would otherwise produce fearful disgust and dread.

86. It should be noted, however, that the scream of the toddler that is kept in the car in the "fantasy" can be heard in the background. This element leaves the reality of the episode ambiguous.

87. For more on direct address in this film, see Brown (2012, 24–30).

88. For two representative examples of academic texts that have asked the "why horror?" question, see Tudor (1997) and the documentary *Why Horror?* (Nikolas Kleiman and Rob Lindsay, 2014).

89. Of course, the comedic treatment does not preclude the affective impact of the images completely, and these films often mix the two formulas successfully so that they can both horrify and generate laughter.

90. See Jones (2013, 27–39).

91. Another important taboo and one that continues to be controversial is that of the sexualised presentation of violence, especially where female bodies are concerned. This has, in the cases of films such as *A Serbian Film / Srpski film* (Srđan Spasojević, 2010) and *The Human Centipede II: Full Sequence*, led to some of the most substantial cuts in twenty-first century UK censorship.
92. *Guinea Pig 2* famously drove actor Charlie Sheen to take action as a result of moral objection: he took the film to the authorities in the belief that he had come across an actual snuff tape. See Balmain (2011).
93. Faux snuff tries to look like a "real" snuff tape/video (Jones 2011). Snuff films as they are perceived in urban legends, are tapes or videos of recorded murder sold in the black market.
94. The fact that both Wendy Jones and Mary Arkadin are played by the same actress, and that Wendy Jones is hired to play Mary for Arkadin's new film, contributes to the Chinese box structure of *Snuff-Movie*.
95. See Akdeniz (1999, 22–6).
96. See Jensen (2007) and Jones (2010, 130–4). "Shock sites" are different from sites with shock content in that the latter are accessed willingly by users, who have to search for the extreme images themselves. The former are normally used to shock users through a confrontation with unexpected obscene and even illegal material, and tend to be "comprised solely by the image/video itself" (Jones 2010, 124).
97. For more on the relation between mediation and these specific films, see Aldana Reyes (2013).
98. The DVD version of *My Little Eye* allows the viewer to watch the events from various points of view (cameras). In *Snuff-Movie*, this dynamic is limited to the intradiegetic reality of the film.
99. See McGuire (2007, 118–9). This website offers tours of the installations and even factsheets with the breakdown of the costs of lethal injections.
100. This is, of course, a point that has consistently been made by cognitivists and phenomenologists since, at least, the 1980s.

Bibliography

Akdeniz, Yaman. 1999. *Sex on the Net: The Dilemma of Policing Cyberspace.* Reading, UK: South Street Press.

Aldana Reyes, Xavier. 2013. "Violence and Mediation: The Ethics of Spectatorship in the Twenty-First Century Horror Film". In *Violence and the Limits of Representation*, edited by Graham Matthews and Sam Goodman, 145–60. Basingstoke, UK: Palgrave Macmillan.

———. 2014. *Body Gothic: Corporeal Transgression in Contemporary Literature and Horror Film*. Cardiff: University of Wales Press.

———. 2015a. "Fear, Divided: Terror and Horror". *Emagazine* 67: 49–52.

———. 2015b. "Gothic Affect: An Alternative Approach to Critical Models of the Contemporary Gothic". In *New Directions in 21st-Century Gothic: The Gothic Compass*, edited by Lorna Piatti-Farnell and Donna Lee Brien, 11–23. London and New York: Routledge.

———. 2015c. "The *[•REC]* Films: Affective Possibilities and Stylistic Limitations of Found Footage Horror". In *Digital Horror: Haunted Technologies, Network Panic and the Found Footage Phenomenon*, edited by Linnie Blake and Xavier Aldana Reyes, 149–60. London and New York: I.B. Tauris.

————. 2015d. "The Mediation of Death in Snuff Films: Reflexivity, Viewer Interpellation and Ethical Implication". In *Snuff: Real Death and Screen Media*, edited by Neil Jackson, Shaun Kimber, Johnny Walker and Thomas Joseph Watson, 211–23. London and New York: Bloomsbury Academic.

————. 2016. "Discipline ... but Punish! The Twisted Pleasures of *Saw*'s Thanatopolitical Scaffold". In *Screening the Tortured Body: The Cinema as Scaffold*, edited by Mark de Valk. Basingstoke, UK, and and New York: Palgrave Macmillan, forthcoming.

Anderson, Joseph D. 1996. *The Reality of Illusion: An Ecological Approach to Cognitive Film Theory*. Carbondale, IL: Southern Illinois University Press.

Arndt, Jamie, Alison Cook and Clay Routledge. 2004. "The Blueprint of Terror Management: Understanding the Cognitive Architecture of Psychological Defense against the Awareness of Death". In *Handbook of Experimental Existential Psychology*, edited by Jeff Greenberg, Sander L. Koole and Tom Pyszczynski, 35–53. New York: Guilford.

Balmain, Colette. 2011. "Flesh and Blood: The Guinea Pig Films". *Asian Cinema*, 22.1: 58–69.

Balun, Chas. 1990. "I Spit on Your Face: Films That Bite". In *Splatterpunks: Extreme Horror*, edited by Paul M. Sammon, 167–83. London: Xanadu.

Barratt, Daniel. 2008. "Post-Theory, Neo-Formalism and Cognitivism". In *The Cinema Book*, edited by Pam Cook, 530–1. London: British Film Institute.

Benson-Allott, Caetlin. 2013. *Killer Tapes and Shattered Screens: Video Spectatorship from VHS to File Sharing*. London, Berkeley and Los Angeles, CA: University of California Press.

Blake, Linnie. 2008. *The Wounds of Nations: Horror Cinema, Historical Trauma and National Identity*. Manchester, UK: Manchester University Press.

————, and Xavier Aldana Reyes. 2015. "Introduction: Horror in the Digital Age". In *Digital Horror: Haunted Technologies, Network Panic and the Found Footage Phenomenon*, edited by Linnie Blake and Xavier Aldana Reyes, 1–13. London and New York: I.B. Tauris.

Bordwell, David. 1985. *Narration in the Fiction Film*. Abingdon, UK, and New York: Routledge.

Bordwell, David, and Noël Carroll, eds. 1996. "Introduction". In *Post-Theory: Reconstructing Film Studies*, edited by David Bordwell and Noël Carroll, xiii–xvii. London and Madison, WI: University of Wisconsin Press.

Briefel, Aviva, and Sam J. Miller, eds. 2012. *Horror after 9/11: World of Fear, Cinema of Terror*. Austin, TX: University of Texas Press.

Brown, Tom. 2012. *Breaking the Fourth Wall: Direct Address in the Cinema*. Edinburgh: Edinburgh University Press.

Calvert, Clay. 2000. *Voyeur Nation: Media, Privacy, and Peering in Modern Culture*. Oxford and Boulder, CO: Westview Press.

Carroll, Noël. 1981/2. "Causation, the Ampliation of Movement and Avant-Garde Film". *Millennium Film Journal* 10–11: 61–82.

————. 1988. *Mystifying Movies: Fads and Fallacies in Contemporary Film Theory*. New York: Columbia University Press.

————. 1990. *The Philosophy of Horror: Or, Paradoxes of the Heart*. London and New York: Routledge.

————. 1992. "A Paradox of the Heart: A Response to Alex Neill". *Philosophical Studies* 65.1–2: 67–74.

Clery, E. J. 1995. *The Rise of Supernatural Fiction 1762–1800.* Cambridge, UK: Cambridge University Press.

Clover, Carol J. 1992. *Men, Women and Chain Saws: Gender in the Modern Horror Film.* Princeton, NJ: Princeton University Press.

Currie, Gregory. 1999a. "Cognitivism". In *A Companion to Film Theory*, edited by Toby Miller and Robert Stam, 105–22. Oxford and Malden, MA: Blackwell Publishers.

———. 1999b. "Traces of the Real: Documentary and the Content of Photographs". *Journals of Aesthetics and Art Criticism* 57.2: 285–97.

Deleuze, Gilles. 1995. *Negotiations 1972–1990*, translated by Martin Joughin. New York: Columbia University Press.

Feagin, Susan L. 1992. "Monsters, Disgust and Fascination". *Philosophical Studies* 65.1–2: 85–90.

Freeland, Cynthia. 2000. *The Naked and the Undead: Evil and the Appeal of Horror.* Oxford and Boulder, CO: Westview Press.

———. 2004. "Horror and Art Dread". In *The Horror Film*, edited by Stephen Prince, 189–205. New Brunswick, NJ: Rutgers University Press.

Gaut, Berys. 1993. "The Paradox of Horror". *The British Journal of Aesthetics* 33.4: 333–45.

Geary, Robert F. 1987. "From Providence to Terror: The Supernatural in Gothic Fantasy". In *The Fantastic in World Literature and the Arts: Selected Essays from the Fifth International Conference on the Fantastic in the Arts*, edited by Donald E. Morse, 7–20. New York: Greenwood Press.

Greenberg, Jeff, Tom Pyszczynski and Sheldon Solomon. 1986. "The Causes and Consequences of a Need for Self-Esteem: A Terror Management Theory". In *Public Self and Private Self*, edited by Roy F. Baumeister, 189–212. New York: Springer.

Greenberg, Jeff, Tom Pyszczynski, Sheldon Solomon, Linda Simon and Michael Breus. 1994. "Role of Consciousness and Accessibility of Death-Related Thoughts in Mortality Salience Effects". *Journal of Personality and Social Psychology* 67.4: 627–37.

Grixti, Joseph. 1989. *Terrors of Uncertainty: The Cultural Contexts of Horror Fiction.* London and New York: Routledge.

Grodal, Torben. 1997. *Moving Pictures: A New Theory of Film Genres, Feelings and Cognition.* Oxford: Clarendon Press.

Hanich, Julian. 2010. *Cinematic Emotion in Horror Films and Thrillers: The Aesthetic Paradox of Pleasurable Fear.* London and New York: Routledge.

Hantke, Steffen, ed. 2010. *American Horror Film: The Genre at the Turn of the Millennium.* Jackson, MA: University Press of Mississippi.

Heller-Nicholas, Alexandra. 2014. *Found Footage Horror Films: Fear and the Appearance of Reality.* Jefferson, NC: McFarland.

Hills, Matt. 2003. "An Event-Based Definition of Art-Horror". In *Dark Thoughts: Philosophical Reflections on Cinematic Horror*, edited by Steven Jay Schneider and Daniel Shaw, 138–57. Oxford and Lanham, MA: The Scarecrow Press.

———. 2005. *The Pleasures of Horror.* London and New York: Continuum.

Hoover, Stephen. 2014. *Cheap Scares: The Essential Found Footage Horror Films.* Self-published.

Jacobs, W. W. 1902. "The Monkey's Paw". *Harper's Magazine* 105 (September), 634–9.

Jancovich, Mark. 1992. *Horror.* London: Batsford.

Jensen, Robert. 2007. *Getting Off: Pornography and the End of Masculinity.* Reading, UK: South Street Press.

Jones, Alan. 2008. "Nervous *[•REC]*". *Fangoria* 276 (October), 32–4.

Jones, Ernest. 1971. *On the Nightmare.* London: Liveright.

Jones, Steve. 2010. "Horrorporn/Pornhorror: The Problematic Communities and Contexts of Extreme Online Imagery". In *Porn.com: Making Sense of Online Pornography*, edited by Feona Attwood, 123–37. New York: Peter Lang.

———. 2011. "Dying to be Seen: Snuff-Fiction's Problematic Fantasises of 'Reality'". *Scope: An Online Journal of Film and Television Studies* 19. *http://www.scope. nottingham.ac.uk/February%202011/Jones.pdf.* Accessed December 2011.

———. 2013. *Torture Porn: Popular Horror after* Saw. Basingstoke, UK: Palgrave Macmillan.

LaBoe, Vanessa. 2014. "Deconstructing the Snake: The Relative Roles of Perception, Cognition, and Emotion on Threat Detection". *Emotion* 14.4: 701–11.

Leibovitz, Florence. 1996. "Apt Feelings, or Why 'Women's Films' Aren't Trivial". In *Post-Theory: Reconstructing Film Studies*, edited by David Bordwell and Noël Carroll, 219–29. London and Madison, WI: University of Wisconsin Press.

Lockwood, Dean. 2009. "All Stripped Down: The Spectacle of Torture Porn". *Popular Communication* 7.1: 40–8.

McGuire, Michael. 2007. *Hypercrime: The New Geometry of Harm.* London and New York: Routledge.

Meyer, Carla. 2008. "A Cursory Drama: 'Cyber' Isn't the Only Crime in the Standard Thriller *Untraceable*". *Tribune Business News*, 25 Jan 2008, n.p.

Morton, Adam. 2013. *Emotion and Imagination.* London: Polity.

Münsterberg, Hugo. 2004. *The Film: A Psychological Study.* New York: Dover.

Neill, Alex. 1992. "On a Paradox of the Heart". *Philosophical Studies* 65.1–2: 53–65.

Ochoa, George. 2011. *Deformed and Destructive Beings: The Purpose of Horror Films.* Jefferson, NC: McFarland.

Öhman, Arne, Anders Flykt and Francisco Esteves. 2001. "Emotion Drives Attention: Detecting the Snake in the Grass". *Journal of Experimental Psychology* 130.3: 466–78.

Paul, William. 1994. *Laughing, Screaming: Modern Hollywood Horror and Comedy.* New York: Columbia University Press.

Perron, Bernard. 2009. *Horror Video Games: Essays on the Fusion of Fear and Play.* Jefferson, NC: McFarland.

Peterson, James. 1996. "Is a Cognitive Approach to the Avant-Garde Cinema Perverse?" In *Post-Theory: Reconstructing Film Studies*, edited by David Bordwell and Noël Carroll, 108–29. London and Madison, WI: University of Wisconsin Press.

Plantinga, Carl. 2009a. *Moving Viewers: American Film and the Spectator's Experience.* Berkeley, CA: University of California Press.

———. 2009b. "Trauma, Pleasure, and Emotion in the Viewing of *Titanic*: A Cognitive Approach". In *Film Theory and Contemporary Hollywood Movies*, edited by Warren Buckland, 237–56. Abingdon, UK, and New York: Routledge.

Plantinga, Carl, and Greg M. Smith, eds. 1999. *Passionate Views: Film, Cognition, and Emotion.* London and Baltimore, MD: Johns Hopkins University Press.

Prinz, Jesse J. 2004. *Gut Reactions: A Perceptual Theory of Emotion.* Oxford: Oxford University Press.

Radcliffe, Ann. 1826. "On the Supernatural in Poetry". *The New Monthly Magazine and Literary Journal* 16.1: 145–52.

Shaw, Daniel. 2001. "Power, Horror and Ambivalence". *Film and Philosophy: Horror Special Edition*: 1–12.

Shelley, Mary. 1818. *Frankenstein; or, The Modern Prometheus*. London: Lackington, Hughes, Harding, Mavor and Jones.

Sinnerbrink, Robert. 2011. *New Philosophies of Film: Thinking Images*. London and New York: Continuum.

Smith, Murray. 1995. *Engaging Characters: Fiction, Emotion, and the Cinema*. Oxford: Clarendon Press.

Smuts, Aaron. 2007. "The Paradox of Painful Art". *Journal of Aesthetic Education* 41.3: 59–76.

———. 2009. "Art and Negative Affect". *Philosophy Compass* 4.1: 39–55.

———. 2014. "Cognitive and Philosophical Approaches to Horror". In *A Companion to Horror Film*, edited by Harry M. Benshoff, 3–20. Oxford and Malden, MA: Wiley-Blackwell.

Solomon, Robert C. 1992. *Entertaining Ideas: Popular Philosophical Essays 1970–1990*. New York: Prometheus Books.

———. 2003. "Real Horror". In *Dark Thoughts: Philosophic Reflections on Cinematic Horror*, edited by Steven Jay Schneider and Daniel Shaw, 230–59. Oxford and Lanham, MA: The Scarecrow Press.

Solomon, Sheldon, Jeff Greenberg and Tom Pyszczynski. 1991. "A Terror Management Theory of Social Behavior: The Psychological Functions of Self-Esteem and Cultural Worldviews". In *Advances in Experimental Social Psychology*, vol. 24, edited by Mark Zanna, 93–159. Orlando, FL: Academic Press.

Stevenson, Robert Louis. 1884. "The Body Snatcher". *Pall Mall Christmas "Extra"* (December), 3–12.

Soltysik Monnet, Agnieszka. 2015. "Night Vision in the Contemporary Horror Film". In *Digital Horror: Haunted Technologies, Network Panic and the Found Footage Phenomenon*, edited by Linnie Blake and Xavier Aldana Reyes, 123–36. London and New York: I.B. Tauris.

Tamborini, Ron. 1996. "A Model of Empathy and Emotional Reacions to Horror". In *Horror Films: Current Research on Audience Preferences and Reactions*, edited by James B. Weaver, III and Ron Tamborini, 103–23. Mahwah, NJ: Lawrence Erlbaum Associates.

Tan, Ed. 1996. *Emotion and the Structure of Narrative Film: Film as an Emotion Machine*. Abingdon, UK, and New York: Routledge.

Tato Reig, Guillermo. 2014. [•REC]: *El libro oficial*. Madrid: Timun Mas.

Tudor, Andrew. 1989. *Monsters and Mad Scientists: A Cultural History of the Horror Movie*. Oxford: Basil Blackwell.

———. 1997. "Why Horror? The Peculiar Pleasures of a Popular Genre". *Cultural Studies* 11.3: 433–63.

Twitchell, James B. 1987. *Dreadful Pleasures: Anatomy of Modern Horror*. Oxford: Oxford University Press.

Vorobej, Mark. 1997. "Monsters and the Paradox of Horror". *Dialogue: Canadian Philosophical Review* 36.2: 219–46.

Walton, Kendall. 1978a. "Fearing Fictions". *Journal of Philosophy* 75.1: 5–27.

———. 1978b. "How Remote Are Fictional Worlds from the Real World?" *The Journal of Aesthetics and Art Criticism* 37.1: 11–23.

Weaver, James B., and Ron Tamborini, eds. 1996. *Horror Films: Current Research on Audience Preferences and Reactions*. London and New York: Routledge.

Webber, David, Jeff Schimel, Erik H. Faucher, Joseph Hayes, Rui Zhang and Andy Martens. 2015. "Emotion as a Necessary Component of Threat-Induced Death Thought Accessibility and Defensive Compensation". *Motivation and Emotion* 39.1: 142–55.

Wetmore, Kevin J. 2012. *Post-9/11 Horror in American Cinema*. London and New York: Continuum.

Wheatley, Catherine. 2009. *Michael Haneke's Cinema: The Ethic of the Image*. Oxford and New York: Berghahn Books.

Whiting, Demian. 2009. "The Feeling Theory of Emotion and the Object-Directed Emotions". *European Journal of Philosophy* 19.2: 281–303.

Wood, Robin. 1978. "Return of the Repressed". *Film Comment* 14.4: 25–32.

———. 1980. "Neglected Nightmares". *Film Comment* 16.2: 24–32.

Woodward, Richard B. 2010. "Dare to Be Famous: Self-Exploitation and the Camera". In *Exposed: Voyeurism, Surveillance and the Camera*, edited by Sandra S. Phillips, 229–39. London: Tate.

Worland, Rick. 2007. *The Horror Film: An Introduction*. Oxford and Malden, MA: Blackwell.

Zimmer, Catherine. 2015. *Surveillance Cinema*. London and New York: New York University Press.

Filmography

Alien. 1979. UK and USA. Directed by Ridley Scott. Brandywine Productions.

August Underground. 2001. USA. Directed by Fred Vogel. Toetag Pictures.

Babadook, The. 2014. Australia. Directed by Jennifer Kent. Causeway Films.

Basket Case 2. 1990. USA. Directed by Frank Henenlotter. Shapiro-Glickenhaus Entertainment.

Black Sheep. 2006. New Zealand. Directed by Jonathan King. New Zealand on Air, the Daesung Group, Escapade Pictures and Singlet Films.

Blair Witch Project, The. 1999. USA. Directed by Eduardo Sánchez and Daniel Myrick. Haxan Films.

Braindead. 1992. New Zealand. Directed by Peter Jackson. WingNut Films, Avalon Studios Limited and the New Zealand Film Commission.

Bunny Game, The. 2011. USA. Directed by Adam Rehmeier. Death Mountain Productions.

Call of Cthulhu, The. 2005. Directed by Andrew Leman. The H. P. Lovecraft Historical Society.

Captivity. 2007. USA and Russia. Directed by Roland Joffé. Foresight Unlimited, After Dark Films and Freestyle Releasing.

Cat People. 1942. USA. Directed by Jacques Tourneur. RKO Radio Pictures.

Chain Saw Massacre, The. 1974. USA. Directed by Tobe Hooper. Vortex.

Cloverfield. 2008. USA. Directed by Matt Reeves. Bad Robot Productions.

Cube. 1997. Canada. Directed by Vincenzo Natali. Feature Film Project, Odeon Films, Viacom Canada, Ontario Film Development Corporation, Cube Libre, Téléfilm Canada and the Harold Greenberg Fund.

Devil Inside, The. 2012. USA. Directed by William Brent Bell. Insurge Pictures and Prototype.

Diary of the Dead. 2007. USA. Directed by George A. Romero. Artfire Films and Romero-Grunwald Productions.

Drag Me to Hell. 2009. USA. Directed by Sam Raimi. Ghost House Pictures.

Evil Dead, The. 1981. USA. Directed by Sam Raimi. Renaissance Pictures.

Evil Things. 2009. USA. Directed by Dominic Perez. Go Show Media.

FeardotCom. 2002. USA and Luxembourg. Directed by William Malone. MDP Worldwide, ApolloMedia, Fear.Com Productions Ltd., Carousel Film Company and Film Fund Luxembourg et al.

Fight for Your Life. 1977. USA. Directed by Robert A. Endelson. Fightin Family Productions.

Final Destination. 2000. USA. Directed by James Wong. Zide/Perry Productions and Hard Eight Pictures.

Final Destination 5. 2011. USA. Directed by Steven Quale. New Line Cinema, Practical Pictures and Zide/Perry Productions.

Fly, The. 1958. USA. Directed by Kurt Neumann. Twentieth Century Fox Film Corporation.

Frankenstein. 1931. USA. Directed by James Whale. Universal Pictures.

Funny Games. 1997. Austria. Directed by Michael Haneke. Wega Films.

Funny Games. 2007. USA, France, UK, Germany and Italy. Directed by Michael Haneke. Celluloid Dreams, Tartan Films and Film4 Productions.

Ghostwatch. 1992. UK. Directed by Stephen Volk. British Broadcasting Corporation. TV.

Goldfinger. 1964. UK. Directed by Guy Hamilton. Eon Productions.

Grave Encounters. 2011. Canada. Directed by the Vicious Brothers. West Wing Studios.

Grotesque / Gurotesuku. 2009. Japan. Directed by Kôji Shiraishi. Ace Deuce Entertainment and Tornado Film.

Guinea Pig 2: Flower of Flesh and Blood / Ginî piggu 2: Chiniku no hana. 1985. Japan. Directed by Hideshi Hino. Sai Enterprise.

Halloween. 1978. USA. Directed by John Carpenter. Falcon International Productions.

Happening, The. 2008. USA. Directed by M. Night Shyamalan.

Hard Candy. 2005. USA. Directed by David Slade. Vulcan Productions.

Hardcore. 1979. USA. Directed by Paul Schrader. A-Team Productions.

Hellbound: Hellraiser II. 1988. UK and USA. Directed by Tony Randel. Film Futures and Troopstar.

Hellraiser. 1987. UK. Directed by Clive Barker. Cinemarque Entertainment BV, Film Futures and Rivdel Films.

Henry: Portrait of a Serial Killer. 1986. USA. Directed by John McNaughton. Maljack Productions.

Hostel. 2005. USA. Directed by Eli Roth. Revolution Studios and Beacon Pictures.

Hostel: Part II. 2007. USA. Directed by Eli Roth. Raw Nerve and Next Entertainment.

House on Haunted Hill. 1959. USA. Directed by William Castle. William Castle Productions.

Human Centipede, The: First Sequence. 2009. Netherlands. Directed by Tom Six. Six Entertainment.

Human Centipede II, The: Full Sequence. 2011. Netherlands, UK and USA. Directed by Tom Six. Six Entertainment.

Inland Empire. 2006. USA, France and Poland. Directed by David Lynch. Absurda, Studio Canal, Fundacka Kultury and Camerimage Festival.

Insidious. 2010. USA. Directed by James Wan. IM Global, Stage 6 Films and Blumhouse Productions.

I Spit on Your Grave. 1978. USA. Directed by Meir Zarchi. Cinemagic Pictures.

I Spit on Your Grave. 2010. USA. Directed by Steven R. Monroe. CineTel Films.

It Follows. 2014. USA. Directed by David Robert Mitchell. Animal Kingdom, Northern Lights Films and Two Flints.

Jaws. 1975. USA. Directed Steven Spielberg. Zanuck/Brown Productions and Universal Pictures.

Last Exorcism, The. 2010. USA. Directed by Daniel Stamm. Strike Entertainment, StudioCanal and Arcade Pictures.

Last Horror Movie, The. 2003. UK. Directed by Julian Richards. Prolific Films and Snakehair Productions.

Last House on Dead End Street, The. 1977. USA. Directed by Roger Watkins. Production Concepts Ltd. and Today Productions Inc.

Martyrs. 2008. France. Directed by Pascal Laugier. Eskwad, Wild Bunch and TCB Film.

My Little Eye. 2002. UK. Directed by Marc Evans. StudioCanal, Working Title Films and WT2 Productions.

Night of the Demon. 1957. UK. Directed by Jacques Tourneur. Sabre.

Nightmare on Elm Street, A. 1984. USA. Directed by Wes Craven. Media Home Entertainment and Smart Egg Pictures.

Paranormal Activity. 2007. USA. Directed by Oren Peli. Blumhouse Productions and Solana Films.

Peeping Tom. 1960. UK. Directed by Michael Powell. Michael Powell (Theatre).

Poughkeepsie Tapes, The. 2007. USA. Directed by John Erick Dowdle.

Prometheus. 2012. UK and USA. Directed by Ridley Scott. Scott Free Productions, Brandywine Productions and Dune Entertainment.

Psycho. 1960. USA. Directed by Alfred Hitchcock. Shamley Production. Brothers Dowdle Productions and Poughkeepsie Films.

[•REC]. 2007. Spain. Directed by Jaume Balagueró and Paco Plaza. Filmax International.

[•REC]2. 2009. Spain. Directed by Jaume Balagueró and Paco Plaza. Filmax International.

[•REC]3: Genesis / [•REC]3: Génesis. 2012. Spain. Directed by Paco Plaza. Canal+ España and Filmax International.

Reel Evil. 2012. USA. Directed by Danny Draven. Full Moon Entertainment.

Saw. 2004. USA. Directed by James Wan. Evolution Entertainment and Twisted Pictures.

Saw II. 2005. USA and Canada. Directed by Darren Lynn Bousman. Twisted Pictures.

Saw III. 2006. USA and Canada. Directed by Darren Lynn Bousman. Twisted Pictures.

Saw 3D: The Final Chapter. 2010. USA. Directed by Kevin Greutert. Twisted Pictures.

Scream. 1996. USA. Directed by Wes Craven. Woods Entertainment.

See No Evil 2. 2014. USA. Directed by Jen and Sylvia Soska. WWE Studios.

Serbian Film, A / Srpski film. 2010. Serbia. Directed by Srđan Spasojević. Contra Film.

Se7en. 1995. USA. Directed by David Fincher. Cecchi Gori Pictures, Juno Pix and New Line Cinema.

Shaun of the Dead. 2004. UK, France and America. Directed by Edgar Wright. StudioCanal, Working Title and Big Talk Productions.

Signs. 2002. USA. Directed by M. Night Shyamalan. Blinding Edge Pictures and the Kennedy/Marshall Company.

Silence of the Lambs, The. 1991. USA. Directed by Jonathan Demme. Strong Heart/ Demme Production and Orion Pictures.

Sinister II. 2015. USA. Directed by Ciaran Foy. Alliance Films, Automatik Entertainment, Blumhouse Productions, Entertainment One, IM Global and Tank Caterpillar, Inc.

Sixth Sense, The. 1999. USA. Directed by M. Night Shyamalan. The Kennedy/ Marshall Company and Barry Mendel Productions.

Snuff Killer / La morte in diretta. 2003. Italy. Directed by Pierre Le Blanc. La Perla Nera.

Snuff-Movie. 2005. UK. Directed by Bernard Rose. Capitol Films.

Snuff 102. 2007. Argentina. Directed by Mariano Peralta. TProd Films.

Terror Is a Man. 1959. USA and The Philippines. Directed by Gerardo de León. Lynn-Romero Productions and Premiere Productions.

Terror Trap. 2010. USA. Directed by Dan Garcia. American World Pictures.

Tingler, The. 1959. USA. Directed by William Castle. Columbia Pictures and William Castle Productions.

Twilight Zone, The. 1959–64. USA. Various directors. Cayuga Productions and CBS Productions.

28 Days Later. 2002. UK. Directed by Danny Boyle. DNA Films and the British Film Council.

Unfriended. 2014. USA. Directed by Leo Gabriadze. Bazelevs Company and Blumhouse Pictures.

Untraceable. 2008. USA. Directed by Gregory Hoblit. Lakeshore Entertainment.

Why Horror? 2014. Canada, Japan, Mexico, USA and UK. Directed by Nicolas Kleiman and Rob Lindsay. Don Ferguson Productions.

Woman in Black, The. 2012. UK. Directed by James Watkins. Cross Creek Pictures, Hammer Film Productions and Exclusive Media Group.

Would You Rather? 2012. USA. Directed by David Guy Levy. Periscope Entertainment, Social Construct and Dreamher Productions.

You're Next. 2011. USA. Directed by Adam Wingard. HanWay Films and Snoot Entertainment.

3 Somatics
Startles, Somatic Empathy and Viewer Alignment

In Chapter 1, I attempted to isolate a number of corporeal images that, within the context of Horror, arouse feelings connected to fearful disgust. The reason for this is that, like the somatic responses to Horror, which are the subject of this chapter, our reactions to certain images of abjection are not always purely a result of cultural coding, even if social practices and distinctive personal traits may well influence our final responses. My intention, therefore, was to identify some of the key examples that recur in Horror to show how representations of the body under physical attack work irrespectively of, and independently from, gender because their desired effect is premised on a corporeal intelligibility that either transcends or, at least, is not necessarily coterminous with, the specificity of the bodies of the intradiegetic characters. This chapter seeks to expand this proposition by exploring the workings of the instance of pain transference that the encounter with bloodied bodies, amputations, attacks on eyes and a myriad other iconic images of Horror elicits in the bodies of viewers. In other words, where I focused on the specificity of the image to evoke certain feelings by virtue of its arousal of instinct and corporeal intelligibility, I here concentrate on the way in which Horror creates a correlation between the filmic and viewing bodies.

Although my interest lies in the somatic aspects of Horror, its capacity to affect bodies pre-cognitively or in ways that bypass complex thought processes, somatics cannot be neatly separated from cognition, as it often relies on feelings of affinity or empathy. As a result, sections of this chapter consider both somatics and the generation of feelings together. Like the previous chapter, it does not necessarily analyse examples that might add a layer of emotional complication or, even worse, guilt and shame, to the horror experience but is primarily concerned with the ways in which threat may appear to feel "real" to viewers who know perfectly well that they are consuming fiction. Since one of the issues at stake in this cinematic exchange is the capacity for the human body to vicariously feel for another, I anchor my theoretical approach, partly, in Pain Studies, because, as a discipline, it has been interested in the ways in which the pain of others may be seen to be transferable despite the fact that it is inalienably personal and hermetic. Cinematic distress is experienced at a distance and, even though the extremity of certain images or situations may sometimes pre-empt more

direct involvement, it uses strategies of contagion that rely on the human capacity to mimic and feel for others. Basing my reading on work in somatic empathy also allows me to take into account the ways in which the moment of discomfort that one feels for the body under threat is not experienced in isolation from the rest of a film even when its particularities rely on aspects that can be taken to be of little narratively importance.

Visual and Acoustic Assaults: The Startle Effect

The startle effect or the "jump scare" is, quite easily, the most prevalent somatic effect encouraged and exploited by Horror; empiric research shows a clear increase in Horror's reliance on it throughout the twentieth century (Baird 2000, 13). It can appear in different subgenres, from the possession film to torture porn, because it works irrespectively of the topic and the themes of the films themselves. Since being startled is an experience that can readily be associated with fear and being scared, it can manifest in a variety of forms.[1] However, the actual object that causes the startle, which can range from a fluffy cat in *Alien* (Ridley Scott, 1979) to a man with a butchering hammer in *The Texas Chain Saw Massacre* (Tobe Hooper, 1974), is not normally enough to startle on its own because the effect does not work representation-ally but somatically.[2] Although not all scenes of dread lead to a startle, they often do, so the startle is normally preceded by a period of anticipation and heightening of emotions that increases the chances of a strong physiological reaction. The startle effect interests me in this chapter for various reasons: firstly, it lays bare the affective quality of Horror, as its ubiquity and capac-ity for transgeneric functioning shows. Secondly, it debunks the notion that Horror affects viewers for notions related to deep psychology. Although meaning can be found *a posteriori* in the nature of the image – by, for exam-ple, examining the use of gender prejudices in the construction of monstrously feminine bodies as a source of fear – the startle effect forces us to make a dis-tinction between the affective (and emotional) work of the film and the con-comitant experiences that surround it. In other words, the startle helps us see that Horror works on many levels at once. Thirdly, it is useful in developing a model of experiential alignment between intradiegetic characters and fictional, situational coordinates that will lead me to the consideration of empathy and sympathy in scenes where the visual and auditory attacks are not enough to explain, for example, the vicarious feeling of pain occasioned by torture.

I have suggested that the startle effect is somatic and, whilst this is the case, because it is largely premised on physiological reflex and is not cognitive in the same way as dread, it is important to acknowledge that the startle also necessarily has a cultural grounding. By this, I mean that both the context of being startled by Horror and the types of experiences that generate startles are part of culture and society. However, whilst some of the specifics will vary, it is arguably its somatic universality, the fact that everyone startles and that genre knowledge of Horror and its tropes does

not preclude its impact, that has made it more significant than any specific human fear (say, of spiders). Awareness of formula, as well as auditory and visual cues, may help in discerning that a startle is about to take place, but often this is not enough to stop its effect. This is also the reason why watching the same Horror film twice, say *[•REC]* (Jaume Balagueró and Paco Plaza, 2007), might change the specific way in which some of its startles are felt, and yet, might not dilute their power altogether. In repeated views, especially where some time has gone by between them, I have found myself still startled by scenes I know are coming. To put it differently, not everyone might find a possession scene scary, but if the startle moment is orchestrated effectively, audiences can be made to jump or scream regardless of their beliefs on demons or spectres. Whether one finds the ghostly figure at the centre of *Mama* (Andrés Muschietti, 2013) – and its rather ineffective use of CGI (computer-generated imagery) might suggest otherwise – it is hard not to be startled by the scene where Dr Dreyfuss (Daniel Kash) encounters her in a derelict shed.[3] The scene, which shows the first full appearance of the character in all its monstrous glory, introduces Mama through bursts of light that come from a camera flashing in the dark (in the style of Alfred Hitchcock's *Rear Window* (1954)). After each shot, the character gets closer to the viewer, who watches from Dr Dreyfuss' POV and is, therefore, eventually "reached" by the creature, by then presented in a threatening close-up. The capacity for this scene to work on the viewer regardless of their thoughts on the rest of the film and its threatening figure is owed to the physiological or biological nature of the startle, as well as the cinematic technique used.[4]

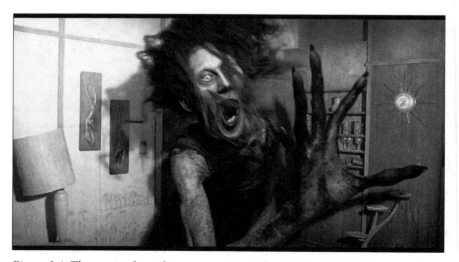

Figure 3.1 The scene where the creature materialises in *Mama* (2013) can startle the viewer through its cinematic orchestration, regardless of whether we "believe" in her.

I have proposed that the experience of Horror is largely premised on the existence of a threat that, given the appropriate treatment, may become a source of feelings and emotions such as anxiety, dread over the characters' and one's safety and, where an escape is possible, morbid suspense over the outcome. The startle effect sits in the spectrum of threat-connected reactions. As anthropological expert Ronald C. Simons explains, there is an evolutionary reason for its development in humans (and animals): "it is the mechanism designed to ensure that the startled organism responds to a potential danger as rapidly as possible, even before the eliciting stimulus is consciously classified or evaluated" (1996, 8). It is hardwired into the human body because it is precisely the "set of behaviours that would be maximally effective" and includes "physical events and alterations in attention, thought, and mood" (Simons 1996, 9). Although, in itself, it is "sensitive" rather than "selective" (8), since it does not assess the scope or extent of the threat but merely identifies it, it is also a primer for action. This biological basis, the fact that human bodies have evolutionarily developed to react to certain stimuli that represent danger, is then manipulated by Horror into specific scenes which, by playing with concentration, focus and suddenness, conjure up the reactions of the startle effect. Like the emotional states encouraged by Horror (such as dread), and even more so because it does not require an investment in the plot, narrative or characters, the startle effect can affect the viewer in the same way a real threat would. Whilst the moment leading up to the reveal, where it is signposted or prefigured, is still invested in the intradiegesis of the film, that where the viewer may be shocked by the image is not. Hence, the members of the audience in the viewings of *Paranormal Activity* (Oren Peli, 2007) I mentioned in Chapter 2 can be seen to pre-empt the images and act in anticipation (hiding behind their shirts) but are not able to control the moment where their bodies are physically prompted to react. The startle effect often translates into involuntary screaming, swearing, jumping out of the seat or various other forms of largely ungovernable behaviour.[5]

Intentionality and readiness are, therefore, key to our understanding of the startle effect, especially in order to distinguish it from the startle we may experience in real life. Although the effect is ultimately not something that can be controlled, it is important that it is perceived as either pleasurable or, at the very least, acceptable to the viewer (Simons 1996, 82). If this is not the case, the viewer will often decide not to engage with the film, images or scene in the first place for fear of the physical and, importantly, mental (traumatic) effects it/they might have on them. This is possible because Horror is a filmic experience premised on the affective and emotional states it prompts in its audience. Although the startles will rely on the same principles as those that we undergo in our everyday lives by using images or shapes that are well-known to startle (snakes, spiders, objects that move towards us at high speed), the experience is filtered by the knowledge that one is engaging in the scare wilfully. In other words, if the body cannot physiologically tell the difference

between a real and a fake strong and impactful aural or visual attack, the mind is quick to position that threat within the fictional continuum of the Horror film and our viewing situation within it. The startle effect, thus, treads the ground between precognitive affects and the intense emotional states that precede and follow it. On the one hand, pacing is important, and a sufficiently slowed-down sequence will not have the desired effect. On the other hand, a series of startle effects without some sense of direction, or within the context of larger sequences where these effects complement similar emotional states, might equally be rendered ineffective or even silly (Baird 2000, 16).

So what types of startle effects do we encounter in Horror? Since the startle effect plays, in part, with our capacity to orient in space and to predict the possible outcome of certain events, Horror messes with our expectations. An example of this is the scissors scene in *Antichrist* (Lars von Trier, 2009): although the viewer can anticipate that something will happen, there are no indications, visual or aural, that the scene will end in self-induced cliter-octomy. Less extreme examples can be found in more generic moments, especially where the threat is introduced beforehand. For example, the sudden sound of a breaking window in *It Follows* (David Robert Mitchell, 2014) indicates "it" has entered the house. Startle effects can also scare at a point where the viewer has decided, following an exposition scene designed to arouse dread, that nothing will ultimately happen. The surprise in this instance comes from both the frustrated feeling of safety and from the suddenness of the subsequent shock. In a scene in *The Quiet Ones* (John Pogue, 2014), where Jane (Olivia Cooke) is hypnotised and the spiritual presence (Evey) asked to manifest, the startle effect is accomplished this way. The viewer expects the startle, as the Professor (Jared Harris) insists that Evey manifest. The lighting and composition, slightly off kilter and focused on a gyrating stroboscope, gives early clues that the scene might end in a scare. When, after a while, this becomes less obviously the case, the viewer is likely to let down their guard and focus on other aspects of the frame or even begin to get bored. At this point, a sudden movement and crashing sound accompany the camera as it crashes on the floor and the image blurs. The startle effect is ensured here by the unexpected (anticipated yet frustrated) shock within a scene that was rather static. There are variations on this startle effect, such as the typical looking once into a wardrobe to find nothing and looking a second time, confident that there is nothing hiding in it, only to encounter the threat one initially expected. Finally, the threat-induced startle can also manifest by deceiving the viewer and appearing from a different side or angle to the one seemingly prefigured. Because these moments allow characters less time to react, especially when the threat is close by, they are less usual. As should be obvious, a lot of these effects play with psychology: viewers' capacity to orient themselves spatially, to view and perceive threats and their origins, and even to apply cause and effect hypotheses (that may or may not be frustrated).

Other forms of startle do not depend on position and the direction or unpredictability of the attack but might be aimed directly at the camera. I am talking, specifically, of direct visual attacks of the camera such as flashing lights, sudden close-ups of scary objects or images shown at great speed, especially when they hide a threat moving towards the viewer. The latter is what Baird has called the "frenzy of motion" (2000, 20), best captured by the fast shock cut of the cat coming out of the closet in *Alien*. In these instances of direct shock, the camera may be aligned with the characters so that we are experientially closer to them. Putting the viewer on the same line of vision as the character means that it is possible to fear the threat as if it coming for us; the camera becomes an extension of our perception. As my reading of found footage showed, Horror has found creative ways of turning subjective POVs into a valid filmic experience because it guarantees a sense of immediacy. This also explains the numerous attempts to produce 3D Horror, an example of which will be considered in full in the next section.

Startle effects are not only connected to the visual and/or positional possibilities offered by camera work and editing. Sound, music in particular, is a crucial part of the Horror experience and specific qualities can readily be associated with it. "[U]nresolved dissonance, atonality and timbral experimentation", as Neil Lerner argues (2010, ix), work together to create a distinctive stylistics that, although not necessarily present in every Horror film, is definitely representative of some of the most highly regarded examples of the genre. Horror music normally aims to contribute to the emotional states I have explored in previous chapters and sections, eliciting threat, unease, discomfort and edginess.[6] But sound is also an inherent part of the image outside the realm of music. It is hard to find examples of Horror where "repetitious drones, clashing dissonances, and stingers (those assaultive blasts that come with shock or revelation)" (Lerner 2010, ix) do not make at least an appearance. Importantly, these sounds are connected to the bestial, threat-detecting part of us and "affect us at a primal level" (ix) so that, when they are connected with visual stimuli that also aim to replicate a form of physical assault, scenes can trigger the startle effect. Sound is so powerful, however, that it may be sufficient to generate the startle effect through its sheer loudness, particularly within the context of cinema theatres, where the sound is amplified greatly and may have an effect beyond that of its aural perception.[7]

Formally, the startle effect can depend on various elements. Julian Hanich has proposed the most up-to-date inventory of these, which include "abrupt and rapid visual change" from one shot to another via shock cut, "frame intrusion from off-screen space" or "movement within on-screen space", and, aurally, auditory stabs.[8] All startle effects can be increased and intensified through use of certain techniques that enhance viewing attention and concentration. These strategies include disrupted relief, especially where a resolution in the narrative, such as the end of the threat, either comes back

or revives; deliberate distraction, by manipulating the attention of a viewer away from the future source of the startle; and by the intrusion of the threat through solid objects where they are not expected.[9] But I am less interested in an inventory of the phenomenological possibilities of the startle effect and more in the implications that this has for the type of connection and exacerbation of the somatic body it proposes. The startle effect may be desired by audiences precisely because it allows to "prove" and feel "how very much alive we are" (Baird 2000, 22), as the startle reminds us of our mortality. This moment, which, undoubtedly, starts with a disruption of the "phenomenological distance between film and viewer" (Hanich 2010, 146), leads, in other words, to a re-encounter or foregrounding of the somatic body.[10] This does not necessarily entail a real reaction to the source of the startle, as the startle is perceived within the context of a fictional encounter with cinematic images. As we saw with Carroll's thought theory, such a fact does not necessarily mean that the reaction cannot have the same quality of a startle in real life. In fact, since, physiologically, the reaction is the same, it could be argued that the corporeal and affective grounding of the startle works irrespectively of its source. It is the fact that Horror can work us up to a state where the somatic body is activated automatically that is significant here, for it speaks to the way in which Horror allows for an awareness and enjoyment of our corporeality. For an instant, we are unable to completely govern our reaction and this helplessness is a source of amusement for us and even those who surround us.[11]

Further work on the possible alignments and connections encouraged by Horror will be provided below but, for now, it is important to see how the premise of being under threat and of, thus, achieving a form of pleasure works out in Horror. Although my emphasis is not be purely somatic, insofar as I also consider the emotional states that surround the startle, I turn my attention to the new ways in which Horror has exploited 3D technology in order to intensify the affective import of given scenes. As I will show, this has often led to perceptual attacks that, as in found footage, create an even stronger effect because the viewer's body is felt to be under direct attack.

Case Study 1: Direct Attack of the Viewer in *My Bloody Valentine 3D* (2009)

Although not perhaps as recognisable or obvious a remake as *The Texas Chainsaw Massacre* (Marcus Nispel, 2003), *Halloween* (2007), *Friday the 13th* (Marcus Nispel, 2009) or *Poltergeist* (Gil Kenan, 2015), *My Bloody Valentine* managed to beat a number of these films at the box office by grossing over $100 million. Various reasons for its success have been suggested, among them the use of special effects, young heartthrob actors and a talented visual director.[12] The film's biggest selling point, however, was the return to 3D Horror. Horror had already been presented in 3D in the 1950s in the classic *House of Wax* (André de Toth, 1953) but not in its

digital (RealD) form. Changes connected to the technological development of 3D (*My Bloody Valentine 3D* was the first HD 3D R-rated film) turned what was initially comedy-laced Horror into a highly sombre and affective piece.[13] Concern that an R-rating might lead to marketing conflicts or mistargeting of audiences were proven wrong and, if ticket sales were not enough indication of its success, the host of 3D Horror films that followed *My Bloody Valentine* surely are.[14] Even films that continued bigger franchises, such as *Saw 3D: The Final Chapter* (Kevin Greutert, 2010), and remakes of non-3D films, such as *Piranha 3D* (Alexandra Aja, 2010), adapted the gimmick. If the general drive towards 3D films, raised by huge blockbusters such as *Avatar* (James Cameron, 2009), has already led critics and viewers to ask questions regarding cinematic realism and the nature of cinema as medium and experience, its use in Horror naturally leads to discussions about emotion and affect.[15] In a sense, the rise of 3D Horror was predictable, since, as the president of distribution for Lionsgate (the Canadian-American company responsible for *Valentine*) put it, "Horror is a perfect genre for 3D because it amplifies the terror by allowing audiences to be fully immersed in the environment" (qtd in Contrino 2009, 15). *Valentine* most definitely does this and managed to bring 3D back to the slasher.[16]

The premise of the remake follows loosely that of the original 1981 film directed by George Mihalka, where a town is suddenly beset by a spate of murders following an oversight which kills a number of local miners. In the former, these killings are initiated by a survivor of the accidents who eats his colleagues to survive and then seeks vengeance on the negligent supervisors and townsfolk who did not take heed of his warnings against celebrating St Valentine's Day (the day of the tragedy). In the 3D version, the murderer is Tom (Jensen Ackles), the mine owner's son, who is possessed by the personality of the survivor (who kills because air supply is not enough to sustain all the survivors), whether paranormally or out of traumatic guilt. In both films, the killings are carried out with a characteristic pickaxe and take place during the St Valentine celebrations. Small plot dissimilarities aside, the biggest difference, and the one that is relevant to my reading, is the aforementioned change in tone. Whilst the 1980s film included touches of "frat" comedy, the 3D remake is a lot more sinister and aims to create a series of immersive and negative emotional states.

Experientially and thematically, the film is not substantially innovative or original. Its plot, itself a spin on the slasher formula, is fairly straightforward and contains a number of the elements that have come to determine that Horror subgenre and which were effectively parodied in *The Cabin in the Woods* (Drew Goddard, 2012): the final girl, the arrival at (and disruption of) the terrible place, the serial murder set pieces that kill off the various, typically young, protagonists one-by-one and the masked killer whose identity will not be revealed until the end. Its use of emotional states is also similar. An early moment of dread, encouraged by Sarah's (Jaime King) venturing into the dark mine alone after boyfriend Tom decides to return

to the car for the keys is virtually indistinguishable from dread moments in other Horror films: the constriction of space and the ensuing sense of claustrophobia, especially underground, which was brilliantly exploited in *The Descent* (Neil Marshall, 2005); the partial occlusion of areas of vision and the silhouetting of the heroine among the spare lamps that illuminate the way, forcing us to focus on the areas we *can* see; the alignment, in some shots, with the character's line of vision, in order to establish the gloominess and potential danger of the place; or the use of dripping and gaseous sounds to punctuate Sarah's advance into the deeper bowels of the mine and, simultaneously, to signal anxiety and disquiet. It is the same case with the startle effects: a fairly standard fake startle, the accidental kicking of a bottle from behind Sarah, is of low intensity but, as in *Cat People* (Jacques Tourneur, 1942), it is sufficient to distract us from the real threat coming from the right-hand side of the screen. The fact that this new threat is also revealed to be bogus – it turns out to be her friend Axel (Kerr Smith) playing a prank – is also fairly standard. His immediate murder, and frustration of a possible sense of safety for the viewer, would also not stick out if it was not for the fact that the man's eye is gouged out and pushed towards the camera by a pickaxe.

Before I focus on direct attack, it is important to note that the use of 3D in *My Bloody Valentine* varies. In places, it is gratuitous or merely resorted to in order to give the scene a sense of depth that, as in the newspaper headlines that open the film, can even come across as unnecessary, superficial or distracting. In these instances, 3D complements depth focus to give the film additional spatial amplitude and toys with the dimensions and proximity of characters, objects and the background. In the opening scene, the foregrounded headlines and different newspaper pieces superposed on each other also serve to ground the 3D quality of the film: it is obvious, from the very start, that this is a film that uses HD 3D technology, as this is an aspect that the film wishes to highlight at the expense of a less atypical presentation of establishing shots. In case the point was missed, a disembodied digital axe is soon fired against the word "Murder?!", both positioned in the centre of the screen. Finally, the camera enters a newspaper picture which gradually gains colour and becomes the film's narrative reality, a further signal that, in this case, perspective and dimension are part and parcel of the narrative. Beyond the gimmick, the look, feel and structure of *Valentine* are, as in *[•REC]*, largely determined by 3D and the desired emotional and affective landscapes this type of immersive and mood-enhancing cinema can achieve.

But, by far the most common application of 3D in this film, and in Horror, as I have hinted at, is the generation of a sense of direct attack on the viewer via the first-person camera. The POV is normally aligned with that of victims and, most importantly, their line of vision.[17] This alignment is, at times, underscored by the film itself, which offers close-ups of the victim's eyes before jumping to the advancing threat, as happens in the scene where the methane gas explodes and a wall of fire engulfs the screen. Before

the fire, the camera zooms in on the upper side of Warden (Richard John Walters) as he slips his mask on. As in found footage Horror, in 3D Horror, the camera is attacked as if characters were suddenly behind it, regardless of which point in the shot or section of the screen they have previously inhabited. There are many moments where objects/body parts are foregrounded: Alex's eye poking out of his face, the shovel handle that sticks out of a girl's (Brandi Engel) mouth and the sliding forward of the severed upper jaw, the pickaxe being pointed at Tom/the camera from above (a low angle), blood spurting from a man's head and upwards (in a shot from above), the light from a helmet pointing our way as the killer looks under the bed. The way these murders are shot and the weapons interact with the bodies is meant to bring these cinematic moments closer to the viewer. The images do not intend to look realistic (in fact, most of the time they do not) and are there for added affective value: the effect will depend not just on their capacity to mimic the broken body digitally but, as with the startle more generally, on whether they manage to disrupt the line of vision and their perceptual experience. As I explained above, objects flying towards the camera are often enough to startle and, so, in a sense, whether Alex's jutting eye looks realistic or not is less crucial than that it juts out in the first place. This becomes more evident when one watches *Valentine* in 2D. Not only does the eye look very fake and digitally manipulated, it fails to gain the dimensional quality 3D should grant it.

For the very same reason, objects flying towards our line of vision (the camera as surrogate viewer) in a threatening manner are more affective than those that merely stick out, as in the shovel handle, or are waved around. Although foregrounded objects create a sense of depth, since they are on focus and the rest of the image blurs, flying or forcefully thrust ones (mostly the pickaxe, but also a gun at one point) can create a stronger physical reaction (reflex) because viewers are not used to following their trajectories in this way in film. The fact that, experientially, we know that approximation means contact and that an object fast heading towards us can be dangerous and painful, means we are likely to react as we would when cowering from the same threat ordinarily. The less time offered to process the threat, the less likely it is that viewers will be able to recognise the threat as not actually dangerous and, therefore, perceive it less intensely. In other words, 3D in these instances aids sound and image to strengthen or create the startle, and thus, becomes a somatic source of affect.

The best example of the use of this technique is the scene where Warden/Tom comes out of the mine and throws the pickaxe at the windshield of the car in which Sarah and her two male friends are hiding. An establishing shot of the killer moving closer, intercut with the car shot from a fairly close distance, prepares the viewer for the spinning weapon. The pickaxe swings a couple of times in the direction of the car (now us), the shot then closes up on Sarah's face and returns to the former. When the pickaxe nears the viewer and looks as though it is about to hit the camera, it is

stopped by the windshield, where it stays stuck in extreme close-up, with the pick pointing directly at, and from, the centre of the screen. The scene manages to bring us experientially closer to the moment of harm by firing the weapon at the camera and aligning the viewer with Sarah. At the same time, however, the scene reminds viewers that the POV is not strictly ours by introducing the windshield: the camera is inside the car and is, thus, perceptually Sarah's (and her friends'). To emphasise the point, the shot pulls sideways and reveals Sarah's face dangerously close to the pickaxe and the torn windshield. This technique is revisited later when Irene (Betsy Rue) is attacked by the killer and tries to protect herself with the bed's frame: the spaces between the metal rods provide ideal stabbing areas for the murderer. Unsurprisingly, the camera is placed behind the frame and, again, roughly in the same tight and confined space as Irene. The camera does not become Irene's eyes; it merely positions itself at an equivalent experiential level to make the attack more palpable. In these moments, viewers are simply, as in all Horror, invited to enter the emotional and affective world of the victim under threat in order to be scared by the situation they are in.

Figure 3.2 The killer's characteristic pickaxe is fired directly at the camera in a key affective scene in *My Bloody Valentine 3D* (2009).

These examples epitomise the basic tenets of 3D technology, which, itself, was developed to exploit the specific qualities of human vision and its processing of depth and focus. 3D techniques have, in fact, been perceived as a continuation of the search for verisimilitude in the production of the cinematic image, or what André Bazin referred to as the "myth of total cinema" (2005, 17–22). According to this view, the introduction of sound and depth of focus helped create a greater sense of proximity in film as a simulation, and 3D may be the logical continuation of a search for "a more realistic,

more natural approximation of how we experience life" (Pennington and Giardina 2012, 5). Human beings, unless they have a significant visual impairment, will normally look at objects with two eyes. These are apart from each other and converge on an object; that is, the images processed separately by each eye are fused into one single three-dimensional image. Significantly, humans only have stereoscopic 3D vision in the central area of their visual field. The nose gets in the way of seeing objects on either side and, equally, the left eye has no access to the far right (and vice versa), so the sides only see in mono (Block and McNally 2013, 4–5). Placing a source of the threat at the centre of the screen, for example, exploits perceptual principles connected to the way in which we see the world around us. Since the objects, in the centre are what our vision focuses on more readily and are already perceived in 3D, shooting them in RealD 3D means the depth perception of the threat is emphasised.

What distinguishes 3D Horror, then, and *My Bloody Valentine 3D* from the 1981 version, is its stylistic, experiential and narrative choices. Firstly, the action is presented from POVs and angles that would normally be avoided because, unless experienced in 3D, run the risk of being ineffective and even draw awareness to the fabrication of the film. Scenes are shot so that threats (objects, but also a fist shattering a mirror in the bar scene) are presented in a straight line and are placed at the centre of the screen. Secondly, when experienced in 3D, because of the optical nature of that specific dimensional trick and the way human vision perceives space, this creates an enhanced sense of immersion and, crucially, of the feeling that the threats are aimed at us. These situations can trigger the startle effect in the same way that sound manipulation and techniques such as partial occlusion or sudden revelation do. Thirdly, because of the privileging of these scenes, which need to be numerous in order to make the 3D aspect significant and relevant, more optical attacks are required. This, in turn, means that the film's structure is affected by, or, at least, significantly different from, that of a non-3D Horror film. Predictably, the body count in this film is a lot higher than that in other Horror films and moments of audio-visual attack, and first person POV shots, are more prevalent.

For viewers, this likely translates into a much more syncopated and over-stimulated filmic experience that constantly reminds them of their corpo-reality and vulnerability. This happens irrespectively of whether they have managed to work out that Tom is the murderer. If that knowledge may lower the overall impact of the scene, it is hard to avoid being affected by the 3D shots themselves. What this reveals is that 3D Horror appeals to the somatic side of the viewer in a way that is more obvious and self-avowed than 2D Horror. This is not to say that 3D Horror relies only on the more pre-cognitive aspects of the cinematic experience. *My Bloody Valentine* uses all the suspense trick and traps typical of slashers and is not particularly distinctive as one. What this case study reveals is that affect works independently from the emotional ties of the story and, most importantly, from

identification with the characters. A cursory look at 3D Horror lays bare that the alignment between camera and body under threat is sufficient to create an empathic connection that need not rely on our siding with, for example, the character's moral standing. Although the somatic part of Horror rarely ever works in isolation, it is important to the overall experience that filmmakers and fans recognise as intrinsic to the genre.

In a sense, however, focusing on 3D Horror does not prove a great challenge: the threat is clearly aimed at the viewer on a surface level and their bodies, therefore, react like they would to an ordinary threat in real life. At this point, then, it is important to explore the connections between identification and somatic empathy in Horror films that do not predominantly use first person POVs to align viewer and film or, as I will move on to discuss later in this chapter, which self-consciously complicate these positionings.

Identification and the Masochistic Viewer

Identification has been a crucial part of work on the processes behind Horror viewing and pleasure: how can we be affected by the characters in Horror when we know that neither the characters (they are played by actors) nor the situation (it is fictional) is real? What type of relationships are established between characters and viewers, and how can we account for the emotions that we feel for them? What happens in cases of films that are putatively based on real events, such as *Paranormal Activity*, and in those that deliberately blur the line between the real and the fictional, such as *August Underground* (Fred Vogel, 2001) and *The Bunny Game* (Adam Rehmeier, 2010), both of which use real images of consensual violence that can be as extreme as branding? The previous chapter looked at the way in which threat is at the heart of Horror and how the concomitant emotions of dread and survival suspense are based on the capacity to be scared by the idea of being harmed by either an object, a subject or a situation. It also analysed the type of cognitive processes at hand when considering the ethical and moral implications of the form of morbid curiosity that I see as crucial to Horror. But if pain and the human capacity for the fictional vicarious experience of distress is largely concerned with the somatic, it is impossible to separate it neatly, in places, from the emotional connection that we may feel with the characters themselves. As such, I want to first focus on the need to embrace identificatory models premised on situational assimilation such as the one Carroll puts forward in *The Philosophy of Horror* in order to then move away from identification with specific personality-driven traits. As I will show, when somatic reactions are triggered in Horror, this can be either a result of a sensory attack or of an emotional connection at a corporeal level that often eschews the psychology of characters.

The logical approach, following Carroll's thought theory of emotions, is that we identify with characters in Horror because we can sympathise and empathise with their plight. After all, Horror gives us visual and auditory

clues for how we should react when faced with a source of threat. It also chimes with the popular belief that, if we are scared by a specific scene, this is because we identify with the characters and are therefore capable of feeling what they are, if at a fictional remove. However, Carroll very soon explains why we should not confuse dispositional understanding to a character's encounter with horror with an identification with that character. Speaking of fictional identification more generally, Carroll proposes that character-identification can be tricky to explain convincingly and may mean different things to different people but that it does not help us explain the Horror encounter.[18] Exact duplication of mental states is rejected as a thesis for the same reasons as illusion theory: the viewer, unlike the character in the film, knows that him/her are not being attacked or under threat and that the threat is, ultimately, fictional. We cannot even say that "relevant duplication" of "emotional states" is at work here because, as Carroll explains (1990, 90–1), sometimes the viewer has more information and knowledge than the character (bathers may be merrily enjoying a river viewers know to be riddled with dangerous fish in *Piranha 3D*). If only a partial correspondence between the viewer and the character is appropriate, then we might want to begin asking, Carroll proposes, why we should refer to the process as identification in the first place.

To counter this situation, much as he does in his thought theory of emotions, Carroll suggests that what audiences may share at this point is the "emotive evaluation of the monster" (1990, 94) by assimilation of their situation. This means that viewers need not identify with the character and that the experiences between the character and the viewer are essentially different. The former perceives the threat as real but the viewer does not. Our responses in such situations would go something like this:

> My response [...] involves assimilating the internal point of view of the protagonist as part of generating another response, a response that takes account of the protagonist's response but which is also sensitive to the fact that the protagonist is assessing the situation in the way our internal understanding indicates.
>
> (Carroll 1990, 95)

According to this proposition, viewers need not identify with the character's response but purely have a sense of its appropriateness or intelligibility in a particular situation. "[M]ental anguish" can also come into play; this is where viewers feel, alongside the art-horror that the encounter with the monster precipitates (the emotion engendered by a fictional "situation in which someone, who is horrified, is under attack" (Carroll 1990, 96)), a sense of sympathy for the characters of which they themselves are not capable.

In my own theory of threat, emotions and affects may be caused, as I have explained, because pain and danger are generally intelligible to the

human mind so that we can speak of "corporeal identification" and not of character identification. My return to this word, problematic as it undoubtedly is for cognitivists like Carroll, seeks to demonstrate awareness that, rightly or wrongly, viewers generally use it to refer to their feelings with regards to characters and I, thus, find its intuitiveness useful. Also, unlike Carroll, I do not understand identification to mean a process of fusion so that we "become one" (1990, 96) with the characters, but one where the situations and, most importantly, the bodies of the characters and their vulnerability can be apprehended.[19]

The type of corporeal-affective model I have been introducing necessarily rejects that viewers may find the source of threat a natural identification point. Horror may momentarily, or even consistently, use alignment with the threat (via, for example, subjective POV shots) but such a positioning generally leads to an increased awareness of threat. This is even more obviously the case when the use of subjective POV shots serves to simultaneously masquerade the specificity of the threat. Whilst, as has been suggested, Horror fans may find a source of pleasure in siding with, for example, the monstrous serial killers of slashers such as *Hatchet* (Adam Green, 2006), especially when the film has been watched more than once, the nature of that pleasure is of a different type (it shows genre allegiance, stealth or glee in perverse and/or countercultural enjoyment) and does not preclude the fact that Horror normally aligns the viewer with the predicament and ordeal of the victim.[20] In other words, in order to affect its viewers, Horror continuously positions them at a concomitant experiential level to that of the victim, even when viewing alignments shift. The treatment of chase scenes or the construction of dread, as analysed in the previous chapter, show that damage to the body of the victim is rarely experienced from a vantage point privileging that of the threat. Even films that grant their sources of threat, frequently killers, significant onscreen time and may even filter the events through their subjectivity (scenes that appear to be footage shot directly by them), as happens in *The Butcher* (Kim Jin-won, 2007), tend to focus on the interest in the cause and effect dynamic of attacks. For this reason, models that have accused Horror of being sadistic fail to paint a complete picture or mistake perceived sadistic pleasures in watching images of pain with the film's own articulation of the moments where the attacks take place. Such accounts may often be found in journalistic pieces that criticise the purpose of the entire film, their makers and their viewers.[21]

Accusations of sadism are, however, easy to disavow through close reading and via a brief consideration of the conceptual notion of sadism and its value in cinematic representations of corporeal harm. It is legitimate to observe that films like *Megan Is Missing* (Michael Goi, 2011), where the eponymous character (Rachel Quinn) is lured and kidnapped and subsequently humiliated and raped by Josh (Dean Waite), in their bleak and nihilistic outlook on human existence and insistence on the attraction of negative affects, might echo de Sade's project of utter "negation" and

"destruction" (Deleuze 1991, 26–7). However, this view overlooks the logic of the masochistic contract. In the case of cinema, this is achieved through the conscious decision of watching Horror. Films like *Megan Is Missing* cannot be sadistic because, firstly, they make a pact with the viewer that validates and legitimises the presence of the violence; it is, in other words, expected. Secondly, if the films are to function as Horror and not as arousing material (an aspect over which no film has control, as it depends on the viewer's psychology), that is, if they are to work within the general affective patterns of the genre, the violence needs to be perceived as sanctionable, upsetting and scary by extrapolation. The latter is achieved via the body of the victim, which becomes an avatar mediating the violence and making it intelligible and palpable. More broadly, the torturer in the masochistic contract cannot be compared to the figure of the sadist other than through their analogical similarity – they both inflict pain – because the pleasure gained by the masochist is very different from the pain suffered by the victim at the hands of a sadist (Deleuze 1991, 46) and, in Horror, the pain is fictional and not experienced directly by the viewer. The masochist in the masochistic contract wishes the torturer to fulfil a form of violent fantasy, whilst the victim of the sadist does not wish pain to be inflicted upon them. In the case of Horror, this is the equivalent of viewers desiring the violent film to affect them through a sense of threat. The true sadist cannot take pleasure in a form of pain that is consensual, for this practice is specifically premised on a lack of agreement on the part of the victim (Deleuze 1991, 40–2). This is to say that, whilst we could perceive the actions carried out by Josh in *Megan Is Missing* as sadistic in and of themselves, the same cannot be said for the film.[22] Once the viewer decides to view the film, they enter the masochistic contract I have referred to.[23] The experience of watching torture porn, for example, is therefore more adequately conceptualised as a form of masochistic pleasure gained from the exposure to affect through a contractual encounter with, among other things, corporeal transgression.[24]

This account is more in tune with recent re-evaluations of the reflexivity of films like *Snuff-Movie* (Bernard Rose, 2005), which concerned me in the previous chapter, and which have seen these products as breeding a form of "self-consciousness in the audience" (Aron 2005, 216) that is aligned with the killer's only insofar as it "expos[es] and exploit[s] the (masochistic) complicity that lies at the heart of spectatorship" (220–1). Such views take up previous work on the capacity of these films to offer comments on the distance between viewers and viewed subjects and connect them to the broader issues regarding the masochistic contract established by Horror. In other words, as Carol J. Clover has put it, Horror's intention is to locate the space of hurting and to mine it for its "masochistic possibilities" (1992, 199, 213) through the repetition of certain recognisable formulas and scenarios. Horror's circularity understands the moment of deliberately choosing to watch Horror as a form of compulsion involving a desire to put oneself in a vulnerable and unpleasant state which may be simultaneously

gratifying. I am following here Clover's proposition that the possible correspondence between onscreen victim and horror viewer

> is a function of masochistic fantasy: that people who make movies sense the iterative "my-turn-is-coming-soon" quality of victimization fantasies; that they consciously exploit the proved willingness of the viewer (proved because he keeps paying for it) to imagine himself as a "next victim"; and that the screen functions as a kind of anticipatory mirror intended not so much to instruct as to heighten the effect (1992, 221).[25]

This type of identificatory transubstantiation, one that revolts against the reluctance of entertaining "the possibility of involvement with the victim's part" (228), is crucial in understanding the role of mutilation in Horror. It relies on the premise that pain resides at the core of the Horror experience and that a good film in this genre will be one that "succeeds in 'hurting' its [masochistic] viewers" (229). My point here is that Horror, in its use of graphic realism, reflexivity and complex alignments that shift from victim to an (often anthropomorphic or bestial) form of threat, further investigates the affective limits of this masochistic system. In Horror, where the connection between the act of looking and the spectacle of realistic harm is emphasised, it is even more important that the film in question is re-evaluated for its affective capacity and not for its potentially detrimental effects on viewers. Horror is not manufactured for the pleasure of sadists who get off on fantasising about hurting others but aims to scare audiences and, frequently, aims for as wide a public as possible. Although different forms of Horror appeal to different audiences and it is difficult to provide definitions of the genre that work for all of its various permutations, it seems fair to conclude that the affective appeal of Horror, by virtue of its intention to scare, puts the viewer in a situation of threat that either mirrors (in dread) or, in most places, relies on the extrapolability of, that of an intradiegetic victim. Insofar as that harm may be experienced vicariously, Horror viewership can be generally understood to be masochistic: Horror viewers wish to be affected negatively by the films they watch, even if negative affect is not all they may seek from the experience. Viewers, especially those who know the genre, expect to be scared and may be disappointed if the film does not perform this task effectively.

But how does this masochistic position become available to viewers, beyond their decision to enter the Horror transaction? What corporeal and identificatory processes take place during the experience of Horror that channel harm in ways that may be felt (at a remove) by the audience? In what follows, I want to pursue the implications of the threat theory I expounded in Chapter 2 and in the first section of this chapter through the notion of somatic empathy and of Pain Studies. This will shed light on the ways in which emotion and somatics are, in places, intrinsically connected.

Whilst, in the previous sections of this chapter, I focused on the sensory war that some films propose, I want to turn to the moments in Horror in which somatic effects occur alongside an emotional investment in the body of the character. If my prior look at the startle effect revealed how sensory attacks can affect the body by provoking reflex and instinctive reactions, the rest of this chapter concentrates on those instances where the viewer may feel attacked (at a remove) by a connection established with the body of the actor. However, lest I am accused of any of the theoretical shortcomings that Carroll finds in theories of identification, I would like to clarify that, as I theorise it here, identification does not rely on the character but on their body. This body is virtually interchangeable – unless the narrative manipulates one's feelings otherwise – is often presented in close-ups and is empathically approximated so that its specificities (gender, age, race) become irrelevant to the moment of horror. Let us begin by considering how somatic empathy works.

Corporeal Identification: Somatic Empathy

Thus far, I have considered how Horror affects the viewer in instances where their bodies are directly attacked by the image on the screen. The startle effect is the best example and 3D Horror is a testament to the fact that alignment with the characters achieves direct responses on the viewer that need not rely on cognitive processes. However, Horror also uses attack, threat and, more recently, in torture porn, pain to affect the viewer in ways that play with somatic and reflex reactions, and yet, are also steeped in emotional and cognitive processes. The latter, the moment where a viewer may react to a character's pain – and I mean physical, direct pain, not traumatic experiences – has received less critical attention, perhaps because it is thought to fall clearly under the category of cognitive responses to characters and their situations. Yet, as I will be arguing throughout, such instances are complex and rely both on the emotional-cognitive and on the affective-reflective. In some cases, the startle effect may also be resorted to within the same scene so that viewer alignment is further complicated, as my case study of *Hostel* (Eli Roth, 2005) will show. For this reason, I want to turn now to somatic empathy and its relation to pain. The temptation, as I have noted, is to think that an understanding of the pain of the character, say the ripping of Evan's (Chester Bennington) skin on *Saw 3D* after his back has been stapled to the upholstery of a car, may rely on our sympathy for the character's well-being, but there is little room for sympathy, strictly speaking, in this scenario.

Sympathy for the characters in a scene is undoubtedly significant and important in the larger engagement of viewers with the film (its narrative, its emotional paradigms), but, despite its potential overlaps with empathy (Plantinga 1999), it should not be collapsed into the latter for methodological purposes.[26] A certain allegiance with the character, or an investment in

their cause, especially when their death/pain takes place or is inflicted under circumstances that we may perceive as unfair and even degrading, have a great effect on us (Tan 1996, 171–82).[27] This link or connection, called "allegiance" is separated from "alignment" (Smith 1995, 82–6), that is, the positioning of the viewer in relation to that of characters or their situations. This allegiance is even stronger if the main character is the victim of the violence, as collaborative viewers will have been on a narrative, emotional and cognitive journey with them and may have had exclusive "subjective access" (Smith 1995, 83) to their thoughts and opinions. These feelings may colour the perception of events to such an extent that, as I will show below in the case of the final retributive scene in *Hostel*, a horrible scene of manslaughter can be turned into a moment of relief and joy via manipulation of events and specific viewing alignments.

In the car scene of the aforementioned *Saw 3D*, sympathy, as understood above, is precluded in more than one way. Firstly, viewers do not immediately know who the man in the trap is and, therefore, it is hard for them to feel the type of connection that longer exposure to characters and their predicaments encourages.[28] Additionally, although a feeling of compassion and pity may arise from the realisation that he is a victim and likely to die (both inferences which even viewers who are not familiar with the *Saw* films would be able to make, since this is not the first test scene in the film), viewers will also know that, if the characters have been put in the situation in which they are, this is possibly because they have done something that, at least one person, the Jigsaw killer, has deemed morally reprehensible. Since Jigsaw's tape very swiftly reveals that the man and his friends, who are also part of the trap, are "racists" who have "intimidated others based on their physical differences" and "judged [them] by the color of their skin", straightforward allegiances may also shift. This is not to say that we do not feel sympathy for Evan: we might feel, as I do, that corporal punishment and the death penalty are wrong in any circumstance, and that Evan does not deserve to die. This might make the viewer apprehensive about what is to follow and, through knowledge of the gruesome nature of the traps and their deadly quality and low escape rate, even cause fear or anxiety about what is going to happen next.

These emotions are not quite sympathetic, or only in the sense that we fear for our own integrity through Evan's predicament. The sympathy we may feel for him as a morally dubious individual is quickly replaced by a concern about his physical well-being and the effects that the trap will have on the viewing of its aftermath.[29] This intensifies as Evan leans forward in an attempt to reach out for the red lever that will stop the chain of events leading all of them to their eventual deaths. As the skin starts tearing from his back and his progress is intercut with shots that show his friends in danger, the viewer will become more corporeally and emotionally engaged in the resulting scene of pain and carnage. This is to say that the tearing of the skin is not perceived as a discrete moment of sympathy for someone

else's well-being but as one where the body of the viewer responds to the vulnerability of the onscreen body. This moment, I am arguing, does not necessitate a sympathetic connection with their character, but with their bodies as sentient flesh (devoid of a specific subject and their personalities) and with a construal-based appraisal of the situation.

Figure 3.3 Somatic empathy allows viewers to identify with Evan's body, not his subjectivity, when the skin of his back and arm tears in *Saw 3D* (2010).

The moment is best captured by the term somatic empathy, which relies on the perception of the body of the viewer and, as I mention, not on the identity-related elements that constitute the personality of a character.[30] In other words, the moment is not one of "recognition" by the viewer "of the perception of a set of textual elements, in film typically cohering around the image of a body, as an individuated and continuous human agent", which Smith (1995, 82) sees as part of the structure of sympathy. Instead, it is one of recognition of the body as an alive, sentient and vulnerable thing, regardless of the individuating aspects that constitute it (the specific subjectivity of its owner). Smith explains that the differences between sympathy and empathy are intrinsically related to cognitive processing: whilst sympathy requires an understanding of the characters and their situation, empathy allows us to "simulate or experience the same affect or emotion experienced by the character" (1995, 102). However, although it is possible, as we have seen, to be directly affected by the film, the somatic backbone of this affective experience is eminently different from that of empathy. It is impossible for us to experience exactly the same emotion or feeling that the character does, as there are very different shades of, for example, responses to fear. The sight of the skin ripping is qualitatively different from that of a monster jumping towards the camera (aligned, say, with the POV of the character).

In the latter, empathy is created by positioning viewers in the direct path of the attack and making them react by, for example, eliciting the startle effect. This is as close as we can get to reproducing the experience of the characters on screen. Our emotions will always be different because, as Carroll has argued, if the experiential realms were the same, we would genuinely fear for our lives and escape the cinema theatre or our living rooms. What is at stake, then, is a form of simulation that can manage to short-circuit reality, or appear to bring us as experientially as possible to the bodies of the onscreen characters. This has been called sensation mimicry and, because it is largely involuntary, cannot really be said to fit productively within the structure of sympathy. Let me turn to somatic empathy first, as sensation mimicry is inherently connected to it.

The best definition of somatic empathy has been provided by Julian Hanich, who has referred to it as a "reflexive, prereflective form of participation or feeling with others" (2011, 107) and as "a particular carnal response that makes us feel ourselves feeling and this enables a strong awareness-of-oneself as an embodied viewer" (2010, 104). This moment is best epitomised by the "vague and diffuse, yet intense sensation one feels while exposed to graphic moving-images of pain" (104). In order to distinguish these moments from more general fear, Hanich explains that painful somatic empathy is "local", "episodic" or "punctual", "abrupt" and "*compulsory*" (104, 105, italics in original), by which he means that it is hard to avoid reacting to it. For Hanich, who relies on Sobchack's work on carnal knowledge (2004), viewers are cinesthetic subjects who cannot help but feel the film through their bodies, as these are their anchoring empiric points. The moment of painful somatic empathy is a "*partially* fulfilled sensory experience" where the viewer's body turns to its own carnal/sensorial knowledge in order to make up for "its frustrated grasp" over the instance of violence (Sobchack, in Hanich 2010, 105). Horror, attuned to this, exploits the visual and aural possibilities of cinema to bring us "closer to the *pain*-ful site", "reduc[ing] the sensual and thus the phenomenological distance" (Hanich 2010, 106) by amplifying sounds, especially those that are meaty/viscous or that may be connected to disturbing thoughts, or by resorting to close-ups of the violence, the wound or the corporeal attack. As Hanich argues, since cinema is predominantly visual and aural, Horror need only "optimize our sensual access of seeing and hearing so that the two senses can be cross-modally translated more easily" (106). Unless viewers vehemently seek to short-circuit the reception of these moments – for example, because they know they would be affected in a negative way or could not handle it – the moment of somatic empathy is virtually guaranteed.[31]

To return to my example, the car trap scene in *Saw 3D*, presented very much as a murder set piece (or one of Freeland's numbers) and slotted in between scenes that are of more obvious narrative importance, actively seeks to elicit somatic empathy. In this sense, it is episodic and local, and almost autonomic insofar as its empathic power is not lost when watched in isolation. What we feel when Evan starts ripping off the skin of his back and

the muscles show, or when Kara's (Gabby West) face is crushed by a racing wheel, is not sympathy but a strong moment of corporal empathy. If the viewer reacts with a negative affect, a discomforting sensorial experience, this will not be purely because of the high-octane rock music, loud screaming and fast cross-cutting of the scene, although these cinematic tricks undoubtedly ratchet up the tension and anxiety. Proof of this is that they all stop after the timer finishes its ticking: the music continues for a few seconds but it is drowned out by the revving of the car, and the editing turns into a more linear and slightly less syncopated one that follows the logic of the trap and the effects it has on the various victims: the descent of the car, the crushing of Kara's face, followed by the ripping of Dan's (Dru Viergever) arms and jaw as the car accelerates and moves forward, the crashing into the garage door and Jake's (Benjamin Clost) body and, finally, the additional crash into a junk pile that kills Evan.[32] This moment in the scene is a lot less empathic than the many close-ups of the tearing off of Evan's back earlier in this scene: the deaths of the gang appear in too quick a succession to be apprehended with more than surprise and fearful disgust, whereas the emphasis on the slow pulling away of the skin from the muscle of Evan's back, of which a number of close-ups are provided, are intended to generate somatic empathy.

In this scene, viewers are not feeling somatic sympathy for Evan, despite the fact that, as the sequence advances, his body and those of the viewers become experientially closer. The cooperative viewer, upon understanding that pulling the red lever will save everyone's life, will automatically wish for this to happen. They will most likely desire for the scene to achieve a happy ending and, at the very least, to avoid the horrible outcome that is introduced via shots of the other characters and their positioning within the room. The scene builds up to its resolution very slowly, with shots meant to generate a sense of wishful mimicry whereby the viewer might even pull their bodies forward or reach out mentally in order to aid Evan. At the same time, the taut and breaking skin generates a feeling of empathy for the body that translates into feelings for one's own, if at an obvious filmic remove. The sympathy here, if the word is appropriate at all, would be with the predicament of Evan's body, one that we can project ourselves onto, and not with his personality. Identification needs to be rethought in order to encompass alignment with the onscreen body *specifically*. The result of being subjected to cinematic moments like the car trap scene is a very intense corporeal experience that is intrinsically somatic and relies on the viewers' ability to feel pain. This pain is not real pain, it is not even a replica or simulation of Evan's pain, but a projected one that is not imagined; it is experienced by association and extrapolation of similar instances of the viewers' experiences of pain in their own bodies. In short, the scene plays with the intelligibility of pain at a reflexive level. This is possible because of the nature of pain – the way we live it and with it – and takes place through the workings of sensation mimicry, which are sparked off by cinematic techniques like viewer alignment.

Sensation Mimicry and Cinematic Pain

I have proposed that somatic empathy is an important part of the emotional and affective exchange between the bodies of viewers and those on the screen, especially in instances where pain or corporeal damage at the hands of an external threat becomes a focal point for a scene. Somatic empathy relies on the human intelligibility of other human bodies to generate emotions that are qualitatively different from real fear or sense of threat but which share enough affective and emotional cognates with them to make viewers feel similar sensations. When it comes to images of mutilation, the images of abjection in Chapter 1, the moment of pain that the character suffers is imaginatively transferable. In other words, the moment of pain and/or mutilation, rests heavily on sensation mimicry and is involuntary. This is not to suggest that it is universal; the effect will depend on gradating factors such as general interest, immersion and attention. But what, exactly, is sensation mimicry?

Cognitivist critic Murray Smith describes affective mimicry as an "almost 'perceptual' registering and reflexive simulation of the emotion of another person via facial and bodily cues' (1995, 99). Basing his ideas on Theodor Lipps's notion of "einfühlung", that is, "involuntary neuromuscular response[s] to physical forms" (99), he explains that there are two basic types of mimicry: motor and affective.[33] The former is essentially muscular and, as its name suggests, is based on the mimicking that takes place when watching another body results in a similar transformation or movement on our own. It is, as Smith succinctly puts it, "a weak or partial simulation of a physical motion" (99). Affective mimicry, a concept developed from Paul Ekman's work on facial expressions, argues that there is a specific form of motor mimicry connected to the basic affects (happiness, fear, disgust, anger) that is similarly involuntary, lies at the heart of human interaction and is primarily concerned with facial and expressive cues we pick up from characters.[34] According to the facial feedback thesis, our involuntary mimicking of certain expressions connected to basic affects, fear in this case, intensify our subjective experience of them, even if the latter will always be a weaker form of the former (Smith 1995, 100).[35] Although for Smith this process is partially external, that is, reaction is visible, however slightly, I agree with Hanich that mimicry can also be "*intensive*" so that viewers do not actively "experience [their] bodies in action" (2011, 111, italics in original) – they might not physically move at all – but might "feel their body activated via the perception of *someone else's* active body" (111, italics in original).[36]

Affective mimicry is useful in theorising the value of a facial close-up of the suffering character during a scene of torture: the parts of the body that are being mutilated or hurt are normally edited alongside shots of the character's face reacting to this. Similarly, the dread scenes that were considered in Chapter 2 also include shots of worried, concerned and anxious faces. However, this understanding of affective mimicry is not exactly helpful when attempting to assess the emotional and reflexive value of the

"pain shot", as the moment when the body is attacked has a somatic value of its own that cannot be described as affective mimicry because there is no facial expression involved, and is not exclusively motor-based, as the bodies can sometimes be static or movement be coming from outside (the drill in Josh's (Derek Richardson's) leg in *Hostel*). Hanich adds the term "sensation mimicry" (2010, 103–4) in order to account for the "empathizing experiences" (Hanich 2011, 269, n57) not captured by the other two terms, and which are more readily connected to recognisable sensations, such as the touch or feel of metal (2011, 108). How then, can we describe the moment where the Horror viewer flinches at the moment of onscreen pain? I want to argue that the process is largely reflexive, but also relies on emotion, namely, our capacity to project and imagine pain.

Sensation mimicry rests, like the other forms of mimicry, on lived body experiences, or the capacity to extrapolate our carnal knowledge onto situations that have not been personally experienced. It relies on anticipated reaction, the ability to foresee the general consequences that a particular action or event would have, yet is not cognitive or strictly emotional. Because the human body, like the animal body, is hardwired to seek survival, and as I have shown, threat-perception is an important skill that we develop early, it is safe to argue that most viewers will have an acute sense of what may be dangerous, especially when cues are provided by the film itself, and that they will react to the possibility of pain and corporeal damage almost instinctively. Thanks to somatic empathy, the moment of pain may be felt via sensation mimicry: it is not necessary for us to know how it might feel to have one of our arms chopped off, as in *Saw VI* (Kevin Greutert, 2009), to react to that moment somatically. The pain is not necessarily imagined but more generally apprehended by the body. Most importantly, the immediate effects of such an action (beyond pain) take central stage: death instantly becomes a possibility, and with it comes anxiety over the potential deadliness of that moment. A sensation akin to pain is felt via somatic empathy that is mixed with fearful disgust, since mutilation and attack often lead to the images of abjection that I discussed in Chapter 1 and that universally remind us of our vulnerability. As I have explained, somatic empathy makes us aware of our somatic body. In scenes of painful somatic empathy, the body is re-apprehended by the conscious self. It is possible that we might, via sensation mimicry, feel something like pinprick pain when watching the torture scene in *Audition / Ôdishon* (Takashi Miike, 1999), where Shigeharu (Ryo Ishibashi) is having needles inserted into his eyes and that we might even blink in reaction. This is the somatic body engaging in a moment of sensation mimicry.

But instances of corporeal attack, torture and mutilation also appeal to the vicarious capacity viewers have for understanding and projecting pain. Pain, in this case, is not so much a sensation as an intermediate state between the somatic, the affective (understood here in its emotive sense) and a mood, especially if the mimicry leads to emotion in cases where the

Figure 3.4 Affective, pain-driven scenes like the needle torture of Shigeharu in
 Audition (1999) make us more aware of our lived body.

scene is a prolonged one. In order to assess the import of this projection, it is
necessary to establish the nature of the transference in the first place. Look-
ing at the basic psychosomatic nature of the body in pain and its capacity
to communicate outside of itself can help devise the theoretical implications
of the fictional consumption of mutilation and torture and of the perception
of external threats on the bodies of characters as harmful to the viewer,
even when the threat is not specifically aimed at them. I, therefore, turn to
the useful work on pain by Elaine Scarry and Drew Leder for a theoretical
approximation to this fictional exchange.

In her seminal study *The Body in Pain* (1985), Scarry lays down the
basis for a theoretical consideration of pain and the tortured body.
Scarry's argument is straightforward: the experience of pain is essentially
a silent one, fraught with a more basic human limitation, the inexpressi-
bility of being. Much as Georges Bataille has seen violence, in its final
and destructive power dynamic, as having no language, for Scarry, phys-
ical pain destroys language (1985, 19). This is not only a consequence of
pain's effect on speech – the very obvious premise being that, when in deep
pain, all communication is suspended and transmogrifies into a language
of sobs, wails and groans – but also of the fact that pain resists linguistic
objectification. We are always hard-pressed to express exactly what it is
that is hurting: at best we can describe its likeness to other feelings and sen-
sations ("a burning feeling") or the effect that physical objects would have
on the body ("pins and needles", "it feels as if I am being sawn in half").
Language is rendered useless when confronted with bursts of intense pain,
and the capacity to transmit the intensity or quality of that pain relies
on how effectively the actual feeling may be vicariously experienced by a
second, external individual.

However, whilst the experience of being in pain is silent and hermetic, the experience of witnessing it can bring about a moment of ontological crisis. Scarry best epitomises this idea when she claims that "to have great pain is to have certainty; to hear another person has pain is to have doubt" (Scarry 1985, 7).[37] It is pain's inherent unsharability that can cause this existential chasm, for pain is a reminder of "presentness", not just of pain itself but of our own human existence. We may forget we exist physically when we daydream but pain anchors us to the empirical world. For the witness, on the other hand, who cannot feel this pain physically, doubt is the usual state of being. As Scarry notes, it is through the objectification of that pain that vicarious projection can be achieved.[38] This objectification can take place through two very different methods. The first one showcases the potential for damage that the simple image of the threatening object has through its referential quality. In cinematic terms, this would be tantamount to a zoom-in on a knife, drill or any other weapon of torture in the *Hostel* films (2005–11). The second involves the objectification of pain itself: the act of "beginn[ing] to externalize, objectify, and mak[ing] sharable what is originally an interior and unsharable experience" (Scarry 1985, 16). This process of "de-objectifying" the work of pain by objectifying the body can only truly take place when a referential content is established in accordance with it. Scarry further elaborates:

> [i]f the felt-attributes of pain are (through one means of verbal objectification or another) lifted into the visible world, *and if the referent for these now objectified attributes is understood to be the human body*, then the sentient fact of the person's suffering will become knowable to a second person.
>
> (13, italics in original)

Horror utilises this objectification of the body as a site of pain, one derived from the impact or effect of the threat, where this has corporeal effects, in its attempt to make pain knowable and, to a certain extent, transferable. I have shown how affect is sought by Horror and how the moment of shared embodiment relies on the capacity to establish a connection between the viewing and onscreen bodies. This is in keeping with Scarry's understanding of the anthropomorphic quality of pain, whereby the degree of transferability of pain, its actual effect on the viewer, will depend on the film's capacity to show the intradiegetic body, the victim's, as anthropomorphic. As soon as the body stops being recognisably human, there is also an end to direct empathy, sensation mimicry, and the possibility for vicarious feelings that might become transferable.

The type of pain I am concerned with is therefore obviously and necessarily imaginary, for the pain recreated in the viewer's body can never be truly corporeal unless one is physically injured in the process. It is possible to consider visual impact as a type of corporeal aggression, but such an

attack will necessarily remain confined to the limits of our imagination and capacity for sentience. This is particularly relevant when, as Scarry reminds us, the "imaginary" and actual "pain" represent extreme and radical experiential polarities.[39] To imagine is to be as far removed from the world of real objects as is physically possible, whilst to be in pain is, as transpires from the work by Drew Leder in this field, to be in direct contact with the act of being. Thus, the experience of imagining harm, however oxymoronic it might at first appear, will be one whereby what is effectively unreachable becomes objectified and therefore made cognitively feasible and apprehensible. If fainting is possible when watching *Hostel*, this is because pain is projected, imagined and somehow re-appropriated by the sentient body in a process that is as much individual (personal) as it is social (cultural). Pain therefore needs to be apprehended before it can be corporeally shared; it needs to be given an external image before it can be invested in bodily terms. Once the image of the harmed body is visualised, viewers can apprehend the degree of damage inflicted and calculate its probable effect. If this is a successfully disturbing experience, viewers may recoil at the encounter with their own fragility and capacity for somatic empathy. It is when pain can be objectified and externalised through Horror that the damaged body is turned into an available experience to be felt alongside fictional characters. This is why pain can be seen, paradoxically, as an empirical catalyst, because it puts viewers back in contact with the body as object. Horror makes us aware of the somatic body, of the world of sensory, non-policed immediacy, and therein lies one of its potential pleasures, namely, the heightening and imaginative figuration of harm (and threat) that, ultimately, leaves no lasting effects on us beyond potential trauma. One of the reasons why re-discovering pain might be an interesting experience for viewers, in the societies that consume these films, is that pain is normally either cast out or eradicated from public view.[40]

Pain scholar Drew Leder, following the work of Maurice Merleau-Ponty, describes the body as "self-effacing"; its natural tendency is to recede, and this can lead, as he explains, to a situation where "our organic basis can be easily forgotten due to the reticence of visceral processes" (1990, 69). In order to function in the world, and particularly at a social level, the body self-effaces to the point where its organicity is only perceptible through moments of dysfunction. These moments are characterised by the process whereby the body becomes other to itself and pain is perceived as an agent working against wholesomeness. This means that to feel other than perfectly unaware of the body's organicity is to be dysfunctional. A perfect example of this is pain, which Leder sees as a "sensory intensification" (70–1), and which I am comparing to the effect of explicit graphic Horror on the viewer. Its temporal and episodic nature makes it work as an "affective call" on the body which enacts a "spatiotemporal constriction" (74). In other words, it induces "self-reflection" and "isolation" (76), and is confined to the limits of our flesh. It pulls the body back to the here and now of the present. This immediacy, coupled with the alien quality of pain, objectifies it, and

it is at this remove from oneself that we may perceive the "body in pain" (76–7) as essentially different from the "normal" one. The healthy body is naturally self-effacing and its visceral quality buried but, when the body senses localised pain, it "dys-appears" or surfaces through a dysfunctional feeling. The subsequent thematisation of the body in its dysfunctional state makes it re-appear, first in a localised manner ("my leg hurts"), and then, more broadly, as a whole (we are put back in contact with the buried side of the body, its organicity). This dys-appearing body is dangerous because it threatens our sense of "self", it puts the social body, or socius, at risk. Hence, it is perfectly legitimate to explain the experience of undergoing physical pain as one that, nevertheless, has an effect on the concept of being in the world. Leder calls this process of ontological awareness a "corporeal hermeneutics" (93).

Horror, particularly graphic Horror, works as a catalyst of the experience of simulated pain through the consumption of images of mutilation and torture where the body suffers physically from the threat at hand. This activates a process of corporeal awareness. Viewers may hiss or even reach out for their own arms when faced with an arm-amputation scene like the one that opens *Saw VI* because the onscreen body is perceived as imaginably contiguous and is recognisable beyond the character and its particularities. The vicarious consumption of these images and their effect mirrors the awakening of pain. Leder's dys-appearing body, fictional pain as transmutable through fictional images, becomes a way into our own sense of corporeality because it allows us to be in touch with our visceral side beyond the unreflective chills of the startle effect. Pain Studies, and its understanding of suffering as an experience which has ontological value, can therefore help in a theorisation of the possible effects of affect to the Horror experience: the filmic body affects the fleshly body of the viewer through a simulation of mutilation that is processed in the manner that physical pain would be via vicarious projection and imagination of the extent and consequences of a specific corporeal attack on our bodies. Through this moment of self-inflicted dys-function, attained through the consumption of mutilation, the somatic body is disclosed both in parts and as a whole. By acknowledging the somatic part of ourselves, we acknowledge our bodies and their materiality. But, as with pain, such a moment of awareness is, ultimately, transient. In the same way that the body in pain seeks relief so as to be able to function normally again, so the viewing body seeks to go back to its original state and conceal its viscerality and capacity for empathic feeling and sensation mimicry.

I have further refined the instance of corporeal threat as a form of painful somatic empathy caused by the recognition of the effect and extent of pain in ordinary life. Such a theoretical move reads the experience of watching mutilation and the moment where threat turns into physical attack as an encounter with the somatic body. The consumption of the mutilated and tortured body in extreme examples of contemporary Horror remains the basis of this experience, but different films propose different scenarios. What is important to notice, as the following and last section goes on to chronicle, is that the

generation of affect through torture and ensuing images aimed at encouraging some form of pain, rests heavily on editing and shot structure. I have explained how somatic empathy can work irrespectively of our feelings for the characters but that sympathy may increase it. Viewer alignment, the positioning of the camera in a specific scene, as well as information acquired prior to the scene of torture, can ultimately shape the specific perception and reception of any given scene. The final potential effects, then, may be strengthened by feelings of helpless for the character or that the wrong person is suffering for the wrong reasons. Focusing on two examples from the film that gave notoriety to the torture porn scandal will allow me to round up this discussion by interpreting the affective scenarios at work and the intended affective-emotional states they encourage.

Case Study 2: Viewer Alignment and the Torture Scene in *Hostel* (2005)

Horror has always aimed to shock by exploiting the body, especially its grotesque permutations in the monsters of Universal Horror, but it would not be until *Blood Feast* (Herschell Gordon Lewis, 1963) that graphic depictions of torture and murder would become affective possibilities in and of themselves.[41] Advances in special effects and bigger budgets also gradually enabled the genre to have a much more visceral effect on viewers. With the coming of CGI and the often hybrid uses of prosthetics with new digital technologies, it is even more possible for the violence in Horror to look realistic. In fact, the recent spate of remakes of some of the most successful rape-revenge and exploitation films of the 1970s and 1980s, of which *My Bloody Valentine 3D* is an example, have tended to up the blood and body counts of the originals.[42] But post-millennial Horror, especially torture porn, is also distinctive for the type of problematic viewing positions it encourages. Ambiguous alignments with both victim and attacker, coupled with ethical conundrums on the legitimate use of torture, ensure that the experience of watching a film like *Hostel* is far from straightforward. Actively encouraged to root for characters who are morally ambiguous and often switch roles from victim to torturer, viewers are put in the delicate situation of understanding plights they simultaneously condemn. This occurs, mainly, because the characters in films like *Turistas / aka Paradise Lost* (John Stockwell, 2006), *Scar* (Jed Weintrob, 2008) or *The Tortured* (Robert Lieberman, 2010) rebuke the usual channels of punitive law and impose their own versions of retributive justice. Here, I turn to the particulars of affect in *Hostel* and explore its novelty through its exploitation of two key elements: the ambiguous treatment of vicariousness and empathic feelings towards the victim(s), and the construction of (a) realistic extreme sequence(s) that allow(s) for the types of somatic empathy I have been tracing.

Hostel starts by eliciting a sense of dread in the viewer through an opening credits sequence featuring a half-glimpsed torture chamber. These first images set up the scene but do not reveal the particulars of the situation. In fact,

part of the artistry in *Hostel*, as in other classics of Horror, resides in the structure and pacing of the action. When the torture sequences finally arrive, they constitute a form of anticlimax anticipated by the build-up of tension and preclusion of specific images of violence.[43] After the credits sequence, a medium shot shows three men, two American fraternity students and an Icelandic "drifter", Oli (Eythor Gudjonssen), arriving in Amsterdam. The nature of their trip is revealed when Paxton (Jay Hernandez) asks where they are headed and Oli replies: "[r]ed-light district. Time for *sneepur*" ("sneepur" being the Icelandic word for "clitoris"). After Josh (Derek Richardson) complains that he has not travelled all the way from America just to smoke pot and that they should attempt to do something that would be perceived as vaguely cultural, his suggestion that they visit a museum is met with sarcasm by the other men. This is followed by a series of scenes that further emphasise their objectification and "meatification" of women. A "cute" young girl who appears to be either autistic or heavily sedated is presented as a trophy; Oli films himself having sex with a girl in a public toilet and then sends a picture text to the other men; an overweight woman on a balcony is called "a fucking hog" and the possibility of sex with her compared to bestiality; and, when the men finally reach the red-light district, Oli offers to pay for the services of one of the prostitutes, who is presented as a "gift" to Josh. The obsessive hyper-masculinity asserted through the extreme sexualisation of female bodies comes, not only at the expense of women, but also at that of gay men. When Josh proves unsuccessful with a couple of girls because he is wearing a bum bag, Paxton prompts him to "go over and have fucking fanny-pack sex" with a gay man dancing nearby. Most tellingly, upon being thrown out of the club, Paxton warns the other men in the queue not to go in as it is a "fag fest".

After this, affect in *Hostel*, beyond the startles, which, as we have seen, work irrespectively of the narrative, is constructed through a straight reversal of the violence perpetrated on female or feminised bodies by the men in the first half of the film. When Josh is initially offered the services of a prostitute, his reaction is to express a lack of enthusiasm: "[t]hanks, but paying to go into a room to do whatever you want to someone isn't a turn on". The full significance of this statement, that the men who pay to torture and kill people through Elite Hunting are only a logical progression of the same exploitative business, only gains full significance after the end of the film or on a second viewing. The primary purpose of this scene is to present Josh as a sensitive man who would naturally shrink away from the type of power dynamics prostitution involves. His image as a conscientious young man would seem to be reinforced by the fact that we soon learn he is trying to get over a bad break-up with his ex-girlfriend and that he is later referred to as "the responsible one" in the group. In the same scene, a contrast is established between him and Paxton, who is seen telling Josh that the only way to "get over [his] chick" is to "bang some new pussy", and is immediately shown having a threesome with Oli and another prostitute. This latter shot focuses on the shadows projected by their heaving bodies and the hands of the

two men as they meet over the body of the woman in a knuckle high-five. Its direct counter-shot, a shy Josh pulling away with a half-smile on his face after having turned down the offer to join, would seem to suggest he is governed not by naiveté but by the repression of a desire he cannot sublimate. This is reinforced by the fact that he proceeds to peevishly look at the silhouettes reflected on the other doors. In a twist of fate, the men who are now making use of the brothel (Oli, Josh and Paxton) will find themselves being tortured and reduced to their material bodies for the pleasure of other men with deviant desires in similarly sordid rooms. The film, thus, establishes an ambiguous relationship between the spectator and the main characters, who are never truly sympathetic. The ambiguous feeling towards them is also encouraged by their rampant jingoism and ignorance of the country they are visiting.

Starting a trend that would continue with films like *Turistas* or *Borderland* (Zev Berman, 2007), *Hostel* parades the potential arrogance and racism of some Americans.[44] In the film, told through the eyes of Americans, Europe is "othered" as a dark continent where "you can pay to do anything". More specifically, the children in Slovakia are reported to "commit the most crime", their women live off prostitution, there is no phone signal, the police are involved in crime rings and the only local attraction is the museum of torture.[45] The dislike is mutual: Josh and Paxton are treated in similarly polarising ways, standing in for a European hatred of American cultural colonisation. For example, when Josh is thrown out of a nightclub for pushing a Dutchman and calling him a "fucking faggot-ass elf", he shouts at the doormen that "he is an American" and therefore "has got rights". This arrogance is met with a very particular form of national retributive violence when Paxton's torturer (Petr Janis), later in the film, insists that it be unequivocally proven that his victim is indeed American. This prerequisite is then revealed to be part of a larger business where the bodies of Americans are worth more than those of Europeans. The moment where Paxton is forced to speak and prove his nationality is therefore key, firstly because it objectifies the American man in a manner comparable to his objectification of Dutch and Slovakian women, and secondly because the scene seems to support the idea that Europeans hold a grudge against Americans.[46]

These racial tensions are picked up by Alexei (Lubomír Bukový), a young man who assures the boys that "not everyone want [*sic*] to kill Americans" and that the girls in Bratislava "love everyone foreign, especially American". The ironic fact that Alexei is really pimping men by sending them to their sure deaths, is cleverly complemented by a scene featuring the failed Dutch surgeon (Jan Vlasák) joining the men on their train to Bratislava. After calling Josh a "handsome American" and putting a hand on his lap, the Americans call him a "fucking freak" and mock Josh for having finally "hooked up". In another of the film's many twists, this man turns out to be Josh's torturer. The man's other apparent eccentricity, a preference for using his hands when eating, resonates at more than one level when he appears in full surgical gown and prepares the scene for the torture and dissection of Josh.

This second encounter between the two men re-enacts the manual fixation of the Dutchman: he will use his hands to kill Josh, further objectifying him and revealing that the initial touch of his lap, as much as it may have been sexually coded, was also a very carnal assessment of Josh's body. This is underscored by the fact that, in the train, the Dutchman touches Josh after he has explained that modern societies have lost their relationship with food. The enigmatic line, "I like to have a connection with something that died for me", spoken whilst the camera focuses on an incredulous Josh, already sets up, albeit inadvertently for the first-time viewer, the scene for what will be their final exchange.[47] I want to discuss this in detail, as it provides a perfect example of the empathic feelings often proposed by graphic Horror.

The torture sequence between Josh and the Dutchman opens with a shot that aligns the camera with the POV of the former. The screen is completely dark but for a peephole that we soon understand is meant to represent someone's partially occluded vision. This connection is facilitated by auditory cues: the inarticulate half-sentences uttered by a man's voice ("what the f...?"), which give away the fact that the POV is Josh's, simultaneously reflect the potential viewing desire to know what is happening. Much like the characters in the film, the viewer has not yet understood what is taking place in the scene's derelict and grubby setting, even if its look is reminiscent of the lugubrious chamber of the opening credits. The camera centres on the tables on each side and what appear to be surgical tools and various torture weapons. By manipulating the image through jerky camera work and a sustained lack of focus, the scene attempts to represent the standard reaction of waking up in an unfamiliar place whilst simultaneously establishing a moment of heightened tension. The POV shot ends with the opening of the door and the glimpse of the by-now familiar figure of the Dutchman. As he lifts up the hood covering Josh's face, the camera shifts to an objective mid-close-up that is vaguely within the other man's visual field: it is offered from above and only Josh's face is visible. After the uncovering of Josh's head and torso, which has helped to develop the logistics of the scene, the camera pulls away to reveal his body strapped to a torture chair.

The rest of the sequence is laden with a myriad different shots that establish anything but a straightforward viewing alignment: over-the-shoulder shots that include the torturer as he prepares his various implements would seem to encourage a certain sense of vulnerability and a victimisation of the spectator, but these are interspersed with counter-shots of Josh as he would be seen from a frontal position, that is, a position closer to that of the torturer. Cut-in shots of Josh's handcuffed feet and hands disclose the particulars of his helplessness – like the camera, he cannot move or get away from what is, slowly but surely, about to unravel. This is reinforced by a return to his POV after the torturer picks up a drill. Such a cinematographic choice would seem to encourage empathy for the victim, particularly since, as I have explained, Josh has been consistently portrayed as the most sensitive man in the group. However, this is frustrated through the use of long shots

that approach and close in on Josh's bleeding body. These have a more predatorial feel and appear to align themselves with the visual field of the torturer. They are complemented by the moments where the different weapons are laid out on the table, these being shot from a mid-close-up that would necessarily remain outside of Josh's eye line.

Affect is generated here in four specific moments. The first and third are predicated on the extreme close-up: one of the shots shows a drill as it penetrates and twists the flesh in Josh's leg, and the other offers a quick shot of Josh's sliced Achilles tendons as they give way under the weight of his body. These are instances where the images of abjection I covered in chapter one are used. In their total disembodiment, created by the lack of a specific POV, they can establish a special vicarious connection.[48] The second moment of affect is constructed through a clever mixture of shots of the torturer shaking his hands in a ghostly fashion, counter-shots where Josh is seen reacting to this in a moment of panic, and more removed long-shots that encase both images from an establishing distance. Once again, there is no clear alignment with one given character. This is not to say that there is no privileging of a POV. Particularly towards the end of the sequence, there is an obvious move towards a more sustained alignment, and this is, in the interest of affect, one that positions the viewer as victim. The moment is first magnified by the creation of a tenuous possibility of escape for Josh. After having mutilated his feet, the Dutchman disappears from the shot, apparently leaving Josh to crawl his way out of the cell. Renewed POV shots follow his attempt to get closer to the exit door until the Dutchman quickly reappears to finish the job. The final slitting of Josh's throat is refracted through a broken mirror, both heads within a short distance of each other, that leaves a final alignment ambiguous at best.

Figure 3.5 The focal positioning of Josh's torture scene in *Hostel* (2005) is complex and aligns the viewer with both torturer and victim in its plea for affect.

The significance of this scene, replicated in countless torture porn features but, most notably, in the death scenes of Lorna (Heather Matarazzo) in *Hostel: Part II* (Eli Roth, 2007), and Mike (Skyler Stone) in *Hostel: Part III* (Scott Spiegel, 2011), goes beyond the mere sensational and establishes a difficult form of elusive viewer alignment. If Horror has traditionally been linked to a form of sadistic sublimation, torture porn would seem to posit the basis for a new form of masochistic interplay. David Edelstein, generally credited with the coinage of the term "torture porn" after his review of *Hostel*, expressed his frustration with what he saw as the purposely disconcerting agency games that forced him to take ambiguous viewing positions. In his own words: "I didn't understand why I had to be tortured, too. I didn't want to identify with the victim or the victimizer" (Edelstein 2006). If the viewer is being visually tortured, as Edelstein professes, then this idea is incompatible with a sense of sadistic pleasure obtained from such a violence, unless we are prepared to imbue the whole viewer/film relation in a process of consensual masochism, as I suggested earlier.

Sympathy for the character is not a necessary part of somatic empathy, but this does not mean that it does not have an effect on our perception of given scenes. I want to finish this case study by focusing on one scene that I saw, by accident, before I watched the rest of the film. This is the closing, unexpected moment where Paxton takes revenge on the Dutchman, presumably for the things that he did to Josh and his general involvement in Elite Hunting. Like the car trap scene in *Saw*, this scene can work independently from the film at the level of somatic empathy, but, interestingly, one's allegiances may change depending on the construal of the situation. When I first watched this scene, I did not know who Paxton was, but since he cuts off two fingers from an older, apparently helpless man, in a public toilet, my sympathies were directly with the Dutchman, as his was the body under attack. As a viewer, I was hoping he would get out of the situation alive or, at least, that he would not be further mutilated. His death by slit throat, a death that mirrors that of Josh (and also uses a reflective surface), came as something of a relief: the attack was over and no further mutilation or torture would take place. The moment of somatic empathy, where the fingers are severed in close-up, was felt even more vehemently because, as I have explained, we are naturally inclined to feel for the body of the victim.

The second time I watched this scene, within the context of the rest of the film, after having experienced Paxton's ordeal through his eyes, my feelings in this scene changed somewhat. I still engaged in the somatic empathy that the severed fingers seeks to generate, but I did not feel as apprehensive. My sympathies were clearly with Paxton this time, even though I did not like him much as a character (I found his chauvinistic and arrogantly nationalistic attitude difficult to stomach) or the fact that I do no support torture or corporal punishment under any circumstance. I still found the killing disturbing, but the violence felt less brutal, perhaps as a result of its comparison with other far more gruesome scenes in the film, one for which

the Dutchman himself is responsible. As should be evident, even something as short as a torture scene – this one lasts less than two minutes – can be incredibly complex and involve various levels of viewer engagement, from the somatic to the emotive and the sympathetic, via the cognitive. It also involves a degree of pleasure in the willing consumption of a cinematic piece that will produce negative affects.

The process of watching Horror constitutes a re-staging of a different type of scopophilia, one that attacks the body of the intradiegetic characters in the hope that it will affect the viewer. In this respect, Horror tends to favour whichever viewer alignment offers maximum affect. This is why, for example, during Paxton's torture sequence, POV shots from both torturer and tortured are foregrounded to the point of being presented one after the other. An initial POV shot that aligns the field of vision with Paxton's reveals the figure of the torturer, now wielding a chainsaw and ready to pounce. This is followed by another POV shot aligning the camera with the torturer's vision as he lunges forwards towards the cowering victim. According to the principle of maximum affect, the death of the American client, Bob (Rick Hoffman), for example, comes as a relief. After a speech that belittles Paxton's chauvinistic discourse by comparison ("I've been everywhere and the bottom line is pussy is pussy"), Bob goes on to explain the thrill of the experience: "this is something you never forget". After Paxton meekly suggests that he might want to make the death of his victim a quick one, Bob summarises, more generally, the appeal of watching scenes of mutilation and torture: "I wanna feel it". Such a diatribe might be applicable to the potential viewer constructed as a voyeur and in the search of ever-increasing affective thrills, but only if such voyeuristic practices are perceived as masochistic in essence. According to this idea, the spectator may be seen as seeking "to feel" the experience from the perspective of the victim without disavowing alignment with the threat where the latter engenders a stronger reaction. The complicated alignments that *Hostel* proposes replace the construction of viewers who condone onscreen violence with one where they take personal pleasure in the simulated yet "lived" spectacle of pain.

Conclusion: The Relevance of Somatics to an Affective-Corporeal Model of Horror

On a primary level, somatics is necessary to an understanding of Horror for various reasons. Firstly, emotions are influenced by affective reactions, such as startles, but also moods created by, for example, dread scenes. These often colour and, in some cases, fully determine our emotional responses to certain scenes. Taking into account the role of somatics as corporeally affective allows us to see how emotions, which can be culturally defined and therefore specific, may shift according to certain perceptual cues provided by the films' structure, editing and general intention. Although an awareness of Japanese culture can certainly increase the fear elicited by a film such

as *Ju-on: The Grudge* (Takashi Simizu, 2002), startles do not rely on it and work independently of social or cultural markers by appealing to the body's reflexes. Studying startles, their effectiveness and their position within a film or scene, as well as general purpose, can grant information about how viewers are positioned, visually, aurally and atmospherically in a situation of threat that enhances the moment of horror. The startle is the more prevalent technique in the genre and somatic reactions to images are perhaps the most universal of the elements of Horror. In the case of 3D Horror, I showed how the will to affect the viewer's body somatically, to generate an almost unavoidable physical reaction, may even affect the final look and feel of certain images and films that are marketed as immersive. Although, in these films, affect does not work independently from emotion, considering startles and their main characteristics separately has demonstrated the need to continue discussions of the ways in which Horror works.

Focusing, as I have done, on the type of viewing alignments Horror proposes, especially those that mix the perspective of an anthropomorphised or humanoid threat and those of the victim, I have suggested that, instead of vouching for a sadistic model that relegates Horror to the mindless (and concerning) process of consuming violence, however extreme, for sadistic pleasure, we may consider the masochistic experience of being scared through the victim's body as the main allure. Doing this is, on the one hand, less abstract than focusing on how Horror affects viewers through conceptual notions (the possible foreign "other", the interstitial, the terrorist) and much more intuitive. More importantly, it grants Horror the complexity it deserves and sees its successful examples as effective because they manage to affect viewers in intentional ways. In other words, considering how cinematography, narrative structure, camera alignment, or sympathy with, and towards, the characters contribute to our experience of threat either directly (dread, the startle) or via the moment of vicarious experience of an intradiegetic character's suffering and pain is basic for a model privileging a focus on the film's framework, structure and framing style. Cultural specificities may, then, be read in addition to this Horror's most basic, but no less complex, genetic makeup.

My aim in this chapter has also been to trace how harm and pain can, and is, transferred from the screen to the viewer in forms that, although relying on emotional states, can be very much equated with the type of reflexes encouraged by startles and by images of abjection. My focal point has been the perception and consumption of sequences where the body of the character is under specific attack and/or torture and, therefore, where a sensation akin to pain is elicited. In order to offer a possible account of the workings behind the moment where the viewer engages with the body in pain on the screen, I have turned to somatic empathy and sensation mimicry. Unlike old identification models, somatic empathy allows us to understand the moment of pain as one where the specificities of the body, someone's personality, matter a lot less than the fact that cinematic bodies are intelligible

to the viewer by extrapolation of their own lived body experiences. Because Horror intends to affect its viewers, especially in graphic Horror that is not comedic in tone, a number of cinematic tricks ensure that the distance between viewing and fictional bodies is reduced. Close-ups or loud screams, often interspersed with shots including expressions of suffering, allow for the viewer's somatic body to be perceived. Other specific techniques connected to viewpoint and viewing alignment, which are different from allegiance, include the way a scene is shot and its use of POV shots. The latter can serve to establish certain affective connections and rapports with the bodies of characters that influence how we react to their pain. A careful analysis of the camera dynamics in any scene is crucial if critics or journalists are to avoid essentialising the role and purpose of certain violent scenes in Horror. As I have shown, although somatic empathy may be experienced when watching scenes in isolation, their positioning within a larger text can sometimes change the particularities of our feelings, if not strictly the workings of affect.

Ultimately, somatics matters because it is a part of the viewer's engagement with the bodies on the screen and, in Horror, with the moment of threat. Because it is not as complex as its emotional dimensions, more obviously historical and social, it is easy to forget what a crucial role somatics, and our experience of the lived body, are to film watching. This chapter has, therefore, underscored the importance of reflex reactions, like the startle effect, and of processes that involve our carnal knowledge, especially pain and harm, to the emotional interactions between Horror and its viewers.

Notes

1. I am not suggesting that the startle is unique to Horror. As David J. Skal has proposed (1993, 31–2), it is quite possible that we can trace the startle to the beginning of cinema, some of which was not narrative in essence.
2. For a different view that sees the startle as more complex, as a proto-emotion, due to the fact that it is characterised by specific facial expressions and it includes elements from fear and surprise, see Robinson (1995).
3. Mama was played by Javier Botet, but CGI enhancement makes certain aspects of the character, particularly the floating hair and the pale blue eyes, look artificial even within the context of "digital mimicry" (Rosen 2001, 309), that is, the capacity for a CGI character to appear "real" within the fantastic context of the film.
4. For more detailed information on the neurophysiology and psychophysiology of the startle, see Davis (1984).
5. This is not to say that certain behaviours cannot be learned and interiorised, such as, for example, reacting with a kung fu kick.
6. For more on Horror scores, see the essays collected in Hayward (2009) and Lerner (2010). See also Donnelly (2008, 88–109). It has been argued that music in the Gothic subgenre may act differently by focusing on the uncanny. See van Elferen (2012, 34–72).

7. I am referring to the moment when we can "feel" the sound waves or blasts, say, in our chest because they are particularly loud.

8. For more on his phenomenology of the startle effect, or what he calls "cinematic shock" in order to establish the frightening aspect of this type of startle, see Hanich (2010, 133–8; 2012).

9. See Hanich (2010, 138–45).

10. Hanich refers to this experience as the awareness of the subjective experience of the "lived-body" (2010, 146).

11. Although the pleasure of watching someone startled is different, especially where one is already privy to the startle. I also have no space here to deal with the ways in which the cinematic context (the cinema theatre) amplifies or qualifies the reaction to the startle, but it is obviously significant. See Hanich (2010, 150–8).

12. See Francis Jr. (2013, 139).

13. It is important to note, however, that *My Bloody Valentine 3D* was not the first Horror film to be shot in HD 3D. That honour goes to *Scar* (Jed Weintrob, 2007), a torture porn effort that was nowhere near as successful.

14. In 2008, 3D had been limited to family-friendly films such as *Fly Me to the Moon 3D* (Ben Stassen), *Bolt* (Chris Williams and Byron Howard) and *Journey to the Center of the Earth* (T. J. Scott, TV film). For the concerns connected the possible success of *My Bloody Valentine 3D*, see Contrino (2009).

15. For more on the effects, especially on marketing and promotion, of 3D films, see Tryon (2013, 76–96).

16. Most notably, *Friday the 13th: Part III* (Steve Miner, 1982) was released in 3D.

17. The POV can also be that of someone watching the murders take place, as when the camera is aligned with Tom's line of vision when he is imprisoned in the mine cell. In this case, the shot clearly wants to convey helplessness and fear at the thought that the killer will eventually turn towards Tom/viewers, at least until it becomes obvious that he might be being framed for the murder that he witnesses. We know it is Tom's POV and not an establishing shot because the metallic fence/door is, albeit blurred, present.

18. Carroll lists some of these possible meanings: "that we like the protagonist; that we recognize the circumstances of the protagonist to be significantly like those we have found or find ourselves in; that we sympathize with the protagonist; that we are one in interest, or feeling, or principle, or all of these with the protagonist; that we see the action unfolding in the fiction from the protagonist's point of view; that we share the protagonist's values; that, for the duration of our intercourse with the fiction, we are entranced (or otherwise manipulated and/or deceived) so that we fall under the illusion that each of us somehow regards herself to be the protagonist" (1990, 89).

19. Carroll acknowledges that it is possible to use "identification" to mean a "sharing of parallel emotive evaluations" (1990, 230). I take it to mean precisely this here.

20. As I have noted, comedy horror works differently, as it intends to make people laugh, often via direct reference to well-known, canonical scenes or well-trodden scenarios. In the cases of the *Scary Movie* series (2000–13), the films may even elicit pleasure through intertextuality and parodic reference.

21. The examples are multiple but see, for example, Tookey (2009) or Platell (2008).

22. A contentious issue itself, since these are mere representations and therefore could only be sadistic at a representational level.

23. This is also applicable to the viewer who inadvertently finds such material. Films that play with corporeal transgression give a warning to their viewers, generally in the form of a pre-credits sequence that sets up the tone for what is to come. The viewer can then decide to stop watching.

24. A similar point has been made in connection to the filmic spectacle more widely, where cinema has been seen as "not a sadistic institution but pre-eminently a contractual one based upon the premise of certain pleasures" (Studlar 1993, 182).

25. There is no space in this book to discuss the gender specifics of such an argument – Clover also calls the form of masochism present in Horror "feminine masochism" to distinguish it from traditional psychoanalytic notions of masochism – but I would contest the feminist bias of this statement.

26. See, for example, Chismar (1988), Neill (1996), Coplan (2004) or Gaut (2010, 260–81).

27. For other aspects, some of them extra-filmic, that affect empathy, see Tamborini (1996, 114–20).

28. Chester Bennington is, of course, the lead singer of *Linkin Park*. A knowledge of this might, if the viewer knows and appreciates the work of the band, skew the emotional response to the scene.

29. Although viewers may be almost certain that Evan will not make it out of the trap, it is inevitable that a certain suspense may colour the scene, especially as time in it is distorted. Viewers will also not know exactly what the chain of events will be if Evan does not pass the test.

30. In other words, the moment is not one of "recognition" by the viewer "of the perception of a set of textual elements, in film typically cohering around the image of a body, as an individuated and continuous human agent", which Smith (1995, 82) sees as part of the structure of sympathy. Instead, it is a recognition of the body as alive, sentient and vulnerable *regardless of the individuating aspects that constitute its owner*.

31. Distractions, aversive stances, poor viewing and sound conditions, extremely unfamiliar cinematic situations (that leave viewers with few points of experiential reference), and impossible or unreal bodily actions will all hinder somatic empathy (Hanich 2011, 109).

32. In fact, the scene can be divided into three parts: exposition, where Jigsaw's strident voice is accompanied by shots that introduce the characters and even an establishing shot; the action, which is a long build-up that covers the thirty seconds Evan has to pull the lever; and the resolution, which shows the prefigured chain of events and the four deaths in a rapid sequence.

33. See Lipps (1965).

34. See Ekman (1982).

35. The facial feedback thesis is not Smith's, but Ekman's.

36. Hanich also argues that, because the "ontological distance" between the viewer and the cinematic world is "unbridgeable", this makes viewers more conscious of their own bodies (2011, 111).

37. For the person in pain, the experience of pain is "'effortlessly' grasped" (Scarry 1985, 4).

38. Her example belongs to a very different social field altogether, since she focuses on Amnesty International's capacity to "transfer" pain onto the body of the newsletter reader by exposing graphically the situation in countries with inferior human rights records (Scarry 1985, 9). The desire to instigate distress and,

more particularly, pain is nevertheless a main feature of contemporary Horror subgenres like the ones analysed in this book.

39. See Scarry (1985, 168–9).
40. I am always referring to physical pain, to the sight of wounds and mutilation. This does not necessarily apply to psychological pain, which can be paraded in television programmes and which has its own cult following. See Morris (1993).
41. Naturally, the Hammer films in the late 1950s also played a role in the mainstream use of bloody and even sadistic images and scenes. See Hutchings (1993, 3–24).
42. *The Texas Chainsaw Massacre, The Hills Have Eyes* (Alexandre Aja, 2006), *The Last House on the Left* (Dennis Iliadis, 2009) and *I Spit on Your Grave* (Steven R. Monroe, 2010S) are good examples. For more on these remakes, see Roche (2015). The last decade has even seen films paying direct homage to exploitation cinema, as in the case of Quentin Taratino and Robert Rodriguez's *Grindhouse* (2007).
43. The only hint that the main characters might be facing a particularly bloody denouement is the picture of Oli's face that appears twenty minutes into the film and is re-sent four minutes later to Paxton's mobile phone with the caption "I go home". The camera follows the image into the torture chamber where it was originally taken and, by pulling outwards from the limits of the picture message, the shot reveals a table where the decapitated head rests. The alleged murderer is, then, seen walking towards his next victim. The moment is significant because it proves Paxton's suspicion that Oli's disappearance was a form of violent kidnapping yet makes that knowledge exclusive to the audience.
44. See Newman (2006, 30).
45. For more on this representation, see Middleton (2010, 12–4).
46. The film makes a point of showing the "price list" written on the back of a business card: an American body is the most expensive to buy at €25,000, compared to that of Europeans (€10,000) or Russians (€5,000). It is unclear, however, whether this is due to specific grudges held against Americans or purely scaled on the basis of exoticism. For example, the Asian Kana (Jennifer Lim) is presented as a special treat (€50,000).
47. They also meet in a pub in Bratislava, where, after the Dutchman has saved him from the local children, Josh apologises for his previous behavior by returning the lap gesture.
48. I mean that there is no clear or topological viewer of this scene, as its extreme detail makes it impossible to align with either the vision of the torturer or that of the victim exclusively.

Bibliography

Aron, Michele. 2005. "Looking On: Troubling Spectacles and the Complicitous Spectator". In *The Spectacle of the Real: From Hollywood to Reality TV and Beyond*, edited by Geoff King, 213–22. Bristol and Portland: Intellect.

Baird, Robert. 2000. "The Startle Effect: Implications for Spectator Cognition and Media Theory". *Film Quarterly* 53.3: 12–24.

Bazin, André. 2005. *What Is Cinema? Volume 1*, translated by Hugh Gray. London, Berkeley and Los Angeles, CA: University of California Press.

Block, Bruce A., and Philip McNally. 2013. *3D Storytelling: How Stereoscopic 3D Works and How to Use It*. New York: Focal Press.

Carroll, Noël. 1990. *The Philosophy of Horror: Or, Paradoxes of the Heart*. London and New York: Routledge.

Chismar, Douglas. 1988. "Empathy and Sympathy: The Important Difference". *Journal of Value Inquiry* 22.4: 257–66.

Clover, Carol J. 1992. *Men, Women and Chain Saws: Gender in the Modern Horror Film*. Princeton, NJ: Princeton University Press.

Contrino, Phil. 2009. "Marketing Horror in 3D: Exhibitors Will Have the Opportunity to Bring 3D Fans and Horror Fans Together with *My Bloody Valentine*". *Boxoffice*, 145.1: 14–5.

Coplan, Amy. 2004. "Empathic Engagement with Narrative Fictions". *The Journal of Aesthetics and Art Criticism* 62.2: 141–52.

Davis, Michael. 1984. "The Mammalian Startle Response". In *Neural Mechanisms of Startle Behaviour*, edited by Robert C. Eaton, 287–351. New York: Plenum.

Deleuze, Gilles. 1991. "Coldness and Cruelty". In *Masochism*, 9–38. New York: Zone Books.

Donnelly, K. J. 2008. *The Spectre of Sound: Film and Television Music*. London: British Film Institute.

Edelstein, David. 2006. "Now Playing at Your Local Multiplex: Torture Porn". *New York Magazine*, 28 January 2006. http://nymag.com/movies/features/15622. Accessed January 2011.

Ekman, Paul, ed. 1982. *Emotion in the Human Face*. Cambridge, UK: Cambridge University Press.

Francis, James, Jr. 2013. *Remaking Horror: Hollywood's New Reliance on Scares of Old*. Jefferson, NC: McFarland.

Gaut, Berys. 2010. *A Philosophy of Cinematic Art*. Cambridge, UK: Cambridge University Press.

Hanich, Julian. 2010. *Cinematic Emotion in Horror Films and Thrillers: The Aesthetic Paradox of Pleasurable Fear*. London and New York: Routledge.

———. 2011. "Mr. Schnitzelicious, the Muscle Man: Somatic Empathy and Imaginary Self-Extension in Arnold Schwarzenegger's Hard-Body Movies". In *Arnold Schwarzenegger: Interdisciplinary Perspectives on Body and Image*, edited by Simon Wendt, Michael Butter and Patrick Keller, 105–27. Heidelberg: Winter.

———. 2012. "Cinematic Shocks: Recognition, Aesthetic Experience, and Phenomenology". In *Amerikastudien / American Studies* 57.4: 581–60.

Hayward, Philip, ed. 2009. *Terror Tracks: Music, Sound, and Horror Cinema*. London: Equinox.

Hutchings, Peter. 1993. *Hammer and Beyond: The British Horror Film*. Manchester, UK: Manchester University Press.

Leder, Drew. 1990. *The Absent Body*. London and Chicago, IL: University of Chicago Press.

Lerner, Neil. 2010. "Listening to Fear / Listening with Fear". In *Music in the Horror Film: Listening to Fear*, edited by Neil Lerner, viii–xi. London and New York: Routledge.

Lipps, Theodor. 1965. "Empathy and Aesthetic Pleasure", translated by Karl Aschenbrenner. In *Aesthetic Theories: Studies in the Philosophy of Art*, edited by Karl Aschenbrenner and Arnold Isenberg, 403–14. Englewood Cliffs, NJ: Prentice-Hall.

Middleton, Jason. 2010. "The Subject of Torture: Regarding the Pain of Americans in *Hostel*". *Cinema Journal* 49.4: 1–24.

Morris, David B. 1993. *The Culture of Pain*. London, Berkeley and Los Angeles, CA: University of California Press.

Neill, Alex. 1996. "Empathy and (Film) Fiction". In *Post-Theory: Reconstructing Film Studies*, edited by David Bordwell and Noël Carroll, 175–94. Madison, WI: University of Wisconsin Press.

Newman, Kim. 2006. "Torture Garden". *Sight and Sound* 16: 28–31.

Pennington, Adrian, and Carolyn Giardina. 2012. *Exploring 3D: The New Grammar of Stereoscopic Filmmaking*. Oxford and Waltham, MA: Focal Press.

Plantinga, Carl. 1999. "The Scene of Empathy and the Human Face on Film". In *Passionate Views: Film, Cognition, and Emotion*, edited by Carl Plantinga and Greg M. Smith, 239–55. London and Baltimore, MD: Johns Hopkins University Press.

Platell, Amanda. 2008. "A Punch in the Face of Decency". *Daily Mail Online*, 15.

Robinson, Jenefer. 1995. "Startle" *The Journal of Philosophy* 92.2: 53–74.

Roche, David. 2015. *Making and Remaking Horror in the 1970s and 2000s: Why Don't They Do It Like They Used To?* Jackson, MI: University of Mississippi Press.

Rosen, Philip. 2001. *Change Mummified: Cinema, Historicity, Theory*. Minneapolis, MN: University of Minnesota Press.

Scarry, Elaine. 1985. *The Body in Pain: The Making and Unmaking of the World*. Oxford: Oxford University Press.

Simons, Ronald C. 1996. *Boo! Culture, Experience, and the Startle Reflex*. Oxford and New York: Oxford University Press.

Skal, David J. 1993. *The Monster Show: A Cultural History of Horror*. New York: W. W. Norton.

Smith, Murray. 1995. *Engaging Characters: Fiction, Emotion, and the Cinema*. Oxford: Clarendon Press.

Sobchack, Vivian. 2004. *Carnal Thoughts: Embodiment and Moving Image Culture*. London, Berkeley and Los Angeles, CA: University of California Press.

Studlar, Gaylyn. 1993. *In the Realm of Pleasure: Von Stenberg, Dietrich, and the Masochistic Aesthetic*. New York: Columbia University Press.

Tamborini, Ron. 1996. "A Model of Empathy and Emotional Reacions to Horror". In *Horror Films: Current Research on Audience Preferences and Reactions*, edited by James B. Weaver, III and Ron Tamborini, 103–23. Mahwah, NJ: Lawrence Erlbaum Associates.

Tan, Ed. 1996. *Emotion and the Structure of Narrative Film: Film as an Emotion Machine*. Abingdon, UK, and New York: Routledge.

Tookey, Chris. 2009. "*Antichrist*: The Man Who Made This Horrible, Misogynistic Film Needs to See a Shrink". *Daily Mail Online*. *http://www.dailymail.co.uk/tvshow-biz/reviews/article-1201803/ANTICHRIST-The-man-horrible-misogynistic-film-needs-shrink.html*. Accessed 24 April 2014.

Tryon, Chuck. 2013. *On-Demand Culture: Digital Delivery and the Future of Movies*. New Brunswick, NJ: Rutgers University Press.

van Elferen, Isabella. 2012. *Gothic Music: The Sounds of the Uncanny*. Cardiff: University of Wales Press.

Filmography

Alien. 1979. UK and USA. Directed by Ridley Scott. Brandywine Productions.

Antichrist. 2009. Denmark. Directed by Lars von Trier. Zentropa Entertainments, Arte France Cinéma, Canal+, Danmarks Radio, Film i Väst, Svenska Filminstitutet and Sveriges Television.

Audition / Ôdishon. 1999. Japan. Directed by Takashi Miike. Basara Pictures, Creators Company Connection and Omega Project.

August Underground. 2001. USA. Directed by Fred Vogel. Toetag Pictures.

Avatar. 2009. USA. Directed by James Cameron. Lightstorm Entertainment, Dune Entertainment and Ingenious Film Partners.

Blood Feast. 1963. USA. Directed by Herschell Gordon Lewis. Friedman-Lewis Productions.

Bolt. 2008. USA. Directed by Chris Williams and Byron Howard. Walt Disney Pictures and Walt Disney Animation Studies.

Borderland. 2007. USA. Directed by Zev Berman. Emmett/Furla Films.

Bunny Game, The. 2011. USA. Directed by Adam Rehmeier. Death Mountain Productions.

Butcher, The. 2009. USA. Directed by Jesse V. Johnson. World Films.

Cabin in the Woods, The. 2012. USA. Directed by Drew Goddard. Mutant Enemy Productions.

Cat People. 1942. USA. Directed by Jacques Tourneur. RKO Radio Pictures.

Descent, The. 2005. UK. Directed by Neil Marshall. Celador Films and Northmen Productions.

Fly Me to the Moon. 2008. USA and Belgium. Directed by Ben Stassen. nWave Pictures, Illuminata Pictures and Le Tax Shelter du Gouvernement Fédéral de Belgique.

Friday the 13th. 2009. USA. Directed by Marcus Nispel. New Line Cinema, Platinum Dunes and Crystal Lake Entertainment.

Friday the 13th: Part III. 1982. USA. Directed by Steve Miner. Paramount Pictures Inc., Georgetown Productions Inc. and Jason Productions Inc.

Grindhouse. 2007. USA. Directed by Robert Rodriguez, Quentin Tarantino, Rob Zombie, Edgar Wright, Eli Roth and Jason Eisener. Troublemaker Studios and the Weinstein Company.

Halloween. 2007. USA. Directed by Rob Zombie. Dimension Films, Nightfall Productions, Spectacle Entertainment Group, Trancas International Films and Screen Gems.

Hatchet. 2006. USA. Directed by Adam Green. ArieScope Pictures, Radioaktive Film and High Seas Entertainment.

Hills Have Eyes, The. 2006. USA. Directed by Alexandre Aja. Dune Entertainment and Major Studio Partners.

Hostel. 2005. USA. Directed by Eli Roth. Revolution Studios and Beacon Pictures.

Hostel: Part II. 2007. USA. Directed by Eli Roth. Raw Nerve and Next Entertainment.

Hostel: Part III. 2011. USA. Directed by Scott Spiegel. Next Entertainment, Stage 6 Films and RCR Media Group.

House of Wax. 1953. USA. Directed by André de Toth. Bryan Foy Productions and Warner Bros.

I Spit on Your Grave. 2010. USA. Directed by Steven R. Monroe. CineTel Films.

It Follows. 2014. USA. Directed by David Robert Mitchell. Animal Kingdom, Northern Lights Films and Two Flints.

Journey to the Center of the Earth. 2008. USA. Directed by Eric Brevig. New Line Cinema and Walden Media.

Ju-on: The Grudge / Ju-on. 2002. Japan. Directed by Takashi Shimizu. Pioneer LDC, Nikkatsu, Oz Co. and Xanadeux.

Last House on the Left, The. 2009. USA. Directed by Dennis Iliadis. Midnight Entertainment, Crystal Lake Entertainment and Scion Films.

Mama. 2013. Spain and Canada. Directed by Andrés Muschietti. Toma 78 and De Milo Productions.

Megan Is Missing. 2011. USA. Directed by Michael Goi. Trio Pictures.

My Bloody Valentine 3D. 2009. USA. Directed by Patrick Lussier. Lionsgate.

My Bloody Valentine. 1981. Canada and USA. Directed by George Mihalka. Secret Film Company.

Paranormal Activity. 2007. USA. Directed by Oren Peli. Blumhouse Productions and Solana Films.

Piranha 3D. 2010. USA. Directed by Alexandre Aja. The Weinstein Company, Atmosphere Entertainment, Chako Film Company and Intellectual Properties Worldwide.

Poltergeist. 2015. USA. Directed by Gil Kenan. Metro-Goldwyn-Mayer, Ghost House Pictures, TSG Entertainment and Vertigo Entertainment.

Quiet Ones, The. 2014. UK. Directed by John Pogue. Hammer Film Productions.

Rear Window. 1954. USA. Directed by Alfred Hitchcock. Patron Inc.

[•REC]. 2007. Spain. Directed by Jaume Balagueró and Paco Plaza. Filmax International.

Saw VI. 2009. USA and Canada. Directed by Kevin Greutert. Twisted Pictures.

Saw 3D: The Final Chapter. 2010. USA and Canada. Directed by Kevin Greutert. Twisted Pictures.

Scar. 2007. USA. Directed by Jed Weintrob. Norman Twain Productions.

Scary Movie. 2010. USA. Directed Kleenen Ivory Wayans. Wayans Bros. Entertainment, Gold/Miller Productions and Brad Grey Pictures.

Snuff-Movie. 2005. UK. Directed by Bernard Rose. Capitol Films.

Texas Chain Saw Massacre, The. 1974. USA. Directed by Tobe Hooper. Vortex.

Texas Chainsaw Massacre, The. 2003. USA. Directed by Marcus Nispel. Radar Pictures, Platinum Dines and Next Entertainment.

Tortured, The. 2010. Canada and USA. Directed by Robert Lieberman. LightTower Entertainment, Twisted Light Productions and Twisted Pictures.

Turistas. 2006. USA. Directed by John Stockwell. 2929 Entertainment.

Conclusion
Horror Film and Affect

This book has followed a corporeal-affective model of viewership to read Horror and assess the degree to which human corporeality is involved in the affective exchanges between viewers' bodies and Horror. The main goal has been to determine how Horror affects viewers by attacking their bodies on more than one level, primarily at somatic, emotional and cognitive ones. The focus has remained the moment where the intradiegetic body of the victim is explicitly attacked and/or under threat, and the images that tend to accompany these moments in graphic Horror, that is, open wounds, severed members, cuts or gashes. However, I have more broadly analysed the role of the body to the experience of Horror, especially how the genre often models itself to fulfil certain affective expectations. Post-millennial Horror has provided a good illustrative source because, among other things, it is more explicit and has found new and increasingly realistic ways of conveying violence and carnage.

I began by considering how the Horror body, one which has, representationally speaking, often been studied under the lens of Gender Studies, can be understood to be ungendered in its elicitation of affect. My starting point were theorisations of abjection, especially the work of Creed and her reliance on a psychoanalytic framework that foregrounds archetypal notions of the female body. Advocating for a more open and corporeal understanding of affection as fearful disgust encouraged by the moment of encounter with the wounded, bleeding or otherwise exposed body, I proposed that abjection is an important part of the representational work of affect. The broken body on screen can have an almost direct and instinctive effect on viewers by appealing to the human ability to understand and project sensations of pain and corporeal distress. These images of abjection raise a challenge to essentialist readings of Horror that insist on the gendered nature of the victims on display and which can accidentally foreground titillating or even sadistic drives that run counter to the film's intention: to affect the readers negatively. The first chapter represented, in this way, an approximation to the affective side of representation that sought to account for, and legitimise, the value of a corporeality that is essentially fleshy. My contention has not been that Horror is ungendered or disinterested in gender, or that analysing gender should not be a priority for Horror critics. Rather, what I have proposed is

that these gendered readings, where they are most relevant, should deal with the thematic preoccupations of films. Horror can, of course, be interesting for what it cannot say or must repress, but this is different from arguing that certain monstrous, broken, suppurating or bleeding bodies affect us because they are female in essence or because they exploit that sex's biology. Broken female bodies can affect us because they foreground images of abjection (understood as fearful disgust) or, if monstrous, due to the danger they pose to the intradiegetic character and the viewer. Horror, as in the case of *Ginger Snaps*, can be said to do both: to affect via images of abjection and to put forward a significant message about the teenage female body. Both levels of representation should not be collapsed.

My discussion then moved towards a broader consideration of the emotional spheres of Horror as they affect the viewing body. First and foremost, what preoccupied me here was establishing threat as the most important emotional state present in the Horror experience. The genre uses cinematic techniques to ensure that viewers are emotionally affected by the film, one of the most significant ones being dread. Dread, as an emotional state premised on the possibility of external harm, articulates the viewing experience in scenes that both align the body of viewers with the body of the victim(s) (directly – by, for example, using POVs – or indirectly – using music, creating a mood) and may affect them directly (via startle effects). At stake here is the difference between the various layers of affect in the Horror experience. The negative affects of Horror can be productively, in the interests of concision, brought together under the term fear, but it is important, in order to understand the specificity of Horror's affective work, to pay closer attention to the varieties of emotional states encouraged by its various techniques. Equally important is to be able to distinguish emotional states from more somatic ones, as reflection plays an important part in emotional reactions but not in somatic ones. In order to assess the role of emotion as a processual state sometimes involving greater cognition, I turned to two emotions of self-assessment, guilt and shame, which have been used, especially in contemporary and post-modern Horror, to generate further affective impact. Thus, by asking viewers to assess and judge their complicity within the fictional exchange, some Horror films can make viewers feel even more touched and upset by the same images or scenarios.

Lastly, I turned to the somatic level of Horror. I began by analysing the most somatic of reactions to moving images: the reflex responses generated by the startle effect. Arguing for the relevance and ubiquity of this technique as one that is addressed at the viewer directly – and thus does not strictly require an intradiegetic avatar – allowed me to expand on the cognitive models of identification that have been used to define the Horror encounter. Relying on the work of Julian Hanich, I moved to an exploration of the various types of mimicry that come under somatic empathy and suggested that the connection between Horror and film relies predominantly on one of identification with the body of the victim and not with the victim's

personality. This means that the body of the victim is apprehended and made intelligible by making use of emotional and other cognitive processes involved in, and developed through, our interaction with the real world and other viewers. A human predisposition towards somatic empathy, coupled with the projective qualities of pain – images of which have predominated in contemporary Horror – mean that it is possible to argue that corporeal threat and harm in Horror can be felt on a somatic plane (hair rising, goosebumps, spine chilling shudders). In a sense, my intention here was to re-establish the somatic side of affect to the emotional encounter I had begun to analyse in Chapter 2. Horror never exclusively relies on sympathetic connections but is more evidently concerned with creating somatic pathways between the bodies on the screen and those of the viewers. The Horror film is a source of negative affect that does everything it possibly can to connect the viewer with the victim and simulate moments of vulnerability dependent on corporeal intelligibility, particularly of the results and effects of pain.

Considering the affective-corporeal side of Horror has a number of benefits that make it an important approach and one that can be applied alongside a number of others, for example, the socio-political approach. In itself, it foregrounds the degree to which Horror is corporeally experienced, its reach beyond the ideological and its more nuanced, often neglected, somatic effects. This dimension of Horror is overlooked because it is felt to be of little interest or to lead to self-evident results, but I have shown that the opposite its true: the methods used by a film in order to affect viewers in a specific way may, as in *Hostel*, tell us a number of things about the implication of the viewer in the cycle of violence and provide a neater picture of the precise workings of a film. Horror that focuses on the body – and I mean that explicitly focuses on it, as all Horror, like all cinema, engages the body of the viewer – merely brings this to the fore. But what specifically can be gained from a narrower focus on affect when studying Horror? In these last few pages, I want to turn to the potential implications and applications of the work carried out in this volume.

What Horror Can Tell Us About Affect

I have analysed affect from three different angles that have accounted for its various levels: the representational, the emotional (and cognitive) and the somatic. The point was, first, to show that the affective experience is an incredibly complex concept inextricable from the way we perceive the world and our bodies. It has also allowed me to exemplify how affect forces us to come into contact with aspects of our corporeality that either lay suppressed or else are only ever invoked in moments of pain or distress. These moments do not simply exemplify the corporeal side of affect but legitimise our continued investment in forms of entertainment that promise negative experiences. Exploring how affect works and why people are interested in it can help us dig deeper into the human need for fictional and mediated forms

of distress, whether strictly corporeal or emotional. Affect, in other words, can feed back directly into discussions around the use, meaning and value of entertainment often presented as vapid and even dangerous. In many respects, an engagement with the nature of affect, introduced here by the very specific example of Horror and its effects on the bodies of viewers, opens a door to new possibilities for thinking about upsetting fictional experiences as necessary for human beings.

Second, I wanted, concomitantly, to show the need to separate the various affective levels so as to account for them and complicate simplistic models of identification. This was a significant challenge, and the various chapters have strongly relied on one another and inferred that total separation of representational, emotional and affective spheres is impossible. Thus, one of the points I have made is that affect is not reducible to a discrete emotion but must be understood as a joint, multifaceted, layered experience bringing together a number of biological and thought processes into the experiential encounter with moving images. Focusing on Horror, especially on singular instances where Horror appeals to the emotional, the somatic and the cognitive, has painted a clearer picture of affect as more than a dispositional state. The body, its psychosomatic dimensions insofar as we can understand and explain them, needs to be an inherent and strong part of accounts of affect, whether this be cinematic or real. This is a reason why Affect Studies would benefit from turning to neuroscience and other empirical methods of observation that unravel the ways in which psychology is eminently corporeal. This should translate into a strong questioning of approaches to aesthetics that may continue to give priority to models of research based on deep psychology, repressed (libidinal) desire and abstract terminology beyond the realm of the visible and measurable.

Horror, with its intense and unfailing investment in corporeality, is a perfect testing ground for affect of the fictional variety. Insights gained from turning to cinematic techniques, such as use of colour, camera lens and filters, camera angle, shots and editing, mise-en-scène or performances, are important in identifying the processes whereby corporeal allegiance with fictional bodies is created. Since Horror is an intense and affect-driven genre, it naturally provides numerous examples of artistic excitation and can be studied to determine the links between scenes and their ideal effects on viewers. Beyond the theoretical scope of this work, it would be possible for Horror to be of interest to sociologists seeking to prove the effectiveness of cinematic techniques intended to bring the viewing and the fictional bodies closer at an experiential level. Experiments measuring reactions to Horror inevitably face the problem that extracting participants from a specific viewing context and transplanting them into a laboratory or scientific setting might alter results such as brain waves. Focusing on the film, alongside quantifiable data extracted from test subjects, will continue to provide us with, at least, part of the intentional picture. An awareness of the various levels of affect will, no doubt, help inform the reading of any data thereby gathered.

What Affect Can Tell Us About Horror

Affect allows us to consider Horror to be in consonance with its obvious purpose: to have an effect on viewers. In other words, it allows for a sincere and honest reading of the genre that takes into account the obvious intentions of the filmmakers and, ultimately, of the film itself. As I have shown, Horror tends to foreground its affective capacities and even use them largely in the marketing campaigns of certain films or in the ready assimilation of immersive techniques such as 3D. Approaches that complicate the meaning of certain images and narrative instances to uncover repressed meanings run the risk of intellectualising Horror to the point where it loses contact with its makers and audiences. Whilst the role of the Horror critic must continue to be to facilitate readings and illuminate on the role and value of Horror, there is a certain journalistic sense or intent that must not be lost if the entire endeavour is to remain useful beyond academia. Abstract readings of Horror that foreground latent messages are helpful in identifying further layers of meaning in the texts, but these are sometimes carried out at the expense of the viewer's experience or enjoyment. This means that, unlike socio-political readings, which focus on a text's importance due to (a) the ways in which it reflects or projects contemporary political or social anxieties or (b) the ways it challenges established normative notions of whichever description (class, gender roles, sexual expression), the affective-corporeal model does not ground a text's effects and potential in its past. Older Horror can affect the contemporary viewer in the same way that contemporary Horror can. This is not to say that affect is ahistorical, as it is strongly rooted in the present. In fact, affect makes it possible to trace developments and continuities not just in its cinematic language but in the areas or topics that have historically been considered taboo or left out of film history. Such an analytical exercise can tell us a lot about the status of the body and our relationship with its harming and destruction. As I explained in the Introduction, it is possible to read the intensity of violence, as visited on the fictional body, as indicative of shifts connected to our own relation to corporeality. A greater sense of the importance of the physical body has led to cinematic nightmares that posit it as the most important locus of Horror: to lose our body is to lose most, if not all, of us.

In its prioritising of a conception of Horror that is, first and foremost, premised on the effects that the film would ideally have on the cooperative viewer, an affective-corporeal model allows us to also understand the interest it awakes in, for example, Horror fans. These, due to their cultural capital, are likely to be some of its harshest critics, so underscoring the novelty of films that have been successful with general and fan audiences can help us determine not just what is innovative about the film thematically but whether this translates into specific techniques. Ultimately, an affective-corporeal model can ascertain the value of the overall experience for viewers – "how and why was I affected by this film?" – and provide stepping stones for the consideration of Horror's phenomenological complexity. Affect can

elucidate the practices of fans who watch low-budget Horror knowing that they will find it less than polished, namely, fans who self-consciously like and even appreciate "bad" Horror. The experiences of these subjects will naturally be different in that they will have a more markedly aesthetic relationship to the images, and fans likely to analyse films for directorial touches or evaluate them using other criteria. However, there is an affective core at the heart of these operations that still relies on the knowledge and expectation that Horror will scare, shock, disturb or repulse, that it will threaten viewers and their bodies. Affect, therefore, can potentially be applied successfully in Audience Studies and create an important bridge between the critic, the occasional viewer and the fan. It can provide insights into the pleasures to be found in the appreciation of difference and repetition, and into the affective kernel that makes Horror the genre it is.

It is this last point that I think is of utmost significance. Establishing a form of pleasurable negative affect on the body, the feel of threat, as the distinguishing feature of Horror can be of use in pinning down what has knowingly been a treacherous genre to essentialise. Rather than emphasise thematic concerns or aesthetic tropes that push the genre into an all-too-formulaic box, an affective understanding of Horror allows for a pluralistic view of it that simultaneously grants its many and multiple incarnations their own specificity. I am not suggesting that single instances of negative affect – the capacity to feel our bodies affected by images designed to do so in unpleasant ways – are sufficient to determine a film's generic affinities, but that Horror may best be understood as the genre that does this most assiduously, most viciously and, in graphic Horror, in most detail. Affect can be a useful means of returning to a working definition of Horror that has meaning for its viewers, both the casual ones and the hardcore fans. If to speak of corporeality and Horror is to speak of the subject and its historical contingencies, then a closer look at affect reveals an ontological picture not unlike that exposed by the cognitivists and phenomenologists when regarding our experience of the world and ourselves more largely. The body, and its inextricability from mind and thought, has grown to become the main character of the Horror film. Exploring its contingencies and limitations is not tantamount to a disheartening assertion of its limits but rather to a continued process of self-discovery that is both committed and intimate.

Index